New
Museums
and
the
Making
of
Culture

New
Museums
and
the
Making
of
Culture

Kylie Message

Oxford • New York

First published in 2006 by
Berg
Editorial offices:
1st Floor, Angel Court, 81 St Clements Street, Oxford, OX4 1AW, UK
175 Fifth Avenue, New York, NY 10010, USA

Berg is the imprint of Oxford International Publishers Ltd.

Library of Congress Cataloging-in-Publication Data

Message, Kylie.
 New museums and the making of culture / Kylie Message.
 p. cm.
 Includes bibliographical references and index.
 ISBN-13: 978-1-84520-453-2 (cloth)
 ISBN-10: 1-84520-453-0 (cloth)
 ISBN-13: 978-1-84520-454-9 (pbk.)
 ISBN-10: 1-84520-454-9 (pbk.)
 1. Museums—Social aspects. 2. Museums—Political aspects. 3. Museums—Philosophy.
4. Popular culture. 5. Political culture. 6. Culture—Philosophy. I. Title.

 AM7.M467 2006
 069—dc22
 2006026656

British Library Cataloguing-in-Publication Data

A catalogue record for this book is available from the British Library.

ISBN-13 978 1 84520 453 2 (Cloth)
ISBN-10 1 84520 453 0 (Cloth)

ISBN-13 978 1 84520 454 9 (Paper)
ISBN-10 1 84520 454 9 (Paper)

Typeset by JS Typesetting Ltd, Porthcawl, Mid Glamorgan
Printed in the United Kingdom by Biddles Ltd, King's Lynn

www.bergpublishers.com

CONTENTS

I first came across the term 'survivance' in the National Museum of the American Indian (NMAI) in Washington DC. A narrative panel displayed at the start of an exhibition called *Our Lives* explained:

> Survivance
> ...is more than survival. Survivance means redefining ourselves. It means raising our social and political consciousness. It means holding onto ancient principles while eagerly embracing change. It means doing what is necessary to keep our cultures alive. The term was first put forward by Anishinaabe scholar Gerald Vizenor in his book *Manifest Manners: Postindian Warriors of Survivance* (1994). (NMAI wall text) (Figure 1)

The focus on cultural self-determination and self-representation did not, in the context of this just-opened museum, surprise me in any way. The NMAI opened in 2004 in a new building designed through an expansive collaborative process that included Douglas Cardinal (Blackfoot) Ltd and GBQC, Native design consultants Johnpaul Jones (Cherokee/Choctaw), Ramona Sakiestewa (Hopi) and Donna House (Navajo/Oneida), architecture firms Jones & Jones, SmithGroup in association with Lou Weller (Caddo) and the Native American Design Collaborative, and Polshek Partnership Architects. The concern with cultural politics and symbolism that motivated its design has also been infused throughout the museum (Figure 2). The main exhibition spaces integrate religious, mythical, and environmental themes and present a series of displays that have been produced by diverse communities via the facilitation of 'community curators' and a variety of delivery mechanisms including video, contemporary art and interactive digital technologies (Figure 3). The museum's overall effect is of a constellation of individual and collective voices that have been articulated though a process of collaborative decision making that is epitomized by the *Welcome Wall*, where hundreds of written and spoken words meaning 'welcome' in Native languages from throughout the Americas are projected onto a 23-foot screen above the Welcome Desk inside the entrance. These voices, and the objects and stories that they speak through and for, have been collected for the common purpose of political advocacy: advocacy for cultural rights including the recognition and repatriation of heritage and the preservation of language, and advocacy for human rights including access to health, education, employment and housing services as well as restitution for the illegal land seizures of the colonial period. Authorship is highly valued here and, unlike many museums across the world, curators and contributors are acknowledged by name throughout the text-heavy displays.

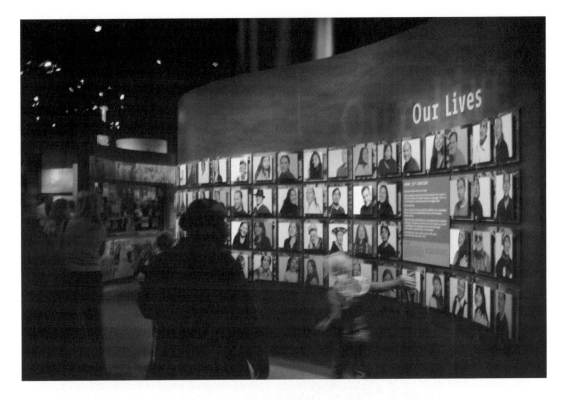

1: *Our Lives* exhibition at the National Museum of the American Indian. Photograph by Kylie Message.

What did jar, however, was the stark contrast that seemed to exist between the NMAI – which presents itself in the mode of museum as activist – and its context: the National Mall in Washington DC. It is not easy to reconcile the NMAI with the other museums located on the Mall, or the multitude of memorials that celebrate the sacrifices made by the war dead and the contribution of past presidents. Inflected by patriotic commemoration and a sentimental reflection of the past, these themes are also reiterated by the nearby National Museum of American History (NMAH) through exhibitions that include the recently opened *The Price of Freedom: Americans at War*. What does it mean that the NMAI, as a highly political and in many cases interventionist museum, is located at the nation's symbolic heart alongside some of the most historically compelling and convincing symbols of American identity? This disparity is acknowledged by the tone of the explanatory labels used by the NMAI, including this one in the *Our Lives* exhibition:

> Survivance is often about making choices.
> Over the past 500 years, Native Americans have been robbed of most of our land and inheritance. While the Americas include some of the wealthiest nations on earth, its indigenous people are among the poorest of the poor.

2: Exterior wall, the National Museum of the American Indian.
Photograph by Kylie Message.

3: Exhibition text, the National Museum of the American Indian.
Photograph by Kylie Message.

Yet Native peoples are rich in culture and community. To remain connected to land, tradition, and each other, we must often make tough choices in a daily struggle with poverty.

In some cases that can mean having to send our children into the mines. In other cases, it can mean bringing gaming into our community.

But if we no longer lived together as a people, we would lose what is truly valuable.
(Jolene Rickard, guest curator; and Gabrielle Tayac, wall text, NMAI 2004)

This contradiction seems to position the NMAI as engaging with the question posed by Ruth Phillips about whether the 'growing popularity of collaborative exhibits' can provide 'a new era of social agency for museums'. If not, does this trend 'make the museum a space where symbolic restitution is made for the injustices of the colonial era in lieu of more concrete forms of social, economic and political redress?' (in Clifford 2004: 22). This motivated me to think about how the political agenda apparent here may be understood in relation to other museums on the Mall, including the less challenging approach to history that is deployed within the NMAH (and the History Channel programmes that it incorporates throughout many exhibitions).

It is common for a disjuncture to exist between museums (as signifiers of high culture) and the quotidian environment that they are at once located within but from which they may seek to maintain a separation. It is, for example, impossible not to recognize such a distinction between the hundreds of homeless men living in cardboard box shanties around the edges of Ueno Park in Tokyo and the opulent Tokyo National Museum (with its extraordinary gardens and armed guards) located opposite. However, for the NMAI, a place on the Mall also means that its political positioning gains a degree of legitimization. Surrounded by iconic institutions, the imposing World War II Memorial that also opened in 2004 (Figure 4), and the older National Air and Space Museum, the NMAI becomes part of the positivist and progressive image of America that is promoted here. Rather than understanding this as the subsumption of difference by the state, however – given that this series of complexities and paradoxes does recur for museums globally (especially for museums located on or nearby public squares or gardens) – I would suggest that the continued existence of a rupture between the conflicting agendas of the NMAI and its neighbouring museums is productive. Rather than attempting to smooth out such distinctions, they can be viewed as important in that they bring a certain heterogeneity to key national spaces like the Mall – a heterogeneity that participates fundamentally and directly in the production of national identity and its various imaginaries.

The NMAI's place on the Mall may also work to reject the order of dispossession that has traditionally regulated the distinction between geographically distant, colonial or rural communities and the privileged urban metropole (National Museum of the American Indian 2000; Gulliford 2000; Deloria 1998). Imperial collections (such as the Musée National des Arts d'Afrique et d'Océanie in Paris) have also traditionally been housed at the heart of metropolitan centres and it is interesting to see that this continues to be the case with the

Musée du Quai Branly (2006), which displays anew the outdated Musée de l'Homme's collections of colonial souvenirs (Aldrich 2005). However, the difference between these examples is that the NMAI aims to achieve a form of self-governance, where the majority of stakeholders and staff identify as American Indian. Not only does this effect a remapping of this iconic strip of land to include previously invisible Americans – it asserts the ongoing importance of discussions about the relative power of the centre and margin. It is imperative to continue this discussion because this same inequality of power threatens to continue to inform discourses that privilege non-urban cultural centres and ecomuseums. This means

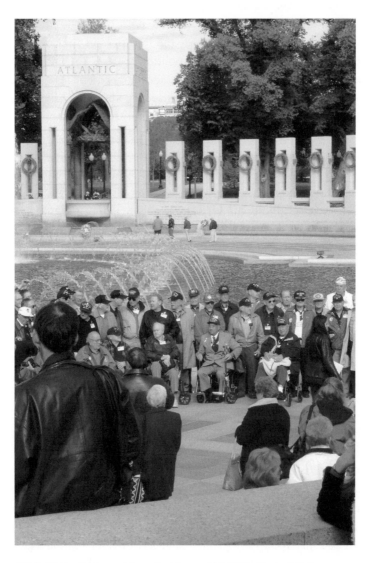

4: World War II Memorial on the National Mall, Washington DC.
Photograph by Kylie Message.

that museums are 'brimming with unresolved cultural contradictions and social conflicts that deserve to be studied more carefully' (Luke 2002: 230) but it is these discrepancies that may in fact enable museums to present a more transparent approach in regard to their relationships with power and pedagogy. Moreover, as the NMAI and its location make clear, the existence and transformation of these inconsistencies is closely related to the socio-political trends and dialogues of the day. Understanding this relationship within and between individual museums and their national and global context is vital for museums, the authority they reflect, the spaces they offer and the publics they produce.

Thinking productively about the dislocation that exists between the NMAI, the National Mall, and the other museums and memorials along this strip, the term 'survivance' might also be seen as an awkward but somehow apt metaphor to describe the changes undergone by contemporary museums. This term has certainly worked in relation to the NMAI, which was designed to be a self-aware, defiantly new and un-mausoleumlike, exhibitionary apparatus (Figure 5). The museum is tied to the preservation and promotion of American Indian cultural heritage (instead of replicating the ethnographic practices of the past) but its organization, structure, content and form have themselves been revived according to the renewed interest in its collections and what they represent. The director of the NMAI, Richard West, Jr, accounts for this shift by explaining that museums 'have become more and more responsive to the communities they serve and the cultures they represent. Changes in museum sensibilities have come about very much as the result of a vigorous ongoing debate' (in National Museum of the American Indian 2000: 8). A wall text within the museum quotes Paul Chaat Smith who says, 'Native peoples reshaped their cultures and societies to keep them alive. This strategy has been called survivance.' This means that in being actively recruited by people and communities who have in the past been either excluded from or contained by museums, these newly reshaped and reconfigured exhibitionary contexts provide tools central to political campaigns of recognition, reconciliation and restitution. They also give museums – as nationally symbolic institutions of living cultures – another chance.

BEYOND THE MAUSOLEUM

'Museum', therefore, is a word acquiring new significance as the twenty-first century gets nearer, and is likely to be a key term in the wider debate over what it means to live in an old continent. Not the museum in the narrow sense of a particular building or institution, but as a potent social metaphor. (Lumley 1988: 2)

Aiming thus to consider the ways that museums relate to the various intersecting socio-political, economic, geohistorical and cultural components that contribute to their production and popularity, my intention has been to create a big-picture book that brings a wide range of globally relevant museums constructed in the last decade into a shared dialogical space. My particular objective and concern in writing *New Museums and the Making of Culture* has been to consider how each of the museums discussed has attempted

5: Promotional banner at the National Museum of the American Indian.
Photograph by Kylie Message.

to balance the tensions arising from the needs of its local context with the often competing demands of the transcultural discourse with which it also seeks engagement. Through mapping the transformations (and the associated shifts in levels of socio-political awareness) that have occurred in museological thought between the early 1990s and the present day in these institutions, I argue that a new museum has emerged as a result of substantive changes in thinking, approach and development. These shifts are practical (caused by changes within professional museum practice and cultural policy), theoretical (a result of the increasing appropriation of museums by scholars of cultural studies) and symbolic (connected to the changing relationship between the museum, the state and other authoritative organisations). They are represented by a clear articulation of the relationship between the museum as a discursive model and the various discourses that have appropriated it as a signifier of something else. Maintaining this distinction between museum and metaphor is important because it offers yet another framing device to provoke and structure analysis of the inter-implication evident between these terms. This may contribute to understanding the role

played by rhetoric in the construction of social and cultural meaning beyond the space of the exhibition. *New Museums and the Making of Culture* interrogates the relationships that this field and style of language have with the museum. Through this study of rhetoric and effect, I explore how these modes of speaking have been incorporated into the ways that writers address the museum, to ask if we now understand – or even expect – museums to function differently.

NEW MUSEUMS, LANGUAGE AND REFORM

New Museums and the Making of Culture aims to locate the rhetorical statements produced by new museums in the context of those made by other similar institutions past and present and by the academic fields of museum studies, cultural studies and other related disciplines. I evaluate the actual representational strategies used by new museums against these claims – strategies that come to appear as increasingly generic modes of compelling but not necessarily affective discourse. This is the task of Chapter 1, in which I engage critically with the theoretical context surrounding new museums. I suggest that the compulsion to be new is associated with a postmodern linguistic turn that is increasingly apparent in museum practice and responsive to academic discourses such as cultural studies. In Chapter 2, I present a case study of the 2004 renovation of the Museum of Modern Art (MoMA) to argue that, throughout its production process, this art museum aspired to exemplify a highly self-conscious image of postmodern newness above all else. I analyse the ways that this encompassing effect has been achieved and suggest that it may in fact owe more to the ongoing project and metanarrative order of modernity than it does to a loudly proclaimed postmodernity. The Museum of Modern Art is an exemplary case study for this discussion because it reveals the tension existing in new museum projects between modernity and postmodernity at theoretical as well as architectural and ideological levels. The key point here is that while 'the modern' has been made new again, 'the new' is also being made new again by remodernizing different interests and rhetorics.

Chapter 3 expands MoMA's penchant for newness against its own history. I explore the project of modernity as it emerged throughout the international exhibitions and world's fairs of the nineteenth century and the late modernity that was championed by MoMA throughout the twentieth century. Foregrounding the links between the early international exhibitions and public museums emerging at this time, this chapter considers the changing perception of 'the public' to note the shift away from more traditional private and princely collections. Not only was the trend for an ongoing newness a key characteristic of modernity but it was made possible by the new technologies, strategies of exhibition and display and the consumer tastes that accompanied these. Occupied principally by the interconnected pedagogical agenda of state-governed national aggregation and class education – whereby the new working classes in Britain and the new subjects of empire from colonial centres were 'civilized', these programmes articulated the objective of asserting a highly aspirational, collective sense of national identity.

As archetypal symbols of modernist progress, the international exhibitions offered innovative new technologies so that the public could engage with and experience spectacles of ethnography, culture, and conspicuous consumption. Rather than being replaced altogether by a renewed postmodern consciousness, this ideological framework of progress, class reform and national aggregation has maintained a dominant role in museums and museumlike institutions that continue to function as instruments of governance. Chapter 4 demonstrates how the ideological foundations of modernity have continued to impact on sites of national significance by presenting a case study of the plans proposed for, but later dropped from, the International Freedom Center (IFC), which had been designed as a central component of plans to rebuild Ground Zero in New York. Like MoMA, the international exhibitions, and the other museums discussed here, the rhetoric surrounding the IFC's plans privileged the effect of newness, yet, like many of these examples, this effect, it seems, was to be produced out of the elaboration of a series of strategies that are more modernist in typology if not form.

The IFC is an extreme case study, given its relationship with commemoration and the highly charged public sphere that formed in response to the events of September 11. Not only was the IFC debilitated by the complicated politics of New York City in the wake of September 11, but the entire rebuilding process has had to contend additionally with the complex politics of the World Trade Center (WTC) before September 11, the confused efforts to rebuild at the WTC site since then, and a multitude of Manhattan-related economic concerns. However, by providing a point of nexus for this collection of forces, the IFC case study clearly demonstrates how exhibitionary contexts continue to function as instruments of governance, indicating also the ongoing importance of programmes that contribute to the consolidation of a national imaginary. The diversity of interests seeking representation in the process of rebuilding the WTC site and the conflicts over politics of the global and local has clearly impacted across all levels and stages of the rebuilding project. However, in this book I can focus only on the IFC and the way in which the themes of local agency, policy directives such as cultural diversity and the pressure for producing a demotic and inclusive space for commemoration have been played out. Through a comparison with the Museum of the Chinese in the Americas (MoCA), I argue that a significant change can be seen to have occurred in relation to the project of reform at key cultural sites. In these museums and museumlike spaces, the focus of reform has shifted away from issues of class to privilege instead programmes of cultural diversity that encourage tolerance of racial difference.

In the penultimate chapter I present a case study of the Centre Culturel Tjibaou (CCT) in Nouméa, New Caledonia and investigate whether the singular progress-oriented narrative of Western modernity might be challenged by reconstructing the museum according to a cultural centre model, or whether the reality of local politics overlaid with global pressures conspire to make this yet another configuration of the ever-new (ever-modernist) museum. I look in particular at the forward-looking ideology adopted by the CCT and examine

whether this approach has enabled it to engage both with other new museums globally and with the political and social objectives associated with New Caledonia's independence struggles of the 1980s. I explore the features of the cultural centre: its relationship with the French government, its juggling of tradition and modernity, and the multitude of varying responses that the centre has received since its opening in 1998. I argue that the CCT has itself become an important and progressive – albeit highly complicated – symbol for a territory undergoing change and that, by looking at how these discussions occur both within and in relation to the centre, we can clearly identify the role that museums play in the constitution of culture.

Bringing the preceding points of discussion into close analysis, Chapter 6 offers a case study of the Museum of New Zealand Te Papa Tongarewa (Te Papa). I argue here that it is possible to identify the way some new museums may attempt to break with a fundamentally modernist narrative to engage more accurately with issues of cultural diversity. This is in fact why Te Papa was designed as a cultural centre, and this explains why it seeks to engage with local communities in more specific ways. Resulting generally from the ethnopolitical dynamics underlying the historical relationship between New Zealand's Maori and European settler populations, the status of New Zealand in the British Empire and the Commonwealth, and Wellington's neoliberal turn in the 1980s, Te Papa is fascinating for the way it presents newness as both a conceptual framework and as a methodology that is fundamental to the structural organization, development and design of all facets of the institution. Indeed, this preference for newness is also indicative of a more particular set of complexities, from New Zealand's ensuing structural reforms, from its political economy, electoral system, and foreign policy to its hi-tech 'knowledge economy' aspirations and the debate over the constitutional authority of the Treaty of Waitangi and the Crown respectively. This collation of effects and outcomes may conspire to make Te Papa the most emblematic of new museums presented here but this museum-as-cultural centre is also most interesting for the way in which it has been designed to promote cohesion between museological and social policy goals that each aim to seek the reformation of the national corpus under a binational framework. Emerging primarily as a result of the changing reform project, Te Papa marks a shift in the project of making national museums, which now aspire to construct an even more contemporary and relevant effect that strikes through the rhetorical claims of the reconfigured modernist museum by engaging with local concerns. Seeking to produce an affective public sphere for dialogue and debate, this last chapter explores whether Te Papa's recent rehearsals of the new museum-as-cultural centre is perhaps the newest moment of the ongoing project of modernity.

As my range and discussion of examples indicates, the 'new museum' exists not just as a model but as a museum that has been constituted as a fundamentally crossdisciplinary institution and a series of effects initiated by changes in the ways it has been presented and discussed. Exploring these alternative approaches and their consequent manifestations, I assert that any representation of the museum as a useful cultural paradigm also requires

serious discussion according to the museum's own languages and modes of expression. Looking at the rhetorics surrounding the new museum, it is important to question what the new museum is (or might be), what it offers and to whom. Central to this is the analysis of the ways that museums – as institutions traditionally understood to be re-presentational and reflective in their vision – have, in fact, played a key role in the production of culture beyond their walls. Crossing from the sphere of academic discourse to the fields of cultural policy and politics, *New Museums and the Making of Culture* presents case studies that focus on the ways in which principles such as cultural diversity and cultural sustainability are applied by and presented in new museums and how specially formulated social policy goals are directed toward interrogating the relationship between the new museum model and the contemporary cultural conditions and context that it reflects and to which it contributes.

NEWNESS

A core theme of this book centres on examining how and why newness itself is always being redefined, reinvented or revitalized. While, for instance, the cluster of innovative discourses and practices today circling around and privileging newness reflects significant shifts in global economics, nation-states, and local communities, I am concerned to explore how and why these are expressed through cultural institutions like museums that consciously privilege official multiculturalism, diversity and social reform as well as the specific discourse of newness in their museological mediations of global and local cultures. It is important to contextualize the new museum against an historical framework in order to highlight the discursive correlation between the strategies of representation used by contemporary museums and museumlike spaces and the ideological pressures and political frameworks that have contributed to the production of culture and history in museums in the past. I argue that, despite its dedication to the outward appearance of newness, the new museum – including its architectural form and attention to surfaces, as well as its function and agenda – has historical precedence. Clarifying these points of connection may also contribute to understanding the difficulties facing the preference for newness (as a fundamentally modernist condition) in a contemporary 'postmodern' environment and thereby inform analyses of whether the new and the postmodern coexist, contradict each other, or develop according to discrete or non-interactive aims and agendas.

In Chapter 3, for instance, I move from describing the compulsion for newness that epitomized nineteenth-century modernity to exploring the ways in which this was transformed into the cultural modernism and social modernization of the early twentieth century. In tracing this trajectory, we can see how newness has been centralized by both discourses of modernity and modernization. We can also observe the ways in which the consumerism and imperialism of the earlier period contributed to the development of certain national imaginaries, which themselves produced new conceptions and networks of international trade, mobility and cultural difference. Not only did these changes mark capitalist societies,

condition urban life and encourage the development around the world of modern publics but their motivation and mode of conceptualization appear replicated in many of the new museums to emerge globally from the 1990s. Offering the combined and heady effects of consumerism, imperialism and spectacle for the first time, in a 'public' sphere that was increasingly understood as accessible to all, the international exhibitions 'anticipated and helped shape both the form and the content of public life in respect to global issues' (Breckenridge 1989: 201). In other words, they showed how culture was constructed and how national citizenry was constituted. These points also contribute to a greater understanding of museums and other exhibitionary contexts today. Thus in this chapter I focus on the historical links between imperialism, trade, education and citizenship in order to establish a firm grounding for the interrogation of contemporary cultural spaces. In Chapters 4, 5 and 6, I explore their relationship to cultural diversity and global economies.

EXCAVATING FOR HISTORIES OF NEWNESS

In identifying and discussing the historical trends that have influenced the new museum in a contemporary context we need to explore the networks of power and persuasion that influence the museum and its various modes of historical representation. We need also attend to the underlying economies – of visuality, progress, consumption, reform, and imperialism – which have promoted the project of modernity that continues in many ways to be embodied by new museums. Shifting away from discussions about the function of language and rhetoric within the new museum, this historical chronology highlights the discursive correlation between the strategies of representation used by museums that represent the past and the ideological pressures and political frameworks that have contributed to the ways that history and culture are represented in museums. Revealing the fundamentally imbricated nature of nation-building and neoliberal capitalist economies, this exposes a relationship that is described by both Néstor García Canclini (1995, 2004) and George Yúdice (1992, 2003) as the essential interimplication of citizenship and consumption. It also reveals a trajectory that links nineteenth-century discourses of national unity, class reform and imperialism to twenty-first-century discourses of multiculturalism.

Links from the present to the past can be easily traced (and have elsewhere been presented far more comprehensively than I have space to do here – see Greenhalgh 1994; Hoffenberg 2001). My intention is rather to argue that this is an acutely political history and to examine the general trends apparent within the imperial spectacles of otherness that were popularized in the international exhibitions and world's fairs of the nineteenth century. This history and the cultural imperialism it reveals as intricately linked to the expansion of economic markets continue to have implications for the way that difference is rendered within sites and spaces of nation and consumption. This point is discussed in Chapter 4 in relation to the debate over rebuilding the sites effected by the September 11 attacks in the US. Furthermore, and as also explored in more detail in this chapter, the democratic principles of 'education for all' that emerged throughout the mid-to-late nineteenth century have been reconfigured

according to contemporary policies of multiculturalism – and function as a variant on the traditional object of class reform. Still directed toward projects of national unity (see Chapter 6), we need to ask who is being reformed by these policies – and to what end. Cultivated in the nineteenth century by programmes of class reform, the notion of national aggregation may benefit even more directly from contemporary multicultural policies. The transformation from programmes directed to the regulation of the working classes to those directed to the regulation of racial otherness moved from what Harold Perkins defined as 'a viable class society' expressed in social terms during the mid-Victorian era to what Peter Hoffenberg calls 'a viable multiracial society in cultural terms' in the twentieth century. This shift, says Hoffenberg (2001: 204), 'reflected the ascent of race and imperialism in the myths and language of national identity, as well as the decline in Liberal optimism about the capacity of the market and its accompanying categories of "class" to forge social order.' Over time, these changes have gained a certain transparency. The visual evidence – or scarring – of these pedagogical shifts has become a feature that is valuable to processes of making new museums and reconstructing old ones, so that:

> On the one hand, the museum still perceives itself as both purveyor of 'objective' sci-
> entific knowledge and as a potential resource centre for a broad-based multicultural
> education. On the other hand, it is clearly hostage to and sometimes beneficiary of the
> vagaries of different state policies and political régimes, and aware of the necessity of
> being seen to perform some vital and visible public function to justify its maintenance,
> while fighting to preserve a measure of autonomy. (Coombes 2004: 294)

Thus, to Annie E. Coombes' (2004: 288) question: 'How then was this purportedly liberal extension of the democratic principle of "education for all" transformed through the institution of the museum, into a discourse inextricably implicated in imperial ideologies?' I think it is also necessary to ask how social reform and imperial ideologies have been further transformed into an ideology of cultural diversity or multiculturalism, noting also that cultural diversity was a dominant feature of the international exhibitions. Moreover, as Hoffenberg (2001: 207) notes, the international exhibitions of the nineteenth century (and the responses to temporary visits from imperial subjects) helped to shape attitudes toward the migration flows of the twentieth century. They also – and as early as 1851 – painted a picture of London as a protomulticultural community. Henry Cole, in his capacity as a commissioner of the 1851 Great Exhibition of the Works of Industry of all Nations, found in the variety of visitors to the Great Exhibition a sign of the "cosmopolitan … character" of the English nation itself' (Hoffenberg 2001: 208; Purbrick 2001: 8). Museums and other exhibitionary sites have continued to register these changes, in strategic as well as discernible ways, but it is also useful to consider how they have in turn been impacted by such discourse.

The 'modern', for Jürgen Habermas (1998: 3), 'again and again expresses the conscious-ness of an epoch that relates itself to the past of antiquity, in order to view itself as the result of a transition from the old to the new.' Directed toward the desire to better understand the present, Habermas presents the concept of the modern to include traces of the past and aspects of the future – each of which is incorporated in the ways that we understand and experience the present. Appropriate to his mode of retrospective theorization, where the past is brought into the present and future, a more radicalized consciousness of modernity can be seen as having emerged and as having achieved mass appeal during the nineteenth century. Driven exclusively by ideas of progress and enlightenment, this heightened consciousness freed itself from a topography of specific historical ties and presented itself instead as forward looking and past effacing; as an emblematic avant-garde (Habermas 1998: 4).

In terms of periodization, Habermas presents modernity as emerging from the mid-nineteenth century. Aiming to maintain a sense of the dialectic existing between the lure of the new avant-garde and its encompassing yet invisible metahistorical context, he argues that to understand the contemporary modern world we must look beyond the aesthetic modernity of the avant-garde and refocus on this larger metatemporal framing project. By maintaining this historical framework, Habermas claims that the project of modernity is ongoing and unfinished. Attempting to read backwards for both the residual traces of newness and the conceptual structure coexisting with this, how can we understand the larger project of modernity and its links with the aesthetic modernization of the twentieth century? How, in particular, did this desire for a permanent state of newness manifest itself in that era that Marshall Berman (1988) refers to as 'good' modernity; the mid-to-late nineteenth century? The processes involved in addressing these questions may also lead us to consider the broader conundrum associated with any attempt to locate history within the discourses of modernism and modernity. Moreover, this engagement may also yield strategies for exploring how MoMA's modernism relates to the modernity of the nineteenth-century metropolis and for understanding how this modernity, in turn, links with global and world cities today.

The museums discussed throughout this book are similar because they each, regardless of local context and purpose, propose a particular notion of newness as their central organizing concept. Individually, they are characterized by a collection of impressive visual proponents, representational strategies, and modes of enunciation. Acutely aware of the persuasive function of language, they attain a kind of newness based on the language that they use, the ways that their discourses are framed and reproduced, and the approach that they take to the re-presentation of the experiences that they offer. *New Museums and the Making of Culture* explores the role that newness has performed in relation to a wide assortment of museums, each of which seeks to present divergent experiences despite their proclivity to use the same formative concepts and strategies. I begin this chapter by looking at the political aspects and aspirations of new museums, and consider the ways that these sites – as, ideally, more democratic and conversable than their predecessors – engage with contemporary issues and debates affecting their cultural context. I explore how museum studies scholars have attempted to account for these relationships, and then look at how and why cultural studies has integrated discussions of museums and what the implications of this may be for museums and for culture in general. This chapter demonstrates the role that language plays in new museums. In addition to offering a tool for the production and understanding of museum experience, I argue that language provides a feedback mechanism that integrates the museum as a public space with the politics, culture, and other aspects of everyday life around it. As a key component contributing to the accumulation of cultural capital, language also contributes in essential and formative ways to the production of the much-desired effect of newness.

THE REBIRTH OF THE MUSEUM?

As a theoretical network of signifiers as well as a physical site or object, the new museum model is indebted to Tony Bennett's paradigm of analysis as outlined in *The Birth of the Museum* (1995). Advocating a Foucauldian methodology of critique, this conceptualization of the museum has provided not only an invaluable tool to those studying museums but has itself been adopted as a widely used *modus operandi* in the production of new museums. Notably, Bennett suggests the current fascination with and appropriation of the museum as a key cultural site has largely occurred at the level of rhetoric and metaphor, with the museum model most frequently being used as a signifier for another cultural product, space or event (Bal 1996b: 2; Rugoff 1998). Foucauldian genealogies of the museum have also importantly

situated the public museum within a broader cultural field that includes 'collateral' – or 'museumlike' – institutions and their practices, such as the fair and the amusement park, which, Bennett argues, can be read in relation to the rise of the penitentiary. Although Bennett arrives at this conclusion by constructing a genealogy that works by analogy, the end point of this teleology is not so much the opening up of a broader cultural field for museum studies – although this is one of its effects – but the elaboration of the museum's social instrumentality as a disciplinary apparatus and tool of governance. In these discourses, the museum becomes a mode of articulation that references other cultural occurrences or situations.

Bennett's work is also interesting in relation to his intent to present the museum as a space that is inscribed with dominant discursive meaning, rather than presenting it as a space to be explored for its textual or predominantly semiotic significance. In this, his work contrasts with that of other writers. This includes art historian and literary critic Mieke Bal, who adopts a poststructuralist (neo-Barthesian) approach toward analysing the museum as a semiotic system. Claiming museums to be constituted by discursive acts, she explores the 'discourse around which museums evolve … which defines their primary function' as procedures of exposition made manifest (Bal 1996b: 2–9). Despite their differing approaches to the issues of representation, language and power, both Bal and Bennett demonstrate examples of how cultural studies interests and methodologies have been incorporated into a study of museums and museumlike spaces. Indicative of the broader turn toward a 'politics of interpretability and representation' that emerged during the culture wars of the 1980s and 1990s, Yúdice asserts that this 'politics of representation seeks to transform institutions not only by means of inclusion but also by the images and discourses generated by them.' He says:

> this politics locates citizenship issues within the media of representation, asking not who count as citizens, but how they are construed; not what their rights and duties are, but how these are interpreted; not what the channels of participation in opinion formation and decision-making are, but by what tactics they can be intervened on and turned around to the interests of the subordinated. (Yúdice 2003: 164)

The literary style semiotic approach is also apparent in the work of frequent *October* contributor, Douglas Crimp (1997), and editors of this journal, Rosalind Krauss (1990, 1996) and Benjamin H. D. Buchloh (Buchloh et al. 2005). This approach has adopted a contemporary and progressive interdisciplinary style of writing that is consistent with other post-1960s academic trends (Duncan and Wallach 1978; Haraway 1989; Said 1991 [1978]; Macdonald 1996: 3; Crimp 1997, 2003; Poovaya-Smith 1998). In the work of these writers, and in the Marxist-influenced projects by art historians such as Carol Duncan (1995, 2002) and Alan Wallach (1998; Duncan and Wallach 1978), the focus tends to cohere onto a study of art museums, museum architecture and design, and the relationship that these have with capitalism (see also Brawne 1965). Not only do these writers examine

the relationship between museums and commodity culture, they often reveal a principal concern with measuring Pierre Bourdieu's theory of cultural capital and distinction against the ways that museums reflect and produce important geographies of taste and value that are both cultural and economic (Prior 2003: 59–68).

Also at this time, connections between the development and continued practices of the modern museum and colonialism came to be highlighted, and ethnologists and anthropologists started to play a more visible role in relation to the recontextualization and critique of meaning in museums (Ames 1992: 52; Bal 1996b: 62). Herself an advocate of the democratization of museums, Margaret Mead (1970: 23–6) argued for their redevelopment so that they would 'welcome those people unaccustomed to the way of seeing and being of museums'. We could, of course, continue to read this as symptomatic of a reformist mentality. However, reflecting on their own relationship to colonialism and aiming to give something back to communities that have been exploited in the past, contemporary anthropologists have made important contributions to the study of museums and the practices of collecting. Notably, they include James Clifford (1997, 1998, 2001, 2004), Michael Ames (1986, 1992), Arjun Appadurai (1996, 2002), Nicholas Thomas (1991, 1994, 1997), Susan Stewart (1984), John Elsner and Roger Cardinal (1994), and Barbara Kirshenblatt-Gimblett (1998) – who has also discussed the role of leisure and tourism in relation to the experience and exhibition of indigenous populations and cultures to interrogate the agency and authority of display. Yet, in line with these changes, it is increasingly common for museums of natural history to redress their links with the colonial activities of the past. For instance, large sections of the American Museum of Natural History (AMNH) remain, as Mieke Bal (1996b: 15) contends, products of colonialism in a postcolonial era where 'the past clashes with the present of which it is also a part, from which it cannot be excised although it keeps nagging from within the present as a misfit.' Currently undergoing a massive process of renovation, these clashes are apparent in relation to the AMNH's organizational structure and sense of pedagogical purpose, where the content and form of display – as well as the order in which these are upgraded – visually demonstrates how museological practice has changed over time. The differences marking the newest parts of the museum (the Hall of Biodiversity) (Figure 6) from the museum's oldest section (the Hall of Northwest Coast Indians) (Figure 7) are startling.

I agree with Bennett's account of the 'birth' of the museum, and share his interest in the role played by the museum as a disciplinary apparatus but I propose that we also need to consider the effect that this 'linguistic turn' has had on the institution. As such, a different – more expansive – set of historical and discursive coordinates are required to map the centrality of the model of newness and the effect of this on the public rhetoric and exhibitionary regimes embodied by contemporary museums (Message 2006b). The Foucauldian model invokes the museum as a way of speaking about other cultural products and their social and spatial significance but I am interested in asking how the rhetorical produces the spatial and experiential, in order to then look at how these discourses are

6: The Hall of Biodiversity at the American Museum of
Natural History (detail). Photograph by Kylie Message.

incorporated into the construction of the new museum. This chapter is thereby concerned
with issues relating to the 'discourse' of the museum in a far more literal sense, so that I
can take the rhetorical construction of the museum itself as my primary object of study.
What effect does language have on the kinds of cultural images that are produced by new
museums, and how can theoretical frameworks influence the way that these are understood
and experienced? In many cases, the image of the museum that is used as a tool of analogy
is, in fact, quite different from the images and ideas promoted by contemporary museums.
Such a discrepancy – between the way they are conceptualized and produced – causes anxiety
for contemporary museums. They find themselves developed in relation to this awareness of
the role that the generic museum is perceived as playing within a broader cultural context.
The strain of simultaneously living up to this metaphorical role and to the traditions of
museology (and of offering something new to both) is often revealed along the faultlines of
the environment that is constructed, the exhibitions that are shown within the space, and
the textual writings that are produced about the spaces.

The new museum may be critiqued on the basis that it exists, first and foremost, as a
conceptual and academic model but it has also inspired vast numbers of museum designers,

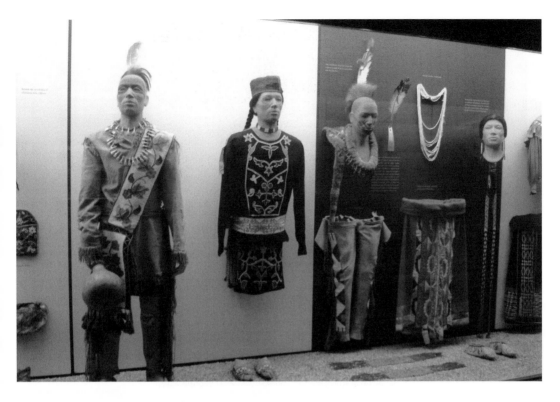

7: The Hall of Northwest Coast Indians at the American Museum of
Natural History (detail). Photograph by Kylie Message.

developers and curators across the world (Newhouse 1998; Macarthur 2001; Montaner
2003). The Sendai Mediatheque, for instance, attracts overseas and domestic tourists to the
city of Sendai (two hours north of Tokyo) primarily to see the Mediatheque's internationally
acclaimed architecture (Ito 1994, 1997, 2001) (Figure 8). The Mediatheque's appeal is
largely generated by the celebrity of its architect, Toyo Ito, but its popularity is equally
a by-product of the global exposure associated with the international exhibitions of Ito's
practice and sales of the CD-ROM catalogues that further promote the highly theorized
design process involved in construction of the Mediatheque as a new kind of institution
that collates the functions of library, museum and cultural centre into a single site (Figure
9). As such, visitors are also interested in its claims of facilitating greater community use (Ito
1994, 1997, 2001) (Figure 10).

Adding to this allure, the Mediatheque is exquisite and ephemeral (Figure 11). Arch-
itecturally, it seems to function as a node; fundamentally imbricated with but also trans-
cendent of the new media technologies and online networks that it promotes through its tech-
nological ingenuity (Barrie 2001). Presenting an uncomplicated glass façade to the street, it
is grounded in its purpose and location, and yet its interior is also strangely transcendent of

8: Street-facing exterior window, the Sendai
Mediatheque, Japan. Photograph by Kylie Message.

9: Interior library facility, the Sendai Mediatheque,
Japan. Photograph by Kylie Message.

10: Library and light well, the Sendai Mediatheque, Japan. Photograph by Kylie Message.

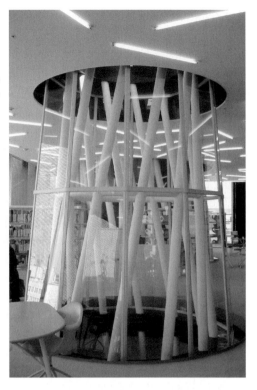

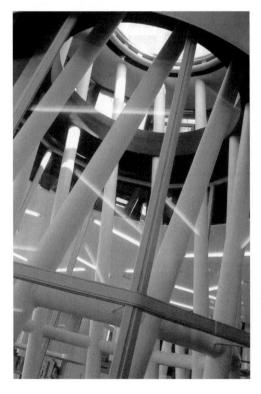

11: Interior light well, the Sendai Mediatheque, Japan. Photograph by Kylie Message.

these concrete components; boasting an upwardly spiralling scaffolding with dizzy tourists struggling to photograph the shattered glimmers of light filtering through. Consequently, the effect achieved by the Mediatheque is physical and pragmatic and yet also symbolic and conceptual. It projects a variety of signifiers and models that are themselves diverse and intertextual. In this form, the new museum might be seen to appeal to museum professionals, humanities scholars and others because it presents theory and praxis and culture and politics as clearly interimplicated, and because it also indicates the possibility of achieving a very real rupture with past paradigms of representation, categorization and definition according to new and interdisciplinary theoretical models (Chakrabarty 2002; Luke 2002; Carbonell 2004; Preziosi and Farago 2004).

The postmodernity of the Sendai Mediatheque marks a substantial shift away from the singular, Western public museum that emerged in the modern nation-building era of the nineteenth and early twentieth centuries. These principally historical museums functioned primarily as 'public chroniclers of the grand narratives of nation and empire' (Neill 2004: 183), and aspired to achieve an image of national unity and aggregation. The purpose of traditional museums at this time was to make sense of the world, and to invoke harmony out of disorder by functioning as 'certifiers of taste and definers of cultures' that were 'intimately involved in the task of defining identities and setting up schemes that classify and relate cultural identities' (Karp 1992: 31). Although it is not a national museum, the Sendai Mediatheque refers knowingly to this homogenizing Western/global museological genealogy primarily through its invocation to ideas of democracy. But rather than replicating a pedagogical model whereby the museum is directed to function as an institution of civic reform, the Sendai Mediatheque offers a clear alternative to this modernist ideal by privileging a rhetoric of dispersion, nonlinearity, and improved access. Usually associated with postmodernism, the shift away from widespread belief in tradition as singular and progressive has rapidly resulted in a series of differences in the ways that museums are designed, made, experienced, and understood to function. However, whether the discourses of the new museum – of access, democracy, the recognition of cultural diversity – do break with the museum's traditional project of civic reform and succeed in offering an alternative, effective framework of cultural production and engagement (or whether they simply re-phrase the reformist agenda according to a new rhetoric), is something that will be explored further throughout this book.

CULTURE

Rather than focusing exclusively on an examination of museological effects as isolated or removed from other socio-cultural images or products, I seek to avoid demarcated definitions or closed categorizations of the term 'culture' as well as the term 'museum' (for discussion and debate over definitions of culture, see Williams 1981; Bauman 1973; Kirshenblatt-Gimblett 1998; Tomlinson 1999; Eagleton 2000; Simpson 2004; Clammer 2005). This approach responds to a change instigated by museums themselves and expands

on trends within contemporary academic practice to analyse the processes and procedures that contribute to the production of museological meaning as implicated in broadly constituted and intertextual cultural fields (Boswell and Evans 1999). Culture is discussed as a fluid, mutable concept that is used in various contexts and for the purpose of different outcomes, in line with David Simpson's contention that: 'It may be that we are beyond the point where anyone can usefully theorise what culture *is*, as opposed to offering another history of what anthropologists, sociologists and literary critics have taken it to be. Culture now describes not only works of art, highbrow or popular, but the dynamics of all social exchange: working, eating, sleeping' (Simpson 2004: 76). Whereas historical museums of national or substantial private collections, including the Louvre (1783), the National Gallery in London (1924), and the Metropolitan Museum of Art in New York (1870) have traditionally been associated with elite culture and higher education, new museums – including projects that seek renewal of what might awkwardly be termed 'old-style' museums – aspire to provide opportunities to the general public to explore what culture is and how it is constituted. Pedagogical initiatives and education programmes have not been reduced in scale or importance, but rather than being tied to issues of class reform or other civilizing motivations, they may articulate more politically informed, progressive, or flexible approaches to understanding the museum in relation to both its past and broader present concerns. The idea that culture is nonconstant and subject to a diverse and changing field of references, investors, and political agendas, is itself a feature often centralized by exhibitions, and it contributes fundamentally to the incorporation of cultural rights and cultural diversity at strategic representational and organizational levels throughout museums.

Strategies to promote discussion about the context of individual museums aim to illuminate their relationship between geographical and conceptual locations and the role museums play within the public realm. This approach is often motivated by the desire to demonstrate the demotic nature of new museums. Aiming to expand this further, new museums reveal an ever-increasing interest in examining the multiple ways that the term 'culture' functions. Sharing Simpson's focus on the wide and diverse field of culture, they appear particularly interested in illustrating how it may in some cases offer new ways to transgress the dichotomous rupture that separates (elite) Culture and higher education as a honed aesthetic from (everyday, ritualistic or foreign) culture as a more rudimentary anthropological practice, way of life or artefact (Clifford 1988: 10; 1997: 218; Eagleton 2000: 64). Perhaps aiming to mark their own distance from traditional anthropological concepts that have in the past been perceived as overly highbrow, new museums often seek reinvigoration via contextualization within the sphere of popular culture and everyday life. It is no surprise then that the 'museum as contact zone' concept has itself become privileged in rhetoric about the new museum. Sourced from anthropologist Mary Louise Pratt (1986), Clifford reframes the notion to argue that translocal exchanges of ideas, commodities, and ways of doing things can be understood as contiguous with the historical mode of commodity exchange and cultural interaction in the Pacific; a point which has

also been discussed by Pacific cultural studies theorists including Teresia Teaiwa (2001) and Epeli Hau'ofa (2005) in different contexts. Clifford (1997: 9), however, contends that new museums offer a positive and vital version of transcultural practice that produces an expression and understanding of cultural identity as historically and contextually located, but as also fluid and changing in relation to the more contemporary challenges associated with the economic and political realities of globalization (see also Anderson 2004).

MUSEUM POLITICS

Despite their dedication to new modes of representation, new museums exist as a viable vehicle for the critique of contemporary culture on the basis that they maintain a distinct relationship with historical museums of social history, including archetypal examples such as the South Kensington Museum (1857) and public art museums such as the Louvre (1793). Aiming to heighten their profile as democratic spaces of representation, they seek to project themselves as spaces equivalent to the public museum and the politics it has historically generated. Persuaded by the rhetoric associated with these predecessors, new museums often appear to echo or privilege historical moments of social change or challenges to mainstream culture, so that the Louvre, for instance, is celebrated now as a princely-cum-popular palace, in accordance with its founding proletarian (turned bourgeois) ideology of liberty, equality and fraternity (Duncan 1995; McClellan 1999).

Indeed, contemporary museum scholars argue that the reformist agenda central to earlier British and French examples has sustained popularity within the educational programmes of more recent museums, contending that these museums 'continue to function as institutions for civic reform, even if the specific aims of such reform are now couched within a rhetoric of cultural diversity rather than public morals' (Witcomb 2003: 17; see also Bennett 1998). The promotion of cultural diversity – a trademark of the new museum – is significant in relation to the apparent privileging of a fairly particular and partial genealogy within new museums. This will be discussed in greater detail throughout this book (see Chapters 4, 5 and 6) but it is worth noting here that this selective chronology should attract greater analysis on the basis that, as Arjun Appadurai and Carol Breckenridge (1992: 38) remind us, 'museums as modern institutions have only a short history and appear to emerge largely out of the colonial period'. This connects collection processes with a colonial mentality but also speaks to the colonial imprint that may still be evident in approaches to exhibition and display. The liberal project of progress and enlightenment that underwrote these colonial activities is also clearly discernible in the world's fairs and international exhibitions of this era (as described in Chapter 3; see also Mathur 2000). The comment made by Appadurai and Breckenridge may be taken as a cautious reminder that museums are cultural institutions that continue to attain power and status from their capacity to classify and define peoples and societies both past and present. They are, in short, 'ideologically active environments' (Duncan and Wallach 1978). Overlaid against the contemporary global (UNESCO) and national governmental policies that direct exhibitions and public programmes, new museums continue to function

as sites of authority in their own right. They impact also on the development of culture and cultural policy issues, including multiculturalism and postcolonialism and sustainability in relation to heritage sites and the preservation of material culture.

The trajectories that govern the continued manifestation of reformist and proactive pedagogical programmes within museums are directed toward sustaining a perceived social function, and are often expressed especially keenly in relation to issues of tolerance and cultural diversity. These articulations sit uneasily with the imperial history that new museums also attempt to challenge. New museums do not replicate, subsume or archive the traditional historical or colonial museum directly but may juxtapose signifiers of the historical public museum model against various politically engaged forms of critique. Aiming to capitalize on these processes of review and display, new museums also often employ postmodern techniques of montage and bricolage, and curatorial practice is influenced in many cases by the installation practice of artists like Fred Wilson, whose work centres on reconfiguring and reordering colonial museums, their collections, taxonomies and ethics (*The Other Museum,* 1991) (Crane 1997; Staniszewski 2001: 293–307). Taking the traditional museum as an object for analysis, the 'old-style' museum is revealed by such strategies as a collection of clearly defined but often invisible ideologies and representational strategies as well as objects.

NEW MUSEUMS AND BROKEN NARRATIVES

One of the earliest examples to embody this self-conscious approach to museum making was the Museum of Sydney (MoS), which opened in 1995 on the site of first Government House (Gibson 1996, 1998; Carter 2004). MoS was designed to challenge dominant modes of meaning construction by putting the exhibitionary logic on display for visitor consideration. Curators aimed to exhibit the history of Sydney as a narrative constructed from a series of sometimes piecemeal moments and broken stories: incomplete and enigmatic rather than comprehensive and neatly packaged (Figure 12). By interacting so explicitly with the local site and its history of crosscultural contact, MoS aimed to put settler nationalism into an historical context that is both discursive and dialogical, as explained by (then) senior concept developer, Ross Gibson (1996: 3–4):

> Exchange does not necessarily imply equality... This cannot be overlooked or erased, for it is basic to the society we now live in. In bearing witness to this fact, we need to examine the processes of violence and subterfuge that have impelled so much colonial experience. Furthermore, to account for the damage all the better, and perhaps to unsettle it somewhat, we need to understand the array of things, feelings, beliefs and ordinances that passed back and forth on the colonial ground... If we can grasp the complexity of this colonial experience, we might find clues to guide us into the tolerant, self-modifying negotiations and exchanges that we are destined to enact now on this contested and congested ground which so many of us wish to know as home.

12: Interior, the Museum of Sydney. (Photograph courtesy of Museum of Sydney, Historic Houses Trust of NSW and © Ray Joyce Photography.)

To achieve the effect of transparency in relation to the histories and racial interactions seen at this site, curators and designers employed new approaches to representation (that incorporated nonlinear or broken narrative forms, and DIY video, for instance), and adopted a different approach to labelling their exhibits using reconstructed historical voices to counteract historical agency against the authority of the curator's voice. Attention to lapsed detail was developed as a key characteristic because it helped distance the museum's activities from the monumentalizing narratives employed by more traditional government institutions in the established environment of Sydney. Yet, although the museum has deployed many general strategies associated with new museums globally – including the use of theoretical discourse to signal a general effect of newness – MoS is unique for the way that language itself is depicted as a site of exchange. Not only does language offer a mode of discourse, engagement, and analysis, it suggests evidence of historical agency that can itself be displayed and interacted with as part of the project of animating the past. This can be seen to represent the role that language played during the early days of discovery and settlement, where it both facilitated and complicated exchange between cultural groups (Bostock 1996). Further acknowledging this function, language is presented as offering visitors their first experience of transhistorical crosscultural contact, as they transgress through the sound installation, *The Calling to Come* (1995), located in the museum's 'Entrance Cube'. Embodying an ambiguous and malleable boundary zone, the project is described by its designer, Paul Carter (2004: 155) as:

an auditory impression of a relationship between an Eora woman known only by her skin name, Patyegarang, and William Dawes, the First Fleet officer, astronomer and surveyor, who studied the Eora language. The stability of the meeting place that their exchange created depended not on understanding but misunderstanding. Trading in sound-alike words, their discourse constantly disclosed new mental places.

Language here is presented as offering more than a sign of newness. It is understood to provoke interest in the experiences of the past – and the contemporary life of the new museum – as an ongoing point of relevance to passers-by.

Despite MoS's subversive agenda, its focus on affects, interactions and surfaces has been interpreted by some commentators as privileging an aesthetic effect that compromises the success of any properly political statement. Christopher Marshall (1997), for example, has argued that MoS 'constitutes, in the final analysis, a new version of an equally moralised, "official" history which only succeeds in communicating its message by [the use of symbols]... It is debatable, in this respect, whether the MoS succeeds in its aspirations to present itself as a true alternative to the "traditional" museum' (see also L. Young 1995). The problem here is that, regardless of being designed according to a representational strategy that was motivated by the attempt to give voice to forgotten elements of history, MoS has been perceived as failing in its aim to open up the discussion regarding lapsed spaces and lost memories. Moreover, critics argued that these were produced as a kind of consumable effect (as a commodity of contemporary museum experience). Further general criticism contended that MoS's structural self-referentiality meant that it and others like it display a paradoxical inability to engage with the museological prehistory that should be evoked by this proclaimed focus on reflexivity. Despite framing history as the key content or subject matter on display, this means that the historical narratives that contribute fundamentally to the methodologies where experience is evoked for the visiting public are not asserted but subsumed. Moreover, traditional modes of historical referencing are replaced by signifiers of a history that are used, paradoxically, as indicators of a compelling newness.

Such attempts to reveal the ideological procedures previously hidden in museums can also be understood, as Bennett (1995) argues, as a demonstration by contemporary museums of a heightened consciousness about the programmes of corporate liberal individualism that motivated the museums of the mid-nineteenth century. This consciousness is now used in reference to a set of dominant policies that include trade liberalization, privatization, the reduction or elimination of state-subsidized social services, education and health, and reforms to industrial relations legislation that threaten the rights of workers (Yúdice 2003: 82). Imbricating symbols of the old regime against those of the postmodern neoliberal organization of global capitalism, new museums may aspire to reveal and possibly comment on the interconnections between the nineteenth-century museum and their embodiment of assumptions regarding the development (that is, production) of a universal typology of 'man'. This understanding of the past (and the political agendas of the past) may provide, as Bennett suggests, a framework for modes of current museological self-critique (1995).

Whether or not we agree with Bennett's line of argument (Witcomb 2003: 17–18; Dibley 2005), I think it is clear that, unlike the traditional museum, which has historically been presented as dislocated from or somehow above politics, the new museum is presented as being an always already and instrumentally political institution.

MUSEOLOGICAL SELF-CRITIQUE AND NATIONAL MUSEUMS

There are, of course, other problems associated with adopting methodologies of self-consciousness and additional interconnected approaches. Bennett (1995: 39) explains that the museum is often understood as having historically provided a 'site in which the figure of "Man" is reassembled from his fragments', as part of a programme that is both universalizing and imperial insofar as its intent is directed toward consolidation of a singular nation-state model and a self-regulating citizenry. If we understand this in relation to the paradoxical fact of new museums – whereby the global majority are indeed state funded, nationally significant institutions – then new museums inevitably run the risk of butting up against their symbolic function of aggregation and consolidation if they attempt to present a postmodern approach to storytelling. Implicated deeply with the politics of complicated funding structures, governmental and public pressure toward the preservation of metanarrative in new national museums in particular, is nothing short of extraordinary. We can see this in the controversies that not only attended the Museum of Sydney, but also the opening of Te Papa Tongarewa in relation to its function as a site of public ownership (Dutton 1998; Dalrymple 1999; Harper 1999; Keith 2000). It is also apparent in the international and local debate over the extraordinary level of French government funding poured into the building and ongoing administration of the Centre Culturel Tjibaou (and the concurrent disappointment experienced by many local people who were unable to afford the entry fee) (Brown 1998: 16; Jolly 2001: 440). The role of government is perhaps demonstrated most explicitly by the recent *Review into Exhibitions and Programs* of the National Museum of Australia (NMA) (Commonwealth of Australia 2003a) (Figure 13). Commissioned by the Australian government (as primary funding body) only one year after the new museum was opened, the *Review* argued strongly for the reassertion of traditional stories of nation. In the first section, it quotes from a submission from independent academic James Gore:

> National museums find themselves in conflict. On the one hand, new interpretations of history have shown that there is no longer one national story for a museum to tell. Museums need to contribute to an understanding of the many different pasts and histories that exist, and only then can a national identity, or more importantly national identities, be realistically discussed. Yet, the national museum exists primarily to tell the story of a nation, and in order to properly understand the story the museum inevitably needs to retain some kind of coherent narrative, to show the nation's progress and to hold all the other stories together. (Commonwealth of Australia 2003a: 6)

Through its recommendations to include a greater focus on more conservative and iconic images of nation and identity, the *Review* may be understood as advising the reapplication

13: The National Museum of Australia, Canberra (exterior detail).
Photograph by Kylie Message.

of a set of guidelines for nation making that would sit more easily within a nineteenth-century pedagogical model. However, it simultaneously speaks to a form of cosmopolitanism that resonates with other cultural policy documents, particularly those commissioned by UNESCO, notably the *Universal Declaration on Cultural Diversity* (2001).[1]

From the interplays and shared points of nervousness evident within both local and global cultural commentaries, we can discern the articulation of increasing interactions between dominant conceptions of national identity and a globalized culture – and the anxieties and promises associated with this. Although, for instance, the NMA's *Review* calls for the

1. The *UNESCO Universal Declaration on Cultural Diversity* (2001) was adopted at the 33rd session of the General Conference of UNESCO on 20 October 2005 in Paris as the *Convention on the Protection and Promotion of the Diversity of Cultural Expressions*. This occurred following completion of this book, thus my references are made in relation to the Declaration.

reassertion of more internally logical and specific symbols of nation, these calls are not unique but are in fact echoed in national museums across the world – and by the cultural policy that directs them to include unambiguous national typologies (as a component in the programme of multiculturalism, for instance). Promoting the 'universal' rights of man by recall to enlightened liberal discourses that underwrote the nineteenth-century museum (and its investment in culture as a key site of reform), documents such as UNESCO's *Universal Declaration on Cultural Diversity* also contribute to this, and yet also provoke a reading that is itself internally contradictory because the forums and models of discourse drawn upon have, in the past, been used to produce and consolidate vastly less diverse ideals of nation-statism. Looking at this from a localized (British) perspective, Raymond Williams (1984: 5) explains that:

> in some ways, the nation-state, for all sorts of purposes, is both too large and too small. It is too small, particularly in the world of the media as they are now developing, to be able to sustain genuine national cultural policies... At the same time, it is too big to be able to promote the diversity of cultural policy which ought to occur even within a relatively homogenous culture like the British.

The anxiety emerging from interaction between nation and global interests can also be seen as guiding the production of the NMA's *Review* as well as its recommendations. However, despite this pressure toward a general homogenization of experience that is both simultaneously and by turns national and global, new museums maintain a clear interest in the motivating desire to reveal, expose, or 'demonstrate' the social implications of their role as the disciplinary apparatus famously labelled by Bennett (1995) as an 'exhibitionary complex', and as inaugurated in many respects by the Museum of Sydney. However, this confessional trait can itself be identified as consistent with other strands of traditional museological practice (or other forms of rationalized cultural policy, for that matter). Evident for example, in science museums, including the San Francisco Exploratorium (1969), the Powerhouse Museum in Sydney (1988), and the new National Science Museum in Tokyo (2004), is a guiding prerogative and dedication to 'show how it works' (Figures 14, 15). Historically, processes of classification in museum practice were framed around a rationale of 'show-and-tell' that has, more insidiously, also been connected to programmes of homogenization that bring the technologies and economies of modernity and industrialization into an awkward relationship with shifts toward postcolonization. Extending Matthew Arnold's preferences for 'the best that has been thought and said in the world' (1994 [1869]: 190), in this configuration, exhibitionary apparatuses have used 'show-and-tell' to show visitors how to perform and what to be or aspire to, according to normative models of sociability and national identity.

CULTURAL POLICY – UNESCO

Moreover, in connection with this pedagogical project, the compulsion to 'show and tell' has also been historically evident within organizations such as UNESCO, which despite

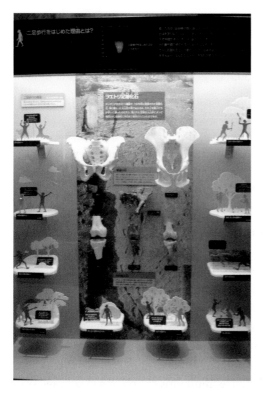

14: *Evolution* exhibition, the National Science Museum, Tokyo. Photograph by Kylie Message.

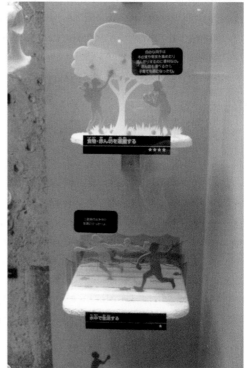

15: *Evolution* exhibition (detail), the National Science Museum, Tokyo. Photograph by Kylie Message.

being nongovernmental and transnational, appear to work toward reiteration of the role and ideology associated with the modern nation-statism underlying the nineteenth-century museum. Such strategic interplays – and the tensions that underlie these – are explained in relation to cultural policy by Jim McGuigan (2004: 65):

> Cultural policy 'proper' is normally studied from a nation-state point of view that is increasingly supplemented by local/regional and international considerations. This is particularly so in research on cultural policy among the members of the European Union. So, while any member country will normally have an administrative apparatus for rationalizing and researching both the justification and effectiveness of its own cultural policies nationally, locally and regionally, it will also participate in inter-state enquiry according to a common Europeanness.

Museums that present an internal critique of the universal symbols of mankind or humanity may attempt to demythologize UNESCO and weaken or challenge the global reach of its cultural policies. However, those that maintain an uncritical reliance on classificatory systems and/or an uncritical allegiance to UNESCO risk reproducing the 'show-and-tell' mentality. Foucault (1982: 216) describes this as the 'simultaneous individualization and totalization of modern power structures' whereby instruments of the state continue to demonstrate and model to its audiences – to us – what kind of public we should be. Seen in relation to comments made by the NMA's *Review*, and the interplay between global and national, this becomes even more problematic because, despite acknowledging cultural diversity in theory, many – even new – museums continue to advocate a far more singular and apologetic position pragmatically. As the above quoted claims argue, the purpose of national museums should be to cohere diverse aspects into a singular narrative. This can also be identified in the NMA's *Review* literally, by recourse toward a greater inclusion of 'sporting, business and scientific achievements', as well as 'the more traditional themes of European discovery, exploration, convicts, settlement of the land, bushrangers, wool and wheat, fire and drought, and so forth' (Commonwealth of Australia 2003a: 9).

As can be seen in this initial discussion of the relationship between the new museum, its local context, state, and global flows and politics, pressure for the inclusion of themes such as cultural diversity within significant representational public spaces does not exist just at a situated, or localized level. Cultural policy has itself undergone a process of globalization; a point that confirms the encompassing role UNESCO now plays in regard to the protection of culture and heritage. A central purpose of UNESCO may be the fashioning of order out of chaos, and Director General, Koïchiro Matsuura explains that the *Universal Declaration on Cultural Diversity*, 'came in the wake of the events of 11 September 2001, and the UNESCO General Conference ... [which was] the first opportunity for States to reaffirm their conviction that intercultural dialogue is the best guarantee of peace and to reject outright the theory of the inevitable clash of cultures and civilizations' (UNESCO 2001: n.p.). Directed toward protecting civil rights against the potential threats of a contemporary

climate in crisis, the *Universal Declaration on Cultural Diversity* lobbies for both the individual and the universal but presents an apparently contradictory argument by asserting that 'Such a wide-ranging instrument [as the *Declaration*] is a first for the international community. It raises cultural diversity to the level of "the common heritage of humanity", and makes its defence an ethical imperative indissociable from respect for the dignity of the individual' (UNESCO 2001: n.p.; see also UNESCO 2001: Art. 1, Art. 4).

The *Universal Declaration on Cultural Diversity* is interesting also for the way that it infers that the success of economic globalization is intricately linked to the respect and protection of independent cultural freedoms, and for its central argument that 'culture is at the heart of contemporary debates about identity, social-cohesion, and the development of a knowledge-based economy' (UNESCO 2001: n.p.). However, possibly due to the clearly mapped historical precedence for this interconnection between trade and imperial expansion (Greenhalgh 1994; McClintock 1995), some analysts assert that UNESCO promotes an uncritical form of cultural imperialism. Paul Jay claims that the Eurocentrism motivating both colonial and transnational economic practices is frequently, 'simply repackaged as globalization' (2004: 83), and Abbinnett (2003: 206) argues that UNESCO is a:

> Cosmopolitcal [sic] institution concerned with the possibility of justice and the application of international law – at the centre of European culture. For while such an institution would always be marked by a certain Eurocentrism, this would at least demand that the globalizing powers of science, technology and economy remain accountable to the structures within which freedom, identity and citizenship have traditionally been enacted.

Relating this back to Bennett's earlier point, it is useful to reiterate that the central aim of new museums globally is to render their pedagogy transparent so that it can be more readily perceived as 'up for grabs'. This is particularly important in a postcolonial global environment, because, as Gyan Prakash explains, and as the Museum of Sydney demonstrates, dominating ideologies can be powerful and convincing, even when they are not explicitly represented. In relation to the establishment in the late 1930s of the Musée de l'Homme in Paris, Prakash (1996: 55) contends:

> Ethnographic humanism, employing the notion of a single 'humanity', organized the foundation of the museum when it opened it doors to the public in 1938, but its display omitted, as James Clifford remarks acutely, the founding source of this projection. In classified halls, the viewers were asked to appreciate the creative spirit of mankind, but the creations of the modern West were nowhere in display. And yet the West was pervasive, as Clifford points out: 'The orders of the West were everywhere present in the Musée de l'Homme, except on display.'

COMPETING AGENDAS

Aiming to achieve transparency and public accountability, new museums work within and therefore aim to evoke existing institutional bureaucracies, boundaries and constituencies.

However, they may also simultaneously aim to provide the means by which these may be challenged or undone. This is itself a fascinating aspiration given the often simultaneous pressure experienced by new museums to provide globally relevant and interesting strategies of transnational currency on the one hand, and a heightened, even parochial, attention to local symbols on the other. It also shows how the contemporary politicization of culture and representational effects and strategies – apparent both in new museums and in cultural policy – has complemented the enhanced attention to identity politics that emerged out of the postmodern and postcolonial theory stream of cultural studies. This is evident in Holocaust museums, such as the Jewish Museum in Berlin (2001) and the United States Holocaust Memorial Museum in Washington DC (1993). These museums have a specific political rationale and aim principally to employ an interdisciplinary postcolonial methodology in order to critique the representational strategies shared by Germany, its occupied territories and its allies during World War II and the museums and other media and communication technologies used at this time. In other words, by displaying images of state propaganda and censorship, Holocaust museums often share the objective to depict the political function of representation (see Linenthal 2001).

While these connections are often evident and publicly discussed in the context of Holo-caust museums, they may continue to be less clear in relation to indigenous museums and cultural centres, such as the NMAI and the Gallery of First Australians at the NMA. These and other examples suggest that acceptance of the role of the state in the dispossession and disaggregation of indigenous peoples remains a sensitive and publicly contested topic in institutional spaces like these that continue to have an affiliation with the state. Although on the one hand, Holocaust museums and museums of indigenous culture may be seen as existing at opposite ends of the scale of representational institutions, they may in fact be more similar than different because of shared theoretical issues and the associated attempts to come to terms with violent experiences. An exhibition in the NMAI that looks at the social and political realities of life for twenty-first century American Indians expresses this best by explaining: 'We work hard to remain Native in circumstances that sometimes challenge or threaten our survival. *Our Lives* is about our stories of survivance, but it belongs to anyone who has fought extermination, discrimination, or stereotypes' (Jolene Rickard, guest curator; Cynthia L. Chavez, NMAI curator; and Gabrielle Tayac, NMAI curator, wall text, NMAI 2004). Furthermore, beyond these perceptions of difference, a multitude of other types of museums also integrate projects interested in responding to or dealing with similar issues of historical conflict and social justice. Crucial to all museums that represent themselves as new is the centralization of this self-consciousness to their architecture, programmes and exhibitions. Given the prominence enjoyed by these demythologizing impulses and the associated shift toward a descientification of museums, it is perhaps most fascinating to note that this theoretical model and methodology is most often produced to replace existing state or national museums – a point that leads to the central and possibly even defining paradox of the new museum: if the conditions for the critique of historically condoned pedagogical

forms of power and authority are implicit within the new museum, what does it mean that many new museums across the world are government-funded?

Given this complex interplay of agendas, the main characteristics of new museums tend to compete awkwardly with the normative and singular components most often embodied by national museums as demonstrated by the NMA's *Review*. In Anna Neill's description of the new museum, it is interesting to recognize the way she explains the skirmishes over ideology that often coalesce within new museums. Here, the new museum refers primarily to a theoretical and rhetorical disciplinary model that is removed from the physical museum. In this context, the new museum appears to slide away from engagement with any properly political debate on the basis that it engages with politics internal to the history of museology. Referring to the new museum as 'the new museology', Neill (2004: 183) argues that it:

> rejects the triumphant narrative of national destiny. It criticises the way in which museums have traditionally upheld the aura of the object and granted the viewer un-mediated access to a frozen past. It advocates exposing the artifice of display in which objects are apparently re-embedded in their authentic environments. New museology advocates strategies of exhibition that involve the viewer interactively, suggesting that history and meaning are constructed and sometimes even contradictory.

A series of serious contradictions and difficulties can therefore be seen to exist for national museums that seek renewal according to the new museum model. What becomes immediately apparent in these reconfigurations is not just the existence but the active performance of tensions between local, national and global levels of articulation – pressures that are also evident in relation to UNESCO. Moreover, as Neill's discussion indicates and the Museum of Sydney demonstrates (in that its principal critics have been scholars of museum studies), the discipline of 'the new museology' is itself contested (Marshall 1997; Linda Young 1995). Yet, regardless of – or perhaps due to – these points of difference, the general preference of new museums for a postmodern (and postcolonial) self-reflexivity, and for the integration of analysis of its traditional ideological associations, the symbols of nation that have traditionally been neutralized or normalized within museal spaces reappear as mediated or persuasive aspirational models at best, and as artificial or cynical systems of regulation at worst.

CULTURE WARS

These tensions have also been connected to increased understanding of the role that the media play in the production of experience (and of the ways that the media actively construct these events), as Lawrence Vale (1999) argues. Enhanced consciousness has contributed to a greater understanding of how and why ideological institutions such as governments, museums and the media function through an interconnected and symbiotic series of relationships. These realizations developed more-or-less throughout the 1970s as concerns that were expressed within the public sphere, and in many countries (particularly

multicultural settler societies), continued contestation over the way that cultural identity and issues of nationhood and citizenship were represented, leading to the recurrent 'culture wars' of the 1980s and 1990s (Said 1993: 257; Chakrabarty 2002; Luke 2002: 19–36). McGuigan (1996: 7–8) accounts for this hostility by arguing that culture and politics came into direct conflict as an effect of policy (as a form of 'policing'):

> The political heat around culture has generally been greatest in societies where the state has played a manifest role in its regulation, often a manifestly oppressive role, most notably, under conditions of modernity, in communist states. Where culture is left to the market a cooler politics is usually displayed. It is curious, however, that just at the moment when European communism was disintegrating in the late 1980s, having failed amongst other things to 'culturally enlighten' its late subjects (White 1990), 'culture wars' broke out spectacularly in the land of free speech and of the free market, the United States of America. These culture wars, albeit generated by sheer ethnic diversity resulting from a complex history of immigration, were focused particularly upon two key issues: public subsidy of the arts and the university humanities curriculum.

As elsewhere in the 1980s, a conservative backlash was generated in the US in response to these antagonisms. Effecting changes in cultural policy, this culminated in a high level of general acceptance of archliberal, economic-driven policies and a suspicion of diversity (McGuigan 1996: 8–12). This position has been modelled effectively by the staunch conservative advocate (and wife of American Vice President) Lynne Cheney in her book, *Telling the Truth: Why Our Culture and Our Country Have Stopped Making Sense – and What We Can Do about It* (1995) in which she promotes the security and values of a singular national story, at the expense of others that are open to the exploration of multiple cultures as proposed in policies of cultural diversity and calls for greater immigration. Demonstrating the links between museums as representational spaces and government diversity policies to reiterate the fundamentally reformist pedagogical programmes of each, Cheney (1995: 144) complains that 'museums used to be places that invited visitors to learn about great works of art, to understand their society, and to know more about the course of history. Today, like so many other cultural institutions, they appear instead to be in the business of debunking greatness, Western society, and even history itself.' Cultural commentator Robert Hughes (1993: 162) contends that this sentiment represents the increasing desire for cultural 'policing' and the associated 'culture of complaint' that he perceives as spreading across the spectrum of American political life. Given the generally conservative political environment of the Western countries with museums that I address throughout this book, and the fact that most of the funding for these museums comes from government bodies, it is curious that new museums promote ideas of transparency in relation to their ideological function. Perhaps it is possible, *apropos* of Neill's description, to suggest that transparency in relation to past museological practices does not necessarily equate to transparency in relation to present structures of funding.

What does become apparent, however, within this potentially unstable context, is a series of shifts in the way that language and styles of address are used. A shift in terminology is designed as a key strategy implicated in the diversification of the museum away from the idea of a monumental and singular institution. The term 'museum' is being replaced by the more engaging-sounding 'cultural centre' or 'heritage centre' – in contexts that include the Centre Culturel Tjibaou, the Uluru-Kata Tjuta Cultural Centre in Uluru, Australia (1995), and the Alaska Native Heritage Center in Anchorage (1999) – or 'ecomuseum' in the case of Vietnam's Ha Long Ecomuseum (2004) and others. This shift away from the more traditional, institutional museum has also worked to reposition the lineage of these institutions with European (principally French, rural) ecomuseums (Galla 2002, 2005; Poulot 1994); with so-called, and predominantly non-Western, 'tribal' museums (Simpson 1996); with 'folk' or historic house museums (Hudson 1987: 126; Walsh 1992); with the museums that Clifford (1997) refers to as contact zones; and even with the theme park or 'nature village' approach to display and representational strategy embodied by the Polynesian Cultural Center in Hawaii. Yet, labelling these examples thus also risks reasserting the power structures implicit in the privileging of the urban metropole over the marginal, colonial, or rurally (dis)located. Furthermore, in seeking to interrogate whether this expansion of the museological term aims also to redefine culture as it is represented in geographically remote sites as a similarly contested political space, it is necessary to be wary of Judith Butler's (1998: 39, 44) riposte against arguments that equivocate the 'merely cultural' to the never possibly political, and to avoid reproduction of the very distinctions that situate certain oppressions within a political economy, and delegate others to a less important cultural space.

Butler's (1998: 42) argument is important at a methodological level, principally for the claim that: 'It would be a mistake to understand such productions as "merely cultural" if they are essential to the functioning of the ... order of political economy, that is, constituting a fundamental threat to its very workability.' Apart from transcending the tyranny of distance that is indicated by such socio-political inequality by globalized technologies of media and communication and mobility, Butler's point may be understood to mean that every networked space contributes in fundamental ways to the production of national capital and culture as much broader and more shifting than dichotomous terms such as 'metropole' and 'margin' or categories such as 'national museum' and 'folk museum' can indicate. With this in mind, my primary aim is to problematize the recently reconfigured new museum-as-cultural centre model by considering its relationship to contemporary culture and representation in relation to the shifting currencies of trade, capital and meaning connected to globalization. This includes analysing the representation of postcolonial forms of cultural diversity in these public spheres (Fraser 1997; Eagleton 2000; Yúdice 2003; Simpson 2004) and the technologies that speak directly to (and in some cases attempt to delimit) these spaces of governance and of individual agency.

Furthermore, the interconnection between the features contributing to the production of the concept of nation in national museums and those that produce points of local reference in community-based cultural centres suggests more than a possible loss of confidence in museums as key sites of national representation. I think that this interplay has, more accurately, occurred in response to a non-dualistic form of globalization together with the transcultural modes of activity and communication that have become vital and centrally framing discourses deployed in the construction of all representational spaces. This shift in power base and the associated representational strategies can be immediately seen to pose a series of problems for contemporary national museums while offering a new toolbox of approaches, effects, and modes of speaking. This is because the central terms of discussion – including the concepts of nation, local, state, and sovereignty – themselves come to be easily understood as shifting configurations and collaborations prone to changes in international as well as local policy, politics, and economics (Macdonald 1996: 3). In addition to the increasing contestation of the cultural spaces that they occupy and to which they contribute, this opportunity for new museums to function as sites of instability has meant that they have become widely perceived as a battleground for disputation involving various individual agendas, state ideologies, and globally significant issues pertaining to museums (Veracini and Muckle 2002; Attwood and Foster 2003; Goldsmith 2003b; Message and Healy 2004).

Many claims are made for and on behalf of new museums, by a wide variety of speakers, who are themselves located in a wide variety of geographical and political positions. However, these claims are generally produced according to a lexicon of postmodern self-referentiality and socio-political critique and tend to be directed toward achieving a subversion of dominant representational strategies and systems within conventional Western state systems. They tend to respond to a crisis in representation where processes of globalization have caused a shift in the relationship between signifiers, so that the concept of what a primary referent is – and where it may be located – has substantially changed (Dalrymple 1999). For instance, in his account of the 'so-called "culture wars" of the 1980s', Chakrabarty (2002: 6) claims that the tension between pedagogic (learned, rational) and performative (embodied, sensual) kinds of democracy has been responsible for 'canons of the Western academy being both vigorously challenged and defended, the rise of varieties of cultural relativism, the accent on diversity and the politics of identity, the coming of postmodern and postcolonial criticism.' Also speaking from a postcolonial perspective, Edward Said reiterates this Foucauldian focus on the interrogation of the tools and institutions of governmentality by an analysis of the discourses, economies and cultures of Orientalism (Said 1991 [1978], 1993: 201–2, 206–7), while Achille Mbembe (2001) examines the ongoing relationships between subjection, governmentality and the distribution of wealth and capital under hybrid post-colonial regimes that are themselves the product of a 'colonial rationality'. Each of these academic concerns are directed toward extending recognition of the ongoing political function of museums or other similar public, representational, institutional spaces in order

to critique governance at a systemic level. The writers acknowledge that culture has always been a contested site and concept in the context of settler societies. They work differentially across and between as well as within the categories of global and local because, although the actual situations addressed are most often locally specific, they exist within a colonial framework that historically offered an effective style of globalization (McClintock 1992; Shohat 1992; Yúdice 1992). Explaining the postcolonial project as it fits into her study of South Africa, *History After Apartheid*, Coombes (2003: 1) explains:

> This book explores how various forms of visual and material culture dramatized the tensions involved in such a momentous shift while at the same time contributing to the process of transformation itself. It argues that the visual and material manifestations of new public histories are both produced by and effectively inform changing definitions of 'community' and 'nation' during periods of political transitions where such concepts become crucial stakes in the resolution or management of social conflict and/or renewal.

CULTURALISM AND POLITICAL ECONOMIES

Further registering the interconnectedness between Foucauldian theory (with its close links to 'the epistemic shift' desired by poststructuralism) and postmodernism, an additional outcome for contemporary debates over culture has been a generalized 'cultural turn' whereby academic discourses have re-embraced the belief that culture not only impacts upon but shapes the human experience. Simpson (2004: 75, 77) argues that implicit to this is the assumption that culture has a politically formative force, so that 'all culture leads to politics'. There are, however, risks associated with adopting such a culturalist position. These are manifested most often when the embrace of culture is universalizing and non-critical, or when it produces an image of culture as separated from issues of politics. Simpson articulates this tension by explaining that although culture is widely accepted as being always already everywhere, politics *could* be anywhere, but is not necessarily (Butler 1998; Mulhern 2000 in Simpson 2004: 74). Simpson contends that this depoliticization is caused by the discipline of cultural studies itself, on the basis that it argues that we can only properly study what we know – that is, our own culture (which risks leading to suspicion of 'the foreign'). Paradoxically, this may also result from attempts to democratize the way we think and talk about culture by expanding its field. Frequently addressed as a supplement to poststructuralism's study of language, this approach risks reframing previously challenged notions of cultural products, lifestyles, and authenticity according to newly celebrated and aestheticized, neoanthropological and oddly depoliticized forms (McGuigan 1996: 6; Jameson 1998b; Sewell 1999: 36–8). In this configuration, 'the cultural turn, in other words, got caught up in the wider culture war', Stearns (2003) explains, to claim further that:

> Theory and jargon helped comfort culturalists amid growing conservatism, but those tendencies discouraged wider persuasion while goading conservative intolerance. And,

while the culture wars may have softened, they are not over today, as new international crises have prompted reassertions of the need to rally around a national culture.

We need continually to reconsider the ideological facility of culture and economy in a variety of contexts and conditions, and case studies. Simpson (2004: 82) suggests: 'To resist the omission of the foreign as part of the national culture, within or beyond its borders, might well be, these days, a form of politics as such, and it can surely lead or be directed to such politics.'

This debate clearly has potentially serious ramifications for museums and other representational spaces. It also informed Baudrillard's argument, made in the 1970s in relation to the Pompidou (Beaubourg) Centre (itself widely acknowledged as a key prototype of both the new museum and contemporary cultural centres), particularly in relation to rhetorics of publicity and accessibility (Baudrillard 1997; Newhouse 1998: 193). Explaining that the referent no longer exists as a discrete and authentic 'cultural' object that is reflected by or even manifested within museums, he claimed that the discourses that have been employed in the production of culture as an effect now function as shared, changeable, and equally simulated points of reference. This argument has since been extended to encompass mass media technologies and the strategies and effects that, despite being promoted widely in relation to museums, have vastly reduced the processes of mediation and recognition that are assumed in liberal democratic theories of politics. New media technologies, for instance, cannot:

> revitalize the dialogical potential of the public sphere, for once they reach a certain level of saturation, the reflective citizen is overtaken by a constant flow of heterogeneous, escalatory and reversible simulacra. The major consequence of this simulation of reality … has been to abolish any reflexive relationship between the citizen, considered as the addressee of social and political norms, and the representative institutions of liberal democracy. (Baudrillard 1996: 214 in Abbinnett 2003: 214)

The social conditions and cultural narratives associated with this reality – and the overwhelming authority of technological capitalism that has both transformed and transgressed dominant geopolitical structures (particularly the nation-state and civil society) – pose a series of problems and also possibilities to Western society in general. Ross Abbinnett (2003: 205) understands this to mean that 'we can no longer assume that the realm of "the political" is adequately expressed in the dialectics of citizenship, participation and sovereignty that are inscribed in the concept of the *polis* (the place of political freedom in which the law is simultaneously given and received by a collectively identical subject).' This may mean that political forces become more insidious and apparent throughout other social structures and forms but it may also imply the opening out of 'the cultural' and other realms, not only so that they may offer spaces of engagement and critique but so that they may offer new modes of critique to pre-existing definitional categories.

Such accounts represent museums as having allegiance with the left-leaning neo-Marxism apparent in cultural studies generally but this positioning clearly causes a series of paradoxes for the increasingly conservative liberal politics supported by the contemporary Western governments and private companies that sponsor or fund the building and administration of these institutions. This contradiction represents the dialectical aspect of Marx's thought, where on the one hand he understands the realm of culture as continuing to refine the ideals of liberty, equality and justice and, on the other, claims that it sharpens the incongruity between those ideals and the exploitative reality of the mode of production (Marx 1977: 48–52). It also indicates the counter-argument made by Adorno and Horkheimer, and by Frederic Jameson, who later claim that technologically produced culture and the bureaucratization of society are necessary counterparts of corporate capitalism (see also Castells 1989). Adorno and Horkheimer assert, for instance, that the 'culture industries' provided an ideological apparatus (and instrumental rationality) to legitimize the process of the industrialization of mass-produced culture, as well as the economic reasons for commodification and standardization. They argue that not only are individuals fully integrated within the capitalist system as workers and consumers but culture has itself become an object of technological reproduction causing it to lose the utopian transformative potential that Marx attributed to it:

> Nothing remains of the old; everything has to run incessantly, to keep moving. For only the universal triumph of the rhythm of mechanical production and reproduction promises that nothing changes and nothing unsuitable will appear. Any additions to the well-proven culture inventory are too much of a speculation. (Adorno and Horkheimer 1986: 134)

Expanding still further on existing tensions between culture and politics, and reflecting how the economics of production, consumption and exchange are inherently tied to the economies of modernity and imperialism (through the production of new two-way markets for the new products and identities that are collected, sold and displayed), Appadurai (1996: 4) suggests that changes in and an increasing multiplicity of media and migration from about 1960 evidence a shift in transnational economies and interrelated shifts in cultural production and consumption: 'both viewers and images are in simultaneous circulation'. Indicating a globally aware citizenry, these factors signal a change in the way people see and imagine themselves. Baudrillard (1993: 26–35) also argues that the concept of exploitation through which Marx expounded the revolutionary potential of colonialism and imperialism has to be revised in view of the increasingly postindustrial nature of capitalist economies – something that may also resonate with what Andreas Huyssen (1995) has referred to as the specifically American character of postmodernism. Baudrillard's theory about the role of 'transeconomic capitalism' intercepts Jameson's (1995: x) equivocation of postmodernity with an aestheticized culture that is characterized by 'the consumption of sheer commodification as a process'. Abbinnett (2003: 91) summarizes the key factors of this as including:

competition and cooperation of multinational corporations replacing the old 'imperialist' competition of nation states; the emergence of an international division of labour (and the dissolution of 'national' proletarian solidarities); the power of corporate finance (Second and Third world debts and the constitution of a new global hegemony); the development of increasingly sophisticated communications and media technology (and the rise of information as a commodity); computerization and automation; Third World production (and the shift of multinational capital out of traditional 'first world' locations); the crisis of traditional labour (and the decline of 'old style' socialism).

NEW MUSEUMS AND SOVEREIGNTY

Given the complexity of this politico-cultural field, it becomes clear that we need to start asking questions that are configured slightly differently – especially given the changes in the ways that global politics, conditions, economic infrastructures and assumptions have become manifest in the postwar period. Decolonization, 'the problems of government in multiethnic, multireligious, and multilinguistic countries', 'nation-building, the cold war, *tiers-mondisme*, globalization, [and] the new world disorder' (Geertz 2004: 577) have all presented a series of urgent and transformative, albeit nonconstant, pressures. Accounting for these changes, Zygmunt Bauman (1998: 62) explained that the sovereignty of the nation depends on its ability to regulate its economy, to maintain armed forces capable of defending its territorial borders together with its capacity to produce cultural norms and values that create a shared sense of identity. Commenting on the passing of economic power into the hands of corporate bodies that have no local affinities, he interprets this to mean that even the most powerful, delineated states have become subject to the chaotic effects of globalization. By 2001, he expresses urgency and alarm about the loss of the nation-state as a meaning-creating agency. He argues that the correlated emergence of an ultra-mobile extraterritorial form of capital demands that we rethink the basic concepts through which we approach the question of politics and representation (Bauman and Tester 2001: 139). A multitude of other writers have also weighed into these discussions, including Clifford Geertz (2004) in a paper called 'What is a state if it is not a sovereign? Reflections on politics in complicated places.' In this he argues that states and other equivalent formations of power exist as diverse and nonconstant representational spaces that continue to exert a significant symbolic effect. I would also propose museums as analogous to the state in order to argue that not only are museums also complicated representational places (especially given their ongoing relationship to and struggles with the nation) but that these complications mean we need to start asking questions about the relationship between globalization and the museum.

Indeed, in seeking to respond to his own question, 'What is a state if it is not a sovereign?' – in which he deploys 'sovereign' to mean 'culturally solidary entities functioning as organized and autonomous … political communities' – and in accounting for the shifts in world politics and the economic structures that have forced dilution of the significance of

the global network of states (toward a more complex and less mappable terrain of states, non-states, and mobile transactions and consumers), Geertz (2004: 578, 583) contends that the state has come to function even more importantly, as: 'The institutional projection of an ongoing politics, a display, a delineation, a precipitate, a materialization.' This means the state itself is the performance of an ideal, or, in Clifford's (2004) terms, an 'articulation', which may also account for why new museums favour elaborate architecture that has a predisposition to attracting media and tourist attention. New museums can be seen, thus, as privileged in their relationship to the commodities, cultural capital, and attractions of the contemporary world and as being able to offer the possibility of opening up dialogue with the historical past. Yet, this does not mean that they cease to function as symbolic projections of the state, as Geertz says. This tends to constrict any properly critical or fully reflective role. It also means that, although they may discuss their programmes in relation to globalization and its attendant theories, many find it difficult to represent the actual issues and debates connected to these topics because of the ongoing ties between the museum and the nation.

TEXTUALITY, CULTURAL STUDIES AND THE PRODUCTION OF KNOWLEDGE

One of the most common characteristics of new museums worldwide is their insistence that visitors should perceive and hopefully come to understand the textual characteristics of the experience being offered. They also attempt to illustrate to visitors the important role that ideology plays in the production of this experience, and seek to reveal this relationship by adopting a poststructuralist position that presents language as a tool used in the production of typologies (Butler 1993: 12–13; Bal 1996b). We can see this illustrated in both literal and abstract form at some level or another in every museum that aims to project an image of itself as new. It is apparent in the architectural detail marking the walls of Daniel Libeskind's Jewish Museum in Berlin and the contestation over whether the architects of the National Museum of Australia 'plagiarized' Libeskind's design. It is also evident in the self-conscious revisions being made to the role and voice of the curator apparent throughout museums – from small museums such as the specialized Museum of Jurassic Technology in Los Angeles (which refers not to the imagined communities of most national museums but to a fictional historic universe) (Weschler 1995; Crane 1997) to large-scale and massively mythologized examples such as the British Museum.

This same pressure – to reveal the ideological component of the museum to the viewer – is also at work in the production of rhetoric and publicity describing the new museum. It is especially apparent in relation to the recently reopened MoMA in New York and the global Guggenheim franchise. Attempting to assert their difference from the colonial, historical, ethnographic or otherwise 'old style' museum, these new museums have embraced the sanitation and currency of a theoretically imbued newness, so that, for example, in the weeks leading up to MoMA's opening in November 2004, banners and awnings outside the emergent site proclaimed 'The Modern is New Again!' Rhetorically effective, this offered

the museum to the public as a renewed commodity. In this guise, MoMA was granted the authority to act as an arbiter of taste and value on the basis of its newness rather than the traditions (or collections) of the institution. Moreover, the (also new) entry fee conspired to give the experience a real – that is, measurable – economic value to be experienced and enjoyed (and widely discussed in the press). The language of newness depicted the museum's rationale, described its newly finished (repackaged) product, and suggested that various new modes of engagement would be available to the visitor.

Cited more frequently than MoMA as the archetypal new museum, the Museo Guggenheim Bilbao has been produced to use language in exemplary ways. Designed by celebrity architect Frank Gehry, and completed in 1997, the Guggenheim Bilbao attracted 1.36 million visitors within its first year of operation, has already paid for its building costs, and has reinvigorated the city through providing new opportunities for economic development, employment and trade. Representing the initial step in the global expansion of the Guggenheim industry masterminded by Thomas Krens and strategically coordinated from the Solomon R. Guggenheim Foundation in New York, the Guggenheim Bilbao was closely followed by the construction of several other Guggenheim branded museums across America and Europe. Although these subsequent museum developments have received vastly varying degrees of success, the homogeneity of the term 'new museum' certainly increased the popularity – and funding possibilities – made available to Krens in the first instance. The Guggenheim Bilbao was also designed as part of a large-scale publicly funded capital works project that aimed to renew the urban environment and infrastructure programme of the previously struggling industrial region in the north of Spain. As any photograph of the area demonstrates, images of the rejuvenated city represent the franchised museum as larger than life, and as overshadowing other more ordinary or everyday urban spaces. In this instance, and at this time, the benefits associated with the Guggenheim's global branding and marketing of culture appeared astute and resilient to criticism.

Designers and supporters of new museums are especially attracted to this new use of language and textuality because they are widely understood to be strategies that provide a particularly postmodern image for the museum, which also appear to convey an image of the museum as being self-reflexive and politically engaged. Following on from the first part of this chapter, I would argue that new museums are always engaged with the politics internal to them as well as with the socio-political environment to which they contribute. However, in addition to this, a key feature of new museums is the presentation of an image of political investment (which is both part of and extra to actual political engagement). The value of this image is greater than the political acuity that it suggests. It indicates a relationship to a desired form of textuality; a postmodernism that geographer and theorist David Harvey (1990: 8–9) explains as privileging 'heterogeneity and difference as liberative forces in the redefinition of cultural discourse. Fragmentation, indeterminacy, and intense distrust of all universal or totalizing discourses (to use the favoured phrase) are the hallmark of postmodern thought.' In terms of Harvey's conceptualization, this image is to be construed in contrast

to modernity, which he outlines as being 'generally perceived as positivistic, technocratic, and rationalistic', and as having been 'identified with the belief in linear progress, absolute truths, the rational planning ideal social orders, and the standardization of knowledge and production' (Harvey 1990: 8–9). In relation to the political project of new museums, this challenge to singular and dominant narrative forms and knowledges is closely connected to the objective of critique – of the museum's own 'exhibitionary apparatus' as well as its role in the production and support of particular economies and cultural politics.

Strategies of postmodernization have been especially favoured by new museums that attempt to problematize the relationship they have traditionally had with truth and authenticity as singular concepts. In this new postmodern guise, museums have started to explore the shift – also apparent in cultural studies – away from discussing the role of a mechanically imposed dominant ideology. This is possibly because museums have traditionally been considered a central tool in the regulation of this form of central power, as indicated by Prakash's comments about the Musée de l'Homme quoted earlier. Positioned thus, museums may seek to ally themselves with hegemonic forms of critique on the basis that this provides a 'better theoretical frame within which to analyze the production of cultural power in its various forms' (Morley 2005: 175). This facilitates our understanding of power as relating not just to one dominating institution, apparatus or form like the museum, but as existing throughout the interrelationships and interlocutions between politics, economics, dualities of form and associated modes of categorization (local, national, global, rural, urban), cultural terms, objects on display, and audiences. Located as it is at a point of nexus between material and symbolic or semiotic forms of culture, its particular mode of textuality and its approach to language may enable the new museum to achieve Donna Haraway's objective of producing 'an account of radical historical contingency for all our knowledge claims and knowing subjects, a critical practice for recognizing our own "semiotic technologies" for making meanings, and a no-nonsense commitment to faithful accounts of a "real" world' (Haraway 1991: 187; see also Haraway 1985). This may also encourage further understanding of Williams' (1981: 207) claim that if culture is understood as a signifying system that also refers to the procedures that make meaning, practices and institutions where symbolic communication and its associated capital is usually the main objective, then we can focus on the interrelationships rather than points of division usually attributed to more traditional conceptions of culture that distinguish and dichotomize an anthropological focus on lifestyle and ways of living from an 'elitist' conception of culture as referring to the fine arts and higher learning.

Addressing a general trend toward the increased textualization of cultural studies, David Morley (2005: 172) draws on Stuart Hall's approach to culture and communication to voice his concern that the factors of power and politics risk becoming re-presented 'as exclusively matters of language (or discourse)' (see also Simpson 2004). This may provide cause for anxiety for new museums and their commentators but the point can also be interpreted to suggest that the museum actually occupies a space of privilege. Morley and Hall's shared unease

is due to the breakdown in the relationship between reality and representation. Ruptured beyond repair, Baudrillard's (1998) universe of free-floating signifiers has ultimately come to pass so that self-referential signifiers no longer pertain or pretend to have a relationship with a referent that is directly signified or authentic in relation to modernity's field of production. Attempting to pin this down, Morley (2005: 173) explains that he is troubled by the 'textualization of cultural studies, which often allows the cultural phenomena to drift entirely free from their social and material foundations'. These are important arguments for us to consider in relation to museums, which exist, obviously, as representational spaces that are increasingly enamoured of textuality and rhetoric. Because of this, we need to engage with general debates about representation if we are to understand the new museum and its claims to political reactivation according to a different, more useful light.

ANTHOLOGIZING MUSEUMS

In addressing the interconnections between terms such as 'text' and 'reader' or 'museum visitor', the cultural studies approach to museum studies may further strengthen the perception of similarities between the museum and the written text or narrative form (including film, advertising and other modes of visual, audio and media culture). This has achieved resonance in the contemporary publication of anthologies of essays that claim for themselves the illusion of providing a 'Museum of Museology' (Karp and Lavine 1991: 7; Greenberg et al. 1996: 3; Carbonell 2004: 2). The widespread implementation of this metaphor can be seen as a strategic device that is effective in projecting museums and academic discourses as equivalent cultural texts. This paradigm provides an ingenious (and notably orderly) mode of formulating edited collections which, like some of the museums they discuss, claim to combine or assemble individual stories or texts into a greater narrative unit so that the voices, reasons and mechanisms of the multiple authorship can be made apparent to readers. An interdisciplinary focus is also usually implicit within this form of analogy, which tends to emerge more from the field of literary studies-inspired cultural studies, rather than traditional museology.

This methodology also contains a self-referentiality and attention to paradox that promotes an understanding of the museum as a cultural model that has been specifically and strategically designed and authored. This self-referentiality is indicated at the beginning of Carbonell's introduction by just such an incongruity; so that despite on the first page quoting Werner Hamacher's contention that 'no museum of the museum – can show us the truth of the museum' (Carbonell 2004: 1), she asserts on page 2 that the collection provides a 'Museum of Museology'. Highlighting the fundamental paradox that exists both as an internal aspect of contemporary museums and between museums and commentaries about them, this contradiction plays with the way that new museums perform both their own representational practices (involving, for instance, the idea that the museum functions as a microcosm of the world in order to critique the historical authority of the museum), and their relationships with metanarrative structures of meaning such as truth and universality.

The first contention – that no model of the museum can reveal the model's truth – also refers to the more general field of museum studies, which is itself increasingly being regarded as an instructive and useful component in the development of both museums and cultural authority. In particular, this comment and its academic field of reference provoke discussion about the death of the museum according to the idea that it can no longer exist as an agent of ideological and institutional authority. This also seeks to open dialogue about the relationship between modernity and postmodernity, and questions where the museum should be located in regard to this sliding division (Roberts 1988; Crimp 1997). In addition to demonstrating how critical cultural theory and museum studies may have productive and informative relationships with the new museums they discuss, these inferences further illustrate how interdisciplinary modes of writing and understanding can be applied to the contemporary museum model.

Discussion about the formal and pedagogical elements of the museum and book, and the similarities between them, are expanded further still by scholars who employ this analogy to illustrate the role that narrative plays both in the production of power structures and as an effective mode of communication. Carbonell, for instance, quotes narratologist Gérard Genette to argue the increasingly common-held belief that any study of the constructive processes of any text, be it museum or novel, must take into account 'the way narrating itself is implicated in the narrative' (Carbonell 2004: 5). Writers who want to reveal the power structures, processes and mechanisms involved in the production of meaning often privilege this relationship between the book and museum. It is particularly popular for writers who have identified poststructuralism as an effective methodology based on its potential to deconstruct all units of textuality into an array of component parts to reveal how the meaning has been produced. Commenting on the potential for this, Morley cites Ullin to observe that 'there is much that we can learn from the critical appropriation of communicative or literary metaphor – an appropriation that discloses, as postmodernists and culture theorists alike have agreed, the proximity of', and here he intercepts with 'the discipline of anthropology', but we could also include the field of museum studies, 'to the art of storytelling' (Morley 2005: 180). This acknowledgement has been especially important for museum scholars and professionals who want to illustrate how certain meanings of authority and authenticity have been naturalized and made to look politically neutral within institutions such as museums, libraries and universities.

Although the book (as model) has provided perhaps the most common metaphorical tool for such critical analysis of the museum, it is not the only one used, and with expanding interdisciplinary fascination with museums, its agendas and programmes are now also being articulated through a variety of models. These include discussion of the museum according to a theatrical metaphor whereby exhibition spaces are spoken of as self-conscious 'stages' that effectively illustrate how the museum is also a constructed space dedicated to the performance of constructed stories enacted by various representational means (Kreamer 1992: 372). This metaphor works to replicate the performativity of culture by showing that

both the museum and the culture it represents and engages with are constituted equally by performance, practice, and the interpretation of these.

Accumulation of metaphors and models has also been accompanied more recently by a backlash against this – as a strategy of deferral – on the basis that any effective critique of meanings construed from the museum could be produced more effectively by directly addressing the material practices of the museum itself. Modelling and metaphorical and metonymic analyses continue, however, to be effective modes of communication, especially when the metaphor of the museum is turned back on itself, as is the case when artists reproduce self-reflective versions of museology that both engage with specific collections and at the same time provide a critical counterpoint to them. Commenting on the increasing incorporation of self-conscious and reflective modes of representation in culture generally, Terry Eagleton (2000: 67) asserts:

> Once its values are challenged, culture can no longer be invisible. The ideal unity of
> Culture is more and more at odds with the conflict of cultures, and can no longer offer
> to resolve them. Hence the celebrated crisis of Culture of our time.

In summarizing both the condition and aspiration of culture thus, Eagleton clearly articulates reasons why museums may want to put their framing mechanisms on display and produce exhibitions that engage critically with the materials and exhibitionary structures that they employ. Moreover, this contention also suggests that the decision to expose, exhibit, or reveal the exhibitionary complex may not actually be a choice made by progressive museums but a necessary condition of contemporary culture in general and a symptom of the new museum itself. Accordingly, new museums present a dedication to revealing their own ideological frameworks and pedagogical structures as a matter of requirement; they are compelled to do so because an important aspect of the new museum is a heightened commitment to political awareness and socio-political currency. In order to be properly and most persuasively regarded as new, they must appear invested in the political context surrounding the museum, and in order to achieve this, they must appear to be critically involved in their own political structure.

CONCLUSION

As we can already begin to see, the new museum is a complex and at times contradictory institution. It exists as a model of a model, and also embodies a critical position of self-referentiality that is connected to such demanding modes of reconceptualization. Its dominant mode of critique rests most often on issues of representation and interpretation, and it constantly attests to its own pedagogical power structures and to the attendant role of representational strategies that are constructive of the images of reality that it displays. New museums exhibit self-reflexive strategies to rupture the genealogy linking them to older kinds of museums that typically have not attempted to expose pedagogical power structures or issues (like the overwhelming authority of the curator's voice). In response to

these changing concerns, museums worldwide have, over the last decade or so, begun to engage in processes of active redevelopment and rejuvenation. Their attempts at redefinition have provided an intriguing shift in the way that both museums and culture are perceived in general.

This chapter has explored the ways that contemporary museums have incorporated new discourses and representational strategies in order to achieve a particular effect of newness. I have argued that this effect primarily appears to be the effect of language – and a language that is often paradoxically disconnected from any direct reference to the objects and stories that it pertains to represent or speak about. While this appropriation of language has signified the almost compulsive commitment to newness desired by these cultural sites, a problem here can be that the invocation of such rhetoric often compromises the political statements that these museums are actually trying to articulate or explore. So while, for instance, the installation cases *Stilled Lives* (2000), made by visual artist Janet Laurence and exhibited in the Melbourne Museum, attempt to engage with the structure that museums employ in the collection and display of material heritage; to an uninformed viewer, these glass cases of labelled birds and variously categorized animal specimens may appear to replicate the traditional exhibitionary complex that it is actually designed to critique. In other words, while the main impact of these strategies of representation and display is the production of an effect of knowingness for the host museum, this itself is paradoxical because many of these institutions have been developed as antimuseums that attempt to undo or challenge the pedagogical structures of power and knowledge within traditional museums. In their place, a new version of knowingness is proposed. Celebrating museums as 'complicated places', a different kind of associated authority is also asserted, directed more toward gaining a cultural currency and cachet that is based on museums' engagement with popular culture and interdisciplinary academic discourses.

The Museum of Modern Art is back. And just in time. The city has grown up since the Modern shut its doors to build its new home two and a half years ago. The hole left by the twin towers. A war in Iraq. A polarised electorate. Our culture is in a crisis as critical as any since the cold war period when Modernism reached its final, exuberant bloom.

That may be the reason the new Modern seems so comforting.

(Nicolai Ouroussoff, *New York Times,* 15 November 2004)

Reopened in celebration of its 75th anniversary, the Museum of Modern Art's new space and new hang proclaimed the institution's much-anticipated homecoming – 'Manhattan is modern again!' (MoMA publicity) (Figure 16). It also pronounced an altogether new identity for an old New York favourite that has found itself described anew as a 'reborn' (Hamilton 2004) and 'even more modern' (Ouroussoff 2004a) institution that now offers 'a cool new box' for its collections (Boxer 2004). Yet, despite the excitations of the museum's department of communications and the arts press, the new MoMA appears strangely similar to the old in its reflection of Alfred Hamilton Barr's earliest aims to create an institution that would offer different and challenging exhibition materials and pedagogical approaches for early twentieth-century museumgoers. Working from 1929 as MoMA's first director, Barr was committed to an ideal image of the museum as an 'instrument of change, the megaphone of newness in the cultural sphere, and the means by which the new art was shown to be not a weird, disjointed and rebellious episode in culture but a new and very serious canon' (Hughes 2004).

In the light of its most recent proclamations, the Museum of Modern Art might be understood to be motivated by the desire to project an image of newness and experimentation for its visitors. However, the institution's renewal has confronted it with the 'post' modern, twenty-first century pressures that are faced by all contemporary cultural and exhibitionary institutions. Their common situation is one of contradiction between the compulsion to project the institution as uncompromisingly new and globally relevant and the newness of modernist purists. This contradiction is demonstrated by the museum's recently completed Fifty-third Street façade. Presenting an expansive wall of fritted, grey and clear glass that is montaged against absolute black granite and aluminium panels, these archetypal postmodern materials are imbricated against sections of the restored façade of the 1939 Goodwin and Stone building, Philip Johnson's 1964 addition, and Cesar Pelli's 1984 Museum Tower. The Fifty-third Street entrance has traditionally offered the signature view of the museum, and in keeping with this, the new façade aims to 'link MoMA's past with its future in a street-level panorama of architectural history' (Museum of Modern Art 2004j) (Figure 17).

16: Bus-stop advertising, the Museum of Modern Art, New York. Photograph by Kylie Message.

17: Exterior architectural detail, Fifty-fourth Street façade, the Museum of Modern Art, New York. Photograph by Kylie Message.

On the face of it this eclecticism might be interpreted as an assertion of close ties between the new museum and the contextualism, allusionism and ornamentalism of postmodernism, and might thus be taken as a rejection of the traditional allegiances to modernism and internationalism represented by the emblematic Bauhaus features of MoMA's façade (one that embodied such an effective critique of the nineteenth-century patrician style architecture surrounding it) (Figure 18). Yet, the incorporation of postmodern architectural strategies may also have provided a way to update the internationalism of the institution and demonstrate its continued relevance in a changing global environment. Attempts to reframe the museum as a key modernist icon according to the schema of a more contemporary and postmodern newness have generated debate and nowhere more so than in relation to the visual inconsistencies of its Fifty-third Street façade. And whereas many of the changes to MoMA's building and curatorial approach have met with positive responses by visitors – for instance, Quebecois Gaetan Gauvin, who said, 'I've seen this art before... But this is new. It's wonderful' (Butler 2004) – for others, the relationship between an historicized version of modernist newness juxtaposed against the signifiers of a more contemporary image of newness, appears fundamentally disjunctive and lacking in logic. In the opening

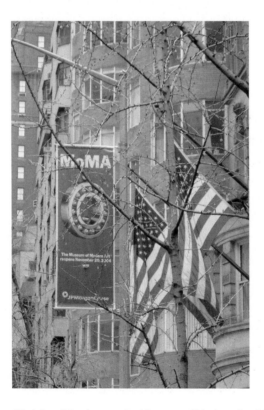

18: Advertising banner, the Museum of Modern Art, New York.
Photograph by Kylie Message.

quote above, *New York Times* journalist Nicolai Ouroussoff suggests that this paradoxical image of newness may be most appealing to visitors who yearn for the security of familiar and past experiences on the one hand, but who, on the other, want this repackaged so that it also has the appearance of being new, exciting, and relevant today.

In this chapter, I explore the preference for discourses of newness that have attended MoMA's most recent renovation. I engage critically with the rhetorics of newness that are presented in relation to the new museum and analyse these with particular attention to the claims to theoretical acuity that they also appear to make. Picking up Ouroussoff's point, I argue that concurrent with the process of renewal undertaken by 'the modern' is a remaking of 'the new', which is itself being made new again by remodernizing different interests and rhetorics. I expand on this to examine the paradoxes emerging from MoMA as an institution that seeks thus to be both self-consciously new and yet also to be postmodern. And I compare this taste for newness against MoMA's traditional commitment to modernism as described by the museum's director, Glenn D. Lowry, who contends that the museum aims to represent 'a humanistic endeavour that will continue to serve as a place of knowledge and enquiry' (Museum of Modern Art 2004j). I then go on to consider whether the rhetoric surrounding the new MoMA outweighs the physical experience on offer. Finally, I argue that, although the new museum is indeed presented as being altogether something new, it juggles the features and effects of postmodernity with its underlying commitment to modernist order. The new MoMA succeeds, consequently, in offering an archetypal image of newness that has been produced through a combination of publicity and rhetoric, architecture, and collections. The newness desired by modernism is achieved according to the techniques of postmodernism.

THE SEMIOTICS OF THE NEW MUSEUM

MoMA is located between Fifty-third and Fifty-fourth Streets. Straddling the block, it has, through the recent acquisition of property, doubled the capacity of the former building to encompass approximately 630,000 square feet of new and renovated space. Extending over six floors, the galleries cluster around a centralized atrium that reaches 110 feet and functions to bring in natural light and glimpses of the cityscape beyond. Linking all areas of the museum and delivering light to most of them, the atrium draws visitors through the galleries and invites them to make visual connections between these spaces. The open space and light of the atrium connects with the large lobby on the ground floor, and offers visitors a kind of agency that is based on the freedom to make their own connections from the series of options that are available in any given gallery, to other options in other spaces. A series of interior windows further encourage associations to be made across and between different chronological periods. Rupturing the escalator space that leads from the lobby to the second floor is the newly restored 1945 Bell-47D1 helicopter (also the largest object in the design collection). Suspended from the ceiling, this acts as a visual lure to attract visitors into the less central architectural and design galleries on the third floor.

The museum's visual openness works to draw visitors' attention to the museum architecture, especially to the block-wide column-free space of the second floor, which includes ceilings that extend almost 22 feet, and that serves as MoMA's first gallery space dedicated to contemporary art (described as 'the art of our time'). Housing gallery spaces designed specifically for video and media, this floor also has galleries for prints and illustrated books, a reading room and a cafe. The design and architecture collections are housed on the third floor, as are drawings, photography and temporary exhibitions. Galleries on the fourth and fifth floors, connected by a stairway, are devoted to exhibitions of the museum's painting and sculpture collection. Works ranging from the postimpressionist period to World War II are exhibited on the fifth floor and the fourth floor displays works dating from the postwar period to the late 1960s. These two floors each include 'fixed' gallery spaces that present a synoptic view of the museum's collections, and 'variable' spaces which 'are designed to interrupt and amplify the fixed ones, providing an opportunity to inflect their synoptic overview – by highlighting the work of an individual artist, say, or by exploring an issue or idea to a level of detail that would be impossible in the fixed spaces' (Lowry 2004: 34). The sixth-floor galleries also have high ceilings, skylights, and expansive spaces, and house temporary exhibitions.

HISTORY AND THE NEW MUSEUM

The museum's treatment of space shows it to be keenly aware of its place within a contemporary social context of spectacle. The building and its visitors complement the exhibited displays, and become implicated in the vistas available at each ideally postured viewpoint (for instance, the largeness of the contemporary art galleries is emphasized by the smallness of people at whom visitors may gaze through the interior windows). Furthermore, the museum's privileging of newness, nonlinearity, and postmodernity seems to disavow the influence of history and the relevance of modernity. History and modernity now appear as predecessors to the themes and approaches that it currently seeks to espouse and replicate. This is clearly problematic for the new MoMA, which, superficially at least, aims to present a continuum with the past practices of the museum. However, as Mary Anne Staniszewski (2001) has argued, the maintenance of a strong sense of amnesia in relation to its own historical past is not antithetical to MoMA, but may actually be considered an historical condition of the institution. This is apparent in contemporary descriptions of the finished building, which describe the new museum as 'a work in progress' (Museum of Modern Art 2004i) and which aim to assert the forward-looking focus of the building in order to differentiate it from past configurations. Such strategies clearly privilege descriptions of how the museum is new, rather than outlining the connections with the museum's previous designs. Yet, as I want to argue, this selective memory may also function to preserve the modernist preference for progress, and reiterate the present and the new for the purpose of arguing, possibly paradoxically, that the exemplary historical fact of the museum is that it has always been forward looking.

Architecturally, this is signified through the eclectic historical references adorning the Fifty-third Street façade. Although these can be seen to signify progress, they provide no contextual information. The connections between the heavily referential and imagistic façade and the interior spaces (which update but remain consistent with the generic qualities of the white cube), moreover, are minimal. A sketchy sense of the role and significance of history can also be seen in relation to the rationale for the special exhibitions that accompanied the new museum's opening. These exhibitions, including *Michael Wesely: Open Shutter at The Museum of Modern Art* and *Projects 82: Mark Dion – Rescue Archaeology, A Project for The Museum of Modern Art*, pointed to the historical past, but presented it exclusively through a forward-looking and progress-oriented lens. Wesely's photographs deploy unusually long exposures to document the building's construction over a three-year time period, and provide a kind of temporal map whereby little detail can be discerned from the blurred mechanical movement of the demolition and building progress. Similarly, Dion's project, which represents his excavation (in 2000) of the Abby Aldrich Rockefeller Sculpture Garden site (previously home to Abby Aldrich and John D. Rockefeller) literally depicts this selective memory via his collection and display of decontextualized and anachronistic artefacts. The third special exhibition was *Yoshio Taniguchi: Nine Museums*. Displaying plans and models of the new MoMA in the context of other art museums designed by Taniguchi, this has clearly been designed to present MoMA as a cutting-edge museum with an outlook of global significance. This intention helps to explain the location of the permanent galleries. In order to reach the paintings and sculptures that represent the period from late nineteenth century through to the late 1960s (described as the core of MoMA's collection, Museum of Modern Art 2004i), visitors must travel up to the fourth and fifth floors of the museum. The privileged, most visually spectacular and easily accessible second floor is now reserved for the display of cutting-edge contemporary art.

In describing the building, we can see that it offers key moments of newness that are identifiable primarily because they are postmodern, or because they allow expansion and updating of the gallery spaces to accommodate installation based and new media contemporary art. As I have already noted, this rhetoric of newness conspires to present the space as paradoxically being without precedent, because these signs of newness speak to a generic postmodern architectural style (something that is widely apparent in recently constructed museums and shopping malls globally). And yet, the fundamental structure underlying these new effects can also be seen as maintaining clear connections with past incarnations of the institution's built form. These links can be demonstrated by Christoph Grunenberg's description of an older version of MoMA, which, curiously, still appears relevant. He writes that the (earlier) building offered: 'no ceremonial staircase but access at street level; no grandiose columns but a flat, clean façade set flush with the street front... Its name was prominently displayed on the side of the building, visible to pedestrians on nearby Fifth Avenue, home of New York's most exclusive shops... MOMA carefully exploited the lessons of contemporary commercial architecture' (Grunenberg 1999: 34).

This intersection between the desire for newness as it has been expressed in the past and the desire for newness as it is expressed in contemporary terms depicts a commitment to the future and invention (at least rhetorically). Of course this cannot account for the similarity of effect that can be perceived between Grunenberg's description of an older MoMA and my account of the current building. However, articulated as further evidence of a general rejection of history, Staniszewski claims that this dominant compulsion to be new is consistent with the museum's absolute commitment to invention – which she argues by noting Margaret Scolari Barr's insistent comments about the importance of Alfred Barr's ground-breaking exhibition installation techniques within the new museum's first exhibition of 1929 (Staniszewski 2001: 62). However, this ideology of innovation contributes to problems of representation for the new – 2004 – MoMA. Bound to two distinct images of newness, the older (guiding) image of newness valued by modernism (and represented by Barr's assertions) sits uneasily alongside the more prominently displayed and privileged features of a postmodern newness. Commenting on the awkwardness that he sees as having resulted from this combination of modernist principles and postmodern effects, one critic asks:

> How will the museum ever incorporate the recent past into history? Will it just keep expanding? What, in the end, does it stand for? It is a cliché to talk about museums today as cathedrals, and of the MoMA as the cathedral of modernism, with its evangelical mission to spread the gospel to its visiting pilgrims, its white box galleries conveying a cleansing spirit, the aura of baptismal refreshment.
>
> But of course the Modern is not a cathedral. It is the custodian of orthodox modernism, and now also a huge bento box of shops, restaurants, cafes, movie theatres, a garden and other diversions, along with art, to justify as a full day's excursion the egregious ticket price. Moving expansively into the future this way, it still has to figure out the present. (Kimmelman 2004b)

As this passage suggests, the museum's desire for an ongoing and ephemeral newness may be understood best through its connection to the renewable energy and desires of commodity culture. In its first decades, aiming to create a museum that was popular and truly representative of modern art, design and culture, MoMA staged numerous exhibitions that drew inspiration from department stores and mass-produced material commodities. These exhibitions addressed the museumgoer as a consumer rather than as a disinterested viewer of art, commended visitors for their good taste, and offered a pure space of repose from the bustling street outside (see Prior 2003: 59; Bourdieu and Darbel 1991; Duncan and Wallach 1978; Duncan 2005 on the sociogenesis of a pure space). Contributing to MoMA's inculcation of links between high art, cultural capital and commercial culture, formative exhibitions such as *Useful Household Objects Under $5* (1938) presented utilitarian objects and artworks in aestheticized and decontextualized arrangements, where they appeared as gleaming new and without price tags. More recently, the 2004 placement of Pinin Farina's Cisitalia 202 GT two-seater sports car (1946) by the large, third-floor curtain window

overlooking the renovated Abby Aldrich Rockefeller Sculpture Garden and Fifty-fourth Street has provided a visual hook for passers-by (Figure 19) and may appear to be in the tradition of those early shows. But I think that this installation may also parody MoMA's function as a cathedral of consumption (and the consumer-led triumphalism associated with late capitalism) by challenging the idea that the gallery space is detached from external interests or belongs to 'the universal and timeless realm of spirit' (Grunenberg 1999: 34). Moreover, as I want to suggest, the architectural rhetoric of newness may not actually exist in contrast with or in opposition to MoMA's commitment to continuity – despite appearances to the contrary. While this preference for newness certainly resulted from the architectural strategies preferred by Taniguchi's commitment to modernism, it may have itself been a commercially influenced strategy on the part of the museum's trustees and director. This appears consistent with the past practices of the museum, and appropriate to the pressures for business-driven institutions such as MoMA to generate financial confidence and excitement among lenders, donors and patrons.

Engaging critically with the emergence, manifestation and organization of this contemporary trend – and taste – for ephemeral newness, Frederic Jameson has connected

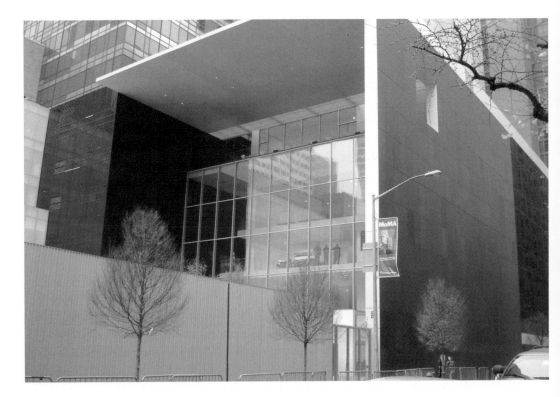

19: View of third floor from Fifty-fourth Street, the Museum of Modern Art, New York. Photograph by Kylie Message.

postmodernism with late, consumer or multinational capitalism by claiming that our entire contemporary social system has started to lose its capacity to retain its own past. He says that we have, instead, 'begun to live in a perpetual present and in a perpetual change that obliterates traditions of the kind which all earlier social formations have had in one way or another to preserve' (Jameson 1998a: 143). Interpreted according to this argument, MoMA's core inconsistency emerges from its invocation of both the structural conditions associated with the ongoing project of modernity (epitomized by the mid-to-late nineteenth-century interest in new modes of display, communication and experience summed up by the department stores emerging at this time), and the rhetorical effects of twenty-first-century postmodernity. As such, it employs features of modernity at a generally invisible albeit fundamental level. This is so in regard to history, display and communication on the one hand, so that on the other it can attempt to undercut the problems of representation associated with modernity by referencing a postmodernity that denies both historical precedents and the connection between museums and modernity as a progress-oriented project.

This is ironic in relation to modernism's belief that 'ornament is a crime' because it looks as if postmodernity has been appropriated within the new MoMA not as a cohering style, or as a guiding principle, but as precisely that: adornment. Possibly aiming to redress anxiety based on this use of decoration, publicity about the museum's postmodern features has tended to reassert the symbolic function of the sculpture garden – reinstated by Taniguchi according to Philip Johnson's original 1953 design, and described as the museum's 'oasis' (Museum of Modern Art 2004i) and 'most distinctive' element (Museum of Modern Art 2004g) (Figure 20). Here, postmodernity offers a form of facadism that can be undercut or counteracted by the modernist garden at the museum's heart. Despite being deployed as a sign of newness, the new museum double-codes its appropriation of postmodernity, so as to also expose it as simulated and empty (thereby further asserting the truth and authority of modernism as the privileged – naturalized – term in this context). This is clearly problematic because in reasserting emblems of an architectural modernity (as with Johnson's original design), the pedagogical aspirations of modernist architecture are recalled, including the belief that architecture might guide the social and moral improvement of 'the public'. This also appears to suggest that the museum may aim to conform with other traditional ideas of pedagogy, value and order.

In both asserting and critiquing the idealized modernity of white cube exhibition spaces through their strategies of display, the new MoMA may be physical evidence for the argument that modernity and postmodernity do not exist in a dialectical relationship, but as influences that overlap and compete for attention. For example, in relation to architectural detail, we can see this depicted in the interior windows, which offer artificial connections between upper and lower galleries and adjacent spaces, and where enormous external windows both let in natural light and frame the surrounding Manhattan neighbourhood as an object of display. However, although an image of interplay between modernity and postmodernity

20: View of sculpture garden and Fifty-fourth Street from third floor of the design gallery, the Museum of Modern Art, New York. Photograph by Kylie Message.

is achieved by allowing external experiences and images to rupture the otherwise ordered galleries (which still appear to favour activities of contemplation), this collection of effects has itself been identified by Rosalind Krauss (1996: 347) as constituting a key generic feature of postmodern museums globally.

THE 'LITERARY TURN' OF THE NEW MUSEUM

The desire to achieve a convincing image of perennial newness, of global attention and of postmodernity, is associated with the use by museums of theoretical language in their profiles, plans and publicity. Thus, the disciplines of cultural studies, social theory and philosophy have come to offer ways of presenting new plans and renovations for existing museum sites. Lowry claims, for example, that the new museum offers what Foucault (1986) referred to as a 'heterotopic' space (Lowry 2004: 24). He also invokes discourses of democratic public space in relation to the new MoMA (Lowry 2004: 10, 12–15; Museum of Modern Art 2004i), and deploys the term 'nonlinear' to describe the internal gallery spaces (Museum of Modern Art 2004h). The use of such theoretical paradigms provides the built space with a rhetorical effect of academic currency and newness that, in many

cases, belies the fundamental conservatism of changes that have been made to the building. Here, theory and discourse are reduced to flourishes so that rather than speaking in any real way to the form they apparently re-present, they seem to be employed as a compensation for a lack of dynamism. Although we may notice, for instance, that MoMA's multilayered façade indexes specific points of historical reference, we are offered no more information at this point. Perhaps most problematically, then, this theoretical way of speaking about the museum often differs from the actual experience of building, curating, or visiting the site; resulting in frustration for visitors who may be induced to expect an experience that has great rhetorical flourish but which delivers little in the way of actual material difference or interest. This means that while it is refreshing to enter MoMA's newly reinvigorated front entrance and move through to the contemporary art spaces that are expansive, intersecting and light-filled, it is disappointing to find that the subsequent galleries follow the general organization developed by the museum in the 1970s and 1980s (Lowry 2004: 31).

Consistent with the renewed interest in language, narrative has been identified as offering useful strategies and tools to reinscribe an embodied sense of place – while also marking the architectural discourse as postmodern because it supplements the functional aspect of the building by being implemented as additional or extra. In referencing or drawing upon multiple influences and references, postmodernism, according to Charles Jencks (1991), refers principally to buildings that treat architecture as a language or discourse. This may culminate in an architecture of 'narrative content' that lifts the building 'out of its primary relationship to function and places it within a new relationship with fiction' (Woods 1999: 99). This is antithetical to the formalist approach of modernism, which – as seen in the white gallery spaces and in the generally non-informative wall texts privileged historically by MoMA – excludes the consideration of content or context and privileges the functional aspect of language or form as a mode of metanarrative (communication and authority). Jameson also describes the changing relationship between architecture and narrative to argue that narrative has been appropriated (as a modernist strategy) to achieve an applied impression of newness (1997: 244), which, he contends, encompasses both the new, postmodern architecture and a new experience of the space. He is especially concerned that these changes, which are, for him, inflected by his critique of the commodity-fetishism of late capitalism, will undermine democratic urban spaces. According to this critique, narrative has been 'borrowed' (or, as Habermas argues, 'quoted') from a modernist trajectory in order to communicate to visitors the production of an additional symbolic value and cultural currency. Similarly, Krauss commented on this shift in a groundbreaking 1996 essay on Andre Malraux's notion of the *musée imaginaire*. In this essay, she notes the phenomenal authority of speech activity as demonstrating the 'Anglo-Saxon desire for language to construct a stage on which things – even ideas – will happen' (Krauss 1996: 344). In making this point, she argued that contemporary museums and their effects are often constructed primarily through rhetoric and speech activity; and only secondly through structural form. Architecturally, we can interpret this as meaning that the debate has transgressed from the

question of form versus function, to a focus on representational effect. Or, as David Harvey (1990: 97) contends, the matter of postmodernism is 'not just function but fiction.'

The paradox of this situation has proven fruitful for theorists, particularly for Jean Baudrillard who, as early as 1977, claimed that the Centre Georges Pompidou epitomized Western contemporary culture as 'a culture of simulation and fascination', rather than as the culture of production and use-value which it once was (Baudrillard 1997: 212). Instead of being meaningful because of its relationship with a primary referent, this means that the museum or object of display comes to function symbolically, as an image that acquires a meaning based on its similarity with other like-signifiers. That is, they are meaningful not because of what they represent or how or why they have been constituted, but because of their status as a representation – as an image. So the new museum achieves currency and interest because of its status as a new museum that is similar to other new museums, rather than because of its collections, or the individual experience it offers visitors. This effect is enhanced by the inclusion of the *Yoshio Taniguchi: Nine Museums* exhibit, which makes the viewer feel that MoMA is but one part of a greater architectural scenario and vision. The legitimacy of the new MoMA is heightened further by being contextualized against Taniguchi's other museums – which contribute to a sense of the architect's international status and celebrity.

According to this postmodern scenario, the context of meaning is developed in association with other similar images or effects that also exist within this particular, shared representational field. As Jameson argues in relation to the nostalgia-fetish of contemporary culture, this does not exist in contrast or opposition to reality, or to a more real or authentic realm of signifiers. It is, instead, a component of it, contributing equally to visitors' experiences of the museum. Indeed, this illusion is extended by the museum shop (MoMA has three on site), where visitors reproduce the experience of visiting the museum (and extend their association with cultural capital) by taking home an object 'as seen' in the museum. This would also confirm Carol Duncan and Alan Wallach's 1978 analysis of MoMA, that it only 'appears to be a refuge from a materialist society, an ideal world set apart', when in fact it not only replicates the same commercial structures and their governing ideology of capitalism, but aims to 'reconcile you to the world, as it is, outside' (1978: 47; see also Prior 2003: 52).

Jameson has expressed concern that 'we seem condemned to seek the historical past' through the nostalgic stereotypes that are reproduced for our consumption (1998a: 135). Baudrillard expands on this by questioning the significance of the relationship between the sign and referent, so that we might be pushed to query exactly what can happen in new museums that are dedicated to a perpetual present that denies history when in fact the very objects they display are themselves, regardless of their commercial value, inherently without meaning or value. Both theorists agree that the free-floating or self-referential signifier or object on display functions as 'a signifier that has lost its signified', and which 'has thereby been transformed into an image' (Jameson 1998a: 138; see also Virilio 1994: 9). This has

been argued not only in relation to the way that new museums have engaged with new modes of display, but in respect of museum buildings themselves. Indeed Baudrillard's argument about the Pompidou Centre may now be most applicable to the perfectly reflective and smooth, imagistic effect produced by Frank Gehry's internationally renowned museum buildings. Epitomized by the Museo Guggenheim in Bilbao, Gehry's buildings exist as beautiful objects, discrete from the material exhibited within them, and are primarily meaningful as signifiers of stylistic newness and global, economic affluence. Baudrillard (1997: 214) extends this line of argument further still, to the point where he claims that although the image has the same potential for affect and meaning that the original (referent) does, the 'supermarketing of culture … as merchandise', has meant that the production of spectacle compromises the possibility for significant – and here he infers political – impact or influence.

A POSTMODERN MUSEUM?

It is necessary at this point to say more about the new museum and its relationship with modernity and postmodernity, and about the friction between these frequently opposed terms. In particular, I want to explore further the tension that I have identified: namely that despite claiming to be principally or effectively postmodern, new museums like MoMA have, in actual fact, appeared in association with strategies and impulses that are more generally associated with modernity. The discourses of newness and futurity that are emblematic of Gehry's 'Bilbao effect', for instance, appear to privilege a kind of newness that aspires to the ahistorical, and this can be seen as indicating, paradoxically, a key characteristic of modernist projects that aim to embrace the teleological desire for a continual newness. Postmodernity, in contrast, is more commonly perceived as questioning the very possibility of newness itself, which is more likely to be presented as a form of mimicry or pastiche. By engaging with these theoretical ideas and modes of expression, the contemporary museum has been widely perceived as a postmodern museum that is removed from the old certainties of more traditional approaches to display because it appears to offer new experiences. However, not only does this theoretical engagement work to provide the museum with the privileged effect of newness, but these images (and the theory that is used to describe them) come to function, as I have been arguing, as a replacement for history. Increasingly out of favour on the basis that it represents a categorizing narrative device, history's demise has been to the gain of theoretical discourse, nostalgia, and postmodernity.

This presents a dilemma, because if museums choose to privilege images of compulsive, eternal newness but express these images through postmodern theoretical discourses, they function as pastiche rather than offering something entirely new. Jameson (1998a: 131) considers pastiche to be problematic because it offers 'a neutral practice of mimicry' that is as effective as 'speech in a dead language'. However, it is also awkward for our purposes because, on these grounds, the new museum appears to be apolitical and removed from social relevance (thereby discrediting all claims to political agency made by new museums

globally). As the opening quotation of this chapter notes, MoMA already exists as strangely externalized from the realm of history. Certainly it was, as Ouroussoff remarks, alienated from the September 11 terrorist attacks and the start of the war in Iraq (2004b: B1), but it has also largely avoided the culture wars and the conservative backlash that has surrounded these events. This estrangement from history contributes further to the museum's notion that it provides an 'urban oasis' (Museum of Modern Art 2004i), and that its postmodern architecture, as Harvey puts it, is a search for 'a fantasy world' or 'the illusory "high" that takes us beyond current realities into pure imagination', and that represents a preference for fiction rather than function (Harvey 1990: 97). Going on from this, and in accord with Jameson's general dismay over the increasingly superficial and imagistic obsessions of contemporary culture, it may be suggested that modernity has been appropriated by postmodern museums as a kind of redressed style, or as a narrative strategy that has been removed from its own concerns and meanings. Jameson (1998a: 132) bemoans this on the basis that an 'essential' message of the new museum will come to 'involve the necessary failure of art and the aesthetic' and 'the failure of the new'.

Despite Jameson's dystopianism, we can see from his argument that postmodern discourse can wield rhetorical power. But should we take the skein of contradictions implied by postmodernity to infer that the (modern) museum is dead, as Douglas Crimp (1997) and others (Roberts 1988) suggest? Or can we understand it to mean that any claims to newness are always already destined to failure? Indeed, this latter claim may work instead to support the museum's greater dedication to modernity and the steady modernist project of progress and enlightenment. Not only does the new museum embody these contradictions, but it appears to do so in such a way that postmodernity is frequently used as a rhetorical device to indicate the newness of the museum, which, regardless of this, tends to function more fundamentally according to modernist motivations – a point that reinforces the idea that there is no historical point of rupture severing modernity and postmodernity as chronological periods, but that as Habermas (1997, 1998) and others have suggested, the project of modernity is ongoing, albeit in dispersed and differentiated forms and according to various discursive models that continue to have an ideological function.

Indeed, this may be MoMA's ultimate conceit, because this new building is itself sure to become victim to the overarching authority of modernity with its insatiable taste for signs of newness and progress. Taniguchi's version is certainly destined to meet the fate of its predecessors – a point confirmed by Lowry (2004: 37) who explains that every installation of the collection is considered to be 'provisional'. It may even be anticipated by Wesely's photographic sequence of the demolition of buildings that previously occupied the site and were excavated for nostalgic effect (as we see in Dion's project). This sequence of events may also expose postmodernity as a style of decoration that adds the value of nostalgia to the more privileged modernist narrative. In a sense, then, this is where the new MoMA meets its discourse. Not only is the structuring modernity brought to bear on the new design, but it is where modernity comes to make sense in relation to the series of decisions that have been

made for the museum because what is most apparent in this newest configuration are a series of connections with the construction of a modernity that can be located in the nineteenth century. This is evident both in respect of the museum's desire to function as a pedagogical and educational space, and as a space that claims to be focused on the animated activities of the street, where it evokes Barr's earliest agendas, by locating its entrance 'directly on the street, instead of up the imposing flight of stairs used by many other museums' (Lowry 2004: 13). Moreover, the attention to new and elaborate forms of architecture can be identified as a revival of interest in the imposing architecture of a nineteenth-century modernity as well as evidencing awareness of the role of 'mediated monuments' in contemporary culture (Vale 1999).

As MoMA and other examples show, contemporary museums invoke rhetorics of newness and postmodern approaches to narrative order and expression primarily in order to achieve a new effect and, secondly, so that they may be perceived as attaining a cultural and political currency and cachet (Prior 2003: 59–60). Evidence of this 'literary turn' is certainly omnipresent throughout the publicity and texts produced by MoMA. While an interest in 'textual' architecture – or 'architecture as text' is apparent in the built form of the institution, particularly in the intertextual references marking the building's façade, it can also be seen in the interior spaces where the internal windows, for instance, speak directly of syntagmatic postmodern architecture that is used widely and generically to signify new museums (as argued by Krauss). The textuality of the architecture comes together with the self-consciously narrativized approaches to exhibition so that works from the collection are exhibited in an essentially chronological sequence (or reverse chronology, with the earliest nineteenth-century works located on the fourth and fifth floors). However within this overarching narrative, it is claimed that the distinctive design of the galleries 'allows that progression to be nonlinear' (Museum of Modern Art 2004h).

The shift Harvey speaks of from function to fiction is particularly noticeable in the booklet written by Lowry to mark the museum's opening (Lowry 2004). Despite his frequent mentions of 'storytelling' and 'narrative' procedures, what is most interesting is the way history is framed. Following the selective memory guiding the transtemporal maps offered by Wesely's time-lapse photographs (where specific detail is subordinated to markers of progress) and Dion's archaeological project (where a few excavated objects are presented as speaking for history), Lowry (2004: 10) presents the museum as aiming to engage with the history of art as a system of narrativity that is forward looking, because 'modern art is still unfolding and its history is still being written'. Demonstrating the literary turn in his account of the museum's primary programme of collection and display, he contends:

> The Museum of Modern Art is constantly revising the narrative of its own history, tracing what Proust called 'le fil des heures, l'ordre des années et des mondes' – the continuous thread through which selfhood is sewn into the fabric of a lifetime's experience. This is a collective process of interlocking dialogues and narratives played out over a theoretically infinite number of lifetimes. (Lowry 2004: 15)

This passage resonates both with the episodic nature of narrative, and with the postmodern taste for broken and incomplete stories and nonlinear modes of expression. Yet, whereas postmodern texts tend to be directed toward consideration of the present, Lowry's text – like Wesely's and Dion's exhibitions – is fundamentally progress oriented. 'The Museum' is clearly represented as the dominant authority here, and the objects collected are grist to the mill of this metanarrative form. Although the author invokes markers of postmodernity – including the desire to include 'visual surprise' (Museum of Modern Art 2004g) and claims that the museum engages with the 'unpredictable order of the city' (Lowry 2004: 24), the threat to the overarching modernist metanarrative structure is not to be taken too seriously. As if to reiterate this, in the conclusion, Lowry (2004: 37) suggests this all combines to achieve an effect of newness, and in so doing, recuperates any possibility for proper subversion (by the constitution, for instance of a properly heterotopic space) or for the manifestation of actual newness: 'The Museum that is revealed by this new installation plan is but another iteration of The Museum of Modern Art envisioned by its founders over seventy-five years ago. It is larger, of course, and more complex, but its underlying principles endure.'

THE MODERN IS NEW AGAIN!

It was in 1997 that the Japanese architect Yoshio Taniguchi won the competition to extend and redesign MoMA. Reiterating the proper modernist elaborative order, he proposed that because MoMA is a '"street" not an "avenue" museum, the direction of [MoMA's] future growth' should be 'linear' (Taniguchi 1998a: 242), claiming further that: 'The circulation spine which unites all portions of the site, and which can also extend to subsequent sites to the east and west, can – at the same time – define a core zone within the Museum about which galleries and offices will be configured' (Taniguchi 1998a: 242). Principally designed according to conservative International Modernism or Bauhaus style, Taniguchi's plan exposed the museum's preference for reinforcing what was already there (Newhouse 1998: 148–61). Responding also to this preference for a pre-existing pedagogical structure, Ouroussoff writes that MoMA's 'vertical hierarchy evokes a Darwinian climb toward the canonical works of early Modernism':

> It reinforces the notion … that museums are as much about the stamp of legitimacy as about aesthetic pleasure. This may irritate people who believe that a 21st-century museum should take a more populist approach … You could argue that Mr Taniguchi is stripping away the egalitarian pose and exposing the museum for what it is. (Ouroussoff 2004b: B7)

It is apparent that the architect attempted, both in planning and execution, to engage with the economy and style of contemporary critical theory and narrativity in order to achieve a certain cutting-edge currency. However, he was unable to break free from the museum's overarching sense of order, so that despite presenting the possibility that modalities of narrative expression (and the theoretical discourses used to explore these)

could offer an intriguing new way of heightening visitor experience, and of manifesting a relationship between the new exhibition spaces and the pre-existing site, Lowry (2004: 31) claims that 'Taniguchi found a way to make physically evident the Museum's commitment to contemporary art, embedding [the] programmatic direction of the institution into the architecture of the building'.

In referencing postmodern ideas by making architectural spaces and surfaces that can be described as textual or 'embodied' (Barthes 1997a: 171), Taniguchi may have hoped to draw on the postmodern idea that the city hosting the museum is constituted according to a series of equally constructed and ideologically invested procedures. MoMA's website, for instance, proclaims that in designing the lobby, Taniguchi has 'taken inspiration from the idea of the street, and transfers it inside' (http://www.moma.org/). It is true that the lobby is an expansive, beautiful space that functions as the information centre of the museum and a meeting point, where visitors have a plurality of vistas open to them; those of the sculpture garden, the multiple floors of the galleries above, and the light-filled atrium. Yet, although MoMA was revolutionary in its earliest days for literally opening the collection to the street – by exhibiting work on the ground floor where it closely echoed department stores that presented their goods to the street – it is interesting that the museum's shop now occupies this position. The collections are exhibited from the second floor upwards, and perhaps most notably, the Philip Johnson Architecture and Design Collections (which houses the most commodity-like aspects of the collection) are housed out of view from the lobby, on the third floor (Figure 21). Rather than offering the conditions required for MoMA to be a site of interaction and thus a properly public, democratic space which may 'be shared with as large a public as possible' (Lowry 2004: 10), it seems to offer the image or the (private, corporate) dream of an idealized public space where everyone knows how to act.

As such, there is little sense of a symbolic let alone an actual flow between the museum and its urban surrounds. Whilst the architecture does not dominate the neighbouring environment, it does provide attractive features and interesting glimpses of artworks for those who are passing by the museum. One of these glimpses is the museum's 'heart' – the sculpture garden; and yet even this only conspires to tease. Separated from the street by a very high, thin wall that cannot be looked through or climbed over, but which has a service gate at one end that can be peered through from up close, this wall makes any interaction between the immediate environment and the museum an impossibility (Figure 22). Moreover, the prospect of achieving a visual connection between people within the museum (standing on the third floor alongside the sports car) and pedestrians on Fifty-fourth Street is certainly encouraged by the massive glazed curtain wall that overlooks the garden and street. However, this kind of spectatorship – or looking from a distance – is not the engagement described in publicity material, which speaks of more literal and pragmatic exchanges between the street and museum. In relation to MoMA, spectators are either inscribed within the museum or are clearly externalized. Although the museum can be seen to accommodate the desire for 'place making' that is usually antithetical to modernist architecture, it does not accede to the

21: Philip Johnson Design and Architecture gallery, the Museum of
Modern Art, New York. Photograph by Kylie Message.

possibility of any proper blurring between the museum and the spaces beyond its borders.
This means, for example, that although the skyline enters the exhibition spaces through
the large windows, the views remain framed and silent, further differentiating that external
environment from the quality controlled inner atmosphere. Given this lack of exchange,
there is no sense of a greater spatiality encompassing both the museum and its surrounding
areas.

In writing about the effects associated with perceiving architectural spaces and the city
as (constituted by semiological) language, Roland Barthes (1997a: 167) speaks in reference
to his own preferred model – employed by Victor Hugo in the novel *Notre-Dame de Paris*,
where the author 'gives proof of a rather modern way of conceiving the monument and the
city, as a true text, as an inscription of man in space'. Barthes, characteristically, frustrates
us, however, by refusing to advise on how this might be achieved; for Barthes meaning
can only, ultimately, be developed by readers, through their own patterns and choices of
movement and their own semiological incursions into these spaces. Perhaps this means that
incursions do exist between New Yorkers and 'the Modern' that they love so much, by virtue
of their own personal stories and movements through and around the museum. Perhaps

22: View into sculpture garden from Fifty-fourth Street, the Museum of Modern Art, New York. Photograph by Kylie Message.

the basic fact of a person walking from the street into the museum transcends the barriers of architecture. Yet this puts architects, designers, and planners in a difficult position and at a clear disadvantage: how are they to literally achieve or foresee this ultimately nonlinear (and postmodern) outcome? Further articulating this problem, Umberto Eco (1997a: 199) suggests that, 'One might at this point be left with the idea that having the role of supplying "words" to signify "things" lying outside its province, architecture is powerless to proceed without a prior determination of exactly what those "things" are (or are going to be)'. This poststructuralist problem – as well as providing the dilemma and framework – can also be seen as contributing the theoretical context with which MoMA's design competition and the charette (architectural preselection process) sought direct engagement, and it is according to this (and MoMA's self-promotion) that the proposed plans each presented a clear desire to produce the new museum as contributing to the semiology of the city. It may also be because of this focus on narrativity and the potential for new kinds of meaning

that are understood, as Barthes explains, to emerge from visitor movement and processes of interaction – and because of the literal focus on language that accompanies these – that the architects turned to postmodern images and conceptualizations in the hope that they would offer both a methodology of design and a response to Barthes' challenge. This would explain why Taniguchi's plans and Lowry's rhetorical statements appear to embody the storytelling and explicitly process-driven methodology summarized by the literary turn (away from function and toward fiction).

DESIGNING THE NEW MOMA: 'A PROCESS OF DISCOVERY'

The pre-building stage of museum development is fundamental not just for the decisions which are made about the architectural form, but also because ways of speaking about a project often translate into ways of seeing a space (for the significance of 'speech acts' to the museum, see Bal 1996a, 1996b; Clifford 2001). Thus, in addition to documenting the building of MoMA's extension, Lowry provided a survey of the rhetoric associated with new museum projects in the MoMA publication, *Imagining the Future of The Museum of Modern Art*. With its keynote essay 'The New Museum of Modern Art Expansion: A Process of Discovery' (Lowry 1998a: 10–27) this publication was intended to document the architectural competition held to attract designers to propose extensions to the existing building. The essay, which included a survey of the entries, also gave an account of the gestation of the design brief itself. It sheds light on the way in which the project was informed by museological discourse. Most notably, Lowry focused on terms such as 'imagining', 'future', 'process', and 'discovery', which combined with the already existing built form and history of MoMA to produce new ways of speaking about museum form, content, and identity.

However, rather than achieving a mode of speaking and building that is notably new, the terminology of *Imagining the Future* exposes the strict, underlying authority of the existing order of structural modernity, as well as the early modernist belief that 'architecture could not only express ideal values but could also help shape them' (Ouroussoff 2004b: B7). This evokes the more traditional museological project of civilizing and socializing the public and offering them the tools to recognize the value of good taste. Thus, as Staniszewski (2001: 292) argues, it affirms the pedagogy of MoMA in the past: 'in keeping with the majority of installations created at MoMA, these exhibitions validated very particular notions of modern subjecthood, such as autonomy, a universal essence, and personal liberty'. The evocative, future-oriented terminology used in publications following MoMA's opening can, therefore, be attached to the built extension; but only momentarily, and only on the understanding that while the effects they speak of may come and go, the overarching metanarrative (and liberal moral position) of modernity will progress stoically. Expanding further on this, Ouroussoff (2004b: B1) offers the following provocation:

> The building, which reopens on Saturday, may disappoint those who believe the museum's role should be as much about propelling the culture forward as about preserving our collective memory. This is not the child of Alfred H. Barr Jr., the founding director

who famously envisioned the Modern movement as a torpedo advancing relentlessly toward the future. Its focus, instead, is a conservative view of the past: the building's clean lines and delicately floating planes are shaped by the assumption that Modernity remains our central cultural experience. The galleries, stacked one on top of the other like so many epochs, reinforce a hierarchical approach to history that will bolster the Modern's image as a ruthless arbiter of taste.

The Museum of Modern Art's expansion project offers a particularly rich case study for critical analysis because of the centrality of the modernist metanarrative – which maintained its authority and framed the decision-making process throughout the renovation process. In deciding to expand the museum, the board of trustees, senior staff, architectural consultants and other experts who collectively became a selection and managing body called the Imagining the Future Committee, raised the issue of 'how the Museum could balance its debt to tradition and history with its commitment to the present and the future' (Museum of Modern Art 1998: 7). Other issues raised by the committee included 'the challenge of making the best use of new technologies' (Lowry 1998a: 13). They sought, in other words, a central unifying narrative trajectory that would bind together the futurist details that would render the building as visibly updated. The way to achieve this was to incorporate this futurity into the built structure so as to maintain the overarching narrative order that provides an authoritative chronology connecting the immanent future to the preeminent past. In explaining the process, Lowry observed that, in order to maintain narrative unity, the board of trustees had chosen the expensive option of acquiring neighbouring sites and expanding adjacently. This approach 'provided the only coherent way to expand, while retaining the sense of the Museum as a single, integrated entity' (Lowry 1998a: 12). Yet, although desiring to maintain this cultural authority over Midtown Manhattan, they also recognized the imperative to be 'new' (Lowry 1998a: 12). Paradoxically, however, despite the postmodern complexion of these rationales, the buildings themselves (and their collections) fit comprehensively within the modernist order. Whilst they replicate modernism physically and structurally they spurn it at a representational and rhetorical level. Thus, for example, the brief for MoMA's charette informed the architects that they must retain the institution's centrally organizing modernist spine so that despite 'the complexity of the narrative, the flow of the principal public spaces should be apparent but not necessarily obvious' (Riley 1998b: 284).

Thus, again, fiction is privileged over function, so that spectatorial attention to the central, regulating order is distracted by the shiny and reflective patina of newness itself – light, the incorporation of new technologies, heady noise and spectacle. This enactment of postmodernism is effected by means of a representational order whereby signifiers of newness predominate. Elsewhere we can see that this is associated with a compulsion for museums to embrace a forward-looking futurism. This is fuelled by attempts to increase visitor numbers and to attract younger audiences. Such attempts include proclamations of the contemporary relevance of the museum and its technological interest. The desire to

represent a museum according to a vision of futurity may lead it into a Baudrillardian world of a-signification where the museum speaks of itself and not of the collection it aspires to represent or promote. Such is the case with the rhetoric surrounding the development of MoMA, where the architect addressed the future relevance of the site to such an extreme extent that a highly paradoxical relationship was established with the site's own symbolic and political function (as celebrating a particular past) (Taniguchi 1998b). Part of this rhetoric of futurity is a controversy for its own sake. Such celebration of controversy threatens a radical change to an existing order by indicating the potential of something new. However it may be noted that the controversy that is legitimated by the museum is itself a fairly tame and limited one which appears to be no more than a 'borrowing' of postmodern principles for the purposes of decorating a fundamentally modernist project.

In the case of MoMA, we can see that newness has been constituted as a rhetorical effect, so that it has become a signifier of modernism as a provocative but ultimately two-dimensional decoration. In a disparaging appraisal of one of Taniguchi's contemporaries, Robert Venturi, Habermas (1997: 227) criticizes architecture that 'transforms the spirit of the Modern Movement into a quotation and mixes it ironically with other quotations'. Clearly concerned with what he understands as being the depoliticization of public architecture and the associated reconstruction of the architect as celebrity, Habermas argues that the superficial effects of postmodernity have actually been achieved according to modernist strategies, techniques, and signifiers.

These strategies of appropriation, which are evident throughout popular culture, have been used at the new MoMA and are visible in Taniguchi's design. The objects of Habermas's critique can be readily detected in MoMA's *Imagining the Future*, as well as in the brief provided for the charette. Moreover, the language of these texts informed the design process from the very outset. The new MoMA was to convey an image of newness (produced from a reconstitution of its historical components) but it was also to conserve a safe modernity. Critical of the general trend within Western global culture toward the celebration of generic postmodern architecture, which he refers to as 'anonymous' and authorless, and in a passage that resonates for descriptions of the new MoMA, Habermas (1997: 235) argues: 'the nostalgia for the de-differentiated forms of existence often bestows upon these tendencies an air of anti-modernism. They are then linked to the cult of the vernacular and to reverence for the banal. This ideology of the uncomplicated denies the sensible potential and the specificity of cultural modernism.' This statement can be used to describe the institutional and ideological context governing production of the new MoMA, which was to convey the look of newness without being outlandish. Not only was this image of newness designed to indicate the current relevance and postmodernity of the building, but it also obscured the enduring ideological modernity of its guiding principles. This should be taken, not so much as an assertion of the historicity of modernism but as a disavowal of modernity in which the 'unfinished' social and political aspects of the modernist project are discarded.

CONCLUSION

The promotion of future-oriented museums is, therefore, a way of constructing spaces that may contribute to redefinitions of the museum as new. However, it seems that the language of contemporary museology is frequently employed to conceal less visionary modes of production. Accordingly, the internal order of the new MoMA is described in terms that are, despite their seductive rhetorical flourish, disappointingly conservative (see Taniguchi in Riley 1998b: 278). This rhetoric aims to evoke a new logic of architectural and narrative development but it is still a transcendental logic that seeks first and foremost to consolidate effect, so that despite the mode of conveyance, what underlies these terms of fancy remains to be a firmly modernist claim to progress. Knowing that, at some level, images of progress are still demanded of cultural (and especially public) sites by the community, museum designers produce narratives with a double action. At the same time as they decry any past reference or organizing metanarrative (privileging instead the fleeting and transitory effect), they underline the built text with singular reference to lasting emblems of progressive modernity.

In focusing on the rhetorical role of language, and the effects that language is understood to provide for the new museum, this chapter has looked at the relationship between the textual production of the museum and the physical production of the museum to which this discourse refers. I have explored, in particular, the way that the rhetorics of language are appropriated according to a desire for a postmodern currency as a condition of the new museum, and argued that this is problematic because the textual and rhetorical postmodern signifiers of futurity and newness that are desired by these projects undercut the physical site's relationship with a continuing modernity. This tension between the formative modernity influencing development of the built environment, and the rhetorical approaches employed to persuade the visitor of the site's postmodernity, is often further complicated by the evocation of terms and concepts from the field of critical cultural theory. Although this indicates the crossdisciplinarity of the new museum, it can also be argued that crossdisciplinarity can itself function as a desirable but empty signifier of postmodernity. It is, therefore, necessary to work through the rhetorical maze of representational terms in order to understand that claims high on futurism and rhetoric may cause speech acts to outrun the visitor's experience of the museum. This actively and convincingly differentiates storytelling from the experience of the site visit. This is problematic for museum projects that rely, as most do, on contextual storytelling to inform the visitor's experience.

In this chapter I contend that the relationship between modernity, modernism, and the ongoing ideologies of trade, progress, social enlightenment and cultural modernization can be illustrated effectively by a brief historical cross-section that links the Great Exhibition of 1851, the 1951 Festival of Britain, and the London Development Agency's 2005 plans for the renewal of the Crystal Palace site in Sydenham, with MoMA's 2004 renovation. While the 1851 exhibition has been identified as the first properly 'international' exhibition and the 1951 exhibition was engineered to offer a more inward-looking yet equally positive image of nation, MoMA – while not of the international exhibition typology – epitomizes the progress-oriented goals and aesthetic qualities of modernization that the earlier examples either aspired to (in 1851) or embodied (in 1951). Similarly privileging an attitude of progress and modernization, the London Development Agency's *Crystal Palace Park Planning Framework* (2005) expresses a preference for a 'revived metropolitan park' to any recreation of the original – which it hopes to respect in sentiment but not emulate in form (London Development Agency 2005: 32).

Denoting Britain's imperial aspirations, in his capacity as Honorary President of the Great Exhibition, the Prince Consort Albert directly expressed the importance of the Great Exhibition a year before it opened. During an address delivered at the Mansion House on 21 March 1850 he exclaimed that it would mark 'a new starting-point from which all nations will be able to direct their further exertions' (Martin 1876: 248). This was consistent with the decision to establish a Royal Commission to prepare for the Great Exhibition, which was to be consciously placed in the arena that Habermas later describes as the public sphere, and 'what the liberal-minded Lord Carlisle called in 1850 "an arena [different from the "crowded saloon" or "the heated theatre"], where all ranks may mingle, where all [including "the workmen and workwomen of the world"] may learn and all may profit from what they see' (in Briggs 2000: 19). Covering 19 acres of parkland in a building constructed entirely of steel and glass panels, and thus referred to as 'the Crystal Palace', the building accommodated over six million visitors in the five months of the exhibition. It was perceived as an engineering feat that instantiated the new technologies and techniques of modernity and progress. One visitor expressed simply that the Crystal Palace 'stands for modernity' (in Purbrick 2001: 2; see also Berman 1988). Articulating thus the motivations of economic progress and social civilization – as hallmarks of this enlightenment period – modernity was framed and popularized by its very promise to offer the new.

Leaping ahead a century, the 1951 Festival of Britain was designed to restore confidence in a nation that had suffered throughout the trials of wartime and the economic difficulties of the postwar period. Inspired by the rhetorics of newness that the new era appeared to bring to fruition, and comforted by the nostalgic renderings of the centennial links with the 1851 Exhibition, the 1951 Festival of Britain demonstrated precisely the changes that the phrase 'modern' had undergone in the ensuing century (Banham and Hillier 1976). As many commentators noted at the time, this transformation indicated that the rhetorics of newness had became ubiquitous in contemporary life. However, when spoken by the festival's organizers, such claims did not accurately represent or express the aims of many of the exhibitors, so that although the phrase was still used to excess (the festival, according to Asa Briggs, 'delighted in what it called "the new"'), many designers, architects and newspaper commentators argued that the festival did not initiate a genuinely 'new style' (Briggs 2000: 22–23). Recounting the launching of the festival's central architectural symbolic icon (called the 'skylon' but usually described as a giant cigar), Briggs (2000: 23) explains: 'Things looked new. Yet for the architects 1951 was a culmination, the climax of activity for what the MARS (Modern Architecture Research Group) group of "modern" British architects had been striving to do since the formation of the group in 1933.' Despite aiming to evoke the ancestral link between the Festival of Britain and earlier international exhibitions, this shows how over time 'the new' is perceived as having lost the promise that it once was understood to inherently embody.

Despite this shift toward embracing architectural symbols like the skylon, and a twentieth-century modernization that had few links with the modernity of the nineteenth century, the term 'the new' has continued to offer a meaningful and popular (if equally empty) signifier today. This thematic link is present in the London Development Agency's *Crystal Palace Park Planning Framework* (2005) which aims to offer 'a new vision' for the park in Sydenham that hosted the relocated Crystal Palace from 1854 until it was destroyed by fire in 1936. This *Planning Framework* is notable also for seeking submissions that will both update and preserve the nineteenth-century principles of democratic access and education as they are protected in the Crystal Palace Act 1914 and the later London County Council (Crystal Palace) Act 1951, and as they are valued today. The vision outlined is 'one of social inclusion, with the Park being a focus of the local community's daily life, enhancing the sense of well-being, local and regional identity and civic pride. The aim being to transform the Park into one of London's treasures, as complex and diverse as the communities it serves' (London Development Agency 2005: 33). Maintaining respect for Joseph Paxton's decree that the site provide a valued educational, leisure and recreational facility for local community use, the call for renewal seeks to extend these ideals further, aiming to promote the area as a 'people's park' so that it might come to function as a cultural centre used by a wide variety of demographic groups. Conceptualized thus as linking education, reform, sport, civic services and infrastructure (including public transport and a children's nursery), the LDA hopes the area will offer a 'forum for social and cultural exchange and activities'

and provide a valuable resource for use by local people – in a borough that suffers from a low socio-economic ranking that is the product of high unemployment and low business density (London Development Agency 2005: 30, 38, 68). In the second half of this chapter I elaborate on how this trend for discourses of newness has also continued to impact – and in an ongoing capacity – on the most recent manifestation of MoMA, which, despite offering itself up as the epitome of modernist aesthetics and architecture, understands the ongoing and persistent currency of the new.

MANUFACTURING AND MARKETING NATION

There are two main reasons why this modernist conception of newness has returned to fashion after more than 150 years. Informed by the ever increasingly market-led desire for new commodities on the one hand, the terms 'newness' and 'modernity' also communicate an equally never-diminishing desire for experience and forms of spectacle and entertainment which may best advocate for and express a new, intelligent, and moral movement that is tied to national aggregation and confidence in the emergent nation-state. This is illustrated by Prince Albert's speech of 1850, which emphasized the image of global solidarity, pertaining to the exhibition's role in 'the realisation of the unity of mankind'. Connected importantly to 'the great principle of division of labour', this was also facilitated by a situation whereby '… The distances which separated the different nations and parts of the globe are rapidly vanishing before the achievements of modern invention, and we can traverse them with incredible ease; the languages of all nations are known, and their acquirements placed within the reach of everybody' (Martin 1876: 247). This point was also proclaimed by the leading article of *The Times* on the opening day of the event (1 May 1851): 'The first morning since the creation that all peoples have assembled from all parts of the world and done a common act.'

Spectacle, entertainment and reformist agendas (supported by an instrumental rationality and disciplinary apparatuses such as the state and its institutions) were to become key factors in the project of unification and nation building that were central to the international exhibitions throughout the nineteenth century. In his 1888 survey book, *Museums and Art Galleries*, Thomas Greenwood records the rapid development of museum culture that occurred at this time throughout England. Resulting, he believed, from cooperation between civic effort and philanthropy, he argued that these new museums inspired a 'craving' for knowledge in the working classes and encouraged 'the duties and privileges of citizenship' and pride in the nation (in McClellan 2003: 11). Successfully combining the symbols and practices of good citizenship with practices of consumption, new technologies made new modes of production and commodification possible, and by converting vast numbers of farm labourers principally to factory work, a new and more economically secure class of consumers emerged. Often having migrated to the cities and industrial areas from agrarian communities only recently, this new (sub) class offered an exemplary audience for programmes of reform and betterment. Matthew Arnold, writing in 1869 (1994), argued that educational institutions should take the place of organized religion for the

newly urbanized society, and John Ruskin 'advocated the role of museums in educating and controlling "the labouring multitude" by offering an "example of perfect order and perfect elegance"' (McClellan 2003: 8). In addition to this, new technologies and the widespread zeal for reformism also enhanced the enlargement of possibilities for visualization (cinema, street lighting, new vistas offered by train travel), and the construction of unified symbols of nationality that were defined in opposition to highly visible stereotypes of cultural and racial otherness.

The material possibilities offered by the new technologies and economies of mass-production and visual literacy escalated with the stages provided by the international and colonial exhibitions held throughout the mid-to-late nineteenth century. New strategies of entertainment and reform contributed to consolidating interest in nationbuilding so that English visitors to the 1851 Great Exhibition came to identify more consciously and proudly with the national entity or polity of Britain than before and less on the local province or rural community in which they resided. Through the improved technologies of visuality, nation became a less abstract concept. Put on display for public consumption, material symbols of nation were differentiated against those of other countries. This meant that national cultures were reduced to the products and materials they exhibited – so that the US was, for instance, represented as an innovative producer by displaying the Colt revolver with its interchangeable parts and the Morse telegraph amongst other machinery and inventions (Victoria and Albert Museum 1950). It also meant that the collective and self-conscious 'conveying of a distinct aesthetic expression' advanced the development of a 'national taste' that assisted in distinguishing one nation from another on the basis of its sophistication (Wornum 1970 [1851]: xxii). In contrast to the US, India became known for the display of well-designed objects, refined fabrics and luxurious furnishings that had been collected by the British East India Company for display in the India court at the Crystal Palace (and then at the 1886 Colonial and Indian Exhibition). Located in pride of place, near the main entrance and the Queen's retiring room, and granted the largest floor space, of 30,000 square feet, the distinction accorded to India within the Great Exhibition also positively influenced the English collectors who attained status, renown and good taste for identifying and collating the finery – which also became a much-desired commodity for display in the homes and clubs of the wealthy (Breckenridge 1989).

As indicated by the expanding English taste for Indian curiosities (and by the Indian taste for English manners) that emerged at this time and continued throughout the nineteenth century across Europe, the relationship between modernism and cultural capital emerged early on and explicitly. This occurred principally through the interlinking of the processes of commodification and spectacularization that were being promoted as the effect of increased industrial strength and confidence in the products and industrial materials of Britain and her colonies throughout the Empire's expanding markets. In line with ideological motivations for trade-based progress, modernization and modernity each became terms used to describe economic and social adaptation to the supposed constraints of a global

market, and capitalism and modernity were interconnected so inextricably that the 'only satisfactory semantic meaning of modernity' was, and continues – according to Jameson – to be its 'association with capitalism' (in Prendergast 2003: 97). Second to this, and as we can see even more directly throughout the historical development of MoMA, from its department-store inspired presentation style, to its aim to replicate 'the new museum' model articulated by John Cotton Dana in 1921 (Weil 2002: 188–92), and its preference during the 1960s for 'art for arts sake' – that is art which is devoid of political intent, narrative, content, or ascertainable 'meaning' (as championed by Clement Greenberg) – the capitalist pressures of late modernism may have also engineered the scission between high art and the impurity of mass culture (Greenberg 1971a, 1971b).

Whereas for Kant, Schiller and Hegel writing during the eighteenth century, culture functioned as a point of mediation between art and society, Prendergast (2003: 107) argues in contrast that: 'Late-modernist ideology was, and to some extent remains, precisely the rupture of that mediation. It operated a highly charged form of modern "separation", between art and culture.' Late modernism was, similarly, responsible for securing the white box style art gallery as the discrete, sanctified place for the contemplation and enjoyment of high art externalized from culture understood as the defiled anthropological product of mass media. Somewhat paradoxically, this differentiation of high art also encouraged the idea that art museums were cathedral-like (offering a pure aesthetic realm produced from universal ideas of taste and removed from both cognitive and ethical spheres).

However, at the same time, this distinction instilled and sought to normalize the processes described by Bourdieu (1984) and others as the fundamental connection between class and the ability to accumulate cultural capital. For Bourdieu, cultivated individuals understand their own distinction as taken for granted and natural, a marker of their social status. Taste becomes more than a marker of social standing, it is a key signifier and element of social identity (Bourdieu 1984: 32–3). Within this social space, 'culture is only achieved by denying itself as such, namely as artificial and artificially acquired' (Bourdieu and Darbel 1991: 16). This means that the real 'masters of the judgement of taste' can appear to rise above the dictates of culture, despite simultaneously occupying the space of culture – in which, paradoxically, high Culture has been dissolved into culture (Bourdieu 1984: 28). Bourdieu expands this argument to contend that cultural classification systems are based on the general organization of class systems. Curiously, though, he also claims these systems to be nationally particular (Bourdieu 1984: 30). In forcing a wedge between art and culture, and in thus separating high art and personal status from conceptions of culture that refer to an anthropological, lifestyle, or mass media context, the pressures of late capitalism have caused a clear shift in preference away from programmes of class reform and nation building. Replaced in Western liberal societies by a cult of the individual, modernization refers increasingly to the personal acquisition of cultural capital rather than to a belief in the need to consolidate the symbols of nation or its global markets (despite the fact that the acquisition of cultural capital generally requires – or at least assumes – the stability of these latter forces).

DEMOCRACY, 'SHILLING DAYS', AND PEDAGOGIES OF NATIONALISM AND CULTURAL CAPITAL

According to their early modes of organization and through their articulation of the premises and trends of cultural modernity and social (capitalist) modernization, the international exhibitions of the nineteenth century functioned as rigorous ideological institutions. Framed according to a clearly stated moral agenda (Bonython and Burton 2003), their propensity to function as a visible actor within commodity culture made them valuable tools for appropriation by the state. During the Victorian era and beyond, explains Andrew McClellan (2003: 7), 'the museum [and exhibition] public was commonly represented as an idealized projection of what liberal politicians and social critics hoped it would become.' In accord with this and the reformist spirit of the day, they preached education to the lower classes and attempted to facilitate learning by offering entry to the Great Exhibition for a shilling on certain days (although the discount rates were not offered on Saturday afternoons, the most popular time for bourgeois visitors and possibly the only time many workers could attend) (*Punch* 1851). Motivated by social unification, these measures aimed to educate 'the layman who enjoyed art'. However, they also aimed to produce a self-aware visitor who would 'behave as a competent consumer who uses art and relates aesthetic experiences to his own life problems' (Habermas 1998: 12).

Rather than replacing the predilection for distinction and differentiation that was emerging as a component of capitalism, mass production and the new middle class worked to increase the symbolic power of the commodity (primarily due to the aspirational sensibility associated with the condition of being middle class). Instead of resulting in the eradication of class difference, the new middle class was even more eager for the self-betterment and education that would add further value to the new leisure time activity of conspicuous consumption: they desired the tools that would enable differentiation from the lower working classes. Not only did the acquisition of cultural capital provide enhanced personal status, the ability to participate with agency (gained by the ability to make purchases) gave people the opportunity to feel liberated momentarily from their everyday lives. Discussing a trade fair held in Paris in 1798 as a forerunner of the *expositions universelles*, Walter Benjamin (1978: 152) described such events as having proceeded 'from the wish "to entertain the working classes, and becomes for them a symbol of emancipation."'

In promoting a class-based nationalism and imperialist ideology, claims were made that the exhibitions offered a democratic space for the interaction of all (Arnold 1994 [1869]: 106–8; Bonython and Burton 2003). Arnold idealistically identified culture and art as a means of unification rather than the 'engine of social and class distinction, separating its holder, like a badge or title, from other people who have not got it', as in the past (1994 [1869]: 29–30). This egalitarian vision was also represented by French and American exhibitions – which promoted the liberty afforded by republicanism and the equality of all men in the postrevolutionary world. Similarly promising social progress for the masses, the promotion of exhibition fervour in England leading up to the opening of the Great Exhibition may have been linked to the desire to distract public attention from urgent

political issues, including the political significance of the Chartist demonstration of 10 April 1848 (which also took place in Hyde Park), and the extent of its suppression by the state. Indeed, in his novel, *1851: or the Adventures of Mr and Mrs Sandboys and Family*, Henry Mayhew argued that the Great Exhibition could not fail to fill working men with pride and 'inspire them with a sense of their position in the State' – and to also 'increase the respect of all others for their vocation' (Mayhew 1851: 132). Combined with anxiety related to revolutionary activities occurring in Europe, this image of equality also marks a shift away from the direct management of class confrontation by means of force (which had occurred in the recent past), toward the governmental implementation of culture as a tool used for the purposes of order (and control by means of civilization). However, while the exhibitions were viewed increasingly as vehicles for integrating and ordering the 'masses' peaceably through large-scale entertainment, it is also notable that an extra policeman stood guard at the much-coveted 'koh-i-noor' diamond on the Shilling Days. Conversely, the *Illustrated London News* (1851) registered expressions of surprise that shilling day visitors were so well behaved.

The promise of a liberal hegemonic egalitarianism was important for English exhibitions that took place prior to the Education Act of 1870 for the additional reason that it was not until then that locally controlled elementary schools were established through new legislation. Moreover, in 1851, working men in England had yet to be awarded the vote. In addition to advocating the education of the working classes, it is also significant that Arnold saw the spread of culture as a way to redress the 'shallow materialism of the expanding middle classes' (McClellan 2003: 12). Indicating a possible paradox in his argument, Arnold perceives the public functions for culture as rigorously stabilizing but also sees in it the potential for subversion, the disruption of conservative middle-class comfort and materialism; a stance that has been described as anti-reifying and anti-ideological by Robert Young (1995: 57; 58, 82–9). Furthermore, the new images of clearly framed 'cultural' products – be they anthropological or artistic – offered British audiences precisely what, according to Arnold, they had previously lacked. Young asserts that Arnold equivocates culture with nationalism and national identity at a fundamental level but he also notes that the connection between culture and 'Englishness is not at all obvious – for the whole argument of *Culture and Anarchy* is that culture in England is lacking. Culture is characteristically defined for Arnold in strictly exotic terms' (R. Young 1995: 57).

Perhaps this differentiation of otherness is more domestic in focus than Young suggests. If so, it may attempt to further consolidate concepts of the nation, even at the expense of providing the English with a culture. Similarly, Paul Greenhalgh (1994: 18) has expressed suspicion in relation to claims that the exhibitions promoted peace and brotherhood between nations, contending 'it is difficult to see the "peace-mongering" of exhibition speech-makers as anything other than empty banter.' The argument made by contemporary scholars that rhetoric had little if any impact on Britain's international relations is interesting, because it may miss the point of Arnold's project, which is more highly localized in focus. Rather than

simply endearing a spirit of good will amongst nations (which Greenhalgh asserts that it did not), and in accord with Arnold's aims to educate the English, such proclamations may have also contributed to producing a sense of national unity amongst members of all classes. Instead of seeking an international unity among men, the banter may have actually been designed to heighten national unity among men across or regardless of class boundaries.

COMMODITY VOYEURISM: NEW ECONOMIES OF LOOKING

The potential of rhetoric to produce a national symbolism or imaginary was also recognized in the accounts of travellers from India and other colonial centres such as Egypt to international exhibitions held in Britain and France (Mitchell 1988). In these instances such language encouraged the consolidation of singular cohesive forms of symbolism for non-English visitors to the exhibitions. For example, at a time when 'India was considered by most if not all Britons to be a set of centripetal communities and factions incapable of ever consolidating into a national whole (and hence unworthy of the gift of self-government)', Antoinette Burton (1996: 143) explains that the '"Indian" eye offered a persuasive challenge' by suggesting that the city could be objectified by a 'centrifugal Indian "national" gaze'. While national aggregation was due in part to the expanding English middle class, the accounts of travellers from India and elsewhere suggest that it may have been connected more directly to the simultaneous imperial expansion of the nation-state, and the way that racial and cultural difference was positioned as other to the English and European visitors to the exhibitions and metropolitan centres. Expanding upon Young's claim that the exhibitions may have provided English audiences with culture as something previously lacking in their self- and national-imaginary, we can also note that in the Great Exhibition, 'empire' was represented as host. Comparisons were made between the batches of products presented by foreign nations, however, as host of the exhibition, Britain encompassed all these nations on show (even if they were not part of the empire) and was to be congratulated for the good taste associated with 'collecting' together the arts and industry of the world (Victoria and Albert Museum 1950).

The taste for new commodities and the economies of looking, and the voyeurism attending these went both ways. As the travelogues published by Indian writers in the latter half of the nineteenth century show, the English also became subject to the travellers' gaze. Consistent with the broader desire for status and personal acumen based on taste and distinction, their writings demonstrate class as a continuing and equally important factor in the constitution of authority in relation to the observing eye/I; whatever the nationality of the observer. For example, similar hierarchies were self-consciously reproduced by the Indian traveller-authors who were themselves often wealthy and cosmopolitan in outlook. In the introduction to his travelogue entitled *A Visit to Europe* (1889), for instance, T. N. Mukharji, an English-educated, upper class Bengali Brahmin, wrote that through such publications, 'the European will learn to see himself as others see him' (in Burton 1996: 143). Moreover, despite the popularity of this commodification of cultural otherness whereby preindustrial

symbols were being used by the British Empire to represent India and to justify and secure the imperial ideology of the age, this same schema was being used by India to strengthen its own emerging nationalist movement. Saloni Mathur argues that the Victorian ideals encapsulated by the 'cult of the craftsman' that emerged in relation to the 1886 Colonial and Indian exhibition offers a point of nexus for this sentiment emerging in India. This exhibition, which ran for six months and was attended by 5.5 million people, offered a far more complex image of India than had been available in the Indian courts at the Great Exhibition (Mackenzie 1984: 101–2). Not only did the traditional crafts as represented in this exhibition acquire a new political importance for Indians, but the romanticized images of indigenous production provided a new language that was, by the end of the century, also being deployed in struggles against the British over Indian nationalism (as evident in Gandhi's ideology of traditionalism) (Mathur 2000: 497–8).

CITY AS SPECTACLE: DISCOURSES OF RACE AND CLASS

Contending that the Indian travellers to London embodied the agency associated with the 'properly bourgeois, gentlemanly subject', Burton (1996: 141) argues that it was the advantage of class that allowed them to enact self-governance in relation to the new metropolis. London not only provided a host to the exhibitions and their visitors but it offered a forum for the expansion of programmes of reform and spectacle beyond the exhibitions' boundaries. The whole city was thus bound up in mythical discourse that contributed fundamentally to the way that visitors were able to suspend their disbelief – which may have contributed to statements by Indian visitors about how authentic certain aspects of the 1886 exhibition were (Mathur 2000: 498). The city came to exist as a site of spectacle and consumption, and offered visitors the means to acquire personal status and cultural capital. Burton contends that for writers such as Jhinda Ram (who published the travelogue, *My Trip to Europe* in 1893), participating in cultural activities and economies – like attending the theatre – offered the egalitarian or liberating effects discussed earlier. Indeed, in attending the theatre, as an archetypal British experience, Ram expressed the feeling of becoming absorbed with the English theatregoing public, 'displaying both good taste and a certain aspect of London life for the benefit of viewers at home' (Burton 1996: 138). Shrouded in darkness and integrated on the basis of shared experience, this example depicts an instance where class status (attained by engaging in the economy of cultural capital) is perceived as surpassing the traditional power relationship of racial differentiation. Indian travellers were able, in certain contexts, to project an image of status by representing themselves as bourgeois subjects.

Although the colonial exhibitions promoted dominant discourses through which the idea and experience of otherness was constituted, the historical subjects of ethnological display, and those travellers from colonial or remote countries who visited the exhibitions can also be seen as having refused the terms of their representation. Critical of the racism demonstrated by visitors to the 1886 exhibition, Mukharji comments 'would they discuss

us so freely ... if they knew that we understood their language?' (in Mathur 2000: 509). Moreover, the new technologies of modernity, including the mass production of glass panels, and the use of gas lighting facilitated the process of looking anew – indeed, few Indian travellers did not remark on the poverty and relative lack of progress they found in London. Terrible poverty, prostitutes, and normal 'domestic' scenes all were described as spectacles, and one writer noted that 'Old King Gas' was only slowly being replaced by 'the Imperial brilliance of the electric light' (in Burton 1996: 134). Burton contends that Indian travellers engaged with the spectacle of London in order to assert their own subjectivity. Their subversive authoritative gaze implicated London into the very spectacle hosted by the city. It became an 'object of colonial scrutiny and in the process made Indian visitors and their readers into civilized and discerning citizen-subjects' (Burton 1996: 143). Yet while international visitors were thus able to achieve a degree of agency through participating in an exchange of gazes and the active framing of the city, discourses of race and imperialism maintained a contemporary authority so that, over time, they became increasingly used for the attribution and description of class difference. By the 1880s, for example, the East End was increasingly understood by middle and upper class Londoners as a different world (Walkowitz 1992). Referred to as 'darkest England', its inhabitants were spoken of as a separate 'race' (Epstein Nord 1987). Mathur (2000: 500) explains that 'London of the 1880s was thus profoundly mapped in imperial terms; whereas the West End symbolized the triumph of empire, the East End was its "foreign, dark, and forbidding" other. In fact, the language of colonial expansion and exploration became the terms in which urban social divisions were conceived.'

THE RACIALIZATION OF CLASS DISCOURSE

As demonstrated both by the Arnoldian desire to inculcate the English working classes with culture (to aggregate them into a unified national polity), and by evidence recorded in Mukharji's book of the contested dialogical ground and shifting power relationships between the English and the Indians, colonialism could not be considered a secure bourgeois project. Moreover, as John Marriott (2003: 42) argues:

> The racialization of the poor ... which began in mid century and intensified during the 1860s and 1880s, was in terms of its chronology, narrative and rhetoric so similar to constructions of colonial others that they can be seen as shared and mutually reinforcing responses to deep anxieties about the future of the imperial race.

Anxiety over this may explain why imperialism continued to trade so consistently in the persistently reproduced symbolic economy of persuasive – if ersatz – images. Elaborating on this, Ann Laura Stoler (1996: 99) argues that colonialism 'was not only about the importation of middle-class sensibilities to the colonies, but about the *making* of them' – a point that we see clearly in relation to the rapidly spreading fashion throughout England and France for Indian fabrics and crafted items. Taken alongside Arnold's provocations that England would benefit from the culture of the non-European, these claims contribute to the

argument that colonization (or the display of colonization in the exhibitions) contributed indelibly to the way in which the European bourgeoisie developed. Although, as Stoler also explains, this issue of contingency or relationality is itself far from simplistic. Amongst other urgent questions, she argues that we should ask whether the language of class has been 'itself racialized in such a way that to subscribe to bourgeois respectability entailed dispositions and sentiments coded by race?' And if, she continues, this relationship between the affirmation of bourgeois hegemony and colonial practices was contingent, 'should we assume that the latter was *necessary* to the former's "cultivation" or merely supportive of it?' (Stoler 1996: 100–1).

SUSPENSION OF DISBELIEF AND THE PRODUCTION OF OTHERNESS

The pressure for English exhibitions to include an educational component has its origins in the Society of Arts' displays in London and the Mechanics Institutes' exhibitions held in the country's northern regions. Motivated principally by the desire to advance industrial culture, these early examples provided a useful forum for the intersection of ideology and the wider – and expanding – public. Pedagogical purpose was also central to Wornum's essay on 'The Exhibition as a Lesson in Taste' (1970 [1851]), which clarified connections between national taste, trade and consumption. Greenhalgh (1994: 19) explains the educational principle as follows: 'if you exposed ideas to an ignorant audience in a language they could understand, you would have influence over them.' At international exhibitions from 1851 the emphasis shifted rapidly from the spectacle of industry (although this was maintained) to the spectacle of the commodity, spectacle and symbolism. The educational principle was also maintained, but likewise, shifted in focus so that descriptions of the exhibitions as 'cornucopias of status symbols' were not only commonplace, but popular. Here, 'people were to be educated about what to buy, but more basically they were to be taught to want more things, better quality things, and quite new things' (Benedict et al. 1983: 2–3; Veblen 1994 [1899]). Addressing the clear preference of the upper classes for systems of order and understanding, George Augustus Sala articulated, in relation to the 1867 Paris *exposition universelle*, the various ways in which the exhibition could be admired and experienced: 'The man of system would take the Exhibition group by group and ellipse by ellipse; the mere sight-seer would saunter easily from France to the Antipodes, and find himself led, by facile and almost insensible degrees' (Sala 1868: 21–2). In this account – which was far from atypical – we gain a sense of the scope, scale, and discourses of the exhibition in relation to broader themes, so that the serious visitor would study the exhibition with dedication, while those more intent on visiting the exhibition for purposes of leisure or entertainment would follow the spectacle (with equal dedication).

Speaking to the audience in language they understood, and including desirable signifiers of spectacle and exotic otherness contributed to collective acceptance of suspension of disbelief. A visitor to the 1886 Colonial and Indian Exhibition wrote: 'The whole makes a singularly beautiful interior, conveying a sense of repose which cheats one into the belief

of being far away from the rattle and bustle of London' (in Hoffenberg 2001: 230). The exhibition's effects were fascinating rather than threatening because they offered situations whereby the societies and individuals represented were thoroughly contained at the same time as they were available (for voyeurism or purchase). Or, as Jeffrey Auerbach (1999: 3) contends, 'Whatever doubts British men and women may have had about the composition of their own society and culture, they had few such doubts about what differentiated them not only from their closest neighbours, but from the exotic, foreign "other".' India, for example – as the 'jewel' most desired by the British Crown – was constructed in the exhibitions (especially of 1851 and 1886) as a museum or archive with 'crafts consigned to the past and their merits unattainable by modern, Western habits of production' (Kriegel 2001: 161). Although this spectacle promoted a sense of interpersonal and geographical proximity on one hand, it also succeeded in preserving a strong sense of cultural distinction between nations. This disjuncture meant that the decontextualized status of fetishized objects was preserved, no matter how popular they were. In fact, the more omnipresent and fashionable these commodities were to become, the more 'oriental' and mythical they also became. For example, one visitor to the 1851 Great Exhibition described cashmere shawls from India as 'designed for eternity in the unchanging past, copied from patterns which are the heirloom of a caste, and woven by fatalists' (in Kriegel 2001: 161). Thus constituting a form of virtual tourism, the displays and depictions of foreign products and technologies combined with visitors and participants from far flung places, together with the human-scale panoramas offered by the exhibitions of the mid-to-late nineteenth century, to produce a collective taste for believing in the unfamiliar and unlikely (*as* unfamiliar and unlikely). Not only did this allow for 'the parochialism of Londoners, and their reliance on vicarious rather than actual travel' (Breckenridge 1989: 197), it developed the taste for actual mobility promoted since 1841 by British entrepreneur Thomas Cook.

Already popular amongst the upper classes, the commodity of tourism – whether physical or imagined – combined the increased mobility and technological advances of the new era with Cook's marketing strategies to make it appear an affordable and even democratic pastime (Friedberg 1993: 59–61; MacCannell 1989: 11; Kirshenblatt-Gimblett 1998). Cook's promotions were a feature of the 1851 Great Exhibition, and particularly notable were the tours to visit not the exhibits of the East, but the 'East itself' (Mitchell 1989: 227). Belief in the effects of virtual travel was compounded by the visitor's curiosity, which was piqued by aesthetics and otherness, so that a group of native artisans displayed in the Indian Palace at the 1886 Colonial and Indian Exhibition was celebrated in *The Indian Mirror* as 'a curiously pretty spectacle of oriental life' (in Mathur 2000: 498). Sentiments of belief were, indeed, widely expressed in relation to the exhibitions' representation of aesthetic and industrial treasures, which were organized for contemplation and awe and for the 'documentation' of ethnic otherness depicted for the purposes of 'scientific' observation and instructional purposes. Offering a conceptual link between the pre-modern (princely) museums and the cabinets of curiosities of the sixteenth century with the systematic and logic-driven approach

to museum making, the suspension of disbelief contributed to the exhibitions' successful institutionalization of entertainment (and its association with education). Indeed, this was commented on by William Whewell's inaugural lecture, 'The Results of the Exhibition' (1851), in which he compared the exhibition to such a cabinet, whilst also congratulating the organizers for having provided a 'scientific moral' in the way they had classified and ordered the objects on display (in Hoffenberg 2001: 204). Moreover, as Hoffenberg notes, 'The historicist appropriation of the mythical Eastern bazaar was part of that seemingly common nineteenth-century manoeuvre by which the new was made popular by appealing to the old, even if the latter was a product of the imagination' (Hoffenberg 2001: 230).

This suspension of disbelief led to a taste for otherness, so that the images of otherness became increasingly familiar due to mass production and popularity, thus constituting a recognized – and paradoxically 'authentic' – code of otherness. Creating stereotypical and reductive scenarios of colonial cultures, new technologies of representation such as panoramas and the new focus on looking (facilitated by displaying objects in glass display cases shown to effect by electric light) were directed to show the 'great diversity' of Her Majesty's subjects (Cundall 1886). However, in constructing simulated displays of different cultures as easily apprehendable and consumable syntagms of symbolic otherness, the stereotype came to acquire an authenticity on the basis that it is subject to the ongoing reproduction enabled by new technologies, new mobilities and the fictions peddled by new symbolic exchanges. This economy of fabricated images covered the representational spectrum, and not even the British sovereign was exempt. Indeed, as the process of devolving power to public institutions increased in speed and effect, the Queen was represented increasingly as being 'more splendid, public and popular', despite the fact that this image did not accurately reflect her reduced participation in the political affairs of the country (Cannadine 1983). This marked a shift away from sixteenth- and seventeenth-century courtly society where, through a process of 'representative publicity', the king could proclaim 'L'etat, c'est moi' (I am the state) to a public who did not exist apart from the king and his court.

EXPLORE THE WORLD WITHIN THE CITY WITHIN ONE DAY

One consequence associated with these changing spectacles – and publicity forms – of empire (and the correlative stereotypes of otherness) was the presentation of the world as reproducible, consumable, and as fundamentally illustrative. The exhibitions (aided by Cook's Tours' advertising campaigns) consistently claimed that visitors could 'explore the world in a day', and so aimed to contain the world to a single sight/site. Moreover, by bringing the produce of the world (more or less) to a single shared location, visitors could also purvey the realm of empire in a single gaze. In presenting an image of the world as a picture, the aim was to make as real as possible for visitors the experience of travel to one of the geographically remote places that were represented. Initiating interconnections between reality and representation (where representation appears more believable than the reality offered by the city outside – which then comes in turn to be itself modelled on the

images within the exhibitions), the international exhibitions offer an exacting case study for the analysis of Edward Said's Orientalism (1991 [1978]). The edifices produced for the exhibitions – and particularly the Crystal Palace, which offered a panoptical approach to control (Bennett 1995: 65) – portray an architectural model of modern politics in which vision, knowledge and power depend on location and positionality. According to Said (1991 [1978]: 7):

> In quite a constant way, Orientalism depends for its strategy on this flexible positional superiority, which puts the Westerner in a whole series of possible relationships with the Orient without ever losing him the relative upper hand... The scientist, the scholar, the missionary, the trader, or the soldier was in, or thought about the orient because he could be there.

This idea of power and position is expanded further by Mitchell (1989: 236) who contends that this 'is not just a nineteenth-century instance of some general historical problem of how one culture portrays another, nor just an aspect of colonial domination, but part of a method of order and truth essential to the peculiar nature of the modern world.'

NEW PUBLIC INSTITUTIONS AND GOVERNMENTALITY

For the nineteenth-century Victorian mind, however, the real value, beauty and novelty of trade as a source of civilization both in a wide sense and with the exhibitions in an immediate and educative one, was that it allowed the mystical and exotic to freely mingle with the practical and the material. The exhibitions offered a world brimming with new experiences and objects. In his 'May Day Ode' written for the opening ceremony of the Great Exhibition, Thackeray (1851a) praised the exhibition with the quality of religious fervour (see also Allwood 1977: 21), and Benjamin (1997) identified international exhibitions as 'the sites of pilgrimages to the commodity fetish' that were integral in the creation of the 'universe of commodities', which included people as well as objects (see also Adams 1964 [1900]). This trajectory was a familiar one for contemporary audiences, who were expected to engage a degree of rigour, commitment and seriousness in relation to these new experiences. Becoming omnipresent, it was a trajectory that transcended institutional distinctions, influencing the new public museums and department stores also emerging at this time across Europe. Self-consciously modern institutions, exhibitions, public museums and department stores were quick to recognize how appealing the connection between spectacle and education was for audiences of all classes. They also capitalized on the new taste for representation, and representational strategies and display techniques were understood to be complementary with the new taste for applied, decorative and industrial arts. These combined to offer new ways of housing historical collections and inviting new ways of displaying mass-produced commodities.

Reiterating the ideological shift toward the production of public spaces which offered democratic access (for the 'good' of those who entered), these new public institutions

demonstrated changes in the way authority is depicted and socially administered; demonstrating further the new methods of order and truth associated with the shifting power structures of the modern world. 'The first goal of a museum', contended the director of the Berlin Royal Museum, Gustav Waagen in 1853, 'is to promote the spiritual growth of the nation by the contemplation of the beautiful' (in Ray 2001: 122). Illustrating the existence of a strong connection between spectacle and aesthetics ('the beautiful') and the instructional, Waagen's statement also illustrates how these factors became increasingly tied to national interests and imperial endeavours (Stonge 1998). The focus on 'nation' and national institutions expressed here is new, and related to a shift in authority whereby the primary authority of the singular monarchical head is replaced by the modern nation-state. The nation-state rapidly instituted its power through a multiplicitous and hegemonic system of governmentality, where authority was devolved to a series of increasingly 'public' institutions, including the new culture and leisure industries. This trend intensified further, so that in 1902 (a year that marked the renewed promotion of a homogeneous national identity and social unity within Britain) the Education Act projected the slogan 'Education for All', and made provision within the school curriculum for trips to museums. Indicating how potentially oppositional subjects could be incorporated into, and thus made complicit with, the hierarchies of the state, this also illustrates the government's recognition of the educational, 'civilizing' potential of such institutions. Coombes (2004: 279) explains:

> The Empire was to provide the panacea for all ills, the answer to unemployment with better living conditions for the working classes and an expanded overseas market for surplus goods. Through the policy of what was euphemistically referred to as 'social imperialism', all classes could be comfortably incorporated into a programme of expansionist economic policy in the colonies coupled with the promise of social reforms at home. It was in this context that museums and in particular the ethnographic sections, attempted to negotiate a position of relative autonomy, guided by a code of professional and supposedly disinterested ethics, while at the same time proposing themselves as useful tools in the service of the colonial administration.

EDUCATION AND REFORM

The concept of the museum as an institution of reform and governance that transcends class barriers was influenced by the learning-by-pleasure principle of the international exhibitions (which was itself guided by an ideological framework of imperialism and social reform). Although consistent with the traditional museological programme of collections and research, in other respects the newly reformist museum challenged past ideas connected with the closed scholarly museum or private collection dedicated to pure research. This level of debate is evident in literature generated by the Museums Association at the turn of the nineteenth century, which registered much discussion and analysis over a concept known as the 'New Museum Idea'. Making reference to William H. Flower's 1893 Presidential Address to the Museums Association in London, Coombes (2004: 288) says:

The primary objective of this 'idea' was to 'afford the diffusion of instruction and rational amusement among the mass of the people' and only secondly 'to afford the scientific student every possible means of examining and studying the specimens of which the museum consists'.

Although this concept and these themes continue to recur, Coombes makes the point that debate over what constitutes the new museum, and how it should communicate to audiences, was not new, even at this time. However, although attempts to distinguish between the rationalized and orderly logic of historical, private or princely museums (which were linked to the accumulation of time) and transitory, potentially chaotic events such as international exhibitions (which are linked to ephemeral experiences, commercialism and trade) may have been dominant throughout the nineteenth century (Foucault 1982, 1991), advocates for 'rational recreations' encouraged by social reformers Matthew Arnold (1994 [1869]), John Ruskin (Morley 1984), Thomas Greenwood (1888) and Henry Cole (Bonython and Burton 2003; Purbrick 1994) all sought to reduce these distinctions in the interests of education. They believed that museums must be refashioned as accessible social spaces clearly differentiated from earlier examples like the British Museum and princely museums such as the Louvre. Both these types of museum, it was argued, offered restricted and socially exclusive forms of sociality (based on the hierarchies of royalty and class). The purpose of this educational focus was elaborated directly by Pitt Rivers, who suggested that the evolutionary paradigm used by the museums might offer a way in which class unity (as vital to the continued expansion of social imperialism, as a key form of social control) might be promoted to all. In a speech to the Society of Arts in 1891, he argued that in addition to conforming to 'scientific' models of classification, museum displays must be 'designed to educate "the masses" to accept the existing social order' (Coombes 2004: 285).

As this shows, despite privileging concepts of liberation and equality, the reform discourse was itself representative of and implicated within the dissemination of centralized modes of authority. Integrated thus into the apparatus of the modern nation-state, the exhibitions and new public museums contributed to 'a network of institutions' both permanent and temporary, that together provided mechanism for the permanent display (securing, and enhancement) of governmental power as a manifold and multifaceted process (Bennett 1995). This process represents Foucault's claims about the discursive construction of disciplinary regimes of power, which have motivated subsequent scholars to explore both the production of colonial discourses and their effects (Stoler 1996). A prefiguration or contemporary awareness of this reconfiguration of power structures can be identified in the title of Arnold's book, *Culture and Anarchy*, which presents culture as having a directly dialectic – rather than oppositional (it is not Culture 'or' Anarchy) – relationship not with barabarism or savagery, but with 'the political term "anarchy", or lack of government' (R. Young 1995: 59).

One of these new museums was the South Kensington Museum. Connected conceptually and geographically to the 1851 Great Exhibition, and differentiated from the older British

Museum (which opened in 1759), the South Kensington Museum originated in 1857 in the West End of London (Purbrick 1994; Bonython and Burton 2003). Itself a product of the 'uniquely modern world-view' made possible by Victorian imperialism (and renamed, appropriately in 1899, as the Victoria and Albert Museum), it was dedicated to the applied arts, and 'targeted the makers and consumers of new manufactured goods with a view to raising standards of domestic taste and stimulating the nation's economy' (McClellan 2003: 10; see also Barringer 1998: 11; Burton 1999). Demonstrating the close relationship between the government of the state and the government of the self, the South Kensington Museum offered a model of good practice for individual visitors. Describing how culture became such an efficient instrument of social reform, Bennett (1995: 23) explains that 'the critical development affecting the sphere of culture' was the shift away from the conception that culture served power directly to a situation where culture became a resource for 'broadly disseminated regimes of self-management.' This means that while new public museums may have appeared to offer the potential to open up a properly discursive 'public' sphere for the debate of social and political issues, they tended in fact to be quickly appropriated by the newly disseminated forms of state power that Bennett, following Foucault, describes as being organized around a logic of governmentality. This appropriation of 'the public' via their institutions was not simply connected to the state's desire to infiltrate the life of its citizens. It also emerged as a result of the pressure exerted by social reformers for the state to host and help the lower classes. Increasingly though, public museums were forced to compete against the exhibitions to attract audiences. Despite integrating the new technologies and strategies of display (as well as displaying innovative displays in science and technology), live people and functioning villages could not be included within museums. So while the ethnographic exhibitions may have been considered less spectacular than the living villages of the exhibitions, this may also have contributed to the museum being regarded as the more serious of the two; as offering an 'authentic' and thereby more educational experience (Coombes 2004: 281).

DEPARTMENT STORES, COMMODITY IMPERIALISM

Evidencing the logic of governmentality and the interconnections between the exhibitions, new public museums, libraries and department stores, an American journalist sparked interest in 1884 by writing that 'It is as inappropriate to regard Liberty's merely as a place of business as it would be to regard the public library at Boston merely as a storage of books. Liberty & Co. is as much a feature of the metropolis as the National Gallery' (in Mathur 2000: 503). Following Benjamin, and aiming to heighten the similarity between department stores and the Great Exhibition, McClintock (1995: 57) argues that the exhibition 'embodied the hope that all the world's cultures could be gathered under one roof – the global progress of history represented as the commodity progress of the Family of Man.' Department stores also contributed to the regime of self-management, and were perhaps directed most explicitly to women, for whom they offered advice on how

to behave. In each of these institutions, however, the themes of consumption and highly visualized forms of difference were central organizing features associated with the logic of governmentality and self-regulation, and the success of capitalist enterprise (Bowlby 1985; Richards 1990). In the winter of 1885 (just months prior to the opening of the 1886 Colonial and Indian Exhibition), Liberty's endeavoured to publicize its imported Indian goods by recreating a 'living village of Indian natives' (in Mathur 2000: 501). The rhetoric advertising the event was framed in terms similar to that of the exhibitions, explaining that it was designed to 'facilitate the manufactures of this country by showing what could be done in India with natives with their own appliances' (Adburgham 1975: 60). Yet, unlike the exhibition that followed the next year, this display was described by all as a resounding failure; a result that Mathur accounts for as being due to the spectacular visibility of the exploitation of the participants. Despite its lack of financial success, however, the Liberty's display contributed to the promotion of reductive cultural typologies (in commodified form). Umberto Eco claims that for him, this type of strategy recalls the opening phrase of Karl Marx's *Das Capital*: 'The wealth of those societies in which the capitalist mode of production prevails presents itself as "an immense accumulation of commodities"' (Eco 1987: 293).

In general, these museums and museumlike institutions have thus been connected historically to the ethics of self-improvement and self-realization and the objectification and valuation of social values and traditions. William Ray (2001: 135) and others have argued that these pedagogical features – which emerged during the nineteenth century and continue to have an important effect on the will to modernization manifested within MoMA's displays of the 1940s and 1950s – contribute indelibly to the inculcation of a cultural logic that is typified by the dual production of conformity and differentiation. Moreover, as Ray claims, this logic of culture emerged from other new sites and forms of discourse that proliferated from the enlightenment. These include the coffee houses and salons privileged by Habermas's conception of the public realm and in the development of newspapers, journals, periodicals and reviews (which also produced new forms of reasoned argumentation in public). Aiming to constitute newly democratized communities of discursive subjects, the tactics of discourse, language and communicative action are all privileged in these spaces – including the exhibitions and public museums – so that it is also notable that Ray (2001: 9) contends that 'the logic of culture is inculcated in the public imagination first and foremost by discursive institutions and practices'.

EXHIBITING PROGRESSIVE ERA AMERICA: MOMA AND *THE FAMILY OF MAN*

Capitalizing upon the contemporary taste for the increasingly commodified 'topoi of progress and the Family of Man' (McClintock 1995: 56) set in place by the Great Exhibition, the international exhibitions instructed an economy-driven modernization that was suited to the progressive capitalist ideologies of the 'new world'. This change became central to conceptions of 'Americanization' – a term that first appeared in the 1867 Paris *Exposition*

Universelle 'as a synonym for industrial modernization' (National Arts Journalism Program, Arts International and the Center for Arts and Culture 2003: 27). Indeed, as Bennett notes, modernization was increasingly synonymous with Americanization in respect of exhibitionary culture and museums. This reflected a shift in influence at the end of the nineteenth century from British to American – especially natural history – museums, which were increasingly recognized as developing new practices that Britain would only adopt later (Bennett 2004: 193, fn. 35). The technologies of newness and spectacle had always been an essential element of international exhibitions, and had always been closely and unabashedly tied to promoting ideologies of national cohesion, imperial expansion, economic progress as facilitated by industry and trade, and the spectacle of commodity culture. In American exhibitions, however, the representation of national wealth now became even more prominent, and more persuasive. Although America's first exhibition, held in 1853 in what became known as the 'New York Crystal Palace', was unsuccessful, modernization was explicitly and effectively connected to the nation's rapidly accumulating wealth in Philadelphia's United States Centennial International Exposition of 1876. The benefits of trade and good governance were signified in this exposition by the production of an idealized – and federated – self-image that was presented as resulting from a recently instigated system of centralized government capable of reconciling the persistent political, economic and social divisions between North and South, East and West. Other significant American exhibitions included Chicago's World's Columbian Exposition 1893, the Buffalo Pan American World's Fair 1901, the Louisiana Purchase International Exposition, St Louis 1904 (conducted to commemorate the purchase of Louisiana from the French in 1803), the Panama-Pacific Exposition, San Francisco 1915, Chicago's A Century of Progress International Exposition 1933–4, and New York's World's Fair 1939–40.

Seen to offer significant potential for nation and empire building, the international exhibitions were attractive to America's wealthiest businessmen and politicians, who financed and supported the nation's exhibitions. Believing that America's prosperity depended on maintaining the momentum of territorial expansion that had continued to push back the frontier in search of new resources and in generation of new markets, the nation's industrialists and entrepreneurs aimed to extend the market for their goods by looking toward the Pacific. Although government embraced this potential, it had to be persuasive in order to attain public support, which is where the exhibitions became instrumental (Maxwell 2000: 7–4). Yet, while the strategies used in early American exhibitions for promoting America's imperial aspirations echoed those of their European counterparts, their points of anxiety were uniquely national – or domestic – in focus. In just one example, the Philadelphia exhibition of 1876 (held just ten years before the Colonial and Indian Exhibition of 1886) had been cautious in its evocation of themes that might provoke the liberal conscience of a white America still wary of the legacy of President Monroe's Indian removal legislation (passed in 1830) and by the South's history of slavery, which, while contributing massively to the wealth of the nation, had also divided public opinion. Indicating the complexity

of these internal politics, Maxwell (2000: 74) explains that in 1876 'most Americans still believed that African-Americans ranked much lower than Europeans on the evolutionary scale, yet the memory of the Civil War was sufficiently fresh to make them nervous about imperialism.'

The American exhibitions deployed two main strategies for the representation of otherness (and by association, their imperial aspirations). Chicago's World's Columbian Exposition of 1893, for example, was divided into two sections. The first, known as the White City, contained the buildings displaying the American states and foreign nations, together with pavilions dedicated to fine and liberal arts, and industry. Reflecting a strongly ideological framework, the white plaster, neoclassical architecture and renaissance-inspired civic spaces represented Anglo-Saxon nations. In the second section, colonized people were presented together, in reconstructed 'native villages' on what became known as the Midway Plaisance – a zone dedicated to entertainment. A narrow section dedicated to food and fairground style amusements produced a chaotic and disorderly melange of colonized peoples, prostitutes, minstrels and Wild West shows (Maxwell 2000: 75). Located collectively here, the 'native peoples' became crude spectacles of racial and cultural difference. Geographically separate from the 'official' pavilions of the White City, the Midway was exempt from the Arnoldian idea that the exhibitions should offer experiences for education and social reform (an idea that continued to have relevance in the 1886 Colonial and Indian Exhibition in Britain). American exhibitions projected the idea that learning could occur through pleasure and consumption, rather than applied contemplation, in the Midway, which, as Rydell (1993: 22) argues, introduced mass audiences to junk food, strip architecture and fun-fair style amusements, but also convinced audiences that empire building could be fun.

MID-CENTURY MOMA

The other approach used by American exhibitions to demonstrate the benefits of empire building was the representation of colonial peoples as victims. Emblematic of concerns expressed by the designers and managers of the American exhibitions about public opinion in the context of the American Indian removals and debates over slavery, colonial peoples were represented as being victimized by their own social structures, and in need of being rescued. That this trope of victimization was successful can be seen in the ongoing legacy it had, which continued for example, in the Christianized, Westernized narratives that framed MoMA's 1955 *Family of Man* exhibition. (Museum of Modern Art 1955: 3).

The preferences and practices inaugurated in the international exhibitions appear to have coalesced in the framing agenda and exhibitions of MoMA. Although the museum had been operating at temporary locations since 1929, it opened its first dedicated premises in 1939 in Manhattan and was promoted as a self-consciously new museum. It sought to offer new experiences that were analogous in many ways to those provided by department stores, and privileged both the consumption and commodification of art and culture. The Museum of Modern Art is an interesting example of the intersections between museums

and museumlike spaces at this time, when department stores were consolidating their popularity, and when international exhibitions were starting to lose their appeal. Moreover, as a privately funded and administered institution that at times produced strong ideological messages reflecting a commitment to the state, it adds complexity to the nineteenth-century trend for the transformation of private collections into state-funded and administered 'public' institutions. Unique at this time as an institution that promoted clear links with commercial culture, MoMA enacted its ideological commitment to national consolidation in the context of the art museum, where it conducted exhibitions that were both challenging and popular. During a period when photography was considered a lesser art, for instance, MoMA reinvigorated the documentary photography that had been commissioned during the 1930s by the Farm Securities Administration (FSA), reframing many of these already iconic images for the purpose of creating a series of exhibitions that included the *Road to Victory* (1942), *Power in the Pacific* (1924) and *Airways to Peace* (1943). Curated by Edward Steichen, these exhibitions certainly appear to replicate the ideological and progress-oriented rationale of the international exhibitions in Europe and America, and other equivalent early displays. Drawing on the ideology of industrial superiority, technological prowess, and ideological purity that underlined the FSA photographs, these exhibitions clearly resonated for American audiences at this time, and impacted on further social history style exhibitions held at MoMA.

Presented according to a clear narrative structure, the *Road to Victory* was organized to evoke a national folktale of romantic proportions. At the entry was a carved wooden folk art American eagle in front of an American flag, which was accompanied by a caption from Franklin Delano Roosevelt clarifying the 'four freedoms' of America as: 'freedom of speech and expression', 'freedom of every person to worship god in his own way', 'freedom from want', and 'freedom from fear' (Staniszewski 2001: 210). Many of the FSA's photographs were cropped, and all of their captions were changed so that the gritty documentary images could be displayed according to the jointly militaristic and sentimental tone of the exhibition. This recaptioning practice was common at the time and would have been recognized as offering further evidence of the exhibition's currency on the basis of its similarity to the popular media of picture magazines and 'real' life. In one image taken by Dorothea Lange, a Texan farmer who had a 'halo like cloud encircling his head', and who, notably, was a man who had been forced to become a migratory worker because of the mechanization of farming, was included in the exhibition with a new caption that read: 'War – they asked for it – now, by the living God, they'll get it.' This image was presented at a right angle with an image of the destroyer *Shaw*'s magazine exploding at Pearl Harbour on which was printed 'December 7, 1941'. Underneath the picture of Pearl Harbour was a photograph of Japanese Ambassador Nomura and Peace Envoy Juru laughing, labelled with the caption 'Two Faces' (Staniszewski 2001: 215; for discussion about the version of *The Family of Man* that was exhibited in Tokyo's Takashimaya department store's gallery in 1956, see Morris-Suzuki 2005: 110–17).

These exhibitions can be seen as developing from (and subsequently offering exemplary models of) the idea that all representational forms (and the consumption of these) are shaped by ideology and history (Lynes 1973; Bezner 1999). Clearly propaganda tools, they presented inspirational and aspirational images with which American audiences were already familiar. The form of the exhibition and selection of photographs evoked the conventions of the family album, encouraging viewers to make links between their own experience and that of strangers (Morris-Suzuki 2005: 110). However to heighten the process of identification anew, innovative installation techniques were used. These included the integration of false walls to produce series of corridors that provided extra wall space and were deployed to guide the visitor through maze-like passages of large-scale photographic reproductions. Through these exhibitions, MoMA combined evidence of America's ideological commitment to freedom through media that evidenced the value of such freedoms. Technological progress was demonstrated through photographs and innovative installation design. National authority on a world stage and protection of the American way of life was represented through the narrativized content of the images. These changes also epitomized the shift from the early or emergent capitalism usually associated with nineteenth-century modernity to a modernization – as it tended to be referred to now – that evidenced Jameson's assertion that 'modernity and the discourses about it – or perhaps: modernity *as* the discourses about it – are essentially ways of talking (or refusing to talk) about capitalism' (Sekula 1984; Prendergast 2003: 109).

Massively popular, these exhibitions shocked and delighted American audiences who were enthralled through the use of technologies such as the 'walk-through' panorama (or 'all-embracing view') that guided the visitor around the exhibition spaces. That the panorama was still considered novel in the 1940s is itself interesting, given that it had been a staple feature of international exhibitions throughout the late nineteenth century. Perhaps this eagerness to be surprised and delighted suggests the willingness of audiences to actively suspend their disbelief. Speaking about the popularity of panoramas among nineteenth-century audiences, Breckenridge (1989: 198) explains that, housed in rotunda-shaped rooms and buildings, they 'encouraged Londoners to cast a transient gaze on their own world as well as on the world beyond them' in such a way that the world itself became presented as a commodity (for discussion of the 1964–5 Panorama of New York, see Phillips 1996; Boyer 1996).

Such novelties of installation and display were also a condition of MoMA's subsequent exhibitions. Indicating another transhistorical interplay was the 'gigantic globe' displayed in MoMA's *Airways to Peace* (1943) exhibition. A century earlier the *Illustrated London News* (7 June 1851: 511–12; 29 March 1851: 247) reported that Mr James Wyld, MP's 'model of the earth' had recently opened in Leicester square. 'The gigantic globe' had a diameter of 60 feet and was praised by the President of the Royal Geographical Society as 'well worthy of the projector and of the spirit of the age'. A hundred years later, on the other side of the Atlantic, the 'Global Strategy' section of *Airways to Peace* featured a much

smaller – 15 foot – wooden 'outside-in' globe as a central attraction. Suspended from the ceiling, with a map of the world painted on its inside surface, visitors could place themselves at the centre of the world. The geographical features were raised within the concave of the sphere, allowing for the whole 'globe' to be seen at once. This visual presentation also encouraged visitors to see and perhaps better understand the geographical organization of colonial territories, wartime alliances, and trade routes. This ability to mentally organize or map relations between countries according to a simplistic Cartesian schema also replicated the tendency to be preoccupied with the organization of the view – as an Egyptian author noted of European audiences at late nineteenth-century international exhibitions (Mitchell 1989: 221). In short, the 'globe' offered visitors the experience of having authority over the domain, or as *Newsweek* put it, the ability to see 'the entire world at one glance'.

The Family of Man, 'directed' in 1955 by Steichen – who called it 'the most ambitious and challenging project photography has ever attempted' (Staniszewski 2001: 235) – was the final stage in this series of exhibitions. Much was made in publicity of the time about the fact that the final number of images included in the MoMA installation was '503 from 68 countries'. This echoed the pride expressed in relation to the scope of the Great Exhibition a century earlier, and its ability to amass goods from 32 invited members of the 'family of nations'. The rhetoric (possibly equal to that described by Greenhalgh as 'empty banter') of diversity, tolerance and universal freedoms apparent in *The Family of Man* replaced the overtly pro-American nationalistic images of the wartime exhibitions (but did not change its fundamentally pro-American nationalistic sentiment) (Sekula 1984; Bezner 1999). Speaking about the Great Exhibition, McClintock (1995: 58) notes that despite bringing all the cultures of the 'civilized' world together under one roof and under the shared banner of progress, at 'the same time, it was clearly implicit, only the west had the technical skill and innovative spirit to render the historical pedigree of the Family of Man in such perfect, technical form'. Similarly, it may be considered that *The Family of Man* sought to represent all the cultures of the world according to similarly novel representational strategies, which centralized America as the exhibition's host and author. While, according to Breckenridge (1989: 201), the international exhibitions of the nineteenth century 'anticipated and helped shape both the form and the content of public life in respect to global issues', they also seem to have anticipated what basically becomes a form of cultural imperialism legitimated by America's dedication to the discourses of freedom and tolerance.

The Victorian imaginary facilitated both by the international exhibitions and increasing mobility, contributed to the production of enhanced notions of culturally specific nation-state identities and a discursive space that was international (or global) in outlook and reference. This also contributed to creating a concept of the cultural other (as a tradeable item as well as a mode of differentiation). The 'aesthetic and political ramifications' of the international exhibitions transcended national boundaries, Breckenridge (1989: 201) explains, because they 'implicated the "world," and not just its regional locales.' In the context of *The Family of Man*, a process of universalization similarly homogenized cultural

otherness and set it apart. In his response to the 1957 version of the exhibition that toured Paris – translated as *The Great Family of Man* – Barthes (1993 [1973]: 107) contended that:

> first the difference between human morphologies is asserted, exoticism is insistently stressed … Then, from this pluralism, a type of unity is magically produced: man is born, works, laughs and dies everywhere in the same way; and if there still remains in these actions some ethnic peculiarity, at least one hints that there is underlying each one an identical 'nature', that their diversity is only formal and does not belie the existence of a common mould.

Describing the exhibition, Staniszewski explains the attitude toward representing cultural difference was assimilationist so that 'The essence of humanity was presumed to be heterosexual and patriarchal, with values and expectations matching those of a 1950s middle-class family.' Papered across the internal walls surrounding the exhibition's entrance was an enormous photomural of a massive crowd, in which tiny faces appeared to embody a humanity greater than themselves – which may be appropriate for an exhibition that was dedicated to the liberal dream of postwar humanism (Staniszewski 2001: 238; Harris 1995: 1108). Passing through the doorway, the visitor became physically implicated in the attempt to encapsulate humanity. Regardless of the scope of cultural, ethnic and religious diversity represented within the images, and the earnest exaltations of an inclusive universalist model promoted by the exhibition's designers, the exhibition maintained the tone of moral (and reformist) Christianity, which presided over the images of non-Western cultures and traditions. 'The diversity of the globe – which was becoming ever-more apparent to the exhibition's audience, thanks to images just like these that were being brought into their homes by the picture press and the television – was reduced to a sameness' (Staniszewski 2001: 241).

Steichen's dream of creating an exhibition about 'the spirit of America, the face of America' was internationalized in the exhibition, and difference became further commodified through the enormous numbers of print catalogues generated and sold in relation the exhibition. By 1978, 5 million people had purchased one of the three catalogues offered (Berlier 1999). Like the international exhibitions of the earlier century, cultural difference was represented, yet, through the universalizing processes of visualization employed (whereby the one is the measure of the many, and vice-versa), difference became neutralized – rather than normalized. This occurred not just symbolically within the exhibition; it also achieved an increasingly allegorical iconography over the following decades due to the ten different editions of *The Family of Man* (150 exhibitions) that were exhibited around the world into the 1960s (Staniszewski 2001: 235).

LATE MODERNISM – *ARS GRATIA ARTIS*

The international exhibitions of the nineteenth century had aimed to endorse the state, trade, and imperial expansion, promoting a kind of neoglobal imaginary. It appears that in

the 1950s – as evident, at any rate, in the Festival of Britain and exhibitions held by MoMA – a substantial shift occurs. While this may have been related to the continually changing form and ideology of the project of modernity that had provided the fundamental point of motivation and *raison d'être* for the exhibitions in the earlier period, it also appeared to signify a clear desire for the assertion of difference from this ongoing historical context. The ideological scene of late modernism – emerging from the Cold War period – promoted ideas of formalism, reflexivity and autonomy, so that the artwork, for instance, became increasingly autonomous, sovereign and self-referring. Instead of implying the cleverness of the nation from which it had originated, the artwork was perceived as aiming more directly to communicate a value internal to itself (be it the genius of the artist or the material value of the object). The increasing taste for self-referring artworks that occurred during this late 1950s and 1960s period does not correspond to reveal a shift toward self-referentiality in the international exhibitions of this time. Indeed, the signifiers of futurity promoted by these exhibitions themselves start to appear as old fashioned, provincial, and culture-bound (in the anthropological sense; furthermore, their interest in the 'applied' arts over 'high' art may have constrained them further). And instead of expressing the desire to attain transcendence from the everyday and an aesthetic idealism, we can understand that the appeal of the 'new' becomes the promise for rupture, where the new is not simply the negation of something already known, but an encounter with something as yet unthought.

At this time, newness itself gains a renewed image that further embraces the individual value and innovation of the singular artwork at the expense of maintaining links with an historical past (although, paradoxically, of course, this 'new' promise for the autonomous artwork itself has connections with the eighteenth-century philosophy of Kant and Schiller, who rejected the tendency in enlightenment thought to rationalize all of nature, seeking instead to articulate the specificity of the beautiful in art and nature). Disengaged from the chronology and concerns of the past, individual artworks refer increasingly to other singular modernist artworks – as like signifiers, and to the visual economies of high art, which offer an articulation of their purpose and a value. The past is pushed even further away by this (ongoing) attempt to reject history and embrace the new, the novel, and the avant-garde. The saleable point of international exhibitions had historically been the relative interdisciplinarity that they offered; members of the bourgeoisie could rub shoulders with the lower classes, and distinctions between the categories of art and industry became more flexible. These features were, however, considered less and less desirable in the context of an increasingly liberal late capitalism, where the cult of the individual (artist, donor, benefactor, and so forth) was the only thing that could inspire feelings of religious observance and diligence.

Rupturing the connections between art museums and international exhibitions, these changes also decontextualized themes of nation and empire from the museum of art. The ever-increasing industrialization and mechanization of the workplace, recent memory of depression-era difficulties, and continuing international conflicts may also have contributed

to the tempering of public appetites for utopian ideals. Whereas throughout the earlier period, the exhibitions, museums, and museumlike spaces each aspired to speak to unified programmes of social reform and to the greatness of national aggregation in the face of empire building, the 1951 Festival of Britain, for example, showed that commitment to this version of newness had itself become old fashioned. The idea that the purpose of trade was to provide national confidence had become outdated, and it was perceived that its primary purpose in an increasingly privatized world should be to directly improve the life of the individual consumer. Moreover, it may be argued that Greenberg's aims to separate art from culture may have been motivated by MoMA's function during the 1940s and 1950s, where it acted as a propaganda tool for the American government. This would have been considered absolutely beyond the pale for the writer who came to prominence in 1939 with the essay 'Avant-garde and kitsch' (Greenberg 1971a), in which he claimed that Modernist avant-gardeism was a means to resist the 'dumbing down' of culture caused by consumerism. Greenberg argued that content should be removed from art to secure and purify the trope of the 'aesthetic' (emblematized as 'art for art's sake') away from more narrative, historicizing forms of popular culture and mass media (Greenberg 1971a, 1971b).

Consequently, the Festival of Britain and MoMA's exhibitions of the 1940s and 1950s marked the culmination of the now old style of exhibition making, and also indicated a taste for the new – albeit one more closely aligned with commerce and less overtly representative of the nation – which was to emerge in the late 1950s and 1960s preference for art for art's sake.

CONCLUSION

A key feature of new museums today is the ability to be self-reflexive. However, as I have demonstrated throughout this chapter, both the dedication to a past-effacing newness and the technologies used to construct this effect themselves have precedence in earlier models of modern museums. By looking at these historical traces we can also see that the effect of criticality so often produced in rhetoric about the new, postmodern museum can itself be connected to the ideologies that informed production of the first public museums and other museumlike spaces. William Ray cites Quatremère de Quincy as a public figure who was active in his critique of the early nineteenth-century museum precisely on the basis that its agenda was restricted to pedagogies of enlightenment and critical analysis: 'Everything there … speaks to us of Art and its devices, of the secrets of its science, the means of studying it; everything there puts you on your guard against its seductions. Curiosity and the critical attitude are there to prevent emotions from getting to our soul or penetrating it' (Quatremère de Quincy 1815: 52, 64; Ray 2001: 123). In looking at the legacy of the exhibitions and their taste for rational recreation and social progress, the function of the state can indeed be seen as clearly embedded within museums and exhibitions and other museumlike spaces (such as early department stores) as cultural apparatuses. There is no doubt that, as Quatremère, Bennett and others have noted, exhibitions and museums were

complicit in the reframing of high culture so that it would become an instrument enlisted for the reshaping of social norms. Not only were these spaces complicit, they functioned as 'technological environments' in which cultural artefacts were 'refashioned in ways that would facilitate their deployment for new purposes as parts of governmental programmes' (Bennett 1995: 6, 22–3). 'Culture' – both the high culture of museums and the 'low' culture of applied arts and ethnography sections of exhibitions – became instruments of governance. Expanding upon the argument that museums function as sites of regulation and pedagogical instruction – in that they were concerned to demonstrate what kind of public their visitors should be, Ray (2001: 123) makes the important point that:

> Quatremère's observations open an issue fundamental to museum theory: what kind of ethical and cognitive postures do museums foster, and what are their political and social ramifications?

In the early twenty-first century, the relationship between the state and governance, the nation as a symbolic configuration, and issues of boundaries, empire and commerce are once again attaining heightened levels of importance. Greenberg's preference for art for art's sake maintains only a marginal level of interest in a post-September 11 America, where the relationship between institutions of power and influence and certain national goals (such as security and expansion) have once again been recognized as useful tools. The next chapter directs the questions posed by Quatremère to an analysis of the proposed architectural commemoration for the sites impacted by the September 11 attacks, and considers the role that memorials and museums have played in the documentation and interpretation of material culture relating to the attacks. In particular, I elaborate further on the role of international markets of economics and trade and interrogate whether cultural diversity can be present in discourses of national aggregation and the imperial, transnational expansion of capitalist markets. More specifically, I ask how these historical events and trends and the legacy they leave contribute to our contemporary understanding of cultural diversity, to ask where cultural diversity fits in relation to contemporary symbols of nation, such as the International Freedom Center once intended for the World Trade Center site.

The International Freedom Center (IFC) was proposed as a cultural centre-like new museum to be located adjacent to the former Twin Towers in New York City. It was selected in 2004 to comprise a key component of the Memorial Center and Cultural Complex projected for the redevelopment of the World Trade Center (WTC) site following September 11, and to accompany the WTC Memorial (Figure 23). Entitled *Reflecting Absence,* and designed by architect Michael Arad and landscape architect Peter Walker to fit Daniel Libeskind's master plan, the Memorial was selected to offer visitors the chance to reflect and remember September 11. The other element advanced for the site is the Memorial Center Museum, which is expected to house an inspiring collection of artefacts and images that recount in detail the story of September 11, 'reminding visitors of the profound loss while celebrating the heroism that prevailed during the attacks and the determination of our nation' (IFC 2005: 5). Next to the memorial, with views overlooking the entire site, the IFC was included in the initial conceptualization of the site, to 'bring hope and resolve to a place of tragedy and grief'. By including the IFC within the Memorial Center and Cultural Complex, the site's designers sought to provide opportunities to 'discuss the connections between civic engagement, freedom, and democracy' as ideals that America has provided a leadership role in defending but which are also part of a larger 'global heritage', and the product of 'more than two thousand years of crosscultural dialogue' (IFC 2005: 5, 13). However, critics attacked the IFC's mission, saying that plans to promote international freedom through exhibits and displays about various genocides and crimes against humanity through history (including American Indian genocide and the slave trade) were inappropriate at a location that many people consider to be sacred. On 28 September 2005, New York Governor George E. Pataki bowed to political pressure and barred the IFC from the WTC's redevelopment plans.

The IFC is an important and fascinating case study for what it proposed more than for the fact it was banished. In designing the IFC, its cofounders, Tom A. Bernstein and Peter W. Kunhardt, recognized that a participatory public sphere had emerged in the period following September 11 and they aimed, through a series of comprehensive public consultations, to emulate this space of interaction and discussion on Ground Zero. Theoretically, this self-conscious replication of the public sphere concept demonstrates that, in a contemporary context, particularly following the media spectacle of the terrorist attacks, the public sphere can be constituted only in the form of spectacle. However, rather than offering either an effective riposte to – or a promising transformation of – the nineteenth-century reformist mentality that proves this point as argued by Habermas (1989), Eley (1992), Huyssen (2000,

23: *From Recovery to Renewal* exhibition banner, World Trade Center
Memorial Design exhibition (LMDC), World Financial Center, New York.
Photograph by Kylie Message.

2003), Sorkin (2003) and others, the expulsion of the IFC suggests that the modernist nar-
ratives of reform and national aggregation continue to have influence in a contemporary,
postmodern, context. In this chapter, I analyse the proposed IFC to consider its function
in the context of surrounding debates and explore its status as a new museum that aimed
to present itself according to a cultural centre model. Interesting not only for the way that
debate has been so intricately tied to concepts of urban renewal, the IFC is a useful case
study because it motivated the generation of some astute discussions about the relationship
between exhibitionary spaces and the representation of trauma, democracy, multiculturalism
and the 'American creed' in a way that was in some cases influenced by other museums and
cultural organizations in the city.

THE POLITICS OF PUBLIC COMMEMORATION

In making the decision to remove the IFC from the site, Governor Pataki rearticulated the
opposition between politically engaged and cultural centre-like new museums increasingly
popular around the world, and memorials that are generally perceived as marking a particular
temporal moment and as commemorating war dead or victims of disaster or tragedy. This

decision also differentiated the IFC from more traditional history museums and reveals a common and overly simplistic assumption often made of museums that they offer a pedagogically inclined and celebratory approach to themes such as victory or discovery (for a broader discussion regarding the relationship between monuments, memorial culture and society, see Mitchell 1992; Kohn 1995; Harris 1995; Brower 1999; Young 1992; Lupu 2005; also Young 2002 on this distinction between museum and memorial). From its initial conception, however, the IFC confounded these assumptions. By offering a global contextualization for the September 11 attacks, which linked local ideas about freedom with international responses to September 11 and other world events, it proposed a challenge to the dualistic stereotypes that separate museums from memorials and traditional museums from contemporary ones. It also aimed to present this through a strong pedagogical programme, and insisted that it would maintain a commemorative respect for those who died (IFC 2005). Importantly, too, it offered a cultural space that would contribute to the renewal of New York and the experience of the city for its residents and visitors, acting as a 'buffer between commercial, memorial and retail space' (Pogrebin 2005).

Having sought to avoid becoming just a sombre container for the storage of historical relics (indeed, relatively few objects survived from the Twin Towers), the 2004 plans initially approved for the Memorial Center and Cultural Complex depicted the site as 'a powerful symbol of resiliency, tolerance and hope in the wake of the 9/11 attacks' (LMDC 2004b: 6) – a 'living memorial' (Goodrich et al. 2005) that enriched the memories of lost ones with the healing stimulus offered by a lively cultural field (LMDC and New York State Council on the Arts 2005). A monument to the democratic values of the 'American way of life' (Canclini 2004: 706), it aimed to commemorate the victims/heroes, to 'remind us of our common humanity' (LMDC 2004b: 6), and to renew and 'reaffirm life itself' (LMDC 2003). Designed by Gehry Partners LLP and Norwegian architecture firm Snøhetta, according to many of the features associated with new museums globally (including the integration of new media technologies and the expectation of commercial viability), the complex offered both an ideologically invested and rhetorically affective cultural centre for the local urban community (Macdonald 2003; Rottenberg 2002). According to Kjetil Thorsen, a founding partner of Snøhetta, the architecture was designed to concentrate on the idea of negotiation – between 'public and private, memories and dreams, past and present and future, a memorial and lively urban hub… The design process is also quite literally a negotiation – between the public and institutions, among the institutions themselves, and among all the individuals present at the meetings' (Haun 2005). It also aimed to offer a symbolic space for the contemplation for and of the nation (for discussion of the way in which aspects usually associated with new museums have been applied in a memorial context, see Brower 1999; Heynon 1999; Huyssen 2000).

This highly self-conscious and inclusive sentiment has been reproduced widely as a motivation for the redevelopment of Ground Zero. Collaboration has been privileged (at least ostensibly), and the site has been managed by the Lower Manhattan Development

Corporation (LMDC) – a joint State-City corporation formed by the Governor and Mayor to oversee the rebuilding and revitalization of Lower Manhattan – in association with a number of organizations including the WTC Memorial Foundation, the Civic Alliance to Rebuild Downtown New York, and New York New Visions. Further modelling this idea of good practice, dozens of large-scale public meetings and workshops were held across the city after September 11 to garner public support for the project. And according to LMDC Chairman John C. Whitehead, the programming concepts approved by the LMDC were the result of a public process forged 'with the assistance of historians, preservationists, curators, victims' family members, residents, survivors, and first responders who gave of their time and themselves to serve on the Advisory Committee and Resource Group, offering their expertise, perspective and insight' (LMDC 2005; see also Civic Alliance 2002).

Perhaps it was appropriate, then, that public criticism ultimately caused the demise of the IFC. However, this also closed down any possibility that further consultation might be held to discuss other possible reconfigurations of the IFC. Indicating the existence of a rupture between the rhetorics and practice of full consultation, the decision to remove the IFC bypassed the meeting that had been scheduled for the LMDC to vote on the project (Dunlap 2005g; Pogrebin 2005). Just prior to a public forum that had been planned to discuss the IFC's fate, Governor Pataki released the statement that said: 'There remains too much opposition, too much controversy over the programming of the IFC, and we must move forward with our first priority, the creation of an inspiring memorial' (Dunlap 2005f; Hirschkorn 2005b; IHT 2005; Pogrebin 2005; Westfeldt 2005c). Despite having been proposed as a 'seamless' (IFC 2005: 5) tripartite design incorporating the WTC Memorial, the Memorial Center Museum and the IFC, it is clear that political concerns – accompanied by anxiety that the IFC would be political – caused it to be dropped. Not only does Pataki's statement further differentiate the project of commemoration from that proposed by the IFC, but in reasserting this separation of art and culture – were it possible – culture is represented as apolitical, and is elevated to the status of cure-all. Yet as this debate also shows, the potential for effective and representative popular participation in the construction of memory is substantially reduced rather than enhanced by such procedures.

While it has been frequently claimed that 'Ground zero is now a public place' (Bridgeland 2005), and that it demands thus the literal and pragmatic integration of many points of view as offered by the IFC, others argued that 'Politics left, right or in the middle do not belong on sacred ground. Ground zero should not be used as a public square' (Anthony Gardner in Westfeldt 2005a). Stigmatized as such by some as un-American, whereas others complained it was jingoistic (Burlingame 2005; Dunlap 2005e; Goodrich et al. 2005; Westfeldt 2005b), the IFC attempted to characterize itself as both a cutting-edge and politically engaged cultural centre. Recalling the features common to new museum projects, it drew inspiration and support from examples such as the US Holocaust Memorial Museum in Washington (1993), the Abraham Lincoln Presidential Library and Museum in Springfield, Illinois (2005), and more controversially, the International Coalition of Historic Site Museums of

Conscience (which include small freedom museums such as the Martin Luther King, Jr. National Historic Site, the District Six Museum in South Africa, and the Gulag Museum at Perm 36 in Russia). Acknowledging the range of responses and the antagonism attracted by the IFC's plans, the *Content and Governance Report* – produced in September 2005 as a last ditch attempt to defend the IFC against claims that it would promote 'un-American' values and attract political protest – argued that 'Some believe that any institution at Ground Zero should be limited in scope to the events of September 11. While we understand this point of view, it does not reflect the way memorials are being built in America and around the globe today' (IFC 2005: 6).

As a cultural zone designed to reside between commercial and memorial space, the IFC was predicated upon the idea that it would offer a site of transition and excess. Located in-between the official memorial and Memorial Center Museum, and hosting family rooms, its function was to represent culture and to encourage various ways of understanding the events. However, this agenda was perceived as challenging to the metanarrative themes governing representation on the site. Indeed, in this, the IFC is similar to other controversial museum projects, from the 1969 Metropolitan Museum of Art exhibition, *Harlem on my Mind* (Harris 1995: 1107–8; McClellan 2003: 29–30), to the *Enola Gay* controversy of the 1990s (Kohn 1995), and also including the decade-long debate surrounding the production of the Holocaust Memorial Museum in Washington DC (Linenthal 2001), as well as a raft of examples in Germany and elsewhere. In an article on museums and controversy in North America, Neil Harris (1995) contends that it is the construction of museums that aspire to a self-consciousness that tends especially to attract such unpopularity, particularly when the exhibitions may encourage visitors to question the role of the museum or state as holding authority in relation to the production of meaning. This is clearly problematic for new museums that aspire to bring various and traditionally discrete categories into dialogue, and that aim thus to offer 'a blurring of cherished artefacts and social contexts, scholarly research and exhibition venues, aesthetic values and cultural meanings' (Harris 1995: 1103). Similarly, Susan Crane (1997: 62) asks how museums can be expected to present such notions to a public that expects and demands to learn the historical 'facts' from museums (Thelen 1995; Kohn 1995; Linenthal 1995; Woods 1995); thereby reiterating the problematic belief that museums are 'expected to set standards, to confer status, and to reflect accepted truth, not to search for it' (Harris 1995: 1104).

Restricted in its ability to incorporate historical analysis or political critique (lest the IFC was chastized further for 'blaming' America, see Kostura 2005), the IFC was unpopular to many because it presented the events of September 11 in a way that was decried as unrecognizable and irrelevant to those who had been involved. It also failed to offer the confirmation of personal experience and memories that was desired by the victims' families. It was understood as threatening to confound their expectations for a heroic and commemorative storyline, and, as Crane (1997: 48) writes in relation to a different case study, 'People who otherwise might not worry about the content or purpose of a museum

may come to care quite passionately when their expectations . . . are thwarted, and they will express those passions publicly.' Although this can result from museums that aim to educate the public (to see things 'differently' for instance), it can also occur when museums aspire to present a self-reflexive attitude to representation, or when – as part of this – they aspire to encourage discussion about the relationship between subjectivities, objectivities and the role of the museum and state in production of these. Indeed, the success of the victims' families' groups in pressuring Governor Pataki to remove the IFC when he had previously expressed support for the project (Hirschkorn 2005b) may prove the point that: 'while historical scholarship is dedicated to the production of knowledge for a larger public, publics continue to harbor and develop their own collective memories which justifiably resist historical re-interpretation and which form an active component of public life' (Crane 1997: 63; for discussion about the conflict existing between the process of academic history writing and the public taste for 'popular' history and facts, see Kohn 1995; Linenthal 1995).

THE NEW MUSEUM-AS-CULTURAL CENTRE

Despite – or possibly due to – its unrealized status, the IFC offers an ideal case study for exploring the intersections and tensions between the public sphere as an idealized concept and the actual production of highly symbolic spaces. Its plans also presented a unique space and experience. Not only did it offer many characteristics of the new museum but it aimed to construct a cultural centre that encouraged widespread community interaction and use. Assessing its mission statement and proposed programmes, we can explore what the cultural centre concept might imply in this context – which is particularly important in relation to the IFC's additional responsibility to portray the WTC site as the 'birthplace of New York City and the cradle of American democracy' (LMDC 2003: 3). To investigate these conflicting agendas, it is useful to scrutinize the language that was used in planning and defending the IFC, as sourced from the transcripts of public meetings, competition briefs, reporting procedures, and other redevelopment procedures (cited throughout this chapter but see in particular LMDC 2003, 2004a, 2004b; LMDC and New York State Council on the Arts 2005; NAJP, AI and CAC 2003; Center for Arts and Culture 2001; IFC 2005, n.d.). Regardless of the failure of the IFC, these archives exist as valuable traces of the spirit of discussion and debate that characterized the response of people in New York to September 11. Many commentators of memorial design competitions also attend to this focus on process and intention. They argue that the production processes involved can be as revealing as the processes of consumption involved in reception of the final form (Linenthal 1995, 2001; Young 2002; Gay 2003). In the case of the IFC, these discussions provide ways to understand the proposed development of a cultural centre-like museum that aimed (perhaps overly self-consciously) to replicate an idealized and interactive public space.

We can already begin to investigate how the pluralistic, multicultural and diverse com-munities that were affected by the attacks, and that spoke out after September 11, are

being included in the ongoing discussions about the overall Memorial Center and Cultural Complex. Doing this allows us to evaluate how the official inclusive rhetoric has been put into practice. Although the removal of the IFC casts some doubt over the possibility that the Memorial Complex will effectively recognize a pluralistic national imaginary, it is an issue that had already received attention by participants of the public consultation process. An example of this is the resource-related question put forth by Robert Lee of the Asian American Arts Center in Chinatown, at a forum sponsored by the LMDC, New York State Council on the Arts and New York City Department of Cultural Affairs in July 2003. Arranged as an information session for the 'Invitation to Cultural Institutions' competition, this forum was designed to elicit submissions from cultural institutions for projects to occupy the WTC site. While suggesting that this renewal might be a way to connect previously discrete community organizations throughout the city and to recognize the importance of cultural diversity, Lee also comments that 'Because of the way in which you are asking for ideas and written materials, it would be hard for, say, any number of diverse organizations in New York City to get together and really write a viable, solid suggestion' – a comment to which the facilitators offered no practical advice (LMDC and New York State Council on the Arts 2003: 88, 66). In addition to revealing the political nature of the interconnections between the processes of the production and consumption of culture that is inevitably illustrated by Lee's query, this example offers insight into the procedures and constitution of collective memorialization. Noam Lupu (2005: 131) defines this process as encompassing the 'social activities and rituals (or representations) through which a community builds its narrative and constructs its social identity.' Although the Memorial Center and Cultural Complex has the overarching aim of assuring the collective memory of the event, Lee's comments suggest already that despite the inclusive and universalizing rhetoric, the resources to realize or evidence this multicultural collective imaginary may simply not be available (also see Wise 2002).

Indeed, as Lee's question indicates, arts organizations and museums were also confronted and challenged by September 11. They were forced to rapidly re-form and reconsider the role they could play in relation to balancing their usual tasks with the immediate needs of their local environments and communities. One report commissioned by an independent agency soon after September 11 documented that no surveyed organizations were going about 'business as usual'. Many had already reconfigured their programmes to account for anticipated funding cuts, drops in attendance and public patronage, and the changed city environment (Kleiman and Duitch 2001). As an indication of what was happening to cultural organizations and institutions across the city, Veronique le Melle from the Jamaica Center for Arts and Learning in Queens said, 'Of course we responded. We are a community institution and we are in one of the most diverse neighbourhoods in the nation' (Kleiman and Duitch 2001). By looking at the reaction of museums to the events of September 11, and the response made by local, state and federal government and the private sector in the form of the architectural briefs and cultural policy documents that followed, the function of

commemoration can be seen in this context as mixing inexorably with the production and documentation of various forms of material culture and experience after September 11. Just as the official September 11 Memorial can be seen as becoming increasingly museumlike in terms of its architectural design, strategies of representation, and mandate to inclusiveness and education programmes, museums surrounding the site – from the South Street Seaport Museum to the Museum of Chinese in the Americas – were charged almost immediately with the task of responding to and commemorating what had happened. Other sites – such as Nino Vendome's Canal Street restaurant – became accidental exhibitionary spaces, and offered a participation-driven site for commemoration and for the attempts at reconciliation and understanding that were embodied by poems and images taped over the restaurant's walls. The actions of individuals, museums and civic organizations were not passive or neutral responses to crisis but contributed significantly to our broader understanding of this historical moment, as well as to the processes of urban renewal that have followed. Moreover, the urban reminders, visual artefacts and material manifestations of this process of rebuilding and commemoration offered new forms of public history and community that are both produced by and effectively inform changing definitions of 'nation' and 'public' in the post-September 11 context.

THE PUBLIC SPHERE

It is, in a sense, self evident that the IFC (and possibly the Memorial Center and Cultural Complex) was instigated to have a formative relationship to the public sphere – given that it was embedded from the beginning in the culture industry (Huyssen 1995: 33, 13-35). However, the conditions of this public sphere need to be explored in greater detail. Rather than dismissing the public sphere as a metaphor or using it for allegorical purposes, the IFC aimed to present itself according to a new museum-as-cultural centre model in order to manifest the multicultural pluralism of voices that did indeed contribute to and constitute a public sphere in the period following the events. In seeking sources to fill in these parameters as set by this discussion, I have privileged documents of public opinion sourced from recorded public reactions, either from the local media or as retold in secondary forums, as well as the official documentation and government publications. Local newspaper articles and letters to the editor – as well as photographic documentation of the spontaneous memorials and other evidence of public response – are especially interesting because of the way they provide an image of the IFC functioning as a social actor even before the construction process was scheduled to begin. These resources are, of course, incomplete given the ongoing status of the broader renewal process. Similarly, they are not comprehensive – principally because criticism rather than support tends to be voiced more readily and spectacularly in the media (Burlingame 2005; Feiden 2005; Hirschkorn 2005a; Lupu 2005: 132). Yet, as evidence of 'publicity', this range of sources provides a textual archive and is important for what it tells us about the public sphere emerging at the time (and its relationship with private memory and personal subjectivity).

Most theorists argue that no attempt to reconstruct the historic bourgeois public sphere can be considered either possible or properly progressive given the structural changes to society and dominant modes of sociability. Habermas however, never completely lost sight of the possibility that a public sphere, contemporary in form, conditions and style, may still appear (1992). Craig Calhoun (1992: 28) explains that Habermas's project aspires to identify a 'form of democratic public discourse that can salvage critical reason in an age of large-scale institutions and fuzzy boundaries between state and society.' Following consideration of whether a contemporary – probably transitory and contingent – public sphere did come to be realized in the post-September 11 period, I would argue that the myriad, ongoing discussions about how to document, commemorate and interpret the attacks evokes the form of the democratic discourse that is described by Calhoun. Moreover, directed – as this public discourse has been – toward a conscious commemoration of a tragic event with which many feel an intensely personal connection, the result may be that the sites of discussion, mourning, commemoration, and documentation come to embody a space of publicity between the state and society. These sites and discourses may also contribute to developing an understanding that complex terms such as democracy, nationhood and citizenship exist as integrated and dialogical rather than as polarized or discreet (for discussion about possibilities, alternatives, and problems with this, see Fraser 1992; Taylor 2002; Warner 2002).

In general terms, the recent revival of theoretical interest in the concept of the public sphere has been widely attributed to the global events of 1989. A resurgence of democratic movements across Asia and Latin America, the collapse of communism in the Soviet Union, the fall of the Berlin Wall, and the events at Tiananmen have all contributed to what Schivelbusch and others have labelled an 'historical turning point' (Lieber 2002: 5–6; Lugar 2003: 2; Schivelbusch 2003: 289). Concurring with this, Dilip Parameshwar Gaonkar (2002: 2) argues that this renewed interest occurred because the public sphere 'seemed to capture something that was missing in earlier discussions of civil society' by pointing to institutions that could generate 'public discussion on issues of common concern that would ideally have an effect on public policy'. It was anticipated by world leaders during this period that the United Nations and nongovernmental institutions would obtain the potential to create a buffer between the market and the state, and flex their ability to influence the policy-making practices of individual nations. The result of this idealized global civil society would, it was hoped, result in the development of a transnational public sphere that was 'dedicated to promoting democratic values, human rights, and ecological justice through a potential "dialogue of cultures"' (Gaonkar 2002: 3). Yet in conceding that this idealism was overly 'optimistic and naïve', Gaonkar explicitly connects the events of 1989 with those of September 11, where global terrorism scarred America so spectacularly for the first time. Despite the failure of the post-1989 project to institute a utopian transnational public sphere, its conceptualization has offered a useful tool in the again recurring resurrection of attention in the ideals of democracy and civil

society – as key components of Habermas's *Structural Transformation* (which was published in English translation in 1989 for the first time). Calhoun (2002: 164, fn 30) articulated the public sphere as:

> focused not just on the ideals of public life but on the question of why apparently democratic expansions in the scale of public participation had brought a decline in the rational-critical character of public discourse, a vulnerability to demagogic and mass media manipulation, and sometimes a loss of democracy itself. The distorted publicity of American-style advertising, public relations, and political campaigns was a manifest focus…

The reillumination of this discussion – in relation to the discourses that saturated the American media following the events of September 11 – may encourage greater understanding of the fundamental interconnectedness of the terms 'nation' and 'individual'. Rather than existing as dualistic opposites where the individual is depicted as either submerged by or antagonistic to the greater project of nation making, these terms are interconnected and tend to be mutually reinforcing. They also help illustrate the role that the individual and the local can play in the constitution of society. This is important, as Calhoun (2002: 154) explains, because as a fundamental component of democracy, 'Belonging to (or being excluded from) "the people" is not simply a matter of large-scale political participation in modern society. It is precisely the kind of question of personal identity that produces passions that escape conventional categories of the political' – and that we can see so clearly in relation to the response to September 11 and the widespread community, national and international interest in its commemoration. More than a simple enactment or commitment to nationalist ideologies, these discussions actively demonstrate the role that public life plays in 'actually constituting social solidarity and creating culture' (Calhoun 2002: 155). Furthermore, by looking at the interplay of publicity that emerged in response to September 11, it may be possible to embrace a radicalism that proposes a point of rupture with the technocratic nationalism often attributed as the sole authority of modernism. The range of discussions made available by the public sphere evidences the dialectic of convergence and divergence, and illustrates it as being played out at different national/cultural sites under the contingencies of history and politics so that it produces multiple localized modernities and forms of personal agency. Calhoun (2002: 171) argues that the importance of the public sphere lies 'not only in achieving agreement on legal forms and political identity, but in achieving social solidarity.' For this to happen, he contends, it needs to occur within a realm of 'cultural creativity as well as rational discourse, and a realm of mutual engagement'. The conditions for this creative dialogue and exchange I suggest, are what may be identified in the responses to 11 September, as offered by museums and community organizations, and as also being reflected, albeit in distilled form, in the competition briefs and publicity for the rebuilding of Ground Zero.

Identifying the symbolic value of September 11 by addressing what for him is the conundrum writ large of the WTC, Andreas Huyssen (2003: 159) proclaims: 'How does one imagine a monument to what was already a monument in the first place – a monument to corporate modernism?' For designers of the IFC, however, this project was facilitated by the survival of Fritz Koenig's sculpture, *The Sphere* (1967–71). *The Sphere* was positioned as central to the IFC. It symbolized the ideals challenged by the attacks, and offered an expression of confidence in the ongoing process of modernization that the sculpture embodies. Explaining this, the IFC's designers stated that 'this sculpture, created decades ago as a monument to fostering world peace through trade, miraculously survived the devastation of September 11 and could now be a fitting symbol of perseverance in the face of tragedy' (IFC 2005: 7). Itself an icon of corporate modernity, the WTC maintained popular appeal throughout its life by a commitment to a neoliberal ideology of economic progress, cultural modernism and a social modernization that presents citizenship and consumption as interconnected and as linked to easily reproduced rhetorics of newness (and tropes of Americanization). Like MoMA, as another key symbol of Western modernity, the WTC was confident in its promotion of the idea that modernity is tied equally to cultural and fiscal forms of capital, and that national cohesion and pride follow on from this. Other points of synchronicity also connect these New York examples, so that discussions about the opening of MoMA's permanent premises in 1939 and its dedication to modernism are often accompanied (or book-ended) by discussion of the equally often-proclaimed 'death' of modernism that resulted from the famous, controlled implosion of the Pruitt Igoe towers in St. Louis in 1972 (Jencks 1991; Woods 1999; for discussion about the equally unconvincing death of the museum, which was also proclaimed during this period – see Huyssen 1995: 17). Modernity's demise, prefigured in the prophetic destruction of the Pruitt Igoe towers (and the 1993 terrorist attacks on the WTC), finds a further link with the now destroyed Twin Towers complex at the WTC because it was designed by the same architect and opened a year later in 1973 (Sorkin 2003: 18).

Although we may recognize that the rhetoric of demise/renewal has functioned historically as a condition of modernity's ubiquitous taste for the ephemeral and the new (Berman 1988; Sala 1868: 21–2), writers such as Huyssen (2003) and architect Michael Sorkin argue that the destruction of the WTC was not part of the carefully orchestrated and authorized Western modernist script (hence the suggestion that we may be better to advocate for a fragmented, postmodern approach to rebuilding and commemoration – as suggested by the IFC's proposed new museum-as-cultural centre typology). As Sorkin suggests, the September 11 attacks bring us face-to-face with this history in paradoxical ways. It causes us to consider the past-effacing modernism of the destroyed Pruitt Igoe towers in the context of the more recent destruction of the Twin Towers. It also causes us to think about the repercussions for changing the way we speak about the WTC, replacing

conversations about the neoliberalism of the global economy and the function of the complex as the headquarters of world trade with the desire to remember the past, people and events of that site. In line with Wesbury's (2002: 3, 9) progressivist argument that 'Al Qaeda attempted an assault on capitalist democracy, but it failed', some people did call immediately for the Twin Towers to be rebuilt bigger and better as a sign of national unity and confidence in the joint ideology of economic progress and cultural modernism as epitomized by the WTC (Sorkin 2003: 16; Colon 2005). However, it is interesting that the main themes and points of contestation surrounding the design of the Memorial Center and Cultural Complex in general (and the IFC in particular) have tended to include debate over the form and function of public space, discussion over the representation of difference in spaces designated as national, and the relationship of the state to these social configurations and their imaginaries.

Rather than simply noting the effects achieved by competing ideologies, it may be more interesting to explore arguments that claim terrorism is itself enabled by, or symptomatic of, modernism's desire for mobility and the ongoing flow of information, commodities and capital that is associated with it. Rosemary J. Coombe (2005: 38), for instance, contends that 'all global flows are cultural to the extent that they acquire or require means of representation – fictions, narratives, and metaphors that enable them to be made humanly intelligible'. This means that the global capitalist system and the global flow of terrorism function according to networks that are similar to those associated with modernism's privileging of progress, despite being based in different ideological spheres.

Sorkin (2003: 17) agrees with this analysis, asserting that 'Al Quaeda – "the global network" – is just one tick away from our own global business as usual.' As these writers propose, each of these spheres, rather than being properly discrete, is crosscultural and discursive: What was the attack on the Twin Towers if not an encounter? Intended to achieve maximum visibility, it was designed to communicate and to be represented in the most spectacular and eminently consumable way imaginable (Virilio 1994; Huyssen 2003; Schivelbusch 2003: 292; Sorkin 2003).

Accounting for this as a form of exchange, the exhibition programmes proposed for the IFC aimed controversially to integrate discussion of this 'dialogue' by looking at the historical and political context of the attacks in order to suggest ways that intercultural processes of discussion and exchange may be continued in more peaceable productive ways. Aiming to convey, for instance, the idea that 'freedom is everyone's story, and that all our lives are connected to this greater narrative' (IFC 2005: 8), the proposed exhibitions included films, artefacts, and recreations that would have involved stories 'from all parts of the earth'. The exhibition aimed, on the one hand, to be strikingly evocative and heavily experiential, but it also included the integration of rigorous education and outreach programmes (IFC 2005).

Moreover, despite being narrative heavy, the proposal also indicated the inclusion of artefacts. Yet it does not list or identify what these would be. This is interesting, given

the fetishization of particular objects that occurred after September 11 (summed up by the interest in the large steel cross that was found by a construction worker in the rubble of the WTC). It is also unusual from a museological point of view, given the potential recognized for these to offer exemplary interpretative tools (Kowalski and Best 2003). Nor does it explain where the objects would be sourced from or how they would be used to tell the story. While the *Content and Governance Report's* approach to museum making does appear to be overly ideological, its focus on language and dialogue is also directed toward making a feature of the IFC's visitors, who were to be centrally implicated as collaborative participants in the IFC's programmes. Proffering the image of a unified citizenry that is both culturally and politically informed and active, however, this also risks appearing to suggest a mechanized and universalized image of citizenship, whereby the individual is seduced and subsumed by the greater ideas of freedom and democracy as presented in the 'film clips and compelling artefacts' offered by the proposed museum as spectacle (IFC 2005: 12–13).

TOWARD A MULTICULTURAL SOCIETY

Although a general acceptance of multiculturalism has been established in recent decades, some critics have used September 11 to argue, *vis à vis* Samuel Huntington (2004), that acceptance of diverse cultures has compromised the US (as leader of the West). This response could not be considered surprising after September 11 (Linenthal 2003), yet, what may perhaps be more unexpected is that – even despite President Bush's infamous 'why do they hate us?' speech to Congress – the rhetoric of multiculturalism has grown even stronger since September 11 in the US (Jones 2005; US Department of State 2005). Coalescing as a general discussion about the coordinates and conditions of democracy, and produced at all levels of policy, pro-multicultural rhetorics demanded that the IFC create an inclusive space open to representing a diverse and pluralistic public. This rhetoric is perhaps epitomized in the US Department of State's *Victims and Heroes Album*, which claims: 'September 11 created a new generation of heroes for America and the world. They came from diverse cultures, and many from faraway lands, but on September 11 – whether they perished in the attacks or bore witness – all were victims and each was a hero' (http: //usinfo.state. gov/albums/911/). In discussing similar programmes and proclamations, Yúdice (2003: 340) has made the historically familiar-sounding point that 'The United States needed to demonstrate via spectacle that it is indeed a community of diverse cultures united behind the American Creed of freedom and justice.' Here we find ourselves back in the realm of language and rhetoric, where the spectacle of freedom, tolerance and cooperative rebuilding needs to outperform the destruction and the challenge to these ideals. This may be why – as tools located within the culture industry that are central to programmes of governmentality, collective activity and centralized identity – museumlike spaces have been recognized as offering such significant capital.

Such pervasive political correctness may be further critiqued on the basis that it reveals an agenda of civic reform that is descriptive as well as proscriptive. Again highlighting the

distinction between rhetoric and practice (and as demonstrated further by the fate of the IFC – which claimed to be the most interactive and inclusive space), this would also mean that the primary aim is not to offer access to representation, but to instruct the community on the value of cultural diversity (Hall 1999: 39; Witcomb 2003: 82; Coombes 2004: 293). This further evidences the point I have argued elsewhere in this book, that the nineteenth-century interest in class reform has gradually given way to other reformist ideas, and in the last 30 years in the US, a new '"American Creed" (those values, ideals and laws naturalized as the American way)', has emerged to include a cultural diversity that is 'pervasively shaped by identity politics, the media and consumerism' (Yúdice 2003: 339). Even where this moral code is not overwhelmingly driven by economics, it tends to continue to promote the ideology governing processes of progressive and imperative modernization. This may also contribute to doubt that the unified public sphere proposed by Habermas in 1962 is able to account for the complex issues of a multicultural society, on the basis that, as Peter Uwe Hohendahl (1995: 39) has argued, the complex issues of contemporary cultural identity cannot be schematized or treated according to the national model of the nineteenth century. It is for this reason, he contends, that 'the renewed search for a national identity and the problems of a multiethnic society stand in an uneasy relationship'.

RENEWING THE FAMILY OF MAN

Following these theoretical discussions, we can interrogate the relationship between a contemporary multicultural and pluralistic public sphere and contemporary museums and museumlike institutions and spaces to ask whether the new cultural centre-like museum continues to function as modernization's privileged cultural agent and authority. If not, is it possible that the proposed IFC may have succeeded in offering a fragmentation or critique of the conditions and exclusions normalized by the modern museum (and the modern nation-state that it has often spoken on behalf of)? Certainly the idea of the IFC integrated this globally aware rhetoric of diversity at a formative level. It worked to draw explicit associations between the local and global by claiming that 'Lower Manhattan has always belonged to the world, providing asylum to freedom seekers from hundreds of nations and reflecting the human family in its great diversity' (IFC 2005: 14). The IFC responded thus to demographic changes in the US as well as increasing transnational migrations, and was supported by key academics in the field of postcolonial and globalization studies (such as Anthony Appiah – IFC 2005: 23). Without the IFC, however, we need to ask whether it is possible that the remaining Memorial Center and Cultural Complex (or the correlative countermemorials, spontaneous commemorations and community museums networked around it) can represent an increasingly and, according to Huyssen (1995: 28), 'more genuinely heteronational culture ... that no longer feels the need to homogenize and is learning how to live pragmatically with real difference'. If not, the resulting Memorial Complex will risk renewing the superficial claims to diversity that are universalizing and reminiscent of Family-of-Man-era America.

Indicating the significance of this tension, these sentiments are both apparent even within the IFC's own – and final – *Content and Governance Report*, which was produced to defend the IFC against criticism from organizations of victims' families (Dunlap 2005e) by defining its programmes with greater clarity. However, this further provoked right-wing organizations and community-value groups that argued: 'Liberals who invite "tolerance and diversity and antidotes to evil"' constitute 'the "weak link in America's response to the attack"' (Martin and Neal 2001 in Yúdice 2003: 342). Consistent with this, a typical response to the IFC's plan to depict the history and role of freedom around the world in exhibits and programmes was made by Michael Burke, whose brother, a firefighter, was killed responding to the attacks. Burke asserted that, 'Nobody is coming to this place to learn about Ukraine democracy or to be inspired by the courage of Tibetan monks. They're coming for September 11' (in Hirschkorn 2005a). Pressure from victims' families' groups and others escalated in August 2005 with an op-ed piece in the *New York Times* by Debra Burlingame, whose brother had been the pilot of the plane that crashed into the Pentagon (Burlingame 2005). At this time and by way of a response to the victims' groups, Governor Pataki requested the LMDC secure an 'absolute guarantee' from the Drawing Center (a 28-year-old gallery previously located in the Twin Towers) and the IFC that they undertake nothing 'that denigrates America' (Dunlap 2005b; Kostura 2005). This caused the Drawing Center to seek residence elsewhere (Dunlap 2005b), and resulted initially in the production by the IFC of the *Content and Governance Report* – which, interestingly, depicted the proposed IFC as hedging its bets rather than ceding to the criticism. Instead of moderating its claims for the importance of a broader contextualization of the September 11 attacks, the IFC projected programmes that would offer a politicized perspective on a global history that presented the US as leader in the international struggle for freedom. This means the IFC retained its themes of global contextualization, but that it redirected these to a valorization of America. Less than a week after the *Content and Governance Report* was released, and following further criticism (made by high profile figures including Democrat Senator Hillary Rodham Clinton), the IFC was dropped from the Memorial Center and Cultural Complex.

In revising the IFC's mission statement, the writers of the *Content and Governance Report* deployed a series of new strategies that situated Franklin Roosevelt's four 'essential freedoms' as a central moniker for the IFC. Simultaneously legitimating the need to contextualize September 11 globally, and reaffirming the IFC's stance as 'proud patriot' (Dunlap 2005f), these were presented as being epitomized by the claim that, 'now enshrined in the preamble of the Universal Declaration of Human Rights, the Four Freedoms have attained a world-wide moral authority and are increasingly embraced in the constitutions of emerging democracies around the globe' (IFC 2005: 11). However, this approach led one critic to argue: 'In building the Freedom Tower, the US reasserts its power in an arrogant way: Does this mean the US will not only build the biggest building, but also define freedom for the world?' (in Feiden 2005). What we see articulated in both the IFC's programme outlines and

in the criticism against it is a continuation of the integration of narratives of modernization and Americanization (which are presented as being correlated to processes of globalization). Modernist in presentation and progress-oriented in approach, the *Content and Governance Report* presents America as central to singular world narratives of freedom and democracy (IFC 2005: 2). This point is made clearer still by the proposal for a central exhibit called 'The Freedom Walk', which was to wind from the IFC's orientation spaces throughout and around the whole building: 'The Walk will not attempt to offer a comprehensive survey of freedom. But as they journey along it, visitors will feel that they are progressing – that there is a forward movement, if not a straight line, to freedom's story' (IFC 2005: 9).

Interestingly though, this singular modernist narrative is represented in the document and the proposed site plans as much more complex and nuanced than this interpretation suggests. Concurrent with the IFC's reassurances that it would do nothing to challenge American values (Feiden 2005) are details that indicated a more astute engagement with the individuals and groups who helped constitute the public sphere that emerged in the aftermath of September 11. The *Content and Governance Report* juggles this potential contradiction most in the plans for a gallery called 'In Freedom's Service'. This was designed to draw influence from the 'civic renaissance' spawned by September 11 to discuss 'the connections between civic engagement, freedom, and democracy' that occur when people offer public support, serve in their local communities, or offer time to national or transnational volunteer organizations (IFC 2005: 13). Although this gallery may be critiqued for simply reasserting the liberalism of a hyper-modern Americanization by linking the individual to the nation (ceding thus to its conservative critics), it may have also aimed to offer agency – or at least the legitimation of representation – to political minorities, within the space of an important symbolic national institution. Indicating the ways in which these competing discourses may be brought into dialogue, the IFC planned to incorporate films, exhibitions and programmes that would 'show how the WTC attracted people from all over the globe to a place in which national and cultural differences were subsumed in trade and commerce – how Lower Manhattan has, in essence, always been an international freedom center, drawing people to a dream of a free and better lives' (IFC 2005: 7). The vision of the IFC that is promoted in the *Content and Governance Report* and other documentation presents it as responding to Huyssen's (1995: 34) statement that:

> What needs to be captured and theorized today is precisely the ways in which museum and exhibition culture in the broadest sense provides a terrain that can offer multiple narratives of meaning at a time when the metanarratives of modernity, including those inscribed into the universal survey museum itself, have lost their persuasiveness, when more people are eager to hear and see other stories, when identities are shaped in multiply layered and never-ceasing negotiations between self and other, rather than being fixed and taken for granted in the framework of family and faith, race and nation.

A new regional pride emerged in New York immediately following the attacks on the WTC. This exacerbated parochialism resulted from residents describing an experience that marked the city apart from the rest of the country. It aimed to counteract the breakdown in urban infrastructure whereby, amongst other things, mobility, communication and basic urban infrastructures were fundamentally disrupted. These conditions caused a more historical experience of the city to emerge that, paradoxically, shifted our attention away from the now institutionalized cultural modernism and social modernization epitomized by both the new MoMA and Minoru Yamasaki's Twin Tower complex, back to the version of modernity canonized by the metropolis of nineteenth-century New York (and Paris and London). Resurgence of interest by New Yorkers in the processes and language of renewal and rebuilding (which we may describe as a project of remodernization) may have also contributed to renewed attention to the possibility of the emergence of ideas such as the Habermasian public sphere (Figure 24).

Echoing the official rhetoric of city and state officials and underpinning the statements made by President Bush and other world leaders in the days and weeks following the attacks,

24: Council signage on Ground Zero, New York. Photograph by Kylie Message.

temporary memorials, spontaneous commemorations, and a plethora of notices ('An Open Letter to Tourists and Picture Takers', posted by the Employees of Downtown Manhattan), propaganda ('Red, White and Blue = Peace', posted by the Realize the Grip the Corporate Media Has On You Coalition), event announcements ('Reflections on memorials' found at NYU), advertising ('We're Back!!! NYC Check Express-Fast Cash Check Cashing is Open!!!'), and other paper-based ephemera emerged as testaments to a heightened regional awareness and community closeness. Of the posters of the missing that were taped all over the city, a hundredfold, one New Yorker commented, 'You would see the same faces over and over; the man with a beard, the cute woman in the turquoise suit. They were everywhere, on every corner, and it felt like you knew them' (Dupre 2005). Combined with the discussions taking place around them, these activities were clearly represented as having provided an active reconstitution of a public sphere. However, we need to ask whether, in collecting the posters, memorials, displays, and artefacts from across the city – from the Fresh Kills Landfill, New York City's Police and Fire Departments, the 24-hour relief centres at St Paul's Chapel and Nino Vendome's Canal Street restaurant, St Vincent's and Mount Sinai Hospitals, Union Square and Pennsylvania Station, the Manhattan School for Children, and the downtown Manhattan neighbourhoods quarantined by the disaster – city museums and cultural organizations can thus be understood as holding the material residue of this public sphere. Collecting material that would come to constitute the *History Responds* project, the New York Historical Society adopted a leadership role in compiling and cataloguing historical evidence related to the September 11 and its continuing aftermath, to produce over 15 exhibitions. We can also ask whether this museum-directed activity contributes to 'the energetic colonization of the cultural realm', that occurs when the state and individuals act to 'rearticulate a functioning political sphere, through those forms of representation and exchange that continue to exist, and which link people to each other in a social context otherwise bereft of common experiences or solidarities' (Charlesworth 2002: 365).

This production and collection of ephemera and the stories associated with them certainly may represent the reclamation of the city by local New Yorkers, who recognized that the local communities throughout the city would continue to experience profound changes that will shape their future for some time to come (Figure 25). Many accounts acknowledge the events as history changing, and many individuals explained that a compulsion for direct action and personal involvement was generated by the experience. The making of posters, signs, and other materials was explained as an important way to express a myriad of responses and emotions as significant, particularly because they were consciously and conscientiously designed to be posted in public (Greenspan 2003; http: //www.citylore.org/). The desire to be involved as active agents participating in the decision-making process achieved a clear point of collective consensus in public meetings held across the city, including the 2002 *Listening to the City* forum which 'emphasised that "our diverse communities [must] remain united ... so we may act and achieve great things for this city, this state of New York, and this nation, together"' (Civic Alliance 2002: 3). The vigorous engagement with and deliberation

25: Graffiti on Ground Zero, New York. Photograph by Kylie Message.

by private individuals about state affairs also generated thousands of newspaper articles and media hours, which may contribute to the veracity of this active enactment or performance (if not actual constitution) of a public sphere according to criteria suggested by Hohendahl (1995: 31) – as a space between the realm of the state and the private sphere of its subjects or citizens where critical discussion of cultural and political matters can take place (see also Ward 1995: 77). Commenting on the level of response recorded in relation to the WTC rebuilding competition (which received entries from over 92 countries), Sorkin (2003: 53) says, 'the outpouring of proposals and opinions has been bracing: At no time in my memory can I recall so many discussing questions of planning and urbanism so fervently'. Reportedly conducted at all levels of society (Civic Alliance 2002: 9), the discussion may itself have become monumental and bigger than what it represented (Young 1992: 52).

The relationship between community and culture can be described in general terms as providing members with 'a positive sense of identity and cohesion while contributing to local democracy' (Strom 2001: 12), but it is articulated specifically in relation to September 11 by a report commissioned by the Center for an Urban Future in late November 2001. This recommended that the city 'Integrate arts and culture into the rebuilding effort' by building and expanding on the fact that 'Before September 11, lower Manhattan had gradually evolved into a cultural center, offering city residents and tourists alike a range of impressive museums and cutting-edge performances' (Kleiman and Duitch 2001). Aiming to maximize this potential, a range of collaborations resulted. These included the cooperation of museums and cultural institutions, the consolidation of support organizations, the work of collectives made up of business and community leaders in Lower Manhattan, and a resurgence of other community interest, not-for-profit and religious groups (including Tuesday's Children, Our Voices Together, the Afghanistan School Alliance, the Coalition for the Human Rights of Immigrants, the War Resisters League, People for Peace, and America-*Speaks*). Developing into one of the key organizations contributing to the renewal of New York, the Civic Alliance to Rebuild Downtown New York describes its role as promoting 'ongoing participation by the public and the civic community in the rebuilding process, and advocates public accountability and sustainable and equitable development' (LMDC 2005).

These collective associations contributed substantially to discursive debate about the process of commemoration and the role of the state contribution to the project of meaning making. However, such claims to inclusiveness involve a risk that is demonstrated by the overwhelming authority that has been assumed by certain associations. This means that while independent interest and advocacy groups (including September's Mission, and the September 11th Families Association) have achieved a substantial visibility and voice that is accompanied by a strong sense of collective agency, in some cases, their statements of advocacy may also be seen to function as a product of political instrumentality. This proves, on the one hand, the overarching political strength of the American constitution (as a commitment to the four freedoms expressed by Roosevelt), and offers a forceful

reiteration of the role 'powerful egalitarianism' plays in the 'American creed' (Sorkin 2003: 20). However, in offering publicity to the rights of victims and their families, independent groups have achieved authority whereby they may legitimately comment beyond the space of their immediate concern. A comment in the Spanish newspaper, *El Diario*, notes: 'the memorial does not belong to the 9/11 families alone. It belongs to all of us' (*El Diario* 2005; McCarthy 2005).

This debate contributed in exemplary ways to the conception of what kind of public space the Memorial Center and Cultural Complex should become. It also strengthened understanding that the site is clearly understood as a space belonging to all New Yorkers and all Americans (Civic Alliance 2002: 6). And yet, this universalizing rhetoric was not inclusive enough to incorporate the IFC. Despite the IFC's removal, it is still interesting to consider the spaces and experiences proposed because they aimed to maintain the new communication frameworks and the attention to representative democracy that emerged after September 11 (Ward 1995: 73). Styled as it was to be a rational-critical cultural centre, the IFC promised to offer many components of the idealized public sphere. It aimed to offer spaces that would enable visitors to contribute to the production of publicity, and aimed thereby to communicate the 'essential message to all visitors' that 'the future of freedom depends on you' (IFC 2005: 12). The IFC's underlying belief was premised on the conviction that the proliferation of multiple and pluralistic public spheres would ensure that it is not just a singular conception of citizenship (rights and responsibilities) that prevails (Yúdice 2003: 76; Warner 1992). Although utopian, this project also responded to the spirit of the day, as summed up by Margot Adler, who explained:

> So here I am in the city that was never loved by America... Here ... I stand with people who are often the 'others' in America, black homeless teens and gay men with AIDS, and they are waving American flags and cheering on the rescue workers who go back and forth to Ground Zero. It's hard not to feel like I am suddenly a citizen of this country for the first time. (http: //www.citylore.org/)

This demonstrates that democracy depends on a public sphere (to fulfil its duties in relation to the constitution of the modern nation-state), but it also shows that, to be realized effectively, it must be enacted *within* this realm.

However, in contrast to an organized community activity, and instead of privileging Negt and Kluge's (1993) concept of a fragmented, multiple public sphere – that Habermas (1992) accepted to a degree in later texts – the resulting proposal for the Memorial Center and Cultural Complex risks reasserting the idea of a singular and universalist space. This is principally because, despite the context of multiculturalism, discussions of cultural diversity and difference appear to have been replaced by the preference for universality. Reiterating the sentiment of Governor Pataki and others on the management board, a statement made by John C. Whitehead, the Chairman of the LMDC (in the preface to the WTC Site Memorial Competition Brief) exhibits this preference for universality over difference when

he says: 'The global outpouring of support in the days after showed that freedom is not an American idea, it is a universal idea' (LMDC 2003; Civic Alliance 2002: 8). However, as Yúdice (1992: 202) notes, this highly commercialized 'We are the world' rhetoric has often been used in relation to New York and is dubious at best (see also Virilio 2002: 29). Robert Lee is also unconvinced. He notes that diverse community arts organizations and museums in New York city have never been effectively networked (LMDC and New York State Council on the Arts 2003: 88, 66). Furthermore, this inclusive rhetoric is problematic because it may simply have no relationship to reality. For instance, despite claiming that 'Many participants [of the *Listening to the City* forum] represented communities whose voices often go unheard' (Civic Alliance 2002: 2), the attendance statistics for this forum showed that far fewer low-income, African-American, Hispanic and mixed race participants attended than is representative of the region (Civic Alliance 2002: 9).

MUSEUMS AND THE CITY

In just one of many dozens of discussions that occurred in the aftermath of September 11 (Wise 2003), the Smithsonian Institution's National Museum of American History (NMAH) and the Museum of the City of New York cosponsored an event on 4 October 2001 that was designed for the benefit of cultural institutions. Attended by over 80 history professionals who represented more than 30 institutions, participants in *The Role of the History Museum in a Time of Crisis* forum discussed the function and responsibility of museums in relation to collecting and interpreting materials. They also considered how museums could present exhibitions and programmes that respond appropriately, sensitively – and interestingly – in a 'useful' way to the events (Gardner and Henry 2002: 38). Held less than a month after the attacks, this forum combined with the external spontaneous artworks and commemorations occurring around the city to draw attention to the public function of museums in a democracy. It also demonstrated the difficulties experienced by some history museums in dealing with the contemporary socio-political situation. According to James Gardner (associate director for curatorial affairs at the National Museum of American History) and Sarah Henry (vice president for programmes at the Museum of the City of New York), the NMAH was one museum that experienced a lack of confidence with the task of framing September 11 according to the museum's usual parameters and agenda. The NMAH had initially claimed that its purpose was to interpret and provide historical perspective rather than contribute to the memorialization of the past, but Gardner and Henry contend that the NMAH was uncomfortable with memorialization because of the relationship between commemoration and emotion (which risks compromising the construction of objective truth). Facilitated, however, by the October 4 meeting, questions were asked about the role of museums in relation to the representation of trauma and subjective modes of experience and understanding. This was followed in December by the involvement of the United States Congress, which directed the NMAH to collect and preserve material relevant to the attacks. Overcoming, at least ostensibly, its discomfort with emotive issues, the NMAH developed an

exhibition called *September 11: Bearing Witness to History,* which aimed to present a certain transparency in relation to the role of the museum in the making of history and focused primarily thus on collating and representing personal responses to the events. Designed to coincide with the first year anniversary, *Bearing Witness to History* has been described as 'more memorial than interpretative' (Gardner and Henry 2002: 50). As this example shows, in reconstructing the spontaneous commemorations and displaying the ephemeral material exhibited in New York after September 11, museums became participants in the process of memorialization. They have also come to offer sites for grieving, and for the public to leave further commemorative material.

In another example, the New York Historical Society collaborated with the New York organization CityLore to produce an exhibition called *Missing: Streetscape of a City in Mourning* (2002). (See also the travelling exhibition, *Recovery: The World Trade Center Recovery Operation at Fresh Kills* curated by the New York State Museum – Kowalski and Best 2003.) Dedicated to chronicling the spontaneous memorials that sprung up following the attacks in New York, the exhibition relocated the memorials into the space of the gallery, and intended in the exhibition's design to replicate the form and layout that the memorials had taken in the street (http: //www.citylore.org/). While the NMAH's anxiety over commemoration may have been connected to discomfort with the exhibition of emotion, it appears that *Missing* relied on these strategies of commemoration in order to avoid interpreting (or challenging) contemporary cultural politics. This choice may have been connected to the perception that the national imaginary was not yet ready to tolerate broader political discussions. However, this strategy also reveals CityLore's objective of promoting the idea that a public sphere with particularities can exist so that, by reconstructing the street layout as authentically as possible, *Missing* demonstrated that the public sphere is already constituted by citizens who are embodied and participatory in their relationship to public space. Rather than articulating a party political statement as a dominant theme of the exhibition, this engagement with ideas about a heterogeneous public sphere contributes to presenting the personal politics of participating citizens as implied or implicit at multiple levels within the everyday life of the city. Constituted within an exhibition space, the other issue that *Missing* alerts us to is the museum's relationship to authority. In choosing what to exhibit and what to exclude (given the vast amount of materials generated and exhibited across the city), the New York Historical Society and CityLore have decided which material to preserve as 'documented history', and thus influenced as well as contributed to our understanding of the past. This means, for example, that the inclusion of culturally and racially sensitive material such as a painting and an open letter from an Islamic American girl to the American public in the *Missing* exhibition continued to promote CityLore's ideological mission statement: 'We believe that cultural diversity is a positive social value to be protected and encouraged; that authentic democracy requires active participation in cultural life' (http: //www. citylore.org/).

In asking what role museums may play in creating or legitimating collective memories of September 11 in the context of this challenging framework, we also need to ask whether the museum in its current form is equipped to account for this skein of complexities (Hudson 1999). How are the multiple publics affected by the attacks going to be represented in these ideologically valuable sites? How are contradictory representational modes – depicted for example by the more institutionally conservative NMAH exhibition as compared to *Missing* – going to function, and what relationship to authority are they going to offer? According to Macdonald, contemporary museums provide the ideal point of focus around which many of our global and local preoccupations and concerns gain visibility. She contends that new museums offer the ideal vehicle for the collection and representation of these issues because they:

> demand attention to questions of how identity and difference are performed, and to how senses of continuity might be intimated in the face of the apparent acceleration of transnational movement and global transformation. They are sites in which seductive totalizing mythologies of nation-state and Enlightenment rationality struggle against alternative classifications. (Macdonald 1996: 14)

As both the *Bearing Witness to History* and *Missing* exhibitions illustrate, museums can convey an authoritative and legitimizing status and provide role models and symbols for identification (for broader discussion of this, see Rumm 1995; Woods 1995; Kennedy 1996; Crane 1997). Through their sitedness and relationship to local communities, they offer points of nexus for the representation of community, and evidence of the centrality of material culture to the formation of culture and cultural identity. Also emerging at this time, as an extension of this, was a recognition that the spontaneous and temporary exhibitions were contributing to the renewed impression that the city itself functioned as an exemplary exhibitionary context. In becoming museumlike, the urban spaces and sites offered spaces for renewed interaction, communication, dialogue and discussion. The analogy between the city and museum is valuable because it both draws on the late nineteenth-century modernist blurring of boundaries that distinguished museums and international exhibitions from the city beyond (Mitchell 1989), as well as MoMA and the street (Chapter 2). It also may extend our understanding that museums themselves exist as distinctive and multilayered cultural complexes (Appadurai and Breckenridge 1992; Macdonald 1996; Canclini 2004).

This interplay between the city and museum as equivalent representational spaces has been acknowledged by attempts made by museums to retrieve material culture from the affected areas. In New York, materials from spontaneous memorials were amassed at sites such as St Paul's Chapel, just across from the WTC site (and are now being held temporarily in an off-site storage facility). They were collected by the New York Historical Society, the NMAH, the Museum of the City of New York, and perhaps most voraciously by the public on behalf of an even wider variety of museums. Given the paucity of remnants from Ground Zero and the largely ephemeral nature of most of this spontaneous material, questions

over how (and whether) they should be preserved, and what exhibition strategies should be deployed, were expressed as pressing during the 4 October meeting. Other questions were asked about the appropriateness of how and when to 'usher the tragic present into the historical past' (Gardner and Henry 2002: 39–40).

Clearly, the events of September 11 thus raised questions and challenges for museums, particularly in respect of the discomfort expressed by public historians concerning the too-hasty interpretation of salvaged items or the events they represent (for an indication of the historical basis of this argument, see Kavanagh 2004; Schlereth 2004). Other relevant ethical issues included discussion over the relocation of memorial material that had been left by mourners who wanted to convey publicly their feelings of loss, and how this relocation would alter the meaning of the material – both by changing its environment and by possibly removing it from a larger memorial cluster (which may have contributed to the decision to structure *Missing* according to the order of the street). In some cases, victims' families or the memorial builder actively sought out museums to collect the material. In most cases, however, photographic and audiovisual documentation projects became the primary way to convey both this contextual information and the scale of vernacular memorialization that occurred. An example of this is the material photographed by Martha Cooper for CityLore (in association with the New York Historical Society). This formed the basis of *Missing*. Other organizations, including the American Folklife Center of the Library of Congress, collected photo documentation of the memorials. A number of electronic archives – notably the September 11 Digital Archive (http: //911da.org/) – have continued to collect and make available photographic and oral documentation, as well as the other paper materials that blanketed the city at this time. In these activities we can discern a dissemination of the museum that indicates the shift in museum practice away from more traditional and dis-cretionary practices toward more inclusive 'cultural centre-like' programmes and agendas. Not only does the city become a comparable exhibitionary space, but these activities suggest that strategies more usually associated with museums have been adopted by a variety of community organizations.

A correlated effect of this interlinking of personal and national imaginaries has been that more people are increasingly concerned with the issues of the custodianship and preservation of museum collections. Gardner and Henry address this in their account of the 4 October meeting as an issue facing museums in relation to the collection and inter-pretation of material connected to September 11. They also explain that the sheer mass of spontaneous memorial ephemera means that the pressure to collect everything may occur at the expense of highlighting more important stories, including 'the detentions and violations of civil liberties, and discrimination and racism' that followed (Gardner and Henry 2002: 43). Outlining the care that they believe needs be taken in relation to the process of historicization conducted by museums, Gardner and Henry ask the important question, 'Can we avoid jingoism and propaganda? . . . Should we focus less on the events of September 11 and more on the need for tolerance and respect for difference in this time of

crisis?' (Gardner and Henry 2002: 52; for questions regarding the process of historicization see Shapiro 1997; Crane 1997.)

Clearly, the terms of this inquiry evoke the tone and exhibition outline proposed by the IFC. Illuminating possible reasons why the IFC may have attracted criticism, Gardner explains that even before September 11, the NMAH had itself been critiqued for failing to offer more celebratory exhibits (although see Kohn 1995; Rumm 1995). He uses the emblematic Star Spangled banner held by the NMAH to discuss the urgency of these negotiations regarding the role of the museum in a time of crisis – where the national flag becomes such a highly visible and emotional motif of popular patriotism. Gardner explains that in the context of the Smithsonian, all objects and exhibitions – including the flag – are tools that are used ideally to challenge the perceptions, assumptions and stereotypes that may be held by visitors. Yet he also concedes that this makes the museum vulnerable. Addressing the Smithsonian's attempts to lure visitors back to Washington with newspaper advertisements that encouraged reconnection with their 'inner patriots' (and by offering exhibitions such as *The Price of Freedom: Americans at War)*, he contends: 'Contested history is not an easy sell in normal times; it's even more problematic in times like today of fear and uncertainty, in a highly politicized climate' (Gardner 2004: 12). These statements reveal an anxiety that is connected to the increasing interest in and public prominence of museums. While this indicates exactly why they are so important for the rebuilding of collective national imaginaries (which is the key function of the Memorial Center and Cultural Complex), this also pinpoints the tension that they embody – between collective identity as it is experienced and national identity as it is represented. Related both to their nationalistic potential, and to their having offered key battlegrounds in past culture wars because of the way that they tell stories, curators and historians seem cautious about telling this history too soon. They also remain fully cognizant of the toll of the *Enola Gay* controversy on the National Air and Space Museum (Linenthal and Engelhardt 1996; Luke 2002; Zohlberg 1996). Yet in attempting to address complex political issues including the interplay between museums and cities as museumlike spaces, and the suitability of museums to deal with complex contemporary issues, we may need to explore further how museums can offer a contemporary and relevant public space for cultural debate without being destroyed or reconfigured by those debates.

THE MUSEUM OF CHINESE IN THE AMERICAS

In contrast to responses made by museums such as the NMAH following September 11, and by the Memorial Center and Cultural Complex as planned for the WTC site, the Museum of Chinese in the Americas (MoCA) engaged with the issues of September 11 according to a methodology that was closest in kind to what the IFC had initially proposed. MoCA recognized that 'As urban places have become home to more diverse populations, traditional channels of representation do not seem adequate to capture the complexity and multiplicity of the needs of different publics' (Loukaitou-Sideris and Grodach 2004: 50).

The museum capitalized on its existing community networks to produce a space of effective publicity in which it encouraged citizens to communicate and where it was also able to document and interpret the events. The potential and real complexities associated with achieving internally pluralistic – or multiple of – public spheres can be demonstrated in relation to MoCA via its post-September 11 strategies to produce a space of communication.

The Museum of Chinese in the Americas is located downtown in the heart of Manhattan's Chinatown, on the second floor of an historic, century-old school building that was once Public School 23 (built during the tides of reform activity of the late nineteenth century as New York struggled to educate the new waves of immigrants entering the city). The museum was founded in 1980 to reclaim, preserve and interpret the history and culture of the Chinese and their descendants in the Western hemisphere, and to document the diasporic experience of the first generations of early immigrants to America and, in particular, New York. It also aims to promote the generation of new hybrid cultural forms and experiences that bring both familiar and less discernible narratives of experiences of the past into the context of contemporary representation. Located just ten blocks from Ground Zero, Chinatown was the largest residential area directly affected by September 11. Much of the impact was strikingly visible on this landscape. For eight days following the attack, parts of Chinatown south of Canal Street were declared 'frozen zones' in which all vehicular and non-residential pedestrian traffic was prohibited, and for nearly two months, some Chinatown residents and businesses were without a telephone service. Given this proximity to the attack, and because the primary industries in the area were tourism and hospitality, Chinatown was the economic region that suffered the greatest unemployment after the attack.

Despite having addressed the issues of trauma, public interaction, and multiculturalism so effectively in relation to September 11, MoCA argues that it continues to suffer from minority status. In exhibiting the regional and global (and past and present) as imbricated and yet also discreet systems, the museum's exhibitions clearly depict the concept of 'nation' as being constructed rather than natural, and as sitting more contingently than is generally taken for granted. It does this, for example, by explaining that for many migrants it is not contradictory to feel loyalty to more than one country. In many of the lifestyle-themed exhibitions, including *Have You Eaten Yet? The Chinese Restaurant in America* (2004), quotidian themes such as food offer a way of linking past heritage with present experience. In this case, '"Have you eaten yet," is a standard Chinese greeting sharing the same connotation as "how are you?"' (exhibition wall text). Providing a way in which to understand or articulate the experience of transnational mobility, this also encourages discussion about the cross-cultural exchange from which it results. The Museum of Chinese in the Americas thus demonstrates how and why museums are implicated in the expression of identity, both symbolically and also practically at a community level. This may be considered problematic on the basis that by focusing principally on the experience of being Chinese in America MoCA highlights the contests at play *within* the nation-state of residence, but it does provide an effective critique of concepts that present identity as bound to nation of origin. This focus

also challenges traditional stereotypes that privilege the image of a unified – homogenous – nation-state that either suppresses signs of internal difference or depicts it as the archetypal 'other'. As such, MoCA puts into practice what the IFC also proposed in its aim to offer a pluralistic and multivocal public sphere that engaged with the issues of trauma, democracy and difference. Although as a nationally symbolic space, the IFC would not have been marginalized to the status of a community or ethnic museum, it is interesting, nevertheless, that its agenda was rejected.

With the outlook of extending this focus on sustained intercultural and intracultural communication, MoCA launched its series of September 11 oral history projects and exhibitions to both document and represent the consequences for Chinatown and Chinese New Yorkers. It formed an association with the Columbia University Oral History Research Office, the September 11 Digital Archive at The Graduate Center of the City University of New York, and New York University's Asian/Pacific/American Studies Program and Institute, and collaborated on an oral history project called *Ground One*. The aim of this project was to 'provide an in-depth portrait of the ways in which the identity of a community, largely neglected by national media following September 11, has been indelibly shaped by that day' (http: //www.moca-nyc.org/). Beginning in Fall 2003, *Ground One* interviewed 30 individuals who lived and worked in Manhattan's Chinatown. The interviewees represented a diverse cross-section of Chinese Americans, including garment and restaurant workers, community activists, non-profit administrators, union organizers, healthcare and law professionals, senior citizens, and youth. Oral history was employed to record and understand how people perceived and responded to the tragic events of September 11 in the context of their life experiences. The life histories supporting this project have a strong physical presence in the museum. They encourage visitors to contribute, by posting notes on the noticeboard provided in the exhibition space. The project is also accompanied by a web presence, and will be archived in the Library of Congress.

Through this programme and the museum's on-site exhibition *Many True Stories: Life in Chinatown On and After September 11th*, MoCA provides an example of two important things. Firstly, it offers a way in which a community can begin to reconsolidate its city and see how members of the community have historically enacted cultural consolidation (Figure 26). Secondly, it offers a point of nexus for a community to rally around in order to explore and reconstruct cultural identity in a post September 11 American context. One interviewee of the *Ground One* project was Tony Wong, a broadcaster at Sino Television (a privately owned Chinese language community television station that was able to broadcast throughout the September 11 attacks). He explains the role of the media at this time in relation to public trust, and accounts for Sino's popularity as being due to its 'grassroots Chinese public support' and 'the power of the medium', especially for people who do not speak English and so could not understand the mainstream reports. Ultimately, Sino collected $1.45 million from viewers to be donated to the WTC Fund and the Red Cross. The popularity of Sino at this time, and the size of this donation, may function as a version

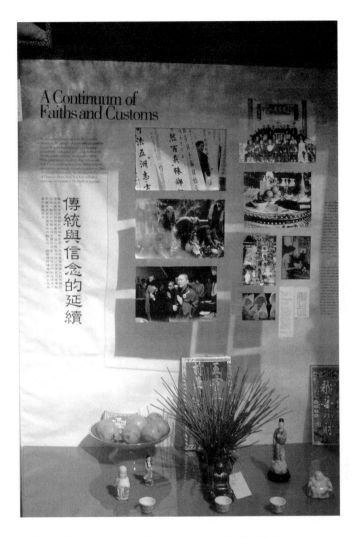

A Continuum of
Faiths and Customs

傳
統
與
信
念
的
延
續

26: *Many True Stories: Life in Chinatown On and After September 11th* (exhibition detail), the Museum of Chinese in the Americas, New York. Photograph by Kylie Message. (Courtesy of the Museum of Chinese in the Americas.)

of Habermasian publicity (rather than conforming with the passively consumed media typifying the culture industries). Wong discusses the impact on and of the September 11 events on the station:

> Well, I have to say that I really, nobody would like to see another incident like 911. But that happening, ironically kind of put us on the map... We give out information, we tell people what happened, and we play a very, very, important role during that period of time, because, you know, at one time I think there wasn't any, even newspaper. (http://www.moca-nyc.org/)

"Where is Home?"

The most basic question.

Home is where you are welcomed,
the door thrown wide at your approach.
Home is where you are safe.
Home is where you are understood.
Home is the comfort of food and familiar talk.

一個簡單的問題，何處是吾家？
家，是一個歡迎你、時常為你打開大門的地方。
家，是一個可感到安全的地方。
家，是一個明白你的地方。
家，是一個養育及教育的地方。

27: *Where is Home? Chinese in the Americas* exhibition (detail), the
Museum of Chinese in the Americas, New York. Photograph by Kylie
Message. (Courtesy of the Museum of Chinese in the Americas.)

真人真事繽紛錄：
911事件之華埠生活

28: *Where is Home? Chinese in the Americas* exhibition (detail), the
Museum of Chinese in the Americas, New York. Photograph by Kylie
Message. (Courtesy of the Museum of Chinese in the Americas.)

The mission of MoCA is to include exhibitions that 'raise questions and raise issues that all visitors – both Chinese and non-Chinese alike – can relate to, as well as, provide a perspective that presents the Chinese American experience as part of the larger history of the Americas' (http://www.moca-nyc.org/) (Figure 27). While Sino television offers a space of discourse and debate as well as entertainment and public service programming for the Chinese-American community, it is a specialized space that may also offer proof of the multiplicity inherent in a contemporary public sphere concept. This means that although a multitude of examples evidence the intercultural communication, it is repeated primarily within the Chinese community, so that the image of this community is one in which 'being Chinese' (or 'being Chinese in America') is itself pluralistic and inflected with difference (Figure 28). Not only does the museum advocate for the needs of the Chinese community (many of whom experienced trouble accessing aid and unemployment benefits after September 11) but it may also mediate between the Chinese community and the broader New York public (a relationship signified by the Red Cross donation). By making Chinese culture and the history of Chinese in America visible to a broader audience through its exhibitions and online archives, MoCA also informs the larger city audience and brings the culture it represents to the city. This potential is exacerbated further by the collaborative relationships and networks with other community, arts and media organizations developed in the wake of September 11.

CONCLUSION

In this chapter I have discussed key examples that epitomize the currency and capital accorded to culture within various historical conceptions of modernity, modernism, and modernization in New York. The proposal for the ill-fated IFC, in particular, demonstrates the ideological instrumentality of culture, multiculturalism and democracy as commodities. I have looked at the ways that culture – including representational strategies, forms and sites – has been used as a central tool of reform in the ongoing project of nation building. Even in relation to the 'high art' of international modernism (summed up in all aspects of MoMA and discussed in the previous chapters), and the programmes of education and self-betterment to the acquisition of taste (not to mention the more literal value of the art), ideology has always been a central core component at work in modernity. This compulsion to educate, civilize and improve has, as such, been motivated by attempts to construct a unified or singular image of identity that is experienced in relation to other people who share the same imagined community.

By discussing the pressures surrounding the rebuilding of the WTC site with reference to the IFC, I have sought to map the transformation of the culture industries that has accompanied the shift from modernity to modernization as well as responses to this that, as some have argued, have led to 'the total obedience of the culture industry to the protocols of the war on terror – its immediate ingestion and reproduction of the state's interdicts and paranoias' (RETORT 2004: 14). In this context, the vocality and attention given to

interest groups provide evidence of the growing authority of disciplinary institutions (in the Foucauldian sense of governmentality) beyond the state (Barnett 1999). This suggests that although rational-critical communication, flexible accumulation, consumer culture, and the new world order of transnational information and publicity are distributed globally to occupy the space of the nation, they are no longer motivated primarily or necessarily by any essential connections to a state, as had been the case with the international exhibitions of the nineteenth and early twentieth centuries. Instead, what we can clearly see from the loudness and authority of the various post September 11 advocacy groups is the fact that local or regional activism maintains an impact on the nation-state. This is clearly evident in the threats made by fourteen victims' families' groups to boycott any fund-raising for the IFC. Further exercising their power, they stated that the Freedom Tower had to be removed before they would support the use of 'public money' for the overall project (Dunlap 2005a). The strength of this threat obviously was more than discursive. It was also commercial, and goes to show that rather than always being subsumed, local interests can continue to exist within national and transnational power networks. This means that 'nation' is still a concept that is very much up for grabs, floating indiscernibly as it does somewhere between the regional and the global. It also means that museums and museumlike spaces – as representational sites that bring together public history and private memory and experience – continue to play a vital role in regard to the enactment and interpretation of history. In the following chapters, I look at the implications of this shift from national/imperial networks and consider further the role of local, regional and national within this overarching framework of meaning and power.

In the final section of *New Museums and the Making of Culture*, I explore two prominent museums in the Pacific region that I have selected because they illustrate the highly political and contested nature of culture in particularly important and astute ways. The Centre Culturel Tjibaou (CCT) in Nouméa (New Caledonia) and the national Museum of New Zealand Te Papa Tongarewa (Te Papa) in Wellington both opened in 1998 as self-consciously new institutions that aimed to project postmodern strategies of representation. They both responded to imperatives to interpret and celebrate national or territorial identities as well as the need to participate in reconciliation processes. However, in accord with their divergent socio-political and economic contexts, each institution has adopted a mode of representing postcolonial identity that reflects different approaches to questions of history and cultural identity in their respective colonial contexts. In the making of Te Papa and the CCT, and in their day-to-day experiences, each museum actively demonstrates that the constitution of culture – both in and beyond their physical spheres – involves a difficult, highly charged and ongoing process of negotiation.

In these two cases, representation of the relationship between politics and culture is significant, and both museums project an image of culture as being interconnected with politics. In the case of Te Papa, this focus was initiated by the state, and is connected to the museum's founding mandate of biculturalism, whereas for the CCT, cultural politics has emerged more from the recent history of independence activism against the state. Moreover, these museums can be analysed for the ways in which they attach a certain rhetorical or narrative spin to their understandings of cultural politics. The role of rhetoric is apparent in the way the institutions have been conceptualized, designed and produced, and the relationships between rhetoric and cultural politics also affect their ongoing role in the context of their communities and governing authorities. Furthermore, the connection between culture and heritage often coalesces as the central point of crisis in regard to the broader state agenda of managing contradictions that emerge in relation to cultural politics. In this chapter I will talk about the CCT in respect of the image constructed – principally by its architecture, but also its exhibitions – for an international audience; analysing the publicity and attention to newness that has attended this process. In the next chapter I consider Te Papa in terms of New Zealand's cultural policy and its effect on the museum's exhibition and representational strategies, and explore the compulsion expressed by this new museum to be a cultural centre.

GLOBAL BACKGROUND AND COLONIAL HISTORIES

As early as 1977, in a document commissioned by UNESCO's International Council of Museums (ICOM), Kenneth Hudson offered a critical summary evaluation of the state of museums and the contradictions faced by this 'institution-in-process' (Hudson 1999). Predicated upon the assertion of identity politics, indigenous rights movements, and the increasingly urgent desire for relocalization that was being expressed globally at the time, Hudson identified what he considered to be the impending transformation of museums into cultural centres, while also outlining the problems implicit in this shift in focus (Kreps 2003; Simpson 1996; Losche 2003; Pacific Islands Forum Secretariat 2005: 171). UNESCO's current description of the role and function of museums can be seen to extend the line of contention made by Hudson 30 years ago. Despite privileging the production of effects of newness (which is a value generally not addressed by Hudson) UNESCO today reiterates many of the principles – and addresses some points of contradiction and contestation – that he articulated:

> Museums, which are centres for conservation, study and reflection on heritage and culture, can no longer stand aloof from the major issues of our time. The museological heritage is both an actor and an instrument of dialogue between nations and of a common international vision aimed at cultural development. The latter may vary considerably in nature and form, depending on the historical and cultural context. (http: //portal.unesco.org/culture/)

This description is fascinating for its acknowledgement of the relationship between discourses of human development (which have traditionally focused on economic and social wellbeing) and culture. Despite being asserted globally here, the connections between culture and development have historically, in the Pacific, been obscured by local and regional systems of governance. This was the position argued by a review report developed in 2004 by the Pacific Islands Forum Eminent Person's Group, which contributed to and was reiterated in the final draft (2005) of the *Pacific Plan* (developed as the key 'road map for the region' – http://pacificplan.org). Constituted by a core group of politicians, academics and diplomats from Papua New Guinea, Australia, Tonga, Kiribati, and Samoa, the group asserted: 'Despite being an integral core to society, culture is rarely considered central to development and is sometimes considered by donors and developers as a threat to the implementation of projects'. Taking advice from this and other groups, the *Pacific Plan* contends that:

> It is assumed that managers and planners have understood the role that culture plays in the communities when developing projects and programmes, yet many examples of project failures in the region are due to a lack of research and a lack of understanding of cultural principles and practices conducted at the design stage. (Pacific Islands Forum Secretariat 2005: 167)

This reveals an inconsistency in understanding between the globally dominant organization of UNESCO and local structures and systems of governance. The UNESCO statement may be understood to mean that, for museums that want to be regarded as relevant and new, it is imperative to present an image of political engagement. However, the *Pacific Plan* argues that presenting an image of political investment may in fact work to the detriment of museums, because at the local and regional level, linking culture and development may be perceived as a political challenge. This does not mean that culture is not valued but that, as another working document explains, 'The diverse cultures in the Pacific mean that cultural issues are often best dealt with at the national level. However, the various economic, social, environmental and even governance pressures impacting on the culture of all Pacific island communities are at a rate that, instead of evolving and adjusting, culture is often being eroded' (Pacific Islands Forum Secretariat n.d.: 1). This additional level of detail makes the examination of relationships between policy and other agencies of governance in New Caledonia in respect of the CCT and in New Zealand in respect of Te Papa even more use-ful for the purpose of elaborating on current trends in the design and function of museums globally as well as in the Pacific. Indeed, the *Pacific Plan* argues that 'at the national level, most [Pacific] countries lack coherent cultural policy' (Pacific Islands Forum Secretariat 2005: 171). As a developed and stable part of the region, New Zealand – like Australia – is exempted from this contention, while the CCT is presented as an exception to the general condition of poorly funded and underresourced cultural institutions (Pacific Islands Forum Secretariat 2005: 168).

Due to their geographical proximity and differing colonial histories, an analysis of the CCT and Te Papa offers a valuable contribution to understanding the ways that museums offer a site for crosscultural exchange. They can also be contrasted with other museums and cultural centres in the region, including the important and successful Vanuatu National Museum and Cultural Centre in Port Vila (Bolton 1994, 1997, 2001, 2003; Geismar and Tilley 2003). This contrast is also apparent in relation to countries that struggle to resource a cultural centre. In Guam, for instance, plans for a cultural centre have long been delayed because of funding problems and changing national priorities (a task force has recently discussed opening a small Guam museum branch at the airport to provide a source of income for the museum foundation) (Worth 2005).

This transregional contextualization also demonstrates how cultural institutions in the Pacific have drawn attention to the material evidence and memory of past encounters through the objects that are collected, stored, exhibited, and sometimes repatriated. These objects provide the raw matter for multiple contested narratives because, as Appadurai and Breckenridge (1992: 35) articulate, through their history of collection, they have always reflected a negotiated settlement between longstanding cultural significations and more volatile group interests and objectives (see also Peers and Brown 2003; Pearce 1992; Kaplan 1994). In seeking to describe and historically contextualize certain social and political events and frameworks that contribute to the production of the museum as an institution,

building, collection and service, I explore how museums actively continue to produce the image – or 'system' – of culture they purvey and perhaps manage. Indeed, this culture (in both contemporary and historical forms) can be described more than ever according to the market-driven policy-speak offered by development agencies and studies, where culture is characterized as '… a complex web of relationships and beliefs, values and motivations … a social operating system that influences attitudes, behavior and responses to change. This system operates on personal and communal levels and may be a barrier to, or a catalyst for, the development of social capital' (Jeannotte 2003: 39; Corsane 2005; see also the definition of policy as 'the governmental use of culture for specific ends' in Bennett 1999: 382–3).

Overlaid against the contemporary pressures outlined by UNESCO, as well as national governmental policies that guide the direction of exhibitions and public programmes, new museums may yet continue to function as sites of authority in their own right. They may, for example, provide a feedback loop that connects back up with these agencies and strategies of governance, to provide an authoritative comment on the development of culture and cultural policy issues – including multiculturalism and sustainability in relation to heritage sites and the preservation of material culture (Wise 2002: 223). This is certainly the case in relation to the Vanuatu National Museum and Cultural Centre, which has influenced and contributed to Vanuatu's national development in concrete ways (Bolton 1994). However, contradictions do persist, so that while new museums frequently claim to facilitate or provoke the public debate of social and political issues, or argue that they present multiple versions of interpretative texts to imply a changing or contested political context, they also tend to maintain a broad attention to identity-enhancing programmes (Vergo 1989; Boswell and Evans 1999). Attempts by museums to intensify their connection with culture is particularly evident in examples that present exhibitions of artefacts as fine art – which, according to Clifford (1997: 121), is one of the 'most effective ways to communicate crossculturally a sense of quality, meaning, and importance'. In both the CCT and in some parts of Te Papa the presentation of artefact as artwork has been motivated by a desire to politicize and challenge issues (such as the museum's relationship to power and authority). This link between museums and culture (as fine art) has also been amplified still further – and presented more literally – by the accumulative trend identified by Hudson (1999: 371) for replacing the term 'museum' with the increasingly valuable 'cultural centre' label. In privileging this association between new museums and culture (which includes heritage and tradition), the connection to politics risks either dropping away entirely, or it may be made stronger and more evident because of a renewed centralization of 'cultural politics'.

CULTURE AS RESOURCE

The definition of culture and its associated capital has shifted somewhat in recent years so that it is now understood as a resource as well as a commodity (Clammer 2005; Wise 2002; Yúdice 2003; Ames 2005; Coombe 2005). UNESCO's attention to tangible and intangible cultural heritage and discourses of sustainability (Malloch Brown 2004; UNDP-HDR 2004)

indicates that globalization has enabled culture to become an increasingly important and translation-friendly resource that is connected to economic and 'social well-being' (Creative New Zealand 2003; New Zealand Government, Ministry for Culture and Heritage Te Manatu Taonga 2003; Galla 2005). The self-conscious production of heritage has in many cases also become a key component of indigenous self-determination politics (Clifford 2001, 2004: 6). Broadly defined, in this guise:

> heritage work includes oral-historical research, cultural evocation and explanation (ex-hibits, festivals, publications, films, tourist sites), language description and pedagogy, community-based archaeology, art production, marketing, and criticism. Of course, such projects are only one aspect of indigenous self-determination politics today. Heritage is not a substitute for land claims, struggles over subsistence rights, development, educational, and health projects, defense of sacred sites, and repatriation of human remains or stolen artefacts, but it is closely connected to all these struggles. (Clifford 2004: 8)

Culture as heritage is thus increasingly recognized as providing a valuable new resource that may contribute clear and assisted development options for the national benefit and for local community development and support. Yet its function as a commodity also persists – as indicated by policy documents and statistical reports with titles such as the Secretariat of the Pacific Community's 'Economic Valuing of Expressions of Culture' (2003) and 'Australia's Trade in Culture' (Australian Bureau of Statistics 2003) – so that it continues to offer new modes of experience and new products as well as renewed labour markets and producers. A critical analysis of this is useful for isolating and understanding how instrumental culture has become within the dominant relationships governing nation, international and domestic politics, social conflict and economic development as well as for demonstrating, as Clifford has noted, that 'What counts as "tradition" is never politically neutral' (2004: 8, 2000; Jolly 2001; Briggs 1996; Butler 1998). Through this study I examine the influence of new museums or cultural centres that continue to offer a dedication to pedagogical programmes and, in some cases, the assertion of objectivity in relation to localized communities as well as global audiences. In the following sections I consider how Te Papa and the CCT have attempted to balance the tensions arising from the complex needs of their local context with the often-competing demands of the transcultural discourse with which they also seek engagement. I argue that the relationship between governance and cultural diversity needs greater analysis, especially as the third term – heritage (with its problematic polarization of authenticity and kitsch) – has become such an increasingly valued and contested factor in discussions about self-governance, representation, and crosscultural dialogue and exchange.

GLOBAL, LOCAL, TRANSCULTURAL MUSEUMS

By considering the effects of globalization within local contexts as depicted in the new museum-as-cultural centre, we can also see how the global and the local interconnect in more general terms and, importantly, identify where the points of emphasis or tension are

placed by those responsible for producing the museum. As Clifford (1997: 126) notes, the '"here" matters'. Similarly, Appadurai (1996: 178) identifies locality as 'primarily relational and contextual rather than as scalar or spatial' (see also Robins 1999: 23). Despite offering a survey of national (or what he calls 'majoritarian') museums and tribal museums and cultural centres in 'Four Northwest Museums' (1997), Clifford claims to reject any straightforward contrast or distinction that is based on like values. Describing these typologies 'schematically', he explains that 'majority museums articulate cosmopolitan culture, science, art, and humanism – often with a national slant. Tribal museums express local culture, oppositional politics, kinship, ethnicity, and tradition' (Clifford 1997: 121). This means that tribal life cannot be 'adequately captured by terms such as "minority" (denoting a location defined in relation to majority power)' because these institutions both do and do not accept the terms of the dominant majority culture. He suggests that he is concerned instead with 'entanglement and relationships' (Clifford 1997: 11). However, these distinctions in aim and agenda become especially discernible when national and local tribal museums or cultural centres hold the same objects, or when a repatriation claim is made by a local community against a national institution. I discuss such a claim in Chapter 6 in relation to Te Papa and Te Hau ki Turanga, a Maori *wharenui* (meeting house) that is variously described as the 'centrepiece of Maori collection' (Waitangi Tribunal 2004b: 588) and 'Te Papa's star Maori attraction' (Alley 2004), and which was forcibly acquired in 1867. In presenting itself as a combination of these terms and their agendas and effects, the new museum-as-cultural centre model makes Clifford's categories appear unstable, especially as the categories he employs seem to forgo the fact that these new institutions aspire to speak of and to dominant national discourses, local interests, and the condition of transnational exchange and communication that overlays and strongly influences each of these (Chakrabarty 2002).

Marshall Sahlins (2005) contends that global and local interests are involved in a more active process of exchange and encounter than is often assumed to be the case. Arguing that these negotiations often take place and become manifest materially in local geographies, he explains that the shift in 'culture consciousness of the peoples involved something more than defensiveness. Many were seen to be actively indigenizing the global forces besetting them: turning the objects and relations of the world system toward their own projects and concepts of the good. Hence a new tilt of anthropological theory, away from globalization in favour of localization' (Sahlins 2005: 4; see also Coombes 1994: 221). Bell (2004) argues that this produces a space of hybridity. Rather than simply arguing for the possibility of a local subversion or appropriation of global resources and interests, however (risking as this does the reassertion of a dichotomy), I would suggest – following Sahlins – that something more akin to a dialogue may occur here. This would encourage discussion about the relationships between the local and global, the past and the present, the authentic and the spectacular or entertaining, and other more specialized museological and anthropological dichotomies, including nature and culture and rational 'scientific' knowledge as contrasted

against 'local' or 'traditional' knowledge (Ames 2005: 47–8; Kreps 2003). This also means that instead of rejecting modernity outright, contemporary cultural centres may aim to renegotiate their place within it, in an act that Coombe (2005: 39) explains to mean that capital encounters must thereby come to 'accommodate or negotiate with the societies and worldviews of others and [acknowledge] that these dialectic transformations constitute alternate and multiple modernities'. This reconfiguration of the new museum as a cultural centre may even indicate both the political leverage (and general taste for culture and culturalism over politics) and the desire to be contemporary, relevant, and still new. This might confirm Appadurai's (1996: 1) idea that 'What is new about modernity (or about the idea that its newness is a new kind of newness)' is linked to the universal desire for such newness, as expressed by startlingly authoritative rhetorical claims; or for such modernity as a mark of progress, while not precluding the possibility of the development of multiple, jostling modernities.

In the wake of the late nineteenth/early twentieth-century promotion of education for all, and following on from the mid-twentieth-century transformations of the dominant social reform/imperialism programmes into broader based and more inclusive pedagogical frameworks (as illustrated by *The Family of Man*), the public museum continues to present itself as both the purveyor of objectivity and a potential resource for a multicultural education (Hudson 1999; Coombes 2004; Museum of New Zealand Te Papa Tongarewa 2004: viii–ix). This is evident in policy documents, and UNESCO claims that it 'can best protect cultural diversity through actions involving sites that bear witness to multiple cultural identities, are representative of minority cultural heritages, are of founding significance or are in imminent danger of destruction' (http://portal.unesco.org/culture/). However, with the increasing capital accorded to culture (Yúdice 1992, 2003; Clifford 2004), and as illustrated most dramatically by the debates over the IFC in New York (Chapter 4), the contemporary museum 'is clearly hostage to … and aware of the necessity of being seen to perform some vital and visible public function to justify its maintenance, while fighting to preserve a measure of autonomy' (Coombes 2004: 294). Offering a further renewal of the new museum model, then, the cultural centre concept may seek closer links to local communities to reinvigorate the relationship between representation and governmentality, through offering sites in which multiculturalism informs decision-making processes. It may also offer new forms of place-based autonomy (especially for people who have been historically marginalized by modern regimes of power). Investigating developments in the current global proliferation of museums and speculating over the almost insatiable taste for these sites, Clifford (1997: 8) also contends that: 'Something more is going on than the simple extension of a Western institution … museums and other sites of cultural performance appear not as centers or destinations but rather as contact zones traversed by things and people' (for discussion of 'borderlands' concept see McLaughlin 1993; for 'zone of contestation' see Appadurai and Breckenridge 1992: 38). Echoing a now very familiar-sounding claim, Clifford (1997: 8) asserts that the aim to understand and experience

museums as contact zones is ' both a description and a hope, an argument for more diverse participation in a proliferating "world of museums"'.

THE CENTRE CULTUREL TJIBAOU

The Centre Culturel Tjibaou (CCT), opened in Nouméa in 1998 to provide a spectacular example of the 'new museum' that has attracted critical and popular interest over the last decade. Designed by Renzo Piano in consultation with the Agency for the Development of Kanak Culture (ADCK), the centre comprises an interconnected series of ten stylized *grand cases* (chiefs' huts), which form three villages (covering an area of 6,060 square metres) (Figure 29). These huts have an exposed stainless-steel structure and are constructed of Iroko, an African rot-resistant timber, which has faded over time to reveal a silver patina evocative of the coconut palms that populate the coastline of New Caledonia.

The CCT draws materially and conceptually on its geopolitical environment, so that despite being situated on the outskirts of the capital city (on the main island, known as Grand Terre), it draws influence from the diverse Kanak communities residing elsewhere across the New Caledonian islands. The circling pathway that leads from the car park to the

29: Exterior of the Centre Culturel Tjibaou, from traditional gardens and Kanak path, Nouméa. Photograph by Kylie Message. (Courtesy of the ADCK-Centre Culturel Tjibaou/Renzo Piano Building Workshop, Architectes.)

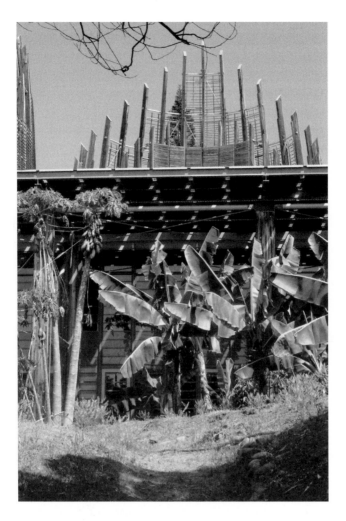

30: Exterior of the Centre Culturel Tjibaou, from
traditional gardens and Kanak path, Nouméa. Photograph
by Kylie Message. (Courtesy of the ADCK-Centre Culturel
Tjibaou/Renzo Piano Building Workshop, Architectes.)

centre's entrance is lined with plants from various regions of New Caledonia (Figure 30).
Together, these represent the myth of the creation of the first human – the founding hero,
Téâ Kanaké. Signifying the collaborative design process, the path and centre are organically
interconnected so it is difficult to discern any discrete edges existing between the building
and gardens (Figure 31). Similarly, the soaring huts appear unfinished as they open outward
to the sky, projecting the architect's image of Kanak culture as flexible, diasporic, progressive
and resistant to containment by traditional museological spaces (Figure 32). Reflecting on
the design process, Piano explains:

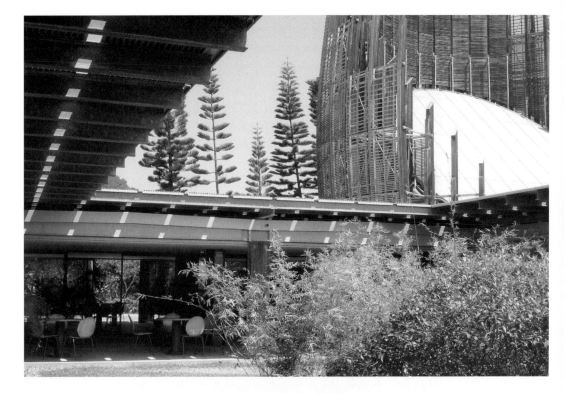

31: Looking from Kanak path into the Pérui House and cafeteria area,
the Centre Culturel Tjibaou, Nouméa. Photograph by Kylie Message.
(Courtesy of the ADCK-Centre Culturel Tjibaou/Renzo Piano Building
Workshop, Architectes.)

> It dawned on me that one of the fundamental elements of Kanak architecture is the
> very construction process: 'building the House' is every bit as important as 'the finished
> House'. From this, I began to develop the concept of a permanent 'building work-site',
> or rather of a place which would suggest an unfinished house-building project. (http:
> //www.adck.nc)

In this chapter I suggest that the centre presents an 'unfinished', transformative effect to
reflect its ongoing commitment to an image of newness. This effect provides the CCT with
features associated with contemporary museums across the world, showing its fluency in
postmodern architectural discourse as well as its ability to perform as a significant cultural
actor on a global stage. While this encourages a steady flow of international visitors interested
in the centre's spectacular architecture and its programmes, the constant reiteration of
the new is tied to the specific political objective of reconciliation between colonizer and
colonized. Fundamentally connected to the CCT's founding mandate, the ideology of the
new is more than dogmatic. It is used to produce convincing symbols of national identity

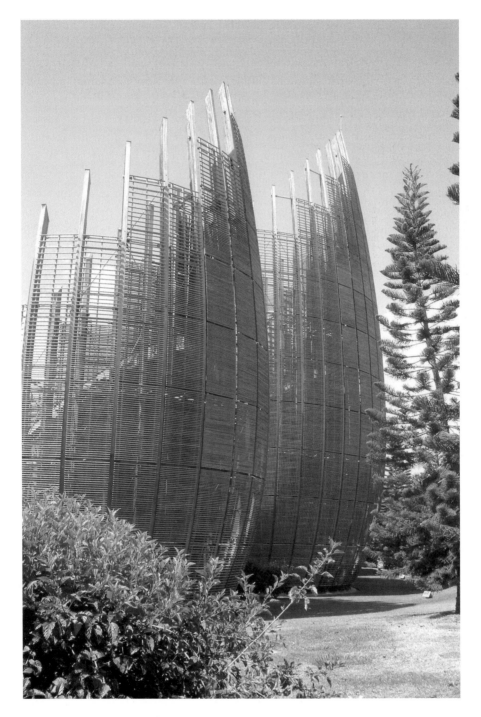

32: Exterior of the third village, including the Mâlep House, the Centre
Culturel Tjibaou, Nouméa. Photograph by Kylie Message. (Courtesy of the
ADCK-Centre Culturel Tjibaou/Renzo Piano Building Workshop, Architectes.)

for a state undergoing a process of political transition, and aims to evoke a real interest and investment in an evolving public culture. The CCT's desire to be new can thus be seen to accord with its role in domestic and international affairs, and as indicating, above all else, the need for a clear articulation of cultural politics in New Caledonia – as well as the inseparability of these terms.

Geographically, New Caledonia is located approximately 1,200 km east of Australia and 1,500 km north-west of New Zealand. The island nation of Vanuatu lies to the north-east. A small group of islands, the main island is about 300 km long and 50 km wide with a mountain range stretching across the central spine. France took formal possession of New Caledonia in 1853 and 'overcame Melanesian resistance to make way for settlement, both convict and free. The Melanesians were displaced, mainly to the east coast and the Loyalty Islands. The first nickel rush in the 1870s brought more settlement and foreign investment. The Melanesians eventually became a minority' (Spencer, Ward and Connell 1988: 2). As a result of both immigration (people from Vanuatu, Indonesia and Vietnam were brought in to work on European enterprises) and the displacement of indigenous people, a multicultural society emerged, with little social *métissage* (or intermixing). This is reflected in the geopolitical conditions and New Caledonia is divided politically into three 'provinces': the South, centred on the economically dominant Nouméa, which is mainly inhabited by white people of European and other origins (but also an increasing number of other Melanesian residents as well as Asian and other Oceanian people), the North, which is mainly inhabited by Melanesians, and the Loyalty Islands, located to the north-east of the main island and also mainly Melanesian. The Kanak movement for independence (or for recognition of Kanak precedence and autonomy) dates from the earliest days of colonization and there was frequent violence between the French and indigenous people from the start. In 1988, after a period of acute conflict, the Matignon Accords were enacted in an effort at reconciliation (*ré-équilibrage*), with the promise of greater respect and recognition for Kanak culture, new interest in a system of power sharing, and the proposal to hold a referendum on self-determination (although this was deferred by the signing of the Nouméa Accords in 1998). Since the passing of the conflict of the 1980s New Caledonia is often presented as a site of stability in the region, in comparison to neighbouring Melanesian countries like Papua New Guinea and the Solomon Islands (Maclellan 2005: 1). With almost a quarter of the world's nickel resources, New Caledonia has become such a valuable mining centre that it is commonly said that 'whoever controls nickel controls New Caledonia' (Horowitz 2004: 308). More recently there have also been significant constitutional changes to New Caledonia's status within the French Republic, creating 'shared sovereignty' and a new citizenship for New Caledonians.

THE CENTRE CULTUREL TJIBAOU AND NEW MUSEUMS

The CCT embodies many of the key components and features that have collectively become identified with a shift in the way that museums are conceptualized in the Western

world. As already illustrated, this movement away from a more traditional museological approach has quickly resulted in a series of differences in the ways that museums are designed, made, experienced, and understood to function (Lumley 1988; Vergo 1989; Preziosi and Farago 2004). The CCT conforms to many of the general characteristics of new museums, as indicated by this description of the centre:

> The Tjibaou Cultural Centre is unsurpassed in the Pacific for its architectural splendor and its expensive, high-tech virtuosity. It sustains a singular stress on contemporary Pacific arts rather than the curating and display of older objects… There are about thirty older artifacts in the Bwenaado house (mainly masks, houseposts, and roof sculptures on loan from European museums), but most older Kanak artifacts are still housed in the Territorial Museum of New Caledonia in town. The emphasis in the Ngan Jila (house of riches) is rather on contemporary works by named artists in both indigenous and introduced genres. According to Emmanuel Kasarhérou this is faithful to Tjibaou's vision of Kanak culture not as frozen in the past, but as open and lived in. (Jolly 2001: 434)

In many ways, the CCT can be understood as an ideal example of this new museum model because although it conforms so closely with the principles and effects also used by many other examples worldwide, it does this for reasons that are very clearly connected to its local context, and with the conditions and reasons for its production. This means that although the architecture is breathtaking and eminently suitable for the global marketplace of postcard photography and tourist imagery, its exhibitions and programmes engage both with the complexity within Kanak communities and the broader geopolitical context of New Caledonia. For instance, while its main exhibition spaces include the growing permanent collection of contemporary Kanak and Oceanian art displayed in the Bérétara Hall and Jinu House, traditional objects of Kanak heritage on loan from the Musée de l'Homme in Paris are exhibited in the Bwénaado House. It also hosts temporary exhibitions such as *Impressions Pacifique: Estampes contemporaines* (2005), which was the result of a collaboration between the CCT and the Centre Culturel Goa Ma Bwarhat in Hienghène, and which aimed to produce interregional partnerships (ADCK 2005: 27). It promotes engagement by rural Kanak communities through outreach programmes that include artists' workshops and ingenious 'Travelling Educational Kits', which are folded-up, suitcase-sized models of the cultural centre, its grounds and its activities. These are taken to schools and community centres to show the cultural centre and its activities, to demonstrate the relationship between Kanak architecture and Renzo Piano's stylized building, and to encourage children to participate in the visual arts. It has a well resourced library and digital catalogue that facilitate access to and the preservation of Kanak cultural heritage (particularly the remaining twenty-five languages spoken across the islands) (interview with Emmanuel Kasarhérou, The Centre Culturel Tjibaou, 16 November 2005). The CCT encourages interaction with other cultural centres and museums in the Pacific region (through agencies such as the Pacific Islands Museums Association [PIMA] – and institutions including the Vanuatu National Museum

and Cultural Centre; with which it discusses issues including the preservation of intangible heritage and language), and promotes dialogue between New Caledonia and museums and other cultural institutions in France and other countries.

These programmes reflect the centre's official primary purpose as expressed in its mission statement, to 'promote and preserve the Kanak archaeological, anthropological and linguistic heritage' (http: //www.adck.nc). This shows the CCT to be concerned with creating a very particular relationship with the postcolonial politics of image-construction – a point that is significant in relation to the centre's official publicity and rhetoric, as well as for the Kanak communities that it aims principally to represent and engage with. The CCT may be seen to provide an official site for testing and holding dialogue and debate over what kinds of images and ideas may be appropriate signifiers of a renewed cultural identity for New Caledonians as the country continues to negotiate its future direction (http://www.adck.nc).

Before the centre opened, the Agency for the Development of Kanak Culture stated:

> The intention is not to make a static presentation of works as in a conventional museum but to make available to be seen, to be admired and, it will be said, 'to live again', objects that have become what the Elders have termed 'ambassadors of Kanak culture' throughout the world. (*Mwà Véé* 1996b: 44)

These objects are part of the 'dispersed Kanak heritage' that exists in museums and collections globally. Emmanuel Kasarhérou, the cultural director of the CCT, explains that an inventory was taken in the 1980s of the objects belonging to Kanak heritage that were acquired during and since the contact period by Western collectors and museums. In the consultations that followed, between the Kanak Cultural, Scientific and Technical Board (the organization that preceded the ADCK) and Kanak communities, it was decided that the centre would not actively seek the return of these objects, many of which have spent up to 150 years away from New Caledonia (and which, according to traditional beliefs, may be dangerous if the conditions of acquisition are unknown). Instead, they would be considered 'ambassadors' of Kanak culture, employed to 'let the rest of the world know that Kanaks exist' (Kasarhérou interview; *Mwà Véé* 2000: 34). The CCT is, however, committed to ongoing discussion about how these objects are conserved and displayed overseas. It is also involved in curatorial projects such as the exhibition of traditional Kanak art, *De jade et de nacre patrimoine artistique kanak,* which travelled from Nouméa to the Musée National des Arts d'Afrique et d'Océanie in Paris in 1990–1 (prior to the centre's opening). Objects from Western collections also visit the CCT, housed for temporary periods in the Bwénaado House, where they are accompanied by a computer monitor that provides further information about how they relate to traditional Kanak systems of cultural heritage. Notably, the CCT also conducts exchanges with European museums, which seek their advice when mounting exhibitions of Kanak work. In a recent case, the CCT sent two Kanak carvers to a regional museum in the south-west of France to show by demonstration and discussion how the sculptures in their collection had traditionally been made (Kasarhérou interview).

Beyond the issue of repatriation, there are other differences between traditional Western-style museums and the CCT. Kasarhérou – who used to be the director of the Territorial Museum in Nouméa (which is a traditional, Western-style ethnographic museum with rich collections of Pacific heritage) – has engaged with this matter at length (Kasarhérou 1995: 90–5). In 1989 (the year President Mitterrand approved development of the CCT to be built as 'headquarters' for the ADCK) he participated in a workshop held in Papua New Guinea designed to explore the changing role of museums and cultural centres in the Pacific. At this time, he explained:

> In New Caledonia many people think that a museum must keep the past but should not exhibit it. Another explanation of our difficulties in attracting Kanak visitors is their fear of entering a place where artefacts of the past are displayed. They feel as if they were entering a cemetery where devils live. The matter however must not be forced, attitudes will change gradually. The only thing to do is to explain why it is important for the future of our cultures to have a museum. We must explain why museums did not exist in the past and why they are important nowadays... (Kasarhérou 1992: 166)

In this same forum, the director of the National Museum and Art Gallery of Papua New Guinea, Soroi Eoe, similarly suggested that this may be a dominantly held perception amongst Pacific Island cultures, where museum collections are perceived as 'little more than odd assortments of exotic curios... This view was and still is reinforced by the conviction that museums are only partly the emanations of an indigenous cultural personality: they do not really meet the needs of the great majority of indigenous Pacific islanders' (Eoe 1992: 1; see also Stanley 1998; Cochrane 1999; Murphy 2002; Pacific Islands Forum Secretariat 2005: 168). As one measure of the CCT's success as a social actor within the local community, it seems that both the CCT and the Territorial Museum now attract larger numbers of Kanak visitors and culture workers than was the case in the late 1980s. Expanding its own agenda from ethnography to include social history and current issues, the Territorial Museum now hosts contemporary events such as *EXPO – La Violence, tu sais ce qu'on lui dit?* (2005). These examples suggest that the new museum paradigm might be more indebted to the practices of museumlike spaces – such as the French lineage of cultural centres and ecomuseums – than to traditional ethnographic museums (Kasarhérou interview). It also shows that by expanding their focus to include an interest in contemporary culture, new museums, cultural centres and other exhibitionary sites in New Caledonia are also playing a part in attempting to bring to fruition Tjibaou's dream that the country would one day be 'irrigated' with 'small cultural centres that would be heritage conservation centres and places for contemporary creativity' (Text from Tjibaou exhibition, in the Mâlep House).

THE POLITICAL CULTURE AND PERSONALITY CULT OF JEAN-MARIE TJIBAOU

The focus on open configurations, representational strategies, and the general commitment to achieving a convincing, ongoing effect of newness is important for new museums

at the level of novelty (as a way to keep audiences coming back and to continually attract others). In the case of the CCT, the dedication to forward-looking and nonconstant images of identity and culture also emerged as a direct extension of the ideology of Jean-Marie Tjibaou, after whom the centre was named. Leader of the dominant, pro-independence *Union Calédonienne* party, Tjibaou was revolutionary in his belief that political strength would emerge as a by-product of cultural pride. In a widely quoted statement, he argues that 'the return to tradition is a myth… No people has ever achieved that. The search for identity, for a model: I believe it lies ahead of us… Our identity lies ahead of us' (in ADCK 1998: 4–5; see also Tjibaou 1996; Tjibaou and Missotte 1978; Rollat 1989). Tjibaou rejected the idea that Kanaks must become 'black Frenchmen' in order to achieve power or authority, and he envisaged 'a peaceful resolution of the settler-native confrontation, as long as Kanak could face France with "a firm personality", meaning a self-confident identity rooted in culture and history' (Chappell 1999: 377). He is remembered by many for being, at least in his later years, moderate and reformist – especially in the wake of the ethnic insurgencies that had taken place throughout the 1980s (ADCK 1998). He believed that if Kanaks worked toward unified expressions of culture, identity, and a progressive version of tradition that was not at odds with contemporary culture, they would be able to achieve political power more effectively than through any policy of direct action or further violence. Tjibaou's pointed inter-implication of culture and politics was strategic and relevant, and responded to the fact that historically, culture has often been the ground on which Kanaks have been persecuted or attacked by the settler community (Maclellan and Chesneaux 1998: 162).

Tjibaou argued that 'to show one's culture is to show that one exists… There is no cultural phenomenon that doesn't have an institutional and therefore political impact' (*Mwà Véé* 2000: 8). Presenting itself as an actor that contributes in concrete ways to social (and possibly political) change, the CCT was designed to embody the intent to formulate a renewed national iconography that is socially progressive as well as culturally sustaining. Despite the sophistication of this objective, it has been writ large in the massive bronze statue of Tjibaou himself that is located atop a nearby hill peak (Figure 33). From here, Tjibaou, dressed partly in Western attire and partly in chiefly garb, oversees his realm – which extends beyond the CCT to encompass the countryside around the city of Nouméa (Figure 34). The statue's privileged location and pose confirm that the centre was envisaged as both 'the recognition of Kanak culture and the souvenir of Jean-Marie Tjibaou' (Kasarhérou in Jolly 2001: 432). Determinedly social realist in style, the statue reveals the potential dangers associated with the desire to produce urgently reconfigured national symbols by promoting the personality cult of Jean-Marie Tjibaou. Indeed, the specific problem here, according to Peter Brown, is that 'in the postmodern age of multiple identities, the search to promote a particular cultural or ethnic identity seems to be a utopian if not regressive gesture, when it is not simply rhetorical and tactical' (Brown 1998: 136). And yet, as Brown also notes, 'this cult is also a subtle shift in significance, as Tjibaou the politician calling for independence

33: Jean-Marie Tjibaou statue, the Centre Culturel Tjibaou, Nouméa.
Photograph by Kylie Message. (Courtesy of the ADCK-Centre
Culturel Tjibaou/Renzo Piano Building Workshop, Architectes.)

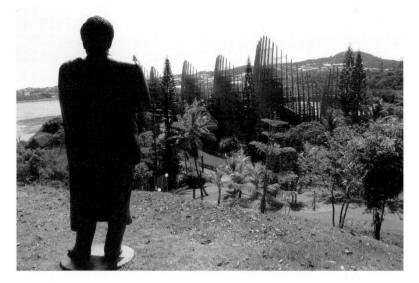

34: Looking over the Centre Culturel Tjibaou from Tjibaou statue,
Nouméa. Photograph by Kylie Message. (Courtesy of the ADCK-
Centre Culturel Tjibaou/Renzo Piano Building Workshop, Architectes.)

is replaced by the image of the promoter of his culture' (Brown 1998: 134). This shift in strategy – whereby the political is overlaid with the cultural, rather than positioned in opposition to it – has formed the framework for the CCT and for events contributing to its development, including the important Melanesia 2000 festival, organized by Tjibaou and held on the site of the CCT in 1975. The festival was designed to invest the culture of politics with 'the art of life' (Chesneaux 1988: 63), so that 'Kanak political culture' could become a more unified and effective force that had a clearer understanding of its relationship with traditional culture and custom. As 'the first great urban cultural demonstration of Kanak culture' that was held in *'Nouméa-la-Blanche'* (white Nouméa), the festival 'aimed at a global representation of the Kanak world and for a unified vision, yet without eliminating the particularities of each of its constituents' (*Mwà Véé* 2000: 8; see also Chesneaux 1988: 62; Graille 2002: 9, fn 5). It sparked a cultural renaissance.

A key figure of support for Tjibaou's legacy throughout the period leading up to the production of the CCT was Alban Bensa. An anthropologist at the Ecole des Hautes Etudes en Sciences Sociales and principal advisor to Renzo Piano, Bensa reiterated Tjibaou's fear that Kanaks would be relegated to the 'prehistoric' (categorized according to stereotyped historical images) (Bensa 2000: 162; *Mwà Véé* 2000: 8). He thus advocated a forward-looking ideology that avoided the depiction – and definition – of Kanaks in relation to past images only, where they can have no current agency, political or otherwise. Bensa's role as advisor to the project clearly had implications in the way it came to be realized. He argued strongly against the simple reconstitution of a traditional Kanak village, which would have been either picturesque or kitsch (with demonstrable links to the Kanak villages displayed at French colonial expositions in 1889 and 1931) (*Mwà Véé* 1996a). He also rallied against building the centre as a theme-park like, and overly saturated media-enriched environment (like the Polynesian Cultural Center in Hawai'i). In recommending against a 'regionalist replica' style of design, and in rejecting the straightforward incorporation of history into the project, Bensa argued for the development of what would become a paradoxical collection of international and global features, and regional references and tensions (Bensa 2000: 162). While this illustrates a rejection of history that is closely connected to the cult of the new in general terms (and reveals the favouring of newness that is the condition of new museums everywhere), what is unique in regard to the CCT is the relationship that this had with Tjibaou's guiding philosophy of newness and regeneration (Bensa 1992).

THE CONSTITUTION OF CULTURE IN NEW CALEDONIA: TRADITION, MODERNITY AND *LES GRANDS TRAVAUX*

Renzo Piano was commissioned to design CCT after winning a competition administered by the ADCK and judged by an international panel of architects and other experts (that included the President of the ADCK, Marie-Claude Tjibaou, the Head of New Zealand's Maori Affairs Department, Tia Barrett, an Australian anthropologist, Marcia Langton, and the Director of the Solomon Islands National Museum, Lawrence Foanoata). The appointment process reflects the desire to project an image of New Caledonia that is

progressive and forward looking. The choice of Piano, which was internationally lauded, provided those involved with a sense of optimism that the CCT might achieve the effect and status of a *grand travaux* (great work), as well as the creation of a renewed and visible concrete symbol of unification – which was regarded at the time as an urgent task (Graille 2002: 6). Indeed, before construction of the new CCT began, the President of France, François Mitterrand, decreed that it was to be one of the French state's most important undertakings. It was to be the first of an elite group of significant institutions, known collectively as 'the Great Projects of the Republic', to be invested in or built outside of France (Main 1998: 9). Other 'Great Projects' in Paris include the Pyramid of the Louvre, the arch at la Défense, and the Bibliothèque nationale de France. The CCT benefited further from the popular 'hearts, minds and pockets' policies of the then Prime Minister Jacques Chirac, so that the French government not only covered the $90 million dollars initially required for building the CCT but agreed to support substantially the ongoing administration costs of the site (Connell 2003: 128).

Given these rich expectations and resources, the CCT aimed to bridge the gap between the apparently conflicting aspirations of the French government and the desire by activists to achieve a new and independent state of Kanaky. This struggle over nationhood is represented in a biographical exhibit dedicated to the life and works of Jean-Marie Tjibaou, demonstrating the '*entanglement* of Kanak and French culture, even as it documented the racism of the French and the violence of New Caledonia's colonial history' (Jolly 2001: 434). Located in the Mâlep House (*Mâlep* means 'to live' in the Yâlayu language), the display includes photographic and textual narrative sections under the headings: 'his land, his loved ones', 'serving others, the priesthood and community works', 'a political vision based on Kanak culture', and 'the Kanak leader opens the way to a common destiny'. Very few objects are included, as is appropriate to Tjibaou's dream of Kanak culture resisting becoming caught in the past or being rendered as static. As objects that correspond directly to the as yet unattained future independent state, a 'Government de Kanaky – FLNKS' stamp, the flag of Kanaky, and Jean-Marie Tjibaou's case and passport are shown in one section. No text explains the significance of this arrangement (which would perhaps be obvious to New Caledonians), yet it refers to an important occasion in 1985 when Tjibaou went to Paris and introduced himself as the head of the provisional government of Kanaky (*Ouest France,* 25–27 May 1985 in Dornoy-Vurobaravu 1994: 11).

Bensa, who saw the CCT as 'a new opportunity to carry forward the political struggle on the cultural and symbolical front where Jean-Marie Tjibaou had so wished it could also develop', also promoted these aspirations for unification under a centralized independent state (Bensa 2000: 175). He understood that the building had to be convincing in a symbolic sense, as well as impressive and effective in terms of the contribution it could make to the more pragmatic development of cultural confidence in Kanak communities. It needed to provide Kanaks with an emblem of cultural identity that was optimistic, contemporary and open enough to be interpreted and appropriated widely. More than anything else, it needed

to embody a promise for the future. Kasarhérou (in Losche 2003: 81) describes the resultant building in the following terms:

> For the main part of JMTCC [CCT], Piano has incorporated the Kanak concept of a central avenue aligned with groups of *grand case* (Kanak chiefs' houses). However Piano has translated this form, giving it a profound new expression: the circular structures of the *grand case* soar up to thirty meters in height but they are not thatched nor are the walls fully clad. Reminiscent of (Kanak) houses but opening onto a dream of the future, they have a feeling of incompleteness, bringing to mind that Kanak culture itself is not static but is always open to change.

In addition to providing a physical manifestation of the ideological principles motivating development of the centre, Kasarhérou explains that Piano's building aspires to the principles of a pure architectural modernism, so that the structure appears to lift ephemerally up and away from the ground around it (Figure 35). Piano himself says 'while the form of the Tjibaou Cultural Centre may have nothing to do with local constructions, it has their spirit, without denying anything of my own modernity' (*Mwà Véé* 2000: 11). Further registering a break between the traditions of Western architectural practice and the cultural practice of the Kanak communities for whom the centre was designed, it has also been reported that Kanak visitors seem to be most interested in and respond most positively to the ground area surrounding the building, where some communities maintain traditional gardens (Kasarhérou and Mozziconacci 1998: 20; Kasarhérou and Wedoye et al. 1998). Instead of seeking a direct relationship with its immediate landscape, however, Piano chose to centralize universalizing symbols such as the atmosphere or air, and the passing breeze. His emblems of identity for the future stretch upward and away from the ground that is occupied by the participating Kanak communities. In association with the airy and expansive exhibition spaces inside the buildings, the structure manifests a beauty that challenges rather than replicates the way that the traditional (closed and exclusivist) power structures of Kanak culture have been reproduced in traditional modes of building. It supports a global image of indigenous architecture, or the revisioning of indigenous architecture according to a renewed globalized genre; and yet simultaneously rewrites the traditional pedagogical non-Western-style of authority (Dovey 2000; Fantin 2003; Memmott and Reser 2000). Consistently with this, the building appears to privilege a particular version of contemporary Kanak cultural practice that is connected to ideas of progress and development implicit within Piano's centralized Western position (Austin 1999). In his critique of the building, Brown quotes from Bensa to suggest that the processes of overinscription (of both the architectural surfaces and the ways of talking about the building) have replaced the traditionally articulated form of closure with the projected illusion of 'a non-discriminatory and "democratic" openness', in this building that has been 'commissioned and underwritten by a modern western European state' (Brown 2002: 283). In appointing Piano and building the project according to an international style of modernism (which links both typologically and genealogically back to

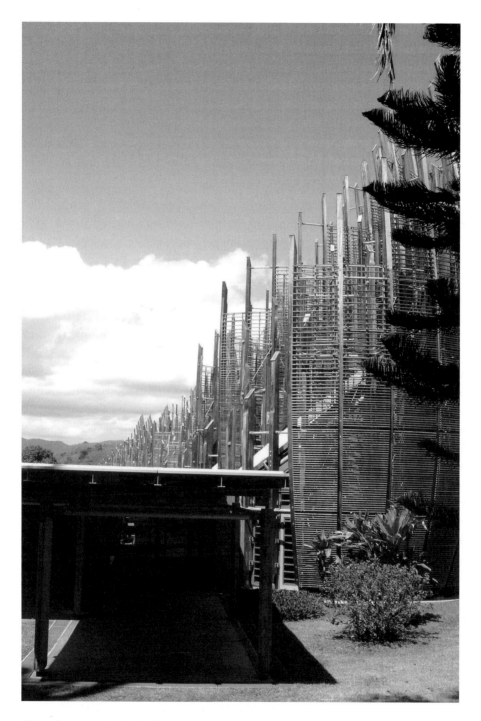

35: Looking over the third village and across the roofline of the Centre Culturel Tjibaou, Nouméa. Photograph by Kylie Message. (Courtesy of the ADCK-Centre Culturel Tjibaou/Renzo Piano Building Workshop, Architectes.)

the Centre national d'Art et de Culture Georges Pompidou in Paris), the CCT manipulates architecture 'to appropriate the spatial power base of an old [privileged Western] regime for use in the identity formation of a new one' (Vale 1999: 393). Furthermore, the CCT's status as a 'great project' evidences how:

> the modern era of nation states calls for multiple allegiances and alliances, often to be upheld across great distances. Especially in cases where single states encompass multiple would-be-ethnic nations, architectural and urbanistic efforts to articulate a single 'national identity' are deeply controversial ... [this reflects] the need to extend international identity through staking some new claim to noteworthy modernity...
> (Vale 1999: 396)

This brings us back to the anachronistic bronze statue of Jean-Marie Tjibaou, and to the risks associated with such overtly singular and non-compromising symbols of nationhood. The primary difficulty with Piano's building is that it appears literally to seek transcendence from its present location, while at the same time it offers to overlay an international kind of architecture into the local context. This integration provides a reinscription of the local custom and culture, not by local Kanaks, but by Piano and his advisers (which is due also, in part at least, to the limited consultation that preceded building) (Brown 2002: 282; Veracini and Muckle 2002: fn. 46). Brown's critique is not directed toward Piano's referencing of customary Kanak huts *per se*, but at his attempt to tweak the politics internal to them. He is concerned that at a symbolic level, Piano's design 'updates' the huts so they fit more comfortably within a European image of social modernity and progress (and as modelled in exemplary form by the Centre Georges Pompidou).

Piano's imprint of unified progress and optimism for the future might thus be interpreted as problematically illustrating a direct connection to the French government's plan to reflect the ideologies and interests of the 'modern' nation-state of France as the commissioning agency and over-riding authority (for the effect of this on other parts of the island's economy, see Horowitz 2004). In this case, the modernist architecture may be understood – possibly too simplistically – as signifying a very specific political statement (keeping in mind that although Piano had won a competition held to find the best designer for the project, he already had a particular history with French institutions and government, having designed the Centre Georges Pompidou in Paris in 1977 with Richard Rogers). Not only is the Pompidou Centre an explicit symbol of social progress and an icon of modernity but it is also widely accepted as the prototype of the new museum model – a point made evident by the architects' intention to 'create a new kind of public forum, a non-monumental building of such infinite flexibility that it would be in constant process. The structure's interdisciplinary organization was supposed to democratize the arts' (Newhouse 1998: 193).

Perhaps Piano's popularity was connected to this prior experience of designing 'populist' buildings that constitute 'anti-monuments'. As the most famous of these, the Pompidou Centre has become connected to and symbolic of Paris, despite the architects' intention

to provide a space that rejected the pedagogical structure and traditional hierarchies of art museums. If we compare the intention toward and effect presented by the Pompidou Centre and the CCT, we can see that not only does the CCT succeed in reflecting an image of New Caledonia that is democratic looking and progressive in outlook, but that it appears to offer a symbolic (if not thematic) synchronicity with the ideological grandeur and impressive scale of the Pompidou Centre. By asking why it was that a self-consciously new and internationalist style of museum was selected for the purpose of representing Kanak culture, it may be possible to evaluate whether the CCT as a new museum can possibly live up to the rhetorical claims made on its behalf. In epitomizing key characteristics of the new museum so effectively, the CCT may ultimately offer an internationally palatable monument for consumption by audiences from outside New Caledonia. If this is the case, it might confirm Claude Patriat's argument that 'out of all democratic countries, the French nation has taken furthest the assertion of an active political presence in the cultural field' as a way to ensure its authority (in McGuigan 2004: 66).

THE DESIRE FOR *RÉ-ÉQUILIBRAGE* (REBALANCING): HISTORY, POLITICS AND INDEPENDENCE

As a result of the competing political and economic pressures historically at play within New Caledonia, however, it is simply not possible to separate the global from the local in the context of the CCT. This means that, whereas an international audience may well have been considered primary for the centre's success, it was also the result of local political action. Specifically, the decision to construct a forward-looking cultural centre dedicated to the preservation and continued development of Kanak cultural traditions emerged out of the obligation of the Matignon (and Oudinot) Accords (1988) to work toward achieving a degree of political and economic self-autonomy for Kanaks in New Caledonia. In signing this agreement, the French government undertook 'to provide for the expression and fulfilment of the Melanesian personality in all its forms' and, 'to ensure that everyone has access to information and culture' (Veracini and Muckle 2002: n.p.). The accords were seen as a way of reducing tension in the area, and of also preserving the principle (and possibly the practice) of the French presence (Maclellan and Chesneaux 1998: 170). They were followed by the Nouméa Accord (1998) which replaced a referendum on independence, which was to have been held that year but was postponed for another 15–20 years as part of the new agreement. This accord formally acknowledged the trauma of colonization for Kanaks, and all signatories recognized that 'Kanak identity' was central to a new, more autonomous territory with its own citizenship. It legislated the end of New Caledonia's previous status as a *territoire d'outre-mer* (overseas territory) of France, and while many felt that this implementation of an 'irreversible' process for the transfer of administrative power did not go far enough toward achieving full *indépendance Kanak et socialiste* (Kanak socialist independence), it was generally understood as a reconciliatory gesture and precedent-setting compromise for decolonization in a multiethnic state (Chappell 1999: 373; Maclellan 2004).

Central to the accords was the recognition that political progress rested on the capacity to put Kanak culture, custom, identity and experience at the centre of life in New Caledonia. As a key signatory of the Matignon Accords (in his capacity as leader of *Union Calédonienne*), Tjibaou lobbied for these principles until he was assassinated in 1989 by a dissenting Kanak independentist, Djubelli Wea (Henningham 1992; Dornoy-Vurobaravu 1994: 10). Despite the belief of extremists that the accords would compromise the potential for independent sovereignty (*Sydney Morning Herald* 1988), the Matignon Accords established the conditions whereby indigenous culture and rights were not to be acknowledged in a rhetorical or symbolic sense only but were to become the basis for the political reconstruction of the new, multiethnic country. The close relationship that emerged between the constitution and development of the CCT and the Matignon Accords and then the Nouméa Accord (the CCT opened one day before the latter agreement was signed) was intended as a gesture of goodwill on behalf of the French government toward Kanaks. The ADCK was established (as part of the Matignon Accords) to be the territory's principal cultural body and was charged with promoting Kanak culture and heritage (as the key component of Tjibaou's vision for the future). The interweaving of culture and politics may, as such, have been officially recognized in the constitution of the ADCK, and the CCT may have been intended to open out a space for what James Tully calls a 'post-imperial dialogue – informed by the spirit of mutual recognition and accommodation of cultural diversity' (in Connell 2003: 141).

NEGOTIATING NEW FORMS OF CULTURAL IDENTITY FOR A MULTIETHNIC STATE

This approach toward representing Kanak culture continues to be legitimated within the CCT on the basis of Tjibaou's desire to create a space of possibility for the emergence of new and shifting forms of cultural identity and practice – a point that continues to be contextualized by another ongoing dialogue about the relationship between modernity and Kanak culture. And while Tjibaou's idea of a modern Kanak identity can be understood according to a postcolonial framework, whereby identity is historically and socially contingent and shifting (Clifford 2001: 468), Caroline Graille comments that in 1998, a curator at the CCT claimed that it would be 'unthinkable' for the CCT to include work by non-Kanak artists in the centre. This has since occurred, however, and may reveal a broader and more recent attempt at constructing – through the agency of the centre as a key actor in this – a 'multicultural Caledonian identity' (Graille 2002: 6). She argues further that:

> the project to construct 'postcoloniality' in a multicultural context as neither a Kanak national state nor a French-dominated quasi-colony is still very recent in New Caledonia... Local artists are only just beginning to produce 'national' aesthetic icons whose symbolism will necessarily break with a very Eurocentric, essentialist vision of Kanak culture as 'traditional'/'pre-contact' (and thus colonized and dead), but also be very different from the colonialist vision of New Caledonia as a 'small France in the Pacific'. (Graille 2002: 8)

This intent is evident in the general style of work included in the contemporary Kanak and Oceanian collection (many of which were commissioned by the CCT) that is exhibited in the Bérétara Hall (Cochrane 1996). The Kanak works – such as Jean-Noël Mero's sculpture *Oubliées de l'Historie (Abandoned by the History)* (2001) and Yolande Moto's painting *Un Nouveau regard sur notre passé (A New Look on our Past)* (1997) – often combine aspects of traditionalism with imagery that is highly narrative in style and reminiscent of the cultural renaissance of the 1970s. While this reveals the struggle to come to terms with what it means to be Kanak in a contemporary world (*Mwà Véé* 1996b: 50; 2000: 34), it also displays the attempt to represent diversity within the Kanak community, and to recognize the immigrant groups living in New Caledonia (the population today is over 215,000 people: 42.5% are Kanak, and while Europeans form the majority, other ethnic groups include immigrants from Wallis and Futuna, French Polynesia, Indonesia, Vietnam, and elsewhere – *The World Factbook,* updated 1 November 2005). Expanding the centre's focus on Kanak cultural heritage and identity has meant that it can focus on the intersections and crosscultural dialogue that have historically occurred between communities and cultural forms in New Caledonia. This agenda is currently employed in a temporary exhibition on Louise Michel (*Paris – Nouméa: Les communards en Nouvelle-Calédonie)* (2005). Exiled to New Caledonia for her involvement in the 1871 Paris Commune, and shown in the Komwi Hall, the exhibition uses events in Michel's life to illustrate colonial relationships and dialogues between French settlers, convicts and Kanaks. Including artefacts such as large shells engraved with images of 'European man' or 'Kanak man', the exhibition shows how each culture represented itself and each other at this time.

As the country grapples with the conceptual issues pertaining to representation in a national context – and how to represent diversity, the centre has become the subject of much debate amongst New Caledonians. While many support the work it does in promoting Kanak cultural identity and representing this to the world, others have criticized it as a biased symbol that is either too focused on Kanak culture or 'not Kanak enough' (Bensa and Wittersheim 1998: 243; Pacific Islands Forum Secretariat 2005: 168; Guiart 2001: 49). Commenting, for example, on the CCT's perceived lack of local visitors and support – 'of Kanaks, for whom the Centre was built, one hardly meets any. Of Caldoches [descendents of early French settlers (Maclellan and Chesneaux 1988: 145)], even less' – local journalist Anne Pitoiset noted that the CCT, 'established to enable and promote the cultural rebirth of the Kanaks ... has become not only an identifiable emblem of New Caledonia; but perhaps, to date, the only really internationally successful symbol' (Pitoiset 2002; see also Maclellan and Chesneaux 1988: 145; Graille 2002: 7). Pitoiset argues that the CCT's lack of support by Kanaks is connected to its repudiation of history on the basis that it risks denying the facts and experiences of colonization. Others, she explains, see it as preaching a version of colonially constructed culture back to them ('we do not need the Centre to know our culture') (Pitoiset 2002). A customary chief who heads the Kanak Socialist Liberation Party,

Nidoish Naisseline, has argued that it is a Kanak centre for white people, saying, 'I have the impression that ethnologists from Paris have come here to teach us about our culture' (in Main 1998: 9). Dissatisfaction with the CCT is not expressed only by Kanaks, and Pitoiset reports that some non-Kanaks resent the CCT as being designed 'only for Kanaks', whereas others wish it represented a more multiethnic population, so that, 'When one goes into the Centre, one should have an idea of New Caledonia as a whole…' (Pitoiset 2002). This controversy about the representational responsibilities of the CCT has also continually surrounded festivals and other cultural events staged there, from the 1998 exhibition of Pacific art that accompanied its opening, to the highly political eighth Festival of Pacific Arts in 1999, which 'generated protests from radical Kanak, who called it a "folk-lorization" of their culture'. On the other hand, though, supporters of this festival 'saw it as the Kanak reclaiming their "place in the sun" as Tjibaou put it' (Chappell 2001: 549).

THE CCT, THE OVERSEAS MEDIA AND THE 'GLOBAL WAR OF IMAGES'

The depth of difference that characterized local receptions to the CCT has not, however, tended to be replicated by international commentary on the centre and its programmes (reception by the popular media has been overwhelmingly positive, however there has been some critique in academic contexts, see Jolly 2001: 440; Brown 2001). This may be because the ADCK actively solicited international press interest during the years leading up to the centre's opening and throughout its opening festivals. While most of this focused on the much-promoted architecture emerging on the site, the reports, if making anything other than the most superficial of comments in relation to the building, frequently correlated the emergent building with a new found peacefulness (the violent insurgencies that wracked the territory throughout the 1980s appeared suppressed to the visiting writers). Located predominantly in the Arts or Travel sections of major daily newspapers, the resulting columns generally expressed the belief that the CCT was designed to function as a new emblem of hope for and belief in cultural reconciliation. In one case, the writer says: 'Just as France has designed a model decolonisation for New Caledonia, it has bestowed a jewel of a monument on its historically troubled territory' (Main 1998: 9).

These expressions of relief reflect more than just the writers' enjoyment of the new spectacle. While every country has to negotiate ongoing issues in relation to the form and content of dominant images of national identity, this process is especially fraught for New Caledonia, which continues negotiations over cultural, political and economic independence (or interdependence) while balancing the national, subnational, international and individual impulses that are associated with an increasingly globalized and transnational context. And while architecture and urban design have always performed important roles in the clarification of spatial and social order, newspaper reportage of the early days of the CCT show how the media contribute to producing or promoting particular images, a point that also demonstrates the ideological processes that are present in the production of the CCT itself. As an important form of 'publicity' (as well as a useful, albeit partial, mode of

gauging public reception), media sources provide a textual archive and are significant for what they reveal about the public sphere and public culture that emerged in New Caledonia in response to the CCT. In explaining the ongoing political urgency of images, whether they be manifested in print or built form, Murray Edelman (1995: 76) says: 'Especially subtle, powerful, and common are buildings that reinforce a belief that people's ties to a historic past or a promising future are their important identities.' Accordingly, of the international responses to the centre that I surveyed, the dominant images produced by the CCT presented an idealized picture of Kanak tribal culture that is depicted as forward-focused, ongoing and part of a much greater universal continuum, but that was combined with a much more chimerical, albeit omnipresent, effect of a still-present colonial regime. This focus on the far-reaching past and future means that the interethnic tensions of the interim period – or the complexity of local responses to the centre – are not highlighted (see for example, Harley 1997; Cerebano 1998; Madoeuf 1998; McLean 1998; Power 1998; Zinn 1998; McGillick 1999; Riding 2000; Venter 2000; McIntyre 2004).

These characteristics present an image of the CCT that is consistent with Lawrence Vale's (1999) definition of a 'mediated monument'. While taking into account the point that 'architecture and design have always performed important roles in the clarification of spatial and social order' so that the built environment can often be seen as providing a demonstration or means to interpret national identity, Vale (1999: 391) contends that the central point of these structures is that they function as 'monuments that are inseparable from the media campaigns conducted to construct (and constrict) their interpretation'. In these buildings, political power is often conveyed through the self-conscious construction of 'forward-reaching symbols' (Vale 1999: 391) that have become further animated by the publicity campaigns and international press interest associated with the CCT's opening. In this case, the media has been particularly influential in shaping public interpretation internationally, and in paying attention to the parade of symbols produced by the opening celebrations and the initial exhibitions of contemporary visual culture and Pacific arts commissioned from across the region. For instance, in one example, the journalist focused on the genius of the architect to open the article: 'Designed by renowned Italian architect Renzo Piano, the monument is breathtaking. It is an ensemble of villages and tree-studded areas, of different functions and different itineraries, of full and empty spaces, says Mr Piano, who this year won the prestigious Pritzker prize for his work' (Main 1998: 9). Another journalist writes that, 'New Caledonia's new cultural centre rises from Nouméa's tropical landscape like a prehistoric temple. The building's striking architecture gives it an almost ethereal quality and the inventiveness of this design has invited comparison with Sydney's Opera House' (Taylor 1998: 21). Focusing thus on the synergies that appear to exist between the building and its environment in the first place, and on the relationship between the building and traditional 'prehistoric' culture in the second, arts columnists may contribute to the political neutralization of the CCT. This reportage risks privileging a forward-looking focus that, when accompanied by a lack of critical analysis, makes only 'politically useful' links to the

past (Vale 1999: 391). Moreover, contributing to the validity of this argument, Vale (1999: 397) contends that 'In the Pacific Rim of the 1990s and beyond, we are witnessing a global war of images'.

CONCLUSION

Driving up from Nouméa to the Centre Culturel Tjibaou for the first time, noticing how the *grand cases* look persistent and unforgiving about having forced their way through the natural vista, the centre's pose appeared to me to be confrontational (Figure 36). Despite the CCT's involvement in contemporary politics (and indeed, considering that it was the product of such politics) the real impact and urgency of these politics – cultural politics – struck me, and something James Clifford had said about Tjibaou vividly came to mind. He said that Tjibaou had insisted that the cultural centre be located in the hostile, settler city of Nouméa because, according to Clifford (2001: 471), 'the politics of cultural and political identity, as he saw it, always worked the boundaries'.

36: Looking toward the centre from the *Mwakaa* (traditional ceremonial grounds), the Centre Culturel Tjibaou, Nouméa. Photograph by Kylie Message. (Courtesy of the ADCK-Centre Culturel Tjibaou/Renzo Piano Building Workshop, Architectes.)

I had initially taken note of this because I had never really understood why the centre was located in such a hostile environment, when to my mind it would have been a more convincing gesture of reconciliation for the French government to finance the existent Centre Culturel Goa Ma Bwarhat, designed by Tjibaou, in the (traditionally pro-independence) northern town of Hienghène (Rosada and Huneau 2004). But when I saw the CCT, looming large – and looking like a series of shields (or upcast fists) that have burst through the ground and now refuse to give way – Clifford's comment about Tjibaou's statement suddenly made sense. Later I asked Emmanuel Kasarhérou for his view on this, and he reiterated Tjibaou's point, explaining that it was important that the centre be in town, as a visible symbolic reminder of the continued existence of Kanak culture (for urban Kanaks, visitors from regional tribes, and non-Kanaks). Further reading revealed it was Jean-Marie Tjibaou's idea to 'implant' the ADCK and the CCT 'in the very city in which Kanaks had hitherto been second-class citizens if not entirely excluded' (*Mwà Véé* 2000: 9). Kasarhérou also said that if the centre had been located in a rural region it would have further ostracized Kanaks by suggesting that they are linked to tradition and the past rather than the contemporary reality and changing cultural identities of Kanaks living in the city (which more and more are doing). This would have amounted to 'putting the Tjibaou Centre out of view, in your back yard' (Kasarhérou interview), rather than offering a contemporary and progressive symbol of national identity. Yet even more than this, the centre appears to stand over the city, holding it to account for the events of the past while also offering a progressive and spectacular symbol of identity. This image has stayed with me – of the CCT as an extremely complex case study that shows perhaps more than any others the interimplication of culture and politics, and the high stakes that are attached to the production of new museums.

> Most museums, then, are brimming with unresolved cultural contradictions and social
> conflicts that deserve to be studied more carefully. In their artistic depictions of culture,
> history, nature, and technology, there are many trails in museums leading back to the
> contested ground of politics. Much can be learned there about the trials of power and
> tests of knowledge, which many regard as legitimate and true, and others see as corrupt
> and mistaken, by following these paths wherever they may lead. (Luke 2002: 230)

Consistent with patterns across much of the Western world, the cultural diversity project in
Aotearoa New Zealand emerged from the debates over biculturalism and multiculturalism of
the 1970s, the political and civil ethnic unrest experienced in the 1980s, and a pedagogical
shift in the 1990s that saw rejection of the more traditional museum and its historical
commitment toward singular representations of identity. In Aotearoa New Zealand, however,
this shift was marked by the decision in the mid-1980s to produce a wholly different and
new museum that would stand in contrast to the architecture and practices embodied by the
Auckland War Memorial Museum and the dour 1930s neoclassicism of the former National
Museum (founded in 1865 as the Colonial Museum, and later renamed the Dominion
Museum after being relocated alongside the national War Memorial in Wellington). Central
to a series of interconnected strategies that were designed to promote cultural pride and
interethnic stability, Te Papa has become emblematic of the New Zealand state's 'enthusiasm
for transforming public policy and institutions at periodic intervals during its relatively
short history' (Bartley and Spoonley 2005: 136).

It was in the 1970s in particular that the New Zealand state's interest in national ag-
gregation and the reconciliation of unresolved decolonization processes coincided with the
establishment of the Waitangi Tribunal, the interest in issues surrounding the indigenous
rights of Maori as *tangata whenua* (the original people of the land), and the impact of
these on all aspects of social, political, economic and cultural experience. Reflecting upon
the place of the Treaty of Waitangi (which was signed in 1840 between representatives of
the British government and over 500 Maori chiefs and led to the declaration of British
sovereignty over New Zealand) within New Zealand society, Sir Hugh Kawharu (2005: v)
explains that:

> When the Treaty of Waitangi was signed in 1840, Maori who signed it generally repres-
> ented local sections of major tribal polities. None signed for themselves; certainly none
> possessed a mandate to sign for the Maori people as a whole. Yet it was seen as a covenant

('kawenata') for relations between all Maori and the British Crown; and this in practice has ever since meant relations between Maori and non-Maori in New Zealand ... have often been problematic.

While the 'covenant' remained central for Maori, it appeared to have been long over-looked by successive New Zealand governments and the nation as a whole. Kawharu (2005: v) continues: 'And so it was in 1975. With the continuing loss of remnant estates, a sense of political impotence and government policies indifferent to the already un-acceptably low levels of Maori health, education, employment and the like, there was a sudden mobilising fervour on a hitherto unforeseen scale.' This took the form of a protest march of unprecedented proportion. Starting in the far north, the hundreds of protestors continued down through the North Island to the nation's capital, Wellington. This event led to the statutory recognition of the Treaty of Waitangi and to the establishment of the Waitangi Tribunal which is the permanent commission of inquiry responsible for making recommendations on claims brought by Maori pertaining to breaches of the principles of the Treaty of Waitangi as caused by the actions or omissions of the Crown (Waitangi Tribunal 2004a; Department of the Prime Minister and Cabinet 2004). Then, in 1985 – in what was probably the most significant signal of the need for reconciliation between the Treaty partners and acknowledgement of any past wrongdoings by the Crown – the Tribunal's jurisdiction was extended to include historical claims going back to 1840. This was a key component of the reforms of the 1980s that became known as 'the New Zealand experiment'. Social and economic theories which had never been tried, let alone proved, anywhere else in the world became New Zealand government policy – first at the hands of a Labour government from 1984 to 1990, and then continued with equal, if not greater, fervour by its National government successor (Kelsey 1995). New Zealand historian Michael King (2003: 503) comments:

> The late twentieth century was the period in which New Zealanders dismantled many of the traditional certainties which had been their foundation for a coherent and national view of the world in trade, defence, the use of primary resources, the operation of the parliamentary system, social welfare, the ethnic composition of the country's citizenry, the balance of the primary relationship between Maori and Pakeha. The combined effect of these changes would produce a period of uncertainty and adjustment in the early years of the twenty-first century, as New Zealanders waited for new patterns to coalesce and new understandings to percolate through society which might restore a measure of the cohesion that had been lost or which, on the other hand, might not, if the price for greater plurality proved to be a degree of disjunction and social divergence.

The interest in public policy and cultural diversity expanded further in the 1980s as changes in immigration policy meant that greater numbers of migrants from the Pacific and non-European parts of the world settled in Aotearoa New Zealand (Bartley and Spoonley 2005). While the 1980s saw an emergence of interest in multiculturalism in countries such

as Australia and Canada (Shohat and Stam 1994; Kymlicka 1995; Eller 1997; Hage 1998), biculturalism was becoming embedded in public policy and in the New Zealand psyche.

Into this dynamic socio-political context of the mid-1980s, the Labour Minister of Internal Affairs, Peter Tapsell put forward a proposal for what would become the most enthusiastically promoted new cultural institution of the period (Tapsell 2005: 268). This proposal was rapidly followed up in 1985 by the publication of the Department of Internal Affairs' report *Nga Taonga o te Motu – Treasures of the Nation* (Project Development Team 1985). This document demonstrates a strong focus on national identity and unity, no doubt partly because the report was written soon after biculturalism had been adopted as official government policy (this process began in 1975 with the establishment of the Waitangi Tribunal), and as Aotearoa New Zealand headed towards the 150-year anniversary of the signing of the Treaty of Waitangi (1990). It clearly laid out the associations between social policy initiatives and cultural institutions by recommending the construction of a new museum that would be premised upon a bicultural Maori-Pakeha relationship that centralized the Treaty of Waitangi as providing a founding mandate. The new museum was designed to host the Treaty as its principal object and model good practices that were supported by a series of pedagogical structures (realized in exhibition form) that developed particular images of nation and identity. It was to promote the image of an embodied biculturalism that would present the museum as a product of a Maori-Pakeha partnership that 'acknowledges the unique position of Maori in Aotearoa New Zealand and the need to secure their participation in the governance, management and operation of the Museum' (Museum of New Zealand Te Papa Tongarewa 2002b: 9). This means that not only was Te Papa a test case in museological and cultural terms, but it was also created as a working prototype of a bicultural institution that aimed to impact on the future development of the country.

In this chapter I consider the function of the Treaty of Waitangi in terms of the museum's strategies of representation. I ask how it is integrated, both physically and conceptually, within the museum, and what role biculturalism plays in respect of structuring Te Papa's approach to representation. I explore how the ideological framework of 'two people, one nation' (Tapsell 2005: 266) has been transformed by the apparatus of the museum in the decade since it opened, and I consider how transformations in public attitudes and public policy have tested the limits of biculturalism. I consider who is represented, and how multiculturalism is accommodated within the bicultural frame. Finally, I ask whether biculturalism facilitates the museum in its initial desire to offer a 'cultural centre-like' new museum, or whether the techniques and effects presented by this self-consciously new, postmodern museum (Phillips 2001) – which is designed, moreover, on the model of a shopping mall complex (Museum of New Zealand Te Papa Tongarewa 2002c [1989]) – results in a different, more polarized and exclusive outcome.

I focus, in particular on changes that have been made to Te Papa's exhibitions and its presentation of biculturalism to explore whether an increasing acceptance of cultural

heterogeneity and diversity can be perceived within the Maori galleries. This includes analysing Te Papa's *iwi* exhibitions, the central *Signs of a Nation – Nga Tohu Kotahitanga* exhibition (including *Poringi: The Evolving Story of the Treaty*), and the museum's display of the *wharenui* (meeting house) Te Hau ki Turanga. Although the museum's *marae* remains a highly problematic fabricated space that offers an exceptional illustration of the museum as a tool of governance (Foucault 1982; Karp 1992; Bennett 1995), it may be that other parts of the museum – such as the *iwi* exhibitions – have engaged with the diversity of Maori culture more actively and effectively. If this is so, the Maori galleries might offer a model of good practice for other parts of the museum and for the crisis ridden guiding social policy principle of 'normative biculturalism' that exists beyond the museum. It may also offer a way to negotiate between the requirements of an institutionalized biculturalism and the 'pragmatic multiculturalism' that exists everywhere in Aotearoa New Zealand, by paying attention to a locally produced and oriented concept of cultural diversity that aims to preserve and promote the particularities inherent within cultural difference as flexible, overlapping and competitive.

THE MUSEUM AND THE CROWN: ENTHUSIASTIC TRANSFORMATIONS AND THE PROBLEM OF POLITICS

In the decade following the opening of Te Papa the general enthusiasm for biculturalism and interest in multiculturalism has largely been replaced by the global policy initiatives associated with UNESCO's 2001 *Universal Declaration on Cultural Diversity* (Yúdice 2003; Message 2005, 2006a). However, the encompassing influence of globalization has been accompanied in Aotearoa New Zealand and elsewhere by an increased understanding of the interplays between nation and region (which has also been encouraged by the growing academic field of Pacific Cultural Studies, see Thomas 1991; Teaiwa 2001; Hau'ofa 2005), so that the past decade has been highly significant in regard to recentralizing identity politics (Museum of New Zealand Te Papa Tongarewa 2004: xiii; Veracini and Muckle 2002). Into this altered geopolitical context, the series of events leading up to the country's 2005 general election unsettled the relationship between politics, biculturalism and the Treaty once again and so brought Te Papa under renewed scrutiny. This situation threatened to undermine both the national confidence in biculturalism and Te Papa's associated, albeit amorphic, commitment to a pragmatic multiculturalism. Contributing to the corrosion of confidence in biculturalism was the furore resulting from the Government's response to the 2004 Court of Appeal's decision confirming the Maori Land Court's jurisdiction to consider applications for title to lands of the foreshore and seabed (Bennion 2005). Within days of the Court of Appeal's decision the Government announced its intention to legislate for Crown ownership of all foreshore and seabed lands, thereby removing the existing rights of Maori to have their claims tested in the court. The widespread protest that ensued was reinterpreted by the right-of-centre, opposition National Party as Maori – and their 'politically correct' supporters, including paradoxically, Helen Clark's Labour government – seeking to deny the so-called 'right' of 'all' or 'mainstream' (Pakeha) New Zealanders to access 'their' beaches.

At the heart of the matter was the ongoing questioning of the relevance of the Treaty of Waitangi to contemporary New Zealand. Fuelled by misinformation and visions of a simpler, sentimentalized (pre-bicultural) past, the reinvigorated National Party intensified the dispute further by claiming that 'Maori "special interests" had gone too far. Insisting on "one rule for all", National declared new policies that included disabling the Maori Affairs ministry, abolishing the seven Maori electorate parliamentary seats, and removing the semi-constitutional authority of the Treaty of Waitangi' (Williams 2005: 81; see also Ruru 2004; Mutu 2005). In a move that echoed the 1975 *hikoi* (protest march) both politically and symbolically, around 10,000 (mostly Maori) protestors gathered in May 2004 at Te Papa to march to Parliament House. They were demonstrating against the government's unsympathetic response to demands for recognition of their interests in the country's foreshore and seabed, promised, they claimed, by the Treaty of Waitangi (Harris 2004; Waitangi Tribunal 2004a; Berry 2004; *Dominion Post* 2004; *New Zealand Herald* 2004; Thompson 2004). Caught between these protests and the broad public support elicited by National's calls to unification, Prime Minister Helen Clark declared that the prevailing 'consensus over Maori issues' had been 'shattered', and that a 'new balance' on Maori policy, 'based on needs rather than race' was required (Braddock 2004).

In relation to the foreshore and seabed, the Government subsequently countered that sovereignty remained vested in the Crown on behalf of all New Zealanders. This action controversially rejected recommendations made by the Waitangi Tribunal for the recognition of the Maori claim. This was problematic because it condoned public criticism of the Waitangi Tribunal. The Government's decision led to an investigation by the United Nations Committee on the Elimination of Racial Discrimination (2005), which expressed concern over the haste with which the legislation was enacted as well as 'the scale of opposition to the legislation amongst the group most directly affected by its provisions – the Maori – and their very strong perception that the legislation discriminates against them.' It also registered concern with the political atmosphere that developed in response to this, and advocated that 'all actors in New Zealand will refrain from exploiting racial tensions for their own political advantage' (United Nations Committee on the Elimination of Racial Discrimination 2005).

As this event illustrates, Te Papa has always been understood as having a fundamental relationship with the bicultural policy that it employs instrumentally to achieve democratic representation within the museum (as a model of good practice to be emulated in the various social spaces around it). In many respects – particularly in relation to its engagement with *Matauranga Maori* (Maori knowledge systems) (Royal 2004), and the preservation and care of *taonga* (treasures) offered by Maori curators – the museum has been very successful (Henare 2004: 59). However, instead of offering a properly discursive space of interaction as initially hoped, the museum has also been criticized for its overt, and in some cases uncritical, association with the state (or Crown). This association is clearly articulated in relation to the 2004 *hikoi* that had been moving steadily to Wellington for some weeks

and that chose to stop and regather at Te Papa (itself built on reclaimed land) as 'our place' before marching to Parliament.

The alliance between the Crown and museum has also been more than symbolic in relation to the Gisborne-based Rongowhakaata *iwi*'s claims over the *wharenui*, Te Hau ki Turanga (the breath, or vitality of Turanga) (Brown 1996: 7). In 2004 the Waitangi Tribunal reported that 'the removal of Te Hau ki Turanga in early 1867 from Orakaiapu was undertaken without the consent of all its owners … [and] without properly identifying all those who had rights to agree to the transaction' (Waitangi Tribunal 2004b: 589). As such, the museum's 'assumption of possession of Te Hau ki Turanga was in breach of the principles of the Treaty of Waitangi' (Waitangi Tribunal 2004b: 588). A case study of this example forms the central discussion of the last part of this chapter.

BICULTURAL POLICY AND 'OUR PLACE'

The relationship between Maori and Pakeha is implicit in Te Papa's architecture as well as its founding documents (Figure 37). In winning the national architectural competition to build the museum, architect Pete Bossley of Jasmax conceptualized a place of convergence

37: Exterior, the Museum of New Zealand Te Papa Tongarewa, Wellington. (Photograph courtesy of the Museum of New Zealand Te Papa Tongarewa.)

that would evoke the liminal space of the beach and demonstrate various traditions as being both imbricated and intersectional (Jasmax 1992; Bossley 1998a, 1998b, 1998c, 1998d; Frankovits 1998). The space was designed to evoke memories of historical crosscultural encounter between Maori and Pakeha, and in physical terms, this meant that a replica of the Treaty of Waitangi was located at a point in the museum where it would occupy the building's central spine. However, at the same time, Maori and Pakeha elements radiate away from each other, outward from the Treaty and the main fourth-floor concourse. Explaining their vision, the architects contend that:

> The building expresses its bi-cultural nature by responding in the south to the European-based urban grid of Wellington, and in the north to the alignment of the most open axis of the Wellington harbour, more in keeping with the traditional approach to landscape adopted by Maori settlers. (Jasmax 1992: section 3: 1)

As this demonstrates, early reports conceptualized the emergent Museum of New Zealand as a 'Pacific Cultural Centre' (New Zealand Ministry for Culture and Heritage 2000a: 12), which would invite greater community participation. Combining the National Art Gallery's collections, this museum – which would eventually be named Te Papa and branded as 'our place' – was designed to present the objects displayed as being of equal cultural value, regardless of provenance. This approach immediately became the target of criticism. Without fully understanding that Western frameworks of tradition, knowledge, value and heritage differed from those of *Matauranga Maori* (Royal 2004), some commentators contested that the tradition, objects and artefacts in the Pakeha section (particularly the controversial and now-closed exhibition, *Parade*) were undervalued relative to the Maori components of the museum, and *Mana Whenua* in particular (Dutton 1998; Dalrymple 1999; Harper 1999; Keith 2001; Phillips 2001: 147; Goldsmith 2003b). Jolly (2001: 447) described the Pakeha sections as demonstrating 'a scrupulous avoidance of the sacred'. However, this underlying democratic agenda – depicted as a kind of universalism through the thumb print logo selected to represent the museum (Cottrell and Preston 1999) – was understood as central to discourses of national identity that portray Aotearoa New Zealand as inclusive and demotic (Figure 38). Extending these ideological procedures was the foundational mandate of biculturalism, and an engagement with economies of global capital that were explained in terms of a 'commercially positive', 'customer focus' (New Zealand Ministry for Culture and Heritage 2000a: 7, 12; Neill 2004: 188). Importantly, however, biculturalism was to be underlined by a commitment to multiculturalism so that Te Papa would in fact be more than a bicultural space. It was to be egalitarian and cosmopolitan; designed to celebrate 'the cultural interests and aspirations of all the people of New Zealand' (New Zealand Ministry for Culture and Heritage 2000a: 17; see also Museum of New Zealand Te Papa Tongarewa 2004: viii, xii). Furthermore, as outlined in the Museum of New Zealand Te Papa Tongarewa Act 1992 (New Zealand Government 1992, section 8b), the new national museum was charged directly with the responsibility of producing a conversation between

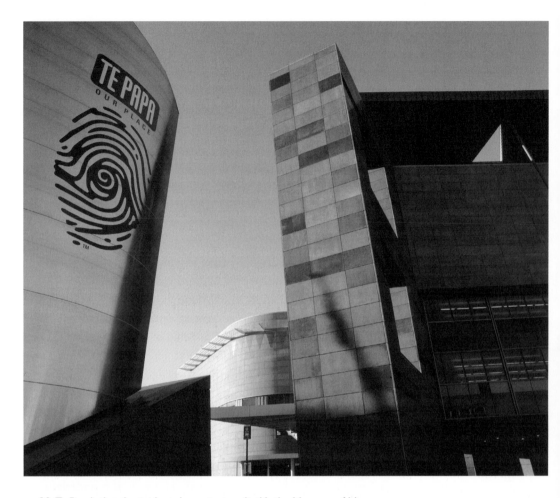

38: Te Papa's thumbprint logo (on exterior plinth), the Museum of New Zealand Te Papa Tongarewa, Wellington. (Photograph courtesy of the Museum of New Zealand Te Papa Tongarewa.)

the modes and effects of representation (responsible for the expression and recognition of diverse cultural identity) on the one hand, and public participation (where the public is called on to 'contribute ... to the Museum as a statement of New Zealand's identity') on the other. Right from the beginning, these strategies were employed to create a new museum that would be also tied to the reconfiguration of the public sphere and national imaginary in Aotearoa New Zealand.

Te Papa's representational strategies have, as such, always been implicated with processes of reconciliation and reparation between indigenous and non-indigenous people. The museum was developed directly around a tripartite thematic structure of *tangata whenua* (Maori; the original people of the land), *tangata tiriti* (Pakeha; non-Maori New Zealanders

there by virtue of the Treaty) and *papatuanuku* (the natural environment; home to all New Zealanders) which aims to link the past, present and future. This structure is also designed to give greater authority to the bicultural legislation underpinning the institution by centralizing the Treaty of Waitangi. Indicating the function of broader government policy in relation to the museum, a former director of Museum Resources at Te Papa, William Tramposch (1998a: 49; 1996), explains that 'the New Zealand government has supported the museum and accepted that museums and culture can help alleviate the pernicious conditions caused by racism and prejudice.' However, by clearly tying the state to configurations of cultural identity – be they Maori or non-Maori, tribal, urban, or migrant – it becomes clear that racial reconciliation itself is often clothed in a more recuperative or regulatory dress. This means that biculturalism is frequently aligned with apolitical images of cultural or natural signifiers (like the *koru* – the spiralling, unfolding fern much used in Maori art and used also by Air New Zealand as a branding device; or the natural environment used in the *100% Pure New Zealand* tourist campaign), and that these are presented to signify all New Zealanders (Cottrell and Preston 1999; Morgan et al. 2002; Phillips 2005). However, Mason Durie argues that at the same time as Maori are brought into the symbolic space of the state; and *tikanga Maori* (Maori custom, culture and protocol) is centrally recognized and appropriated, Maori control of their own development is diminished (in Brown 2002: 290). Paul Tapsell argues this further still, claiming that 'the Museum's biculturalism is in reality no more than a monoculturally governed vehicle for the "Maorinization" of post-colonial New Zealand'; a point he argues to suggest that Te Papa has appropriated Maori language, tradition and culture to not just represent but to also actively promote the state's political agenda (in Brown 2002: 291; see also Tapsell 1998).

For Te Papa, biculturalism means that the museum has been built out of a Maori-Pakeha partnership that 'acknowledges the unique position of Maori in Aotearoa New Zealand and the need to secure their participation in the governance, management and operation of the Museum' (Museum of New Zealand Te Papa Tongarewa 2002b: 9). In accord with guidelines set out by their bicultural policy, the museum's consultation process has been conducted principally with *iwi Maori* (Department of Internal Affairs 1994: 20). In practical terms, Te Papa acknowledges *te reo Maori* (the Maori language) as an official language of Aotearoa New Zealand, and uses it throughout the museum's texts and pamphlets as well as in policy and corporate documents (Museum of New Zealand Te Papa Tongarewa 1997). They employ a human resources structure that is informed by biculturalism, and Maori are involved at every staffing level throughout the museum (although they have yet to meet the 1: 1 ratio of Maori: Pakeha staff achieved by some other museums, including the Tairawhiti Museum in Gisborne). As part of the restructuring process involved in transforming the former National Museum into Te Papa, the museum created two new positions that indicate an engagement with symbolic and practical demands of a bicultural state in which power is distributed equally. One of these appointments was a Maori CEO, called the *kaihatu*, who shares authority equally with the Pakeha CEO, but whereas the Pakeha CEO answers to the

government, the *kaihatu* is accountable to Maori. Te Taru White, as current *kaihatu*, also performs the important role of providing the museum with a public face. The other newly created position is *poutakawaenga*, who is responsible for the 'interface' between *iwi* and the museum. These new positions both include responsibility for borrowing and lending of *taonga*, deciding what can be displayed and where, necessary protocol, and advising *iwi* about what information they may prefer to keep restricted (Joe Doherty in Williams 2003: 225).

The objective of achieving unity through partnership may have also been perceived as a way of resolving, symbolically if not more instrumentally, the ethnic tensions occurring in Aotearoa New Zealand during the museum's development phase (Spoonley 1995: 106; Pearson 1990). The 1985 report *Nga Taonga o te Motu* was followed by the 1989 *Statement of Intent*, which claimed that the museum would 'strengthen national identity and uphold the principles of the Treaty of Waitangi' (Museum of New Zealand 2002c [1989]). Changes in general policy objectives and agendas have continued to impact on Te Papa, so that the 1992 Act (New Zealand Government 1992, section 8a) claimed a multicultural focus for the Museum, demanding that it accommodate the contributions of all cultures in Aotearoa New Zealand. This registered a need to reassess the ways of framing the Maori contribution to the national experience, and was followed in 2000 by *In The Heart of the Nation: A Cultural Strategy for Aotearoa New Zealand*, which explained, 'It is the intention of this strategy that things Maori should be devolved to Maori', and 'we are not proposing that biculturalism should be abandoned, but redefined' (New Zealand Government, Ministry for Culture and Heritage 2000b: 84). However, the interconnection evident here between the state and articulations of cultural identity – where the principle of biculturalism has been rediscovered in the words of the Treaty, reinterpreted as a founding document, and centralized in the national museum – means that any shift away from biculturalism towards cultural diversity carries enormous implications (Bennett 1995: 142; 1997; Moss 2004: 6; Bartley and Spoonley 2005: 138–9).

CULTURAL WELL-BEING

This turn to multiculturalism has also been reflected explicitly throughout government policies developed before and since Te Papa's 1998 opening, including the Ministry for Culture and Heritage's *Cultural Well-being* policy of 2003. This policy states that 'cultural well-being' could be expected to 'encompass the shared beliefs, values, customs, behaviours and identities reflected through language, stories, experiences, visual and performing arts ceremonies and heritage' (Local Government Act 2002 in NZ Ministry for Culture and Heritage 2003). Such documents may propose a multifaceted and universally inclusive but also distinct identity in order to avoid having to face an ambiguous colonial legacy, where colonization has not simply ended with the restitution of sovereignty to the original inhabitants. Ruth B. Phillips contends that such unresolved decolonization processes invite us to 'embrace the proposition that this history is probably unfinishable in settler societies in

which indigenous peoples will not only remain demographic minorities but also increasingly have to contend with a growing number of diasporic immigrant societies engaging in their own identity politics and projects of cultural and political empowerment' (in Clifford 2004: 25). Statements that manifest this sentiment evidence not only the simultaneously aspirational and normative nature of cultural policy – which names the cultural practice it seeks to promote as being 'of' the nation – but also clearly demonstrate why cultural policy is such a useful tool in the interrogation or analysis of national political intent. Extrapolating on the tension between biculturalism and multiculturalism and their respective relationships with policy in New Zealand, Michael Goldsmith (2003a: 285) argues, 'It is intriguing that this sort of rhetoric often *implicitly* recognizes multiculturalism as always already existing, while stating that its *official* recognition must constantly be deferred.' However, writing in 1993 in justification of the maintenance of bicultural policies, Raj Vasil (in Božić-Vrbančić, 2003: 310) suggests:

> For the present it is better to accept the notion of a bicultural New Zealand, as preferred by Maori, than to create an unnecessary and damaging controversy by insisting on multiculturalism... Some Pakeha ... insist on arguing with a certain vehemence that New Zealand, in view of the existence of many ethnic minorities, can properly be viewed only as a multicultural... In many cases it is a fact that this argument provides a convenient means by which many Pakeha can deny Maori what they want... It would be advisable for Pakeha to view New Zealand as a bi-racial and bi-cultural nation for the time being.

ACCOMMODATING MULTICULTURALISM IN A BICULTURAL FRAME

As acknowledged by UNESCO's 2001 *Universal Declaration on Cultural Diversity*, how-ever, discourses of multiculturalism have fallen out of favour somewhat (Shohat and Stam 1994; Eller 1997; Docker and Fischer 2000). Reasons for this are generally connected to concerns that multiculturalism promotes certain images of difference that become 'fixed', where discrete communities and traditions are represented as unchanging entities (Hage 1998; Macdonald 2003). Instead of trying to replicate the interests of distinct communities in responding to this policy shift, museums now appear to prefer expressions of mobility and fluidity in respect of cultural boundaries. Even in Te Papa – which maintains an un-ambiguous allegiance both to nation and to biculturalism – the country is clearly positioned as a Pacific island, where its relationship to the rest of the world is framed according to a series of globally changing flows (that are political, economic, social, climatic, and environ-mental). This profile of its changing relationship to the world is mapped by attention to a contemporary New Zealand population in flux as demonstrated by *Passports*, an ex-hibition presenting migration stories from the last 200 years. Focusing on narratives of early British immigration to New Zealand and including accounts of immigration by more recent arrivals and the mobility of Polynesian peoples who travelled to Aotearoa and other Pacific islands, transnational movement is a story well suited to Te Papa. According to Jock

Phillips (2001: 154–5), the museum has also attempted to capitalize on this effect in its other sections by incorporating the enormous *waka taua* (war canoe) Teremoe (which had been used by both Maori and British in the military campaigns on the Whanganui river in the 1860s) alongside *Mana Whenua,* and by positioning on a high wall at the entrance to the museum the anchor left by French explorer Jean Francis Marie de Surville in 1769 (when a storm forced him to cut his ship from this anchor and leave New Zealand, just as Cook was 'rediscovering' the country). Used as corresponding objects at significant points in the museum, the *waka* and anchor are presented as marking the different traditions of Polynesian mobility and European journeys of discovery. However, rather than emphasizing fluidity and transgression, the theme of mobility is reproduced to conform to the dominant Maori (*tangata whenua*) / Pakeha (*tangata tiriti*) dichotomy that is employed by the museum.

PASSPORTS' COMMUNITY GALLERIES; MANA PASIFIKA

While Te Papa is a national museum that seeks to engage with the abstract concept of nation, it also aims to integrate local and community involvement. Seeking to involve specific local communities – who are made complicit in this representation of the nation – the museum is involved in long-term consultation over the development of community exhibitions. Located within *Passports,* these temporary exhibitions showcase and represent participation by ethnic community groups in the construction of the nation. Since Te Papa's opening, four such exhibitions have been hosted: *The Making of a Chinese New Zealander, Nieuw Zeeland: Going Dutch, Aainaa: Reflections through Indian Weddings*, and the current display, *Qui Tutto Bene: the Italians in New Zealand*. These exhibitions present various objects as *lieux de mémoire* valuable to both individuals and collective memory. Despite foregrounding a display methodology that is unchallenging and temporary-looking, the small space holds objects that are of unparalleled interest, and that seem to have no place in the other parts of the museum. One such object is a picture frame made by Florindo Comis in the early 1940s, when, as an immigrant to New Zealand at the time Italy declared war on the Allies in June 1940, he had been interned on Matiu/Somes Island in Wellington harbour. Comis made the frame to hold a photo of his family. He constructed it from wood that he had to hand, and included an inlay of paua shell that he collected on the island. In addition to revealing many stories – including the personal memories of Comis and his family, and the years of internment on Somes island (with all that entailed) – this frame functions as a key symbol of transnational or crosscultural exchange. The frame is striking because it directly reflects the negotiation of agency between Comis's personal and cultural significations and the more volatile and political group interests and objectives of the New Zealand government at the time. However, it also incorporates materials that present a relationship between Italian culture and Maori – rather than Pakeha – culture. The association is not confined to this object, and is also apparent in the paua shell *tiki* made by Paolo Casa in the 1940s. Articulating these crosscultural interactions, the objects also make

possible the performance of a certain museological self-awareness, working to show how objects themselves always tell stories of encounter and exchange (between communities and museums or collectors). Perhaps by focusing more on stories and objects where traditions come into contact in such clearly visible intersecting ways, Te Papa might become more successful in presenting biculturalism as a policy of interaction, exchange and negotiation, rather than as the preservation of discrete cultures.

The response to *Passports*, according to its key concept developer, Jock Phillips, is that visitors leave 'with a rich sense of the myths which have motivated New Zealanders in the past and [a realization] that identity is continually under change' (in Neill 2004: 192; see also Phillips 2001). However, it seems that for the most part, the myths included are meta-narrative and directed to the project of nation building according to a bicultural frame, which means that the museum is, strictly speaking, restricted to including stories that confirm and fit into the nominated categories of *tangata whenua* (Maori) or *tangata tiriti* (Pakeha). And yet, it may be possible to read Phillips' text more subversively, to perhaps understand him as positioning biculturalism as one of these myths of the past – given that it was created out of the Treaty of Waitangi as a historical document (signed in 1840). If so, Phillips may be acknowledging the need to include more hybrid and flexible forms of identity. By incorporating objects such as the inlaid paua shell frame into exhibitions of established and nationally significant myths, the museum may be more able to articulate the impact that nation-building programmes have had on individuals and communities in the past, at the same time as indicate the changing face of the nation.

Also produced as an emblem of contemporary crosscultural interaction, *Pisupo lua afe (Corned Beef 2000)* is a life-size bull made out of compressed corn beef tins by Michel Tuffery in 1994. Of this artwork, Tuffery says, 'My corned beef bullock talks about the impact of global trade and colonial economies on Pacific Island cultures. Specifically it comments on how an imported commodity has become an integral part of the Polynesian customs of feasting and gift giving' (in Vercoe 2002: 198). *Pisupo lua afe* is located behind *Passports* and forms a link between the corresponding fourth-floor galleries, including *Mana Whenua*, *Signs of a Nation* and the permanent *Mana Pasifika*. *Pisupo lua afe* is a central figure in the Pacific galleries, which, according to an intriguingly ocean-like configuration, sweep behind the Treaty exhibition to unite each of the exhibition spaces of the fourth floor. *Mana Pasifika* celebrates Polynesian diaspora in Aotearoa New Zealand largely by celebrating the contribution of Pacific Islanders to popular culture (especially music), sport, and the visual arts in Aotearoa. However, it also acknowledges New Zealand's colonialist past in the Pacific and its continued administration of the Cook Islands and Niue (in Free Association), and Tokelau (Museum of New Zealand Te Papa Tongarewa 2004: 242–3) through a presentation of the cultural heritage of the Pacific and the points of interchange and influence occurring between these. A key object here is the 'ahu 'ula (Hawaiian feather cloak), that was worn by Kalani'opu'u, a high chief on the island of Hawai'i, when he greeted Captain James Cook on the beach at Kealakekua Bay in January 1779 (and later

gifted by Kalani'opu'u to Cook). Offering evidence of an official diplomatic encounter, this object and its theme relate to Tuffery's narrative about *Pisupo lua afe* in a way that expands upon and illustrates the ongoing, transhistorical implications and ongoing changes to trends and practices pertaining to the symbolic flow of meaning and capital. Linking past and present by focusing the objects and stories of exchange and encounter may offer a way for Te Papa to address other contemporary flows of economic exchange and migration patterns as depicted, for instance, in Comis's frame.

Neither *Passports* nor *Mana Pasifika* has been exempt from criticism. In particular, the question of how to position minorities in the overall scheme of the museum is a substantial problem for Te Papa, and its approach – of producing representational profiles or exemplars that articulate ethnic-based nationalisms (so that for instance, the focus of *Qui Tutto Bene* is on the experience of Italians in New Zealand, rather than on hybridity) – is unsatisfactory. Senka Božić-Vrbančić elaborates on this argument, by claiming that biculturalism produces and privileges a centralized Maori and British mainstream culture (broadly called 'Kiwiana') within Te Papa, which is symbolized principally by *Signs of a Nation* but is also celebrated elsewhere throughout the museum, including within the exhibits *Golden Days* and *On the Sheep's Back,* at the expense of minority cultures. Božić-Vrbančić's (2003: 300) suggestion, that 'other ethnic groups' are 'presented as locked into their ethnicity' whereby they '"enrich" ... "non-Maori New Zealand society" with their different "lifestyles"' through temporary exhibitions including those in the community gallery critiques the image of multiculturalism as a mosaic or lifestyle choice, whereby interaction between groups is minimal, and restricted for the main to apolitical encounters of hospitality and entertainment. This means, for instance, that despite the inclusion of Comis's paua-inlaid shell or Casa's paua *tiki* in *Qui Tutto Bene*, the images used to advertise the exhibition reiterate stereotypes associated with food and lifestyle. On promotional material we see a laughing Italian group dining with San Pellegrino (Italian) mineral water and Monteiths (New Zealand) beer at their table, while young children play on a Vespa motor scooter. Combined with the exhibition's slogan, 'A vibrant encounter with the life and style of Italians in New Zealand', this reveals clear weaknesses in the concept design of *Passports*, which aimed, according to Phillips (2001: 149), 'to give visitors three approaches – identity is the sum of immigrant cultures, identity comes from interaction with a distinct environment, identity is a construct of the mind.' The expression of distinction that is apparent in this statement of aim is not challenged by the discrete floorspace and high walls separating the community exhibitions from other parts of *Passports*. Indeed, in seeming to preclude anything but the adaptation of either/or approaches (there is not even any sound-bleed between or across exhibitions), Te Papa illustrates Bennett's contention that despite their appeals to newness, contemporary museums maintain a reformist agenda that attempts to preserve a universal image of citizenship. 'In their commitment to the depiction of different communities with different cultures and values', he asserts, 'such projects entail changing museums into sanctuaries of examples'. This means that instead of

offering effective interaction or engagement with communities, the museum enacts 'mutual tolerance and understanding' (offering the 'image' of dialogue) as the ideal civic virtues of our time (Bennett 1997: 21).

Hage (2005) also expresses suspicion over this logic of tolerance, arguing that it asserts politically correct ideas at the expense of actual interpersonal interaction and crosscultural communication – messy and unpredictable as these might be. On the one hand, this problematic foregrounding of tolerance fits well with Te Papa's bicultural frame. However, it also demonstrates the potential for policy to entrench a narrow form of 'bicultural ethnic structuralism' (Williams 2003: 265). This means that non-Anglo immigrants are excluded from the museum's dichotomous focus on Maori and Pakeha but are at the same time included within the increasingly awkward category of *tangata tiriti* (Pakeha). The bicultural organization of the museum literally has no tools to account for or articulate the experience of non-Anglo immigrants who are represented as obtaining the right to live in Aotearoa and be included in the museum by virtue of the Treaty – *tangata tiriti* – but subsumed by the Pakeha galleries and the cultural heritage privileged by them. The museum's interpretation of the Treaty thus means that regardless of their representational marginality or invisibility, immigrants have become elevated to the status of equal Treaty partner. The Treaty thus comes to have an additional ethical dimension that surpasses its actual historical terms of reference and influence.

There is no doubt that these arguments are convincing. Yet these critiques do tend to overlook an important point in relation to Phillips' accompanying statement of intention, where he explains that the museum seeks to provoke visitors to reflect on the nature, conditions or implications of crosscultural interaction. This reveals the objective to motivate visitors to make conceptual leaps between and across such categories 'for themselves' – as a sentiment that always appears to accompany such proclamations of intent in relation to the production of exhibition spaces. Typically, these additional statements of intent are phrased in less concrete terms: 'The hope was that questions would be asked, perceptions opened, not closed down'; similarly it was hoped that 'visitors would make the leap in a postmodern kind of way' (Phillips 2001: 149). This preference for self-directed experiences may not (or could not) have been adequately signalled by the museum, which, as an instrument of the state, is responsible to a variety of stakeholders (including members of the Italian community who wanted no references to fascism or Mussolini in *Qui Tutto Bene*, despite this being the main reason for Italian immigration). It may have also been curtailed on the basis that it is now considered an outdated or fallible approach. However, the optimism associated with such intentions certainly appears to have provided the museum with a strong sense of purpose in the days of planning. Although it may not mean anything in terms of how the exhibition is interpreted by visitors, it may be useful to keep in mind for the way it reveals the museum's association with postmodernity, as a key signifier and language of newness.

POSTMODERNITY, INTENTIONALITY AND AUTHORITY

The aim to construct a space that is rhetorically effective and engaging provided the rationale for the museum's approach to interpretation, and it was in this spirit that the controversial opening exhibition, *Parade*, confronted visitors with statements such as: 'Is it art? You decide!' Te Papa aimed thus to engage visitors with questions pertaining to the relationship between representation and reality, and asked visitors to consider the institution's own relationship to authority (although these attempts to actively challenge the visitor were never used in *Mana Whenua*). However, to be successful, this strategy required visitors to become fully cognitive of the role they play as participants in the production of meaning within the museum – and, by extension, the nation. This approach and rationale revealed an omnipresent postmodernity, which may be further evidence that Te Papa 'exemplifies something of the intellectual climate in which the museum took shape' (Museum of New Zealand Te Papa Tongarewa 2004: xiii). In addition to its incorporation of video games and theme-park rides and its performative populism that has been promoted through a blurring of boundaries between art, culture and politics (which is not necessarily convincing), the museum was certainly marked as vibrant and cutting-edge through its architecture and 'visitor-friendly' approach (where the museum guards, called 'hosts', dressed in colourful uniforms and actively solicited conversation with visitors). At a conceptual level, it has embraced playful, interdisciplinary concepts borrowed from cultural studies and critical theory, and incorporated strategies of subversion and deconstruction. In light of these strategies, it has even been suggested that biculturalism may itself be considered a rhetorical device employed by the museum to maintain its profile as a new and engaging space for visitor participation (Henare 2004: 55).

In suggesting that the rhetorical strength of the bicultural image produced by Te Papa works in fact to obscure a more fundamentally unaltered reliance on universal represent-ativeness (that attests to the museum's success in constructing histories that imagine an integrating and progressive unity for its subjects), we are reminded of Bennett's contention that in aiming strategically to involve minority groups that are more traditionally represented and silenced by museological displays, the museum is simply extending its essentially conservative function. Bennett's critique is directed to Clifford's equally rhetorically splendid and critically informed contact zone concept. Counteracting Clifford's utopian contention that indigenous peoples use museums to force a break in representational forms of order and logic (which might contribute to a rupture in the way national identity is understood and imagined), Bennett (1998: 212) asks:

> For what is the perspective of museums-as-contact-zones if not a proposal that, by tinkering with a range of practical arrangement, the inherited form of the museum might be refunctioned in a manner calculated to bring about a redirection – indeed, reversal – of its reforming potential with a multicultural civics premised on a need for greater cross-cultural understanding and tolerance?

Clearly, Te Papa did not aim to close down discussion – or limit the expansion of identity politics – by segregating cultural groups on the basis of ethnic or national affiliation. It was a museum developed in the spirit of encounter, exchange and participation. However, the fact that it can be so easily critiqued on this basis means that it did not elect a flexible enough mode of approach or interpretation toward exhibition-making and that it did not explain this clearly to visitors and stakeholders. It may have also been mistaken in its decision to order and display community groups according to ethnic identity and to then configure the gallery space in ways that emphasized this difference. These errors in judgement combined to reveal a more formidable and fundamental museological problem of power and representation, where the museum speaks with the authority of the state, and the dominant population is still generally responsible for depicting (if not constituting) the nation. In this case, the aim to produce a space that welcomes public debate is not enough. Equality can only be achieved by the integration of diversity at an organizational level throughout the museum and by expanding the museum's allegiances beyond the abstract image of nation to seek engagement with the multitude of communities and individuals that constitute the nation in more practical terms.

Similarly, the museum's focus on images of racial harmony (evident in Te Papa's *marae*) at the expense of more realistic stories of negotiation – exemplified for example, by Te Hau ki Turanga – is not enough. Although historian, W. H. Oliver explains that 'Many of the bicultural initiatives of the 1980s were intended to "do justice" and bring about a degree of reparation for past losses, ranging from economic resources to spiritual authority' (Museum of New Zealand Te Papa Tongarewa 2004: xiii), the privileging of culture and culturalism has come at the expense of engaging with socio-political issues more critical to Maori well-being in the community, including health, housing, education, and access to employment. Presenting Maori culture as fundamental expressions of customary practices and beliefs promotes ideas associated with the Maori Renaissance of the 1970s. It risks reinforcing the idea that biculturalism *is* little more than a rhetorical strategy used by the museum to evidence its role as a leader in contemporary life; as Oliver notes, biculturalism does not work as effectively 'in the real world' as it does in the museum (Museum of New Zealand Te Papa Tongarewa 2004: xiii). But surely this is no reason to not let the real world influence the museum. The strategy of self-referentiality that was adopted early on by the museum as a way to ask visitors to engage with the authority of the museum could still be used effectively if the museum was actually and a little more honestly self-reflective about the objects that it chose to present in this way. It might also offer a way to materialize the utopian framework of the museum. Making a display of its own story in order to tell the interaction between institution and community would offer an extremely effective embodiment of biculturalism. It may also offer an entry point to access critical analysis about the expanding settler desire (and market) for *taonga Maori* in the latter part of the nineteenth century, and the impact this trend had for colonial collections where nineteenth-century Western museums and international exhibitions presented the 'cultures of colonialism for the edification of the

audience' (Brown 1996: 15; Tapsell 1998: 18). Providing explanation of the history of alterations made to Te Hau ki Turanga, for example – with annotations about why they were made, when, and by whom – might enhance understanding of the object's contested history, allow understanding of conservation and negotiation issues, and exploration of the museum's role in these procedures (Waitangi Tribunal 2004b: 602). Or imagine a display to accompany Te Hau ki Turanga that integrates the following account of the *whare*'s removal, written in 1867, by the senior politician J.C. Richmond, who was at this time informally acting as the director of the Colonial Museum and who had ordered the removal of the *whare*:

> I have been travelling along the East Coast addressing 'mass meetings' of darker brethren, pursuing in short, the celebrated 'face to face' policy. So far my East Coast dealings have not had brilliant success. The only great thing done was the confiscation and carrying off of a beautiful carved house with a military promptitude that will be recorded to my glory. The Governor and an agent of the Melbourne Museum were trying to deal for it but the broad arrow and Capt Fairchild and the Sturt carried the day. (Waitangi Tribunal 2004b: 590)

COUNTERPOLITICS: *IWI* EXHIBITIONS

Confronting similar problems as the community galleries, but located within *Mana Whenua* (an exhibition that refers to the importance of the land and the deep significance the natural environment has for Maori), are the *iwi* exhibitions. *Awa Tupua – The Whanganui Iwi* is the fourth in a continuing series of exhibitions developed as partnerships between *iwi* and Te Papa. These began in 1997 with an exhibition from Te Atiawa, which was followed by exhibitions from Te Aupouri and most recently Ngai Tuhoe. The *iwi* exhibitions clearly face the same problems of separation from the main exhibition areas that face the community exhibitions – and the consequent implication that these groups are separate from or marginal to the project of nation building. These issues are also similar in that they are manifested in substantially spatial ways – the *iwi* exhibition is located in a corner, squeezed in between a café and the large *waka taua* Teremoe. However, unlike the community exhibitions, which have generally been void of political content, the *iwi* exhibitions offer a space in which Maori authority is actually acknowledged as powerful and political, produced in many cases to contest assertions about cultural sovereignty and the right of self-representation. This may be because many Maori stakeholders welcomed Te Papa's creation as an opportunity for control over representations of their culture and as providing a site in which Maori political aspirations could be articulated.

Given such high expectations, the museum's level of engagement with and attention to Maori resistance might be considered gestural. While it is often represented within the *iwi* exhibitions, there is notably little information elsewhere in the museum about resistance in general, or attention to specifics such as the New Zealand Wars of the mid-to-late nineteenth century. Yet, conversely, within the constrained spaces available for the

temporary *iwi* exhibitions, alternate systems of governance, authority and negotiation are acknowledged. In relation to the *Tuhoe: Children of the Mist* exhibition, Ngahuia Te Awekotuku and Linda Waimarie Nikora (2003: 63) write 'There has been a recent initiative to modify any sense of loss, by sharing in the museum experience on Tuhoe terms'. Developed in partnership between the museum and individual tribes, these systems are depicted as fitting within a bicultural frame, and as being extra or additional to it, so that these displays privilege the preservation and continuation of traditional culture but function also as an indication of the political role that Maori have in contemporary Aotearoa New Zealand. In addition, the *iwi* exhibitions are important because they allow for the telling of alternative and heterogeneous histories, and versions which may have remained largely invisible or unknown to many audiences – both Pakeha and Maori (Te Awekotuku and Nikora 2003: 64). This encourages new spaces of dialogue, where, for example, counter-narratives about historical prophets such as Te Kooti and Rua Kenana and their communities are told (in the *Tuhoe* exhibition), and where the spiritual connection between *iwi* and *awa* (river) is centralized in the current exhibition, *Te Awa Tupua*. It also opens a space of counterpolitics and multiple narratives, with the inclusion of an audio-visual (interview-based) and object-based presentation of the Pakaitore (Moutoa Gardens) occupation in 1995 in *Te Awa Tupua*. This presents heated debate between local councillors and Maori delegates as well as putting forth the points of view of *iwi*. In another part of the exhibition, a potentially contentious wall panel outlines allegations regarding an instance of poisoned flour in the years following the signing of the Treaty. Under the heading: 'Poisoned relationship?' the panel says:

> In 1847, some of our people who opposed sales of their land and the growing influence of the Pakeha government attacked Wanganui town and raided settlers' houses. Reports subsequently emerged that the attackers' families had been poisoned by eating plundered flour and sugar which had been laced with arsenic.
>
> Ever since, this matter has been a cause of deep-seated bitterness among the Whanganui iwi (tribe). At its source is a belief that our people were deliberately poisoned by Pakeha settlers.
>
> This belief was fuelled by reports that two settlers boasted of poisoning food in anticipation of the taua (war party) raiding their houses. 'We hope the rascals ate it!' wrote one approving townsperson.
>
> Other accounts suggest it was an accident – that the raiders had discovered and carried off flour that had been poisoned for rat bait.

Further down this wall text, Morvin Simon, Whanganui *kaumatua* (elder) is quoted as explaining this approach. 'Our histories have been passed on orally', he says. 'If these things were spoken of in the community as having had happened, then people would have believed them to have taken place. As far as we're concerned, it's really about acknowledging that it did happen, reporting history from our viewpoint.'

As a national museum, Te Papa may be unable – or unwilling – to do little more than gesture toward these *iwi* groups as significant actors. However, by including the stories of encounter as told by *iwi*, they demand acknowledgment as participants in the construction of a New Zealand state (that they have historically been officially excluded from), and that they are, perhaps problematically, included within now. Moreover, as this panel demonstrates, although the *iwi* exhibitions do succeed in presenting tribal concerns as overlapping and integrated with issues and concerns of the nation, this success also draws attention to the agenda and aims of the museum, which do not always appear commensurate with each another. For example, although Te Papa is structured to embody the national narrative framework of biculturalism, it also relies methodologically on transcultural or cosmopolitan inferences to define its status as a new, globally relevant 'cultural centre-like' museum. This evidences the contention made by Stephen Pritchard (2005: 69) that despite embodying a widespread critique of dominant, subordinate, or exotic cultures, the promotion of contingent, overlapping, hybrid versions-of-identity-in-emergence has produced a 'complex interface of cultures [that] has tended to mean that pre-established or presupposed defini-tions of cultures can offer little to the complicated lives and identities of those who find themselves less easy to categorise.' Further to this concern, Te Papa's presentation of distinct and parallel cultures cannot easily accommodate the 'hybridity', which is often promoted as a progressive tactic to break away from the old colonial relationships and identities (Bell 2004: 126–7, 131; Papastergiardis 2005), and which, as in the case of the *iwi* exhibitions, effectively presents identity as contingent and changing.

SIGNS OF A NATION – NGA TOHU KOTAHITANGA

The incapacity to be inclusive of such hybridity is indicated by the museum's central exhibit, which, called *Signs of a Nation – Nga Tohu Kotahitanga*, brings the twin strands of Maori and Pakeha into a common space to be contemplated, studied and debated (Jasmax 1992). Integrating an architectural symbolism that echoes this intent by signifying both the *marae* (the courtyard in front of a meeting house that offers a ritualized place for the reception of visitors and exchanges of oratory) and the cathedral, with a soaring, wedge-shaped roofline that has interlocking brown and white beams that represent the clasping of white and brown hands (Phillips 1999), this exhibition is located at the central nexus conjoining the Maori and Pakeha galleries. However, for this museum, which solicits active visitor participation at every other point, this space – perhaps because of its obviously pedagogical agenda – is strangely empty and void of the signs of everyday cultural imbrication and interaction that are so valued elsewhere in the museum. For many children, out of breath from having run around and around the *marae*, the colourful Britten motorcycle located in the café immediately opposite the Treaty exhibition, or the large *waka taua* Teremoe, located on the Maori side, provide eminently more exciting recovery points. Perhaps demonstrating its role as the museum's – or nation's – classroom, an introductory wall text asks visitors to examine the Treaty as a 'living social document', and to consider whether it is: 'An irrelevancy, or

the platform in which all New Zealanders can build a future? The meaning of the Treaty changes depending on who's speaking. Engage with our founding document. Here are a range of voices from past and present. The floor is open for discussion.' However, this exhibition seems not to attract the large crowds or excitement of other parts of the museum, and the public sphere that it seems so determined to produce within this space is enacted by the museum itself, via the thicket of audio-infused pole clusters that surround the replica Treaty, which might actually repel visitors rather than hail them. Stage-managed by the museum, these offer a multitude of voices, each presenting predictably different talkback radio style views about the Treaty.

The (replica) Treaty itself resides at the crux of this core space. Standing 8 metres high and weighing three-quarters of a tonne, it is enormous in scale as well as symbolism. Its lower layer shows the neglected, tattered 1840 original, while a light-infused glass overlay gives the full text. A wall panel explains: 'By using light as a living medium, the Treaty also literally reflects life as it goes on today within the Treaty exhibition. The words of the Treaty form a gathering point, a place where all are welcome and from which, symbolically, we start our life as New Zealanders together.' Set reverentially back from the Treaty, and situated parallel to the corresponding angles of the wedge shape, long pews invite visitors to contemplate tall wooden panels hung from contrasting sides. Inscribed with the full text of the Treaty – Maori on one side, and English on the other (with an English translation of the Maori text) – an accompanying display outlines how the two versions differ, and asks visitors to consider the implications of this inconsistency. More than just a display of the Treaty as the nation's founding document, this exhibit offers a physical emblem for the museum's ideological project, as it is described by Oliver:

> New Zealand is a country with many divergent collective memories. Whose memory will be celebrated is a question to be answered by the exercise of power; in a society in which no community is wholly disenfranchised, many memories will find a place – for some, a subordinate place. Te Papa can be seen as existing at the interface of memory and power, of knowledge and politics. (Museum of New Zealand Te Papa Tongarewa 2004: ix)

The physical design of the Treaty exhibition can be seen thus as embodying the museum's intention to bring Maori and Pakeha people together in a spirit of partnership and cooperation. It offers the new national museum's agenda in microcosm. Seeking to prove evidence of the continuing contemporary relevance of the Treaty and bicultural partnership (and possibly of the museum itself), a special section was added more recently to the upper mezzanine level of this exhibition space. Called *Poringi: The Evolving Story of the Treaty*, this exhibition shows the Treaty partnership in action through the Treaty claims process (by focusing on the experience of Te Aupouri *iwi* in the Waitangi Tribunal's Muriwhenua inquiry, and the *iwi's* efforts to negotiate a settlement of its claim with the government). Rotating panels located on opposing sides of the space discuss grievances over breaches of

the Treaty and show the process by which claims against the Crown are made and how they are settled. Although it offers useful information on the tribunal process and Te Aupouri's submission, this display is unusual in that it has no objects at all – by including objects, or audiovisual commentaries and Tribunal reports, the implications of the tribunal process might be clarified for visitors. Objects may also help visitors see the tribunal process in context – of crosscultural interaction, for instance, or of the ongoing need for the reparation of historical misdeeds by the Crown. It would be interesting for this space to build on connections – where they exist – with currently displayed *iwi* exhibitions (extrapolating, for example, the allegations of poisoned flour or the Moutoa Gardens occupation described to great effect in the Whanganui *iwi/awa* exhibition), to further demonstrate both the importance of Maori governance, and its contestation in Aotearoa New Zealand.

Rather than further evidencing the museum's claims that it offers open and democratic modes of discussion and representation about the Treaty (and by association, the tribunal process), the *Poringi* exhibition seems to confirm claims made more recently that the Treaty exhibit 'may equally be seen to divide "the two mainstreams of tradition and cultural heritage'. As noted by Amiria Henare (2004: 58), 'It is left to the visitor to judge whether this narrative is one of partnership or segregation.' This outcome is heightened by this display, which renders Maori and Pakeha experience as distinct, and the tribunal process itself as strangely abstract and ephemeral. Moreover, despite being information (and rhetoric) heavy, there is almost no mention of Te Papa's own involvement in the tribunal process; apart from a passing comment that 'even Te Papa is affected', which is located on one exhibition text (made in reference to Te Hau ki Turanga). Surely, the story of Te Hau ki Turanga, and the claim brought to the Tribunal by the Rongowhakaata *iwi* would be an excellent way of illuminating the process, as well as providing discussion of the museum's connection both to community and Crown (as a case study of how biculturalism works in practice). According to Paul Williams (2003: 252–3), Te Papa's inconsistency conspires to mean that the main and mezzanine spaces carry conflicting messages in relation to the Treaty:

> Downstairs the accent is on the relevance of the Treaty for the entire public, whereas upstairs, by laying stress on the specific relationship between iwi and the Crown, it avoids any idea of social conflict between the broad categories of Maori and Pakeha. At the end of the room is a window with painted white godwits that appear to soar towards Wellington's hills. Viewers are told that the birds symbolize the nation's open future and ongoing bicultural partnership.

CONTESTING THE CENTRE

While the Treaty and *Poringi* displays are located literally in the museum's centre (as the 'heart of the nation'), Te Papa's *marae* and Te Hau ki Turanga (both on the Maori 'side') are also presented as holding special claim to a certain pre-existing central spiritual authority. This problem of spatial signification leads Goldsmith (2003b: 10) to ask whether these spaces may in fact 'jointly constitute the sacred centre within a wider Maori area'. As has

been suggested elsewhere, there has been much debate over the perception that the nation's central symbols are located in the Maori section, while the Pakeha displays have been constituted by a more irreverent approach to identity. An exception to this did exist at the time of opening. Entitled *Exhibiting Ourselves*, this display offered a reconstruction of New Zealand's contribution to the 1851 Great Exhibition, the 1906 Christchurch International Exhibition, the 1940 New Zealand Centennial Exhibition and the Seville Exposition of 1992. It demonstrated how New Zealand has historically represented itself on a world stage. However, even in this relatively straightforward and otherwise conservative historical exhibition, visitors were asked to adopt a reflexive, postmodern attitude to museological processes of meaning-making to understand that the museum – as well as its displays – is also a product of its time (Phillips 2001: 149). In contrast to this, the Treaty exhibition illustrates the bicultural ideology of 'two peoples, one nation' in an overly determined manner on uneasy-looking and generally empty middle ground, while the *marae* in Te Papa is used to embody the feel-good Treaty partnership aspirations of New Zealand. Contending that Te Papa has appropriated the *marae* concept, Paul Tapsell (2001: 117) asserts:

> [despite the] Crown's rhetoric of honouring the treaty, it has still to fulfil its trustee responsibility to the local kin group upon whose land Te Papa stands … by creating its own Maori rules – mana taonga and non-tribal marae – it appears that Te Papa, as an arm of the Crown, continues to disregard its ongoing Treaty responsibility to the local kin group upon whose land it stands.

Tapsell is referring to the fact that in fabricating its *marae* (called Rongomaraeroa) and *wharenui* (meeting house, called Te Hono ki Hawaiki – the link back to Hawaiki), and claiming that it is for all visitors and for both cultures to use (Museum of New Zealand Te Papa Tongarewa 1992: 17), Te Papa both ignores and usurps the authority of the *tangata whenua* of the Wellington region – including Ngati Toa who at the time of the museum's opening, had an outstanding Treaty claim against the Crown over the land and sea upon which Te Papa resides. According to Tapsell, this means that the museum is not abiding by the Treaty-based principles according to which it was designed. He presents this as further complicated by the museum's representation of the primary connection for the *marae* as being the connection to *taonga* rather than land which, he argues, implies that the museum (as representative of the Crown) has 'attempted to prescribe mana taonga in place of customary marae rituals of encounter' (Tapsell 2001: 117; Museum of New Zealand Te Papa Tongarewa 2004: viii, 299). While this critique suggests quite concretely that the Crown has actively intervened in the organization of traditional Maori tribal units under the aegis of biculturalism and that Maori spiritualism has been commandeered by Western materialism (and the desire for universal commodification), Te Papa claims, in its defence, that despite appearing traditional in respect of its general form, Rongomaraeroa differs vastly in the colours, details and symbolism it presents (Haden 1998) (Figures 39, 40), and in respect of the protocols asked of its visitors (who

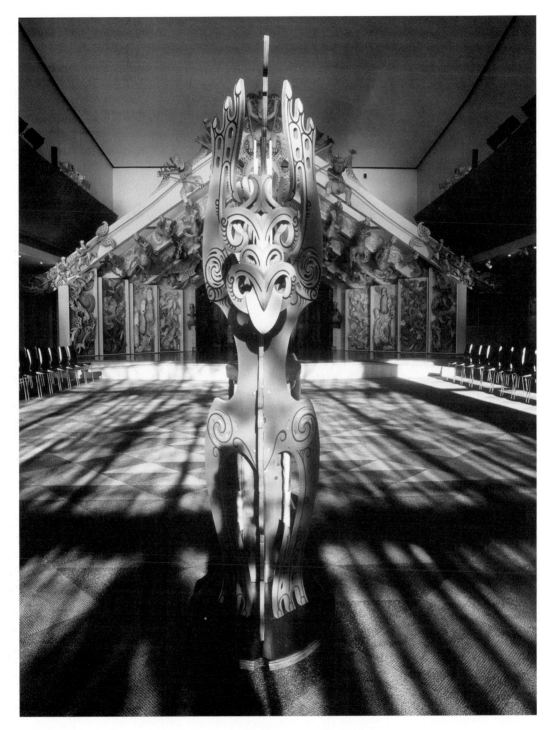

39: *Te marae*, the Museum of New Zealand Te Papa Tongarewa, Wellington.
(Photograph courtesy of the Museum of New Zealand Te Papa Tongarewa.)

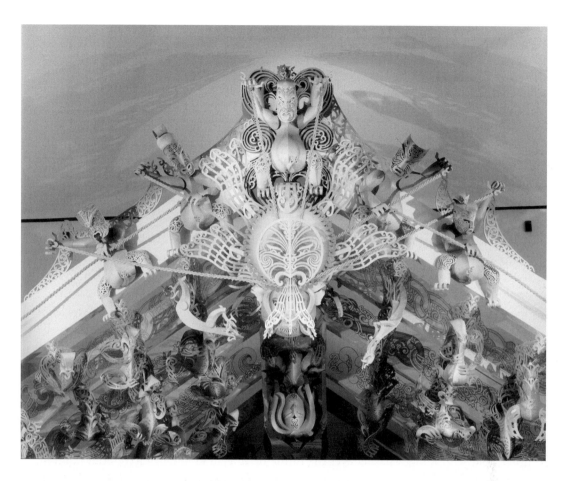

40: Maui and his brothers, *Te marae*, the Museum of New Zealand Te Papa Tongarewa, Wellington. (Photograph courtesy of the Museum of New Zealand Te Papa Tongarewa.)

are exempted from traditional protocols) in order to differentiate it from traditional *marae*. Moreover, in presenting Te Iwi Kainga o Te Papa (the staff of Te Papa) as its resident group – instead of Te Ati Awa and Ngati Toa, the *marae* claims to offer an image or product of negotiation that was designed to enact crosscultural dialogue on Maori, rather than Pakeha, terms (although this point also contributes to Tapsell's argument of the 'Maorinization' of postcolonial New Zealand). Adding further to this critique is Goldsmith's (2003b: 9) observation that Te Papa has incorporated the Maori meeting houses into its greater (bigger) whole to signify the not necessarily conflicting agendas of 'imperial conquest and absorption' and 'the dominant culture's stated desire to protect and preserve the minority and/or indigenous culture.'

TE HAU KI TURANGA

While *Signs of a Nation* provides the most literal and pedagogical depiction of the Treaty of Waitangi and Rongomaraeroa provides a forum for the 'spirit of the Treaty' to be enacted and experienced, sitting between these areas is the contested meeting house, Te Hau ki Turanga. After spending time in the *marae*, which is located at the main entry point to the fourth-floor culture galleries, visitors are invited to rub their hands over the large *pounamu* (greenstone) for good luck, before being interpellated through a small, darkened and womb-like corridor into *Mana Whenua*. The *whare*, Te Hau ki Turanga, is the first display visitors come to. The garish artificiality of Rongomaraeroa is immediately counteracted by this authentic house that is displayed under soft lighting and surrounded by *taonga Maori* and paintings by Robyn Kahukiwa and other Maori artists that evoke the Maori cultural renaissance of the 1970s. There is no question that one would remove their shoes before entering this house. Faced with this initial combination of visual cues, visitors understand instantly that it is in *Mana Whenua* – if not Te Hau ki Turanga specifically – that Te Papa has located its authority. However, in claiming Te Hau ki Turanga as its principal ('real') link to tribal custom, the museum enters risky ground – both in relation to its own claims that the *marae* symbolizes the museum's bicultural mandate, and in respect of Tapsell's concerns about the Crown's disregard for the tribes of the Wellington region as expressed by the museum. This position becomes complicated further still by the claim brought to the Waitangi Tribunal by representatives of the aggrieved descent group Rongowhakaata who believe that the house was confiscated and that the museum's treatment of the *whare* has amounted to desecration (Waitangi Tribunal 2004b; *New Zealand Herald* 2002). Te Papa refused my request to include an image of Te Hau ki Turanga, saying that until the discussions with Rongowhakata over the future of Te Hau ki Turanga have been resolved, the museum has decided not to release any images of it (an image can be viewed in Waitangi Tribunal 2004b: 588, Fig.20).

Te Hau ki Turanga is the oldest extant meeting house in New Zealand and is renowned for the beauty of its carvings. Its significance is articulated by Deidre Brown (1996: 22n), who explains that it is considered to be the finest example the Turanga school of carving. The building was constructed under the supervision of the carver Rahatuhi Rukupo as a memorial to his elder brother Tamati Waka Mangere, at Manutuke, near Turanga (now known as Gisborne) in 1842 (Waitangi Tribunal 2004b: 587). It was forcefully acquired for the Colonial Museum by the colonial government in early 1867 during a period of conflict on the East Coast. Later that year, Rukupo 'petitioned the Government for the return of the whare. But the Government's response was that the building appeared to be deteriorating, a considerable amount of money had been paid for it, and, because the owners of the land and the whare were "rebels", the whare had "strictly speaking" been "forfeited to the Government"' (Waitangi Tribunal 2004b: 587–8). Negotiations between *iwi* and government continued, but the *whare* remained in the possession of the museum (on display initially in the Colonial Museum, later being restored under the supervision

of the prominent Maori leader and member of Parliament, Sir Apirana Ngata, and then moved from the former National Museum into Te Papa). Interestingly, the Tribunal's report shows that despite acknowledging that the *whare* was in fact, stolen, the museum continued to argue its ownership over it as a point of law (Waitangi Tribunal 2004b: 601, 606). This reluctance is apparent also in the *Poringo* exhibit, where the *whare* is described briefly as having been 'alleged to have been confiscated'. Noting that they are not a court of law (so have no real powers of jurisdiction), the Tribunal advised that they can clarify the point that Te Papa does not own the *whare*, but cannot make the museum return it (Waitangi Tribunal 2004b: 602). They did, however, advocate that the wall panel accompanying Te Hau ki Turanga be reworded. Given 'the importance of the role of institutions such as museums in increasing public understanding of our shared past', they outlined their view that:

> the reference on the board to Te Hau ki Turanga being 'acquired by the government in 1867' is an inadequate explanation of the unhappy circumstances in which the whare was removed from the possession of Rongowhakaata. We consider that Te Papa should consult with Rongowhakaata on a revised wording which reflects, appropriately and honourably, the forcible removal of the whare in the aftermath of the siege of Waerenga a Hika in 1865. (Waitangi Tribunal 2004b: 607)

While the word 'acquired' has remained, the wall panel is fascinating for slightly different semiotic reasons. On the one hand, while the museum was not forthcoming in accepting that they had no right to ownership over the *whare*, the sign illustrates a paradox, because as part of its commitment to biculturalism, Te Papa has been consistent and progressive in relation to insisting that those who best know their complex histories should control the mode of interpretation used in the museum. An example of this is illustrated by the statement by Rongowhakaata that also occupies the panel in question: 'Our love for our ancestors and their heritage keeps alive our interest and involvement in this house. Today, Te Hau ki Turanga symbolizes the proud identity of Rongowhakaata, our contribution to the nation, and our commitment to a bicultural partnership with Te Papa Tongarewa, the Museum of New Zealand.' In place of relinquishing legal ownership to Rongowhakaata (the sign was erected prior to the Tribunal's outcome) the museum has developed a concept of 'cultural ownership', which means it acts as guardian on the understanding that Maori *iwi* and other tribal groupings have unrestricted access to the object for significant occasions like *hui* (assemblies) and *tangihanga* (funerals). Indeed, throughout the hearing over Te Hau ki Turanga, the Tribunal noted evidence that this relationship had existed since 1990, and advocated further that Rongowhakaata be made jointly responsible for management of decisions over the preservation and care of the *whare* (Waitangi Tribunal 2004b: 605–7).

In many ways, this case study shows Te Papa to exemplify the statement made by Ames (2005: 44–5), that 'Museums are compromised institutions, caught between their twin desires for both authenticity and the spectacular', whereby they require at least some of these authentic 'objects to be spectacular while simultaneously asserting in a democratic

spirit that all their objects are important'. It also shows how disputes over material culture and heritage can be used to strengthen community relationships, presenting the museum as a positive agent, whereby it may even corroborate Clifford's contention that in making visible various contrasting and different agendas, the museum functions as a contact zone by offering the conditions required for dialogue that incorporates a multiplicity of diverse voices and agencies (Coles and Clifford 2000). In the context of Te Papa, Te Hau ki Turanga offers both the preeminent and the most evidently fraught possibility for achieving properly bicultural – crosscultural and transhistorical – dialogue and may, as such, offer evidence for Stephen Weil's (2002: 68) argument that museums can offer distinctive public spaces 'in which diverse elements of the community might intermingle in ways not readily available elsewhere'. Both authentic and spectacular, Te Hau ki Turanga also offers an additional point of nexus whereby its spatial location in the museum conspires with its symbolic importance to bring the Treaty of Waitangi (as something that is authentic but not necessarily entertaining) and the *marae* (as spectacular but not necessarily authentic) together, making it even more valuable for the museum.

CONCLUSION

In the last part of this chapter I have focused on the representation and display of Maori culture and heritage to examine Tapsell's contention that 'the new and exciting challenge of today's museums' is to expand the museum's initial agenda of innovation in order to find more contemporary and accurate ways in which they might explore and ascribe meaning to the Treaty principle of partnership. While Tapsell (2005: 266) is concerned with 'finding balance between customary values (lore) and policy (law)', I have argued that this also requires achieving a greater equilibrium between the museum's commitment to 'normative biculturalism (as a guiding social policy principle)' and the 'pragmatic multiculturalism' (Bartley and Spoonley 2005: 146) that is evident beyond the museum and that indicates also the diversity of Maori, Pakeha and migrant communities. This study has tested the hypothesis that in order to continue to be a socially important cultural institution (as it was designed to be), the museum must continue to engage with debates over biculturalism and the preference for multiculturalism that is discernible in the general community. If the museum seeks to reproduce a meaningful engagement with multiculturalism, I argue that it must also demonstrate a dedication to the diversity of Maori culture and an acknowledgment of particularities within the Maori galleries. If this fails to be realized, multiculturalism continues to be the exclusive domain of non-Maori, which means that the museum risks reiterating the assumption that biculturalism and multiculturalism are mutually exclusive systems. Not only does this disregard the possibility of diversity within Maori communities, but it further disenfranchises groups which are neither Maori nor European, who are thereby 'frozen out of the debate on the identity and future of the country' (Thakur 1995: 271).

Further acknowledging the important role that museums perform in relation to this connection between culture, the state, and citizenship – especially in a contemporary context

– Clifford (1997: 218) acknowledges that, 'In a global context where collective identity is increasingly represented by having a culture (a distinctive way of life, tradition, form of art, or craft) museums make sense.' Of course this can be taken as meaning two things: either museums can model or embody a progressive approach and understanding, or they can preserve old ideas about the singularity of national identity and work, therefore, to maintain conviction in historical boundaries. However, the association between museums and older ideas of more traditional nation-statist identities is now increasingly coming under attack because the transformations implicit in the process of becoming-global mean that (in theory, at least), notions of citizenship and national identity are being renegotiated, and that in many cases, the trajectory of such exchange is far from clear (Van den Bosch 2005: 84). As such, and in addition to blurring the relationship between the cultural and other national and internationally structuring forms, museums like Te Papa and the CCT play equally vital but highly different roles in motivating us to question how the global forces of dispersion, mobility and monopoly have transformed our own experiences of political freedom and cultural identity.

> Most of the uses of culture that I have reviewed in this book have been premised on a
> reasonably stable world. Under those circumstances, museums and renovated waterfronts
> can contribute to the economic development of cities and attract innovators for local
> industry; community artists can help trouble-shoot acute social problems like racism,
> segregation, and residential displacement; supranational cultural integration can provide
> the means for practitioners from peripheral countries to compete with those in the first
> world; consumption can be a means for practicing citizenship; and so on. But what
> happens when there is economic crisis, terrorism, or war? Can we always rely on a stable
> world? And if not, what is the role of culture in times of ongoing crisis...? (Yúdice 2003:
> 338)

I started writing this book several months before the 2004 Boxing Day tsunami. As Yúdice
expressed a feeling of hopelessness in response to the September 11 attacks, I wondered what
role culture or the reconstruction of cultural heritage could – or should – play in the post-
tsunami period; when so many people had lost loved ones and faced an uncertain future
without food, shelter, or work prospects. I was particularly interested in the contradiction
apparent between the speeches made by various world leaders in regard to the almost
unthinkable scale of reconstruction that lay ahead. Speaking from the globalized perspective
of the United Nations, Kofi Annan focused on the specificities of cultural diversity and
plurality, and lamented the loss of the 'religion, spirituality and culture [that] lie at the heart
of human existence… The very things that define people's identities and values have been
swept away' (Barker 2005). In contrast, the Australian Prime Minister, John Howard, praised
the public's generous financial contributions as a signifier of 'Australianness' (Fitzsimmons
2005). His discourse of a unified national identity deployed a familiar, centralizing and
singular agenda, which positions hybridity as a potentially divisive force. According to this
strongly nationalizing agenda, key components of cultural diversity, including religion, were
politically neutralized via a new framework that represented cultural difference according
to a discourse of suffering. In this context, the cultural hybridity that Annan addressed risks
being replaced by such images of universal suffering, whereby the great humanist 'family of
man' model is reasserted as being beyond question.

In contrast to this rhetoric, soon after the disaster ICOM established a website to
assist in disaster-relief efforts (http://icom.museum/disaster_relief/). It was designed to
provide immediate strategies for minimizing and managing damage to areas of cultural
significance (such as museums, heritage sites, as well as archives and other collections).

It also established a series of funds to help people rebuild their lives. These efforts were important and reflected the fact that, for most people, culture does not evoke the sense of life-threatening urgency that the need to grieve, to rebuild dwellings, or to find food does. However, in the face of unprecedented public interest and contributions to relief funds, it also struck me as problematic that culture was being separated so distinctively from the other procedures of renewal – when, in normal circumstances, culture cannot be removed from strategies of nation building (which is itself a process that is always ubiquitous, even in the most economically fragile or chaotic state). Although it was vital to recognize that the principal concern of local and overseas government groups had to be the reconstruction of infrastructure and services in the disaster affected areas, it also seemed important to provoke interest in the preservation of memory and intangible culture; both for the survivors, and in recognition that this kind of cultural regeneration also participates in the political and infrastructural reconstruction of the affected areas and national imaginaries. Indeed, this interrelationship is noted by the *UNESCO Universal Declaration on Cultural Diversity*, which locates culture 'at the heart of contemporary debates about identity, social cohesion, and the development of a knowledge-based economy' (UNESCO 2001: n.p.).

NEWNESS AND POLITICAL AGENCY

To recognize, examine and comprehend museums as complex, multilayered and multifunctional sites that maintain vast networks of significance across history, place and politics, mobility, identity and economics, it is necessary to employ a critical comparative methodology. Within this framework, both theoretical and evaluative approaches are necessary for understanding the empirical data offered up by museums and the broader field of museum studies, because the cultural institutions discussed here have already adopted strategies from government policy, social theory, postcolonial studies and development studies. For instance, the interaction between museums and national politics is acutely evident in the relationship between national museums like Te Papa and the NMA and the 'culture wars', and the CCT and Kanak nationalism. Analysis of these dynamics contributes to our understanding of these museums and cultural centres and the relationship that they have with dominant cultural trends and systems of governance. Given that museums have internalized many of these strategies within their architecture, exhibitions and public programmes, I contend that now is the time to reflect academically on how all these aspects have come together to produce new forms of the museum and new strategies for the attraction, entertainment, education and possibly reform of its various publics.

As I have explored throughout this book, the preference for newness and the privileging of cultural diversity have combined in museums built since approximately the mid-1990s to produce a new kind of institution that seeks to function more like a cultural centre. Rather than privileging traditional ideas of museological practice, the new museum aspires to a museumlike exhibitionary complex. This new museum-as-cultural centre acts

self-consciously as a political agent and plays an advocacy role in the reconstruction of cultural identity and the promotion of crosscultural dialogue. For example, the relationship between culture and politics is clearly rendered in museums like the National Museum of the American Indian, the Museum of Chinese in the Americas and the Centre Culturel Tjibaou, which all aim to provide access to self-representation for particular communities. Yet, this struggle to achieve a workable balance and dialogue between heterogeneous con- stituencies is itself a politicization of the museum and the culture it promotes. By linking this contemporary discourse of 'newness' to historical examples it is possible to examine afresh the unresolved tension existing between discourses of modernity and postmodernity. This is most clearly evident in my examination of MoMA. However, this deeper chronology demonstrates how the preference for newness was consistently connected to the reformist nation-building programmes from the mid-nineteenth century onwards. Emerging from a concern with class reform and civilization, these programmes developed alongside col- onization to define, classify, produce and control racial otherness. These programmes and concerns principally expanded through the world's fairs and international exhibitions, which also played a key role in the commodification of newness, spectacle and otherness.

Against this background, I have evaluated whether more recent attempts to bring a pol- iticized and inclusive view of culture into the mainstream public sphere may have actually caused the downfall of the plans to build the International Freedom Center on Ground Zero. And in presenting an analysis of the CCT's direct relationship with politics, I have explored the effect that this 'entanglement' continues to have on the emerging national culture to consider whether this cultural centre – designed according to the features of new museums globally – might in fact offer a new set of possibilities for the promotion of diverse local cultures. I have concluded with analysis of Te Papa's aim to achieve a new style of museum that functions as a cultural centre responsive to a heterogeneous and diverse nationhood. While the other case studies focused on the aims and desires of the new museums discussed, Te Papa is particularly fascinating for the way it reveals the new museum as struggling pragmatically with these aspirations and the question of how to manifest them in concrete ways.

COMPETING LABELS

In a useful summary of the new museology, Geismar and Tilley (2003: 171) explain that 'studies within the "New Museology" (Vergo 1989; Powell 1991) emphasize that museums encapsulate a culturally defined method of ordering and controlling the world through objects (Hooper-Greenhill 1992, 2000; Hein 2000), representing both people and places via material culture (Pearce 1990, Ames 1992, Bolton 1997)'. In contrast, I have argued that the new museum (which is, in some respects, a post-new-museology model) privileges above all an (historical) image of *newness* and that it orders and controls its objects and spaces so as to emphasize this image of newness. The two paradigms are clearly very similar. The new museum is no less interested in – and is no less a product of – 'culturally defined

method[s] of ordering and controlling the world', however its primary techniques are not tied to objects or material culture, but to the image and allusion of newness that is largely produced through intertextual promotions and rhetorics. The basis of the new museum may hence be critiqued for privileging the effects of rhetorical language (which support production and maintenance of images of newness). However, the anti-ethnographic and anti-material culture characteristic of this linguistic turn is problematic for the new museum because it competes against many of the core interests and projects conducted by museums today (which often focus less on material culture as such than on the relationships and networks that objects are seen to facilitate). It also rubs up against escalating patterns of global heritage tourism and the renewed attention to issues of authority and authenticity that accompany this, as well as the attempt by museums and exhibitionary spaces to develop more lasting and productive relationships with communities.

This might mean that 'the new museum' proper referred to a short-lived moment in the history of museums (barely spanning a period from the late 1980s to the present day) that was associated with a revitalized popularization and surge of investment in museums and culture. However, I think it is more reasonable to suggest that the new museum was always more compromised than this and that it never really functioned as a discrete model (or product of language) disconnected from the realpolitiks of museums. It might, as such, be more valuable to think about the new museum as occupying a point of transition between the material culture focus of the new museology and the current fascination with transforming museums into more relational and contextually embedded and relevant cultural centres. It is important, too, to recognize that this most recent shift does not represent a move away from globalization (any movement is well informed by UNESCO and ICOM policy as well as international agreements over culture and trade), however it may indicate that the centralized Western taxonomy of order and regulation that has been embodied by museums historically (as 'microcosms' of the world) is being reconfigured by a different, less universal and homogenous view of globalization. According to this view, globalization functions according to a 'complex connectivity' that may challenge the traditional centralization of world power and connect phenomena, people and experience through an alternate logic from that produced through traditional colonial flows of people, resources and knowledge (Tomlinson 1999; Sassen 1991, 2003). Reflecting a situation whereby culture is no longer relatively autonomous, but is itself collapsed into other phenomena, this clearly offers both a challenge as well as opportunities for the new generation of institutions built according to a museum-as-cultural centre model.

CRITIQUE, AFFIRMATION AND PRAGMATISM: THE NEW MUSEUM-AS-CULTURAL CENTRE?

Despite the somewhat thin association often drawn between the new museum and an increasingly generic homogenized, globalized enterprise culture, it has been my argument that no singular museological model is sustainable, if indeed it ever was. Museums have always juggled diverse agendas (even as they have attempted to assert authority over difference), and

despite producing difference, they have not altogether been able to control the silent subject positions of minority and marginalized groups that have historically been represented within the museum but given no voice. In this book, I have explored how museums have functioned as tools useful for the projects and discourses of colonization and modernization (and been instrumental in the discourses of civilization, reformism, industrialization and progress that are associated with this). In doing so, museums have also, and perhaps unwittingly, engaged those categorized as 'other' so that the exhibitionary apparatus has itself become subject to observation and analysis; at least to a degree. Furthermore, as I have shown in relation to a wide survey of examples, more and more museums aim to present themselves as nuanced cultural institutions with practices that are interdisciplinary, multipurpose, collaborative and crosscultural. This objective reflects attempts by indigenous groups to control the way they are represented, responding also to the assertion of self-sovereignty within complex processes of decolonization and the multiculturalism that is privileged in many cases by the dominant state. Progressively, thus, the 'new museum' (with its abstract theoretical, postmodern undertones) is being reconfigured through attempts to create new 'museums as cultural centres', which embody postcolonial frameworks and that seek to manifest a more empirically connected set of relationships with communities.

The increasing preference for replacing singular museums with a series of discrete cultural centres that speak to particular communities may reiterate national policies of multiculturalism and global policies of cultural diversity, whereby difference is tolerated (and thus contained), culture is increasingly tied to tradition and heritage (as a commodity attractive to cultural tourism), but where crosscultural encounter and accounts of difficult historical events may be avoided. In this, the new museum-as-cultural centre risks invoking what Ghassan Hage calls 'the workings of the multicultural spectacle of the nation', and manifesting organizing tropes that 'derive from the classificatory systems of collections and zoology which "belong to a long Western colonialist tradition of exhibiting the national self through the exhibiting of otherness"' (Hage 1993: 123 in Gunew 2004: 29).

How can we interpret this shifting context, these changed preferences, and the range of implications that these might have for contemporary museums? How, in particular, are we to understand the relationship that becomes apparent here 'between critique and affirmation?' (During 2005: 214). As During notes in his survey account of the discipline of cultural studies, 'loose ends, irresolutions, contradictions and frictions' abound. Cultural studies has become the dominant approach used in the analysis of museums and culture, even more so because this state of contingency relates also to the museums and cultural institutions which are subject to our analysis. During's position is to welcome the articulation of diverse opinion and debate and contributes to reminding us, *vis a vis* Geertz (2004), that as the subject of contested viewpoints, museums are complicated places.

Each museum in this book has visibly and publicly struggled to manage governmental demands and organizational pressures and to experiment with innovative and varying approaches to exhibition, experience, and meaning production. Like the discipline of

cultural studies itself, they have struggled to discover intersections between their desire for transnational extension and their aim to maintain respect for difference, and they have struggled similarly to create a space of dialogue between the museum's 'embrace of enterprise and of marginality' (During 2005: 214). They have employed postmodern strategies, often drawn from the fields of architecture and literary theory, to create a compelling effect of newness, and in many cases, the architectural and rhetorical flourish has been taken as evidence of their resounding newness (see Brawne 1965). And yet, within the desire to be perceived as both postmodern and new (within an overarching modernist frame that continues to privilege newness as a sign of progress), lies something of a paradox that may lead us to doubt whether these museums' claims to be new (or, by extension, the claims made by cultural studies to immediate practicality) can be justified.

There does, however, continue to be something compelling in their ongoing attempts – particularly in their attempt to provide a public space that is inclusive and open to the self-representation of diverse voices and political positions. Each museum's embodiment of irresolution, methodological gaps, loose ends and contradictions conspires to produce another discussion, about whether the discourses of the new museum – of access, democracy, the recognition of cultural diversity – might break with the museum's traditional project of civic reform and succeed in offering an alternative and effective framework of cultural production and engagement (rather than rephrasing the reformist agenda according to a new rhetoric). The focus on multiculturalism and cultural diversity that is increasingly presented as a signifier of newness may thus gain more than a rhetorical impact than the now passé trend for postmodernity, and might contribute to produce further negotiations about the relationship between new museums and culture.

ABBINNETT, Ross (2003), *Culture and Identity: Critical Theories*, London: Sage.

ADAMS, Henry (1964 [1900]), 'The Dynamo and the Virgin', in *The Education of Henry Adams: An Autobiography*, New York: TIME Reading Program Special Edition.

ADBURGHAM, Alison (1975), *Liberty's: A Biography of a Shop*, London: George Allen & Unwin.

ADORNO, Theodor W. and Horkheimer, Max (1986), *Dialectic of Enlightenment*, trans. John Cumming, New York: Continuum.

AGENCY for the Development of Kanak Culture (ADCK) (1998), *Tjibaou Cultural Centre*, trans. Roy Beynon, Nouméa: ADCK.

—— (2005), *Programme saison 2005 centre culturel Tjibaou*, Nouméa: ADCK.

ALDRICH, Robert (2005), *Vestiges of the Colonial Empire in France: Monuments, Museums and Colonial Memories*, Basingstoke: Palgrave Macmillan.

ALLEY, Oskar (2004), 'Te Papa Treasure "Stolen"', *The Dominion Post*, 2 November.

ALLWOOD, John (1977), *The Great Exhibitions*, London: Studio Vista.

AMES, Michael M. (1986), *Museums, the Public and Anthropology: A Study in the Anthropology of Anthropology*, Vancouver: University of British Columbia Press.

—— (1992), *Cannibal Tours and Glass Boxes: The Anthropology of Museums*, Vancouver: University of British Columbia Press.

—— (2005), 'Museology Interrupted', *Museum International*, 227(57.3): 44–50.

ANDERSON, Gail (ed.) (2004), *Reinventing the Museum: Historical and Contemporary Perspectives on the Paradigm Shift*, Marburg an der Lahn: Basilisken Press.

APPADURAI, Arjun (1996), *Modernity at Large: Cultural Dimensions of Globalization*, Minneapolis: University of Minnesota Press.

—— (2002), 'Deep Democracy: Urban Governmentality and the Horizon of Politics', *Public Culture,* 14(1): 21–47.

—— and Breckenridge, Carol A. (1992), 'Museums Are Good to Think: Heritage on View in India', in Ivan Karp and Christine Mullen Kreamer (eds), *Museums and Communities: The Politics of Public Culture,* Washington DC: Smithsonian Institution Press.

ARNOLD, Matthew (1994 [1869]), *Culture and Anarchy and Other Writings*, ed. Samuel Lipton, New Haven and London: Yale University Press.

ART Journal (1970 [1851]), *The Crystal Palace Exhibition. Illustrated Catalogue: London 1851,* New York: Dover.

ATTWOOD, Bain and Foster, Stephen (eds) (2003), *Frontier Conflict: The Australian Experience,* Canberra: National Museum of Australia.

AUERBACH, Jeffrey A. (1999), *The Great Exhibition of 1851: A Nation on Display,* New Haven and London: Yale University Press.

Austin, Mike (1999), 'The Tjibaou Cultural Centre', *Pander OS, 2.0,* issue 8 (Winter), http://www.thepander.co.nz/architecture/maustin8.php.

Australian Bureau of Statistics (National Centre for Culture and Recreation Statistics) (2003), *Australia's Trade in Culture 2000–01*, Canberra: Cultural Ministers Council Statistics Working Group, Commonwealth of Australia.

Bal, Mieke (1996a), 'The Discourse of the Museum', in Reesa Greenberg, Bruce W. Ferguson and Sandy Nairne (eds), *Thinking about Exhibitions*, London and New York: Routledge.

—— (1996b), *Double Exposures: The Subject of Cultural Analysis*, New York: Routledge.

Banham, Mary and Hillier, Bevis (eds) (1976), *A Tonic To the Nation: The Festival of Britain 1951*, London: Thames & Hudson.

Barker, Anne (2005), 'UN to co-ordinate international relief effort', *PM*, 6 January., http: //www.abc.net.au/pm/content/2005/s1277753.htm

Barnett, Clive (1999), 'Culture, Government and Spatiality: Reassessing the "Foucault effect" in Cultural-policy Studies', *International Journal of Cultural Studies,* 2(3): 369–97.

Barrie, Andrew (2001), 'A Shift from the Transparent: Media Architecture – Architectural Media', *Blurring Architecture*, August., http: //www.artspace.org.nz/shows/Ito.htm.

Barringer, Tim (1998), 'The South Kensington Museum and the Colonial Project', in Tim Barringer and Tom Flynn (eds), *Colonialism and the Object: Empire, Material Culture and the Museum*, London and New York: Routledge.

Barthes, Roland (1993 [1973]), *Mythologies*, trans. A. Lavers, London: Paladin Grafton.

—— (1997a), 'Semiology and the Urban', in Neil Leach (ed.), *Rethinking Architecture: A Reader in Cultural Theory*, New York: Routledge.

—— (1997b), 'The Eiffel Tower', in Neil Leach (ed.), *Rethinking Architecture: A Reader in Cultural Theory*, New York: Routledge.

Bartley, Allen and Paul Spoonley (2005), 'Constructing a Workable Multiculturalism in a Biculturalism Society', in Michael Belgrave, Merata Kawharu and David Williams (eds) *Waitangi Revisited: Perspectives on the Treaty of Waitangi*, South Melbourne: Oxford University Press.

Baudrillard, Jean (1993), *The Transparency of Evil: Essays on Extreme Phenomena,* trans. J. Benedict, London: Verso.

—— (1996), *Jean Baudrillard: Selected Writings*, ed. Mark Poster, Cambridge: Polity.

—— (1997), 'The Beaubourg-Effect: Implosion and Deterrence', in Neil Leach (ed.), *Rethinking Architecture: A Reader in Cultural Theory*, New York: Routledge.

—— (1998), 'The Ecstasy of Communication', in Hal Foster (ed.), *The Anti-Aesthetic: Essays on Postmodern Culture*, New York: The New Press.

Bauman, Zygmunt (1973), *Culture as Praxis*, London and Boston: Routledge & Kegan Paul.

—— (1998), *Globalization: The Human Consequences*, Cambridge: Polity Press.

—— and Tester, K. (2001), *Conversations with Zygmunt Bauman*, Cambridge: Polity Press.

Bell, Avril (2004), '"Half-castes" and "White Natives": The Politics of Maori-Pakeha Hybrid Identities', in Claudia Bell and Steve Matthewman (eds), *Cultural Studies in Aotearoa New Zealand: Identity, Space and Place*, South Melbourne: Oxford University Press.

Benedict, Burton (ed.) (1983), *The Anthropology of World's Fairs: San Francisco's Panama Pacific International Exposition of 1915*, London and Berkeley: Scolar Press.

Benjamin, Walter (1978), *Reflections,* ed. P. Demetz, trans. E. Jephcott and K. Shorter, London: New Left.

—— (1997), *Charles Baudelaire: A Lyric Poet in the Era of High Capitalism*, trans. H. Zohn, London: Verso.

BENNETT, Tony (1995), *The Birth of the Museum: History, Theory, Politics*, London and New York: Routledge.

—— (1997), 'Museums and their Constituencies: Community, Audiences, Publics and Citizens', *New Zealand Museums Journal*, 26(2): 15–23.

—— (1998), *Culture: A Reformer's Science*, St. Leonard's, New South Wales: Allen & Unwin.

—— (1999), 'Useful Culture', in David Boswell and Jessica Evans (eds), *Representing the Nation: A Reader*, London and New York: Routledge.

—— (2004), *Pasts Beyond Memory: Evolution, Museums, Colonialism*, London and New York: Routledge.

BENNION, Tom (2005), 'Lands Under the Sea: Foreshore and Seabed', in Michael Belgrave, Merata Kawharu and David Williams (eds) *Waitangi Revisited: Perspectives on the Treaty of Waitangi*, South Melbourne: Oxford.

BENSA, Alban (ed.) (1992), *La réalisation du Centre culturel Jean-Marie Tjibaou: analyses, enquêtes, documentation*, Nouméa/Paris: Ministère de la Culture, Mission des Grands Travaux.

—— (1995), *Chroniques Kanak: L'ethnologie en marche*, Paris: Ethnies-Documents (peuples Autochtones et Développement).

—— (2000), *Ethnologie et Architecture: le Centre Culturel Tjibaou: une Réalisation de Renzo Piano*, Paris: Adam Biro.

—— and Wittersheim, Eric (1998), 'Jean Guiart and New Caledonia: A Drama of Misrepresentation', *The Journal of Pacific History*, 33(2): 221–25.

BERLIER, Monique (1999), 'The Family of Man: Readings of an Exhibition', in Bonnie Brennen and Hanno Hardt (eds), *Picturing the Past: Media, History and Photography*, Urbana and Chicago: University of Illinois Press.

BERMAN, Marshall (1988), *All That Is Solid Melts Into Air*, London: Penguin.

BERRY, Ruth (2004), 'Foreshore Bill Passes After Marathon Session', *New Zealand Herald*, 19 November.

BEZNER, Lili Corbus (1999), *Photography and Politics in America: From the New Deal into the Cold War*, Baltimore: Johns Hopkins University Press.

BOLTON, Lissant (1994), '*Bifo Yumi Ting se Samting Nating*: the Women's Culture Project at the Vanuatu Cultural Centre', in L. Lindstrom and G. White (eds), *Culture-Kastom-Tradition: Developing Cultural Policy in Melanesia*, Suva: Institute of Pacific Studies, the University of the South Pacific.

—— (1997), 'A Place Containing Many Places: Museums and the Use of Objects to Represent Place in Melanesia', *Australian Journal of Anthropology*, 8: 18–34.

—— (2001), 'The Object in View: Aborigines, Melanesians and Museums', in A. Rumsey and J. Weiner (eds), *Emplaced Myth: Space, Narrative and Knowledge in Aboriginal Australia and Papua New Guinea*, Honolulu: University of Hawai'i Press.

—— (2003), *Unfolding the Moon: Enacting Women's Kastom in Vanuatu*, Honolulu: University of Hawai'i Press.

BONYTHON, Elizabeth and Burton, Anthony (2003), *The Great Exhibitor: The Life and Work of Henry Cole*, London: Victoria & Albert Publications.

BOSSLEY, P (1998a), 'Container Ship', *Architecture New Zealand,* 1: 77–83.

—— (1998b), 'Concepts: Concepts in Culture', *Architecture New Zealand,* 1: 18–19.

—— (1998c), 'Concepts: Redirect, Redevelop', *Architecture New Zealand,* 1: 22–3.

—— (1998d), 'The Treaty', *Architecture New Zealand,* 1: 64–7.

BOSTOCK, Gerry (1996), 'Colebe', in Ross Gibson (ed.), *Exchanges: cross-cultural exchanges in Australia and the Pacific,* Sydney: Historic Houses Trust of New South Wales.

BOSWELL, David and Evans, Jessica (eds) (1999), *Representing the Nation: A Reader: Histories, Heritage and Museums,* London and New York: Routledge.

BOURDIEU, Pierre (1984), *Distinction: A Social Critique of the Judgement of Taste,* London: Routledge & Kegan Paul.

—— and Darbel, Alain with Schnapper, D. (1991), *The Love of Art: European Art Museums and their Public,* trans C. Beattie and N. Merriman, Stanford, CA: California University Press.

BOWLBY, Rachel (1985), *Just Looking. Consumer Culture in Dreiser, Gissing and Zola,* New York and London: Methuen.

BOXER, Sarah (2004), 'The Modern's Cool New Box: Displaying Art, Not Fighting It', *New York Times,* 5 May.

BOYER, M. Christine (1996), 'The Panorama of New York City: A Paradoxical View', in Patricia C. Phillips (ed.), *City Speculations,* New York: Queens Museum of Art and Princeton Architectural Press.

BOŽIĆ-VRBANČIĆ, Senka (2003), 'One Nation, Two Peoples, Many Cultures: Exhibiting Identity at Te Papa Tongarewa', *Journal of the Polynesian Society,* 112(3): 295–324.

BRADDOCK, John (2004), 'Tensions Erupt Over "Preferential" Policies for Maori', *New Zealand Herald,* 26 February.

BRAWNE, Michael (1965), *The New Museum: Architecture and Display,* New York: Praeger.

BRECKENRIDGE, Carol A. (1989), 'The Aesthetics and Politics of Colonial Collecting: India at World's Fairs', *Comparative Studies in Society and History,* 31(2): 195–216.

BRIDGELAND, John (2005), 'At Ground Zero', *New York Sun,* 23 September.

BRIGGS, Asa (2000), 'Exhibiting the Nation', *History Today* 50(1): 16–25.

BRIGGS, Charles (1996), 'The Politics of Discursive Authority in Research on the "Invention of Tradition"', *Cultural Anthropology,* 11(4): 435–69.

BROWER, Benjamin C (1999), 'The Preserving Machine: The "New" Museum and Working through Trauma – The Musée Mémorial pour la Paix of Caen', *History and Memory,* 11(1): 77–103.

BROWN, Deidre (1996), 'Te Hau ki Turanga', *Journal of the Polynesian Society,* 105(1): 7–26.

BROWN, Maria (2002), 'Representing the Body of a Nation: The Art Exhibitions of New Zealand's National Museum', *Third Text,* 16(3): 285–94.

BROWN, Peter (1998), 'New Caledonia: Strangers in Paradise, Stranger than Paradise', *International Journal of Francophone Studies,* 1(3): 125–39.

—— (2001), 'New Caledonia: A Pacific Island or an Island in the Pacific? The Eighth Pacific Arts Festival', *International Journal of Francophone Studies,* 4(1): 33–41.

—— (2002), 'Book Review: *Ethnologie et architecture: le centre culturel Tjibaou: une réalisation de Renzo Piano', The Contemporary Pacific,* 14(1): 281–4.

BUCHLOH, Benjamin H. D. Davidson, Cynthia. Boise, Yve-Alain and Wigley, Mark (2005), 'The New MoMA', *Artforum,* 43(6): 131–46.

BURKEMAN, Oliver (2004), 'Moma Comes Home to Manhattan, at a Price', *Guardian*, 28 September.

BURLINGAME, Debra (2005), 'The Great Ground Zero Heist', *Wall Street Journal*, 7 June.

BURTON, Anthony (1999), *Vision and Accident: The Story of the Victoria and Albert Museum*, London: Victoria and Albert Museum.

BURTON, Antoinette (1996), 'Making a Spectacle of Empire: Indian Travellers in *Fin-de-Siècle* London', *History Workshop Journal*, 42: 127–46.

BUTLER, Desmond (2004), 'Thousands of Visitors View New York's Reopened Museum of Modern Art', *San Francisco Chronicle*, 20 November.

BUTLER, Judith (1993), *Bodies that Matter: On the Discursive Limits of 'Sex'*, New York: Routledge.

—— (1998), 'Merely Cultural', *New Left Review,* 227(1): 33–44.

CALHOUN, Craig (1992), 'Introduction: Habermas and the Public Sphere', in Craig Calhoun (ed.), *Habermas and the Public Sphere*, Cambridge, MA: MIT Press.

—— (2002), 'Imagining Solidarity: Cosmopolitanism, Constitutional Patriotism, and the Public Sphere', *Public Culture*, 14(1): 147–71.

CANCLINI, Néstor García (1995), *Hybrid Cultures: Strategies for Entering and Leaving Modernity*, trans. Christopher L. Chiappari and Silvia L. López, Minneapolis: University of Minnesota Press.

—— (2004), 'Remaking Passports: Visual Thought in the Debate on Multiculturalism', in Donald Preziosi and Claire Farago (eds), *Grasping the World: The Idea of the Museum*, Burlington, VT: Ashgate.

CANNADINE, David (1983), 'The Context, Performance and Meaning of Ritual: The British Monarchy and the Invention of Tradition', in Eric Hobsbawm and Terence Ranger (eds), *The Invention of Tradition*, Cambridge: Cambridge University Press.

CARBONELL, Bettina Messias (ed.) (2004), *Museum Studies: An Anthology of Contexts*, Malden MA: Blackwell.

CARTER, Paul (2004), *Material Thinking: The Theory and Practice of Creative Research*, Carlton, Victoria: Melbourne University Press.

CASH, Stephanie and Ebony, David (2005), 'New MOMA Packs 'em In', *Art in America,* 93(1): 160.

CASTELLS, Manuel (1989), *The Informational City: Information Technology, Economic Restructuring, and the Urban-Regional Process*, Oxford: Blackwell.

CAVE, Damien (2004a), 'A Day of Art Appreciation as the Modern Reopens', *New York Times*, 21 November.

—— (2004b), 'A Day to Savor Art as the Modern Reopens', *New York Times*, 21 November.

CENTER for Arts and Culture (2001), *America's Cultural Capital: Recommendations for Structuring the Federal Role*, Center for Arts and Culture (Art, Culture and the National Agenda), http://www.culturalpolicy.org

CEREBANO, Ron (1998), 'Noumea Centre Focuses on Kanak Culture', *Canberra Times,* 15 June.

CHAKRABARTY, Dipesh (2000), *Provincializing Europe: Post-colonial Thought and Historical Difference*, Princeton: Princeton University Press.

—— (2002), 'Museums in Late Democracies', *Humanities Review,* 9(1): 5–12.

CHAN, Sewell (2004), 'Next Big Hit at The Modern: It's Reopening', *New York Times*, 19 November.

CHAPPELL, David A. (1999), 'The Noumea Accord: Decolonisation without Independence in New Caledonia?' *Pacific Affairs,* 72(3): 373–91.

—— (2001), 'New Caledonia: Melanesia in Review: Issues and Events, 2000', *The Contemporary Pacific,* 13(2): 541–51.

CHARLESWORTH, J. J. (2002), 'Twin Towers: The Spectacular Disappearance of Art and Politics', *Third Text,* 16(4): 357–66.

CHENEY, Lynne (1995), *Telling the Truth: Why Our Culture and Our Country Have Stopped Making Sense – and What We Can Do about It,* New York: Touchstone.

CHESNEAUX, Jean (1988), 'Kanak Political Culture and French Political Practice', in Michael Spencer, Alan Ward and John Connell (eds), *New Caledonia: Essays in Nationalism and Dependency,* St Lucia, Queensland: University of Queensland Press.

CIVIC Alliance to Rebuild Downtown New York (2002), *Listening to the City: Report of Proceedings,* New York: Civic Alliance to Rebuild Downtown New York convened by Regional Plan Association in partnership with NYU/Wagner, New School University, the Pratt Institute and AmericaSpeaks.

CLAMMER, John (2005), 'Culture, Development, and Social Theory: On Cultural Studies and the Place of Culture in Development', *The Asia Pacific Journal of Anthropology,* 6(2): 100–119.

CLIFFORD, James (1997), *Routes. Travel and Translation in the Late Twentieth Century,* Cambridge: Harvard University Press.

—— (1988), *The Predicament of Culture: Twentieth-Century Ethnography, Literature, and Art,* Cambridge, MA: Harvard University Press.

—— (2000), 'Taking Identity Politics Seriously: The Contradictory, Stony Ground', in Paul Gilroy, Lawrence Grossberg and Angela McRobbie (eds), *Without Guarantees: Essays in Honour of Stuart Hall,* London: Verso.

—— (2001), 'Dialogue: Indigenous Articulations', *The Contemporary Pacific,* 13(2): 468–90.

—— (2004), 'Looking Several Ways: Anthropology and Native Heritage in Alaska', *Current Anthropology,* 45(1): 5–30.

COCHRANE, Susan (1996), 'Pacific Stories from New Caledonia', *Artlink,* 16(4): 52–4.

—— (1999), 'Out of the Doldrums: Museums and Cultural Centres in Pacific Islands Countries in the 1990s', in Barrie Craig, Bernie Kernot, and Christopher Anderson (eds), *Art and Performance in Oceania,* Honolulu: University of Hawai'i Press.

COLES, Alex and Clifford, James (2000), 'Siting Ethnography' (interview), in Alex Coles (ed.), *Site-specificity: The Ethnographic Turn,* London: Black Dog.

COLON, Alicia (2005), 'Make WTC More Than 9/11 Memorial', *New York Sun,* 17 June.

COLLINS, Glenn (2005), 'A Return Engagement for a Ground Zero Oasis', *New York Times,* 23 July.

COMMONWEALTH of Australia (1999), *A New Agenda for Multicultural Australia,* Canberra: Commonwealth of Australia.

—— (2003a), *Review of the National Museum of Australia, its Exhibitions and Public Programs, a report to the Council of the National Museum of Australia,* Canberra: Commonwealth of Australia.

—— (2003b), *Multicultural Australia: United in Diversity. Updating the 1999 New Agenda for Multicultural Australia: Strategic Directions for 2003–2006,* Canberra: Commonwealth of Australia.

CONNELL, John (2003), 'An Infinite Pause in Decolonisation?' *Round Table,* 368: 125–43.

COOMBE, Rosemary J. (2005), 'Legal Claims to Culture in and Against the Market: Neoliberalism and the Global Proliferation of Meaningful Difference', *Law, Culture and the Humanities,* 1: 35–52.

COOMBES, Annie E. (2003), *History After Apartheid: Visual Culture and Public Memory in a Democratic South Africa*, Durham and London: Duke University Press.

—— (2004), 'Museums and the Formation of National and Cultural Identities', in Donald Preziosi and Claire Farago (eds), *Grasping the World: The Idea of the Museum*, Burlington, VT: Ashgate.

CORSANE, Gerard (ed.) (2005), *Heritage, Museums And Galleries: An Introductory Reader*, London and New York: Routledge.

COTTER, Holland (2004), 'Housewarming Time for Good Old Friends', *New York Times*, 19 November.

COTTRELL, Anna and Preston, Gaylene (dirs) (1999), *Getting to Our Place*, in association with NZ On Air and TVNZ (videorecording), 72 mins.

CRANE, Susan A. (1997), 'Memory, Distortion, and History in the Museum', *History and Theory*, 36(4): 44–63.

CREATIVE New Zealand (2003), 'Understanding "cultural wellbeing"', Paper presented at *Local government – unlimited? – Local Government New Zealand Conference*, Queenstown, http: //www. creativenz.govt.nz/resources/cultural-wellbeing.rtf.

CRIMP, Douglas (1997), *On the Museum's Ruins*, Cambridge, MA: MIT Press.

CULTURAL Affairs Committee of the Parti Socialist Unifié (1978), 'Beaubourg: The Containing of Culture in France', *Studio International*, 1: 27–36.

CUNDALL, Frank (1886), *Reminiscences of the Colonial and Indian Exhibition*, London: William Clowes & Sons.

DALRYMPLE, Theodore (1999), 'An Amusement Arcade Masquerading as a Museum', *New Statesman*, 12(542): 32–3.

DAVIS, Douglas (1997), 'MOMA looks to the future', *Art in America*, 85(10): 33–5.

DAWSON, Ashley and Edwards, Brent Hayes (2004), 'Introduction: Global Cities of the South', *Social Text*, 81(22.4): 1–7.

DEAN, David and Rider, Peter E. (2005), 'Museums, Nation, and Political History in the Australian National Museum and the Canadian Museum of Civilization', *Museum and Society*, 3(1): 35–50.

DELORIA, Philip J. (1998), *Playing Indian*, New Haven and London: Yale University Press.

DEPARTMENT of Internal Affairs (1992), *Museum of New Zealand Te Papa Tongarewa Act*, Wellington: Department of Internal Affairs.

—— (1994), *Museum of New Zealand Te Papa Tongarewa Annual Report 1 July 1993–30 June 1994*, Wellington: Department of Internal Affairs.

DEPARTMENT of the Prime Minister and Cabinet (2004), *Foreshore and Seabed Bill: Departmental Report*, Wellington: New Zealand Government.

DIBLEY, Ben (2005), 'The Museum's Redemption: Contact Zones, Government and the Limits of Reform', *International Journal of Cultural Studies*, 8(1): 5–27.

DOCKER, John and Fischer, Gerhard (eds) (2000), *Race, Colour and Identity in Australia and New Zealand*, Sydney: New South Wales University Press.

DOMINION POST (2004), 'Axe Attack as MPs Pass Foreshore Law', 19 November.

DORNOY-VUROBARAVU, Myriam (1994), *Policies and Perceptions of France in the South Pacific: New Caledonia and Vanuatu*, Vanuatu: Institute of Pacific Studies and USP Complex.

DOVEY, Kim (2000), 'Myth and Media: Constructing Aboriginal Architecture', *Journal of Architectural Education*, 54(1): 2–6.

DUNCAN, Carol (1995), *Civilising Rituals: Inside Public Art Museums*, London and New York: Routledge.

—— (2002), 'Museums and Department Stores: Close Encounters', in Jim Collins (ed.), *High-Pop: Making Culture into Popular Entertainment*, Malden: Blackwell.

—— and Wallach, Alan (1978), 'The Museum of Modern Art as Late Capitalist Ritual', *Marxist Perspectives,* 1 (Winter): 28–51.

DUNLAP, David W. (2005a), 'Critics Call for Boycott of Memorial Fund-Raising', *New York Times*, 26 July.

—— (2005b), 'Drawing Center May Drop Plan to Move to Ground Zero', *New York Times*, 23 July.

—— (2005c), 'How a Cultural Building Divides the Trade Center', *New York Times*, 28 July.

—— (2005d), 'Freedom Museum Is Headed for Showdown at Ground Zero', *New York Times*, 22 September.

—— (2005e), 'Freedom Center in Doubt', *New York Times*, 25 September.

—— (2005f), 'Governor Bars Freedom Center at Ground Zero', *New York Times*, 29 September.

—— (2005g), 'Downtown Board Criticizes Pataki for Barring Museum', *New York Times*, 7 October.

DUPRE, Judith (2005), 'The Temporary Memorials of 9/11', Paper presented to *Commemoration, Monuments and Public Memory conference*, Humanities Research Centre, The Australian National University, 3 August.

DURING, Simon (2005), *Cultural Studies: a Critical Introduction*, London and New York: Routledge.

DUTTON, Dennis (1998), 'New National Museum Resembles a Junk Shop', *New Zealand Herald*, 21 May.

EAGLETON, Terry (2000), *The Idea of Culture,* Oxford: Blackwell.

EBONY, David (2004), 'MOMA Returns to Manhattan', *Art in America,* 92(10): 43.

ECO, Umberto (1987), 'A Theory of Expositions', in *Travels in Hyper-reality: Essays*, trans. W. Weaver, San Diego: Harcourt Brace Jovanovich.

—— (1997a), 'Function and Sign: The Semiotics of Architecture', in Neil Leach (ed.), *Rethinking Architecture: A Reader in Cultural Theory*, New York: Routledge.

—— (1997b), 'How an Exposition Exposes Itself', in Neil Leach (ed.), *Rethinking Architecture: A Reader in Cultural Theory*, New York: Routledge.

EDELMAN, Murray (1995), *From Art to Politics: How Artistic Creations Shape Political Conceptions*, Chicago, University of Chicago Press.

EL *Diario* (2005), 'A Memorial for All of Us', 26 September.

ELEY, Geoff (1992), 'Nations, Publics, and Political Cultures: Placing Habermas in the Nineteenth Century', in Craig Calhoun (ed.), *Habermas and the Public Sphere*, Cambridge, MA: MIT Press.

ELLER, Jack David (1997), 'Anti-anti-multiculturalism', *American Anthropologist,* 99(2): 249–56.

ELSNER, John and Cardinal, Roger (eds) (1994), *The Cultures of Collecting*, Carlton, Victoria: Melbourne University Press.

EOE, Soroi Marepo (1992), 'The Role of Museums in the Pacific: Change or Die', in Soroi Marepo Eoe and Pamela Swadling (eds), *Museums and Cultural Centres in the Pacific,* National Capital District, Papua New Guinea: Papua New Guinea National Museum.

Epstein Nord, Deborah (1987), 'The Social Explorer as Anthropologist: Victorian Travellers among the Urban Poor', in William Sharpe and Leonard Wallock (eds), *Visions of the Modern City: Essays in History, Art, and Literature*, Baltimore: Johns Hopkins University Press.

Fantin, Shaneen (2003), 'Aboriginal Identities in Architecture', *Architecture Australia,* September–October. 2003 http: //www.archmedia.com.au.

Feiden, Douglas (2005), 'Another Insult to America's Heritage at Freedom Center', *New York Daily News*, 21 August.

Fitzsimmons, Hamish (2005), 'Australians Commemorate Tsunami Victims with Day of Mourning', *AM*, 17 January.

Foster, Hal (ed.), *The Anti-Aesthetic: Essays on Postmodern Culture*, New York: The New Press.

Foucault, Michel (1982), 'Afterword: The Subject and Power', in Hubert L. Dreyfus and Paul Rabinow, *Michel Foucault: Beyond Structuralism and Hermeneutics*, Chicago: University of Chicago Press.

—— (1986), 'Of Other Spaces', *Diacritics,* 16 (Spring): 22–7.

—— (1991), *Discipline and Punish: The Birth of the Prison,* trans. A. Sheridan, London: Penguin.

Frankovits, A. (1998), 'Te Papa Tongarewa', *Art Monthly Australia,* 110: 13–16.

Fraser, Nancy (1992), 'Rethinking the Public Sphere: A Contribution to the Critique of Actually Existing Democracy' in Craig Calhoun (ed.), *Habermas and the Public Sphere*, Cambridge, MA: MIT Press.

—— (1997), 'Heterosexism, Misrecognition, and Capitalism: A Response to Judith Butler', *Social Text,* 52/53: 279–89.

Friedberg, Anne (1993), *Window Shopping: Cinema and the Postmodern*, Berkeley and Los Angeles: University of California Press.

Galla, Amareswar (2002), 'Culture and Heritage Development: Ha Long Ecomuseum, a Case Study From Vietnam', *Humanities Research,* IX (1), http://www.anu.edu.au/hrc/publications/hr/issue1_2002/article07.htm

—— (2005), 'Cultural Diversity on Ecomuseum Development in Viet Nam', *Museum International,* 227(57.3): 101–9.

Gaonkar, Dilip Parameshwar (2002), 'Toward New Imaginaries: An Introduction', *Public Culture*, 14(1): 1–19.

Gardner, James B. (2004), 'Contested Terrain: History, Museums and the Public', *The Public Historian*, 26(4): 11–21.

—— and Henry, Sarah M. (2002), 'September 11 and the Mourning After: Reflections of Collecting and Interpreting the History of Tragedy', *The Public Historian*, 24(3): 37–52.

Gay, Caroline (2003), 'The Politics of Cultural Remembrance: The Holocaust Monument in Berlin', *International Journal of Cultural Policy*, 9(2): 153–66.

Geertz, Clifford (2004), 'What Is a State If It Is Not a Sovereign? Reflections on Politics in Complicated Places', *Current Anthropology,* 45(5): 577–93.

Geismar, Haidy and Tilley, Christopher (2003), 'Negotiating Materiality: International and Local Museum Practices at the Vanuatu Cultural Centre and National Museum', *Oceania*, 73(3): 170–88.

Gibson, Ross (ed.) (1996), *Exchanges: Cross-cultural Exchanges in Australia and the Pacific*, Sydney: Historic Houses Trust of New South Wales.

—— (1998), 'Gary Warner interviewed by Ross Gibson: Ecologies of Meaning,' *Media International Australia Culture and Policy,* 89: 11–20.

GOLDSMITH, Michael (2003a), 'Culture, For and Against: Patterns of "Culturespeak" in New Zealand', *Journal of the Polynesian Society,* 112(3): 280–94.

—— (2003b), '"Our Place" in New Zealand Culture: How the Museum of New Zealand Constructs Biculturalism', *Ethnologies Comparées,* 6, http: //alor.univ-montp3.fr/cerce/r6/m.g.s.doc.

GOODRICH, Donald, Magazine, Susan, Roger, Thomas and Stern, Nikki (2005), 'A Memorial That Lives', *New York Post,* 26 September.

GRAILLE, Caroline (2002), 'From "Primitive" to Contemporary: A Story of Kanak Art in New Caledonia', *State Society and Governance in Melanesia* Discussion Paper 1/02, Canberra: Research School of Pacific and Asian Studies, The Australian National University.

GREENBERG, Clement (1971a), 'Avant-garde and Kitsch', in *Art and Culture: Critical Essays,* Boston: Beacon Press.

—— (1971b), 'The Plight of Culture', in *Art and Culture: Critical Essays,* Boston: Beacon Press.

GREENBERG, Reesa, Ferguson, Bruce W. and Nairne, Sandy (eds) (1996), *Thinking About Exhibitions,* London: Routledge.

GREENHALGH, Paul (1994), *Ephemeral Vistas: The Expositions Universelles, Great Exhibitions, and World's Fairs, 1851–1939 (Studies in Imperialism),* Manchester: Manchester University Press.

—— (1988), 'Education, Entertainment and Politics: Lessons from the Great International Exhibitions', in Paul Vergo (ed.), *The New Museology,* London: Reaktion Books.

GREENSPAN, Elizabeth L. (2003), 'Spontaneous Memorials, Museums, and Public History: Memorialization of September 11, 2001 at the Pentagon', *The Public Historian,* 25(2): 129–32.

GREENWOOD, Thomas (1888), *Museums and Art Galleries,* London: Simpkin, Marshall & Co.

GRIFFIN, Des, Saines, Chris, Wilson, Rodney T. L. (2000), *Ministry of Culture and Heritage Report of Specific Issues Relating to the Museum of New Zealand Te Papa Tongarewa,* Wellington: Ministry for Culture and Heritage.

GRUNENBERG, Christoph (1999), 'The Modern Art Museum', in Emma Barker (ed.), *Contemporary Cultures of Display,* New Haven and London: Yale University Press.

GUIART, Jean (2001), 'Comment: A Reply to A. Bensa and E. Wittersheim, "Jean Guiart and New Caledonia: A Drama of Misrepresentation"', *The Journal of Pacific History,* 36(2): 247–9.

GULLIFORD, Andrew (2000), *Sacred Objects and Sacred Places: Preserving Tribal Traditions,* Boulder, CO: University Press of Colorado.

GUNEW, Sneja (2004), *Haunted Nations: The Colonial Dimensions of Multiculturalisms,* London and New York: Routledge.

HABERMAS, Jürgen (1989), *Structural Transformation of the Public Sphere,* trans. Thomas Burger and Frederick Lawrence, Cambridge, MA: MIT Press.

—— (1992), 'Further reflections on the Structural Transformations of the Public Sphere', in Craig Calhoun (ed.), *Habermas and the Public Sphere,* Cambridge, MA: MIT Press.

—— (1997), 'Modern and Postmodern Architecture', in Neil Leach (ed.), *Rethinking Architecture: A Reader in Cultural Theory,* New York: Routledge.

—— (1998), 'Modernity – An Incomplete Project', trans. Seyla Ben-Habib, in Hal Foster (ed.), *The Anti-Aesthetic: Essays on Postmodern Culture,* New York: The New Press.

HADEN, Frank (1998), 'The Museum of Lady Godiva', *Sunday Star Times,* 22 March.

HAGE, Ghassan (1993), 'Republicanism, Multiculturalism, Zoology', *Communal Plural,* 2: 113–37.

—— (1998), *White Nation: Fantasies of White Supremacy in a Multicultural Society*, Sydney: Pluto Press.

—— (2005), 'Multiculturalism in Warring Societies: the Government of Cultural Pluralism in the Shadow of the War on Terror.' Paper presented to *Biculturalism or Multiculturalism* conference, Christchurch, New Zealand, September.

HALES, Linda (2004), 'Made-Over MoMA Rearranges the Furniture, and the Attitude', *Washington Post*, 30 October.

HALL, Stuart (1999), 'Culture, Community, Nation', in David Boswell and Jessica Evans (eds), *Representing the Nation: A Reader*, London and New York: Routledge.

—— (2000), 'Whose Heritage? Un-settling "the Heritage", Re-imagining the Post-nation', *Third Text*, 49 (Winter): 3–13.

HAMILTON, William L. (2004), 'A Reborn Museum Redesigns Design', *New York Times*, 7 October.

HARAWAY, Donna (1985), 'Teddy Bear Patriarchy: Taxidermy in the Garden of Eden, New York City, 1908–1936', *Social Text*, 11 (Winter): 20–64.

—— (1989), *Primate Visions: Gender, Race, and Nature in the World of Modern Science*, New York: Routledge.

—— (1991), *Simians, Cyborgs and Women: The Reinvention of Women*, London and New York: Routledge.

HARLEY, Robert (1997), 'Renzo Piano Building A Vision', *Australian Financial Review*, 28 November.

HARPER, Jenny (1999), 'For the Sake of Your Art', *Dominion*. 22 June.

HARRIS, Aroha (2004), *Hikoi: Forty Years of Maori Protest*, Wellington: Huia.

HARRIS, Neil (1995), 'Museums and Controversy: Some Introductory Reflections', *Journal of American History*, 82(3): 1102–10.

HARVEY, David (1990), *The Condition of Postmodernity: An Enquiry into the Origins of Social Change*, Oxford: Blackwell.

HAUN, Sarah (2005), 'Snøhetta's Vision for the WTC Cultural Institutions', *Urban Journal*, 18 January.

HAU'OFA, Epeli (2005), 'The Ocean in Us', in Antony Hooper (ed.), *Culture and Sustainable Development in the Pacific*, Canberra: ANU E Press and Asia Pacific Press.

HEIN, Hilde S. (2000), *The Museum in Transition: A Philosophical Perspective*, Washington DC: Smithsonian Institution Press.

HENARE Amiria (2004), 'Rewriting the Script: Te Papa Tongarewa the Museum of New Zealand', *Social Analysis*, 48(1): 55–63.

HENNINGHAM, Stephen (1992), *France and the South Pacific: A Contemporary History*, Sydney: Allen & Unwin.

HEYNON, Hilde (1999), 'Petrifying Memories: Architecture and the Construction of Identity', *Journal of Architecture*, 4 (Winter): 369–90.

HIRSCHKORN, Phil (2005a), '9/11 families protest cultural plans at Ground Zero', *CNN.com*, 21 June.

—— (2005b), 'Ground Zero "Freedom Center" Quashed', *CNN.com*, 28 September.

HOBHOUSE, C. 1950. *1851 and the Crystal Palace*, London: John Murray.

HOFFENBERG, Peter (2001), *An Empire on Display: English, Indian, and Australian Exhibitions from the Crystal Palace to the Great War*, Berkeley: University of California Press.

HOHENDAHL, Peter Uwe (1995), 'Recasting the Public Sphere', *October*, 73: 27–54.

HOOPER-GREENHILL, Eilean (1992), *Museums and the Shaping of Knowledge,* London: Routledge.

—— (2000), *Museums and the Interpretation of Visual Culture*, London: Routledge.

HOROWITZ, Leah S. (2004), 'Toward a Viable Independence? The Koniambo Project and the Political Economy of Mining in New Caledonia', *The Contemporary Pacific,* 16(2): 287–319.

HUDSON, Kenneth (1987), *Museums of Influence*, Cambridge: Cambridge University Press.

—— (1999), 'Attempts to Define "Museum"', in David Boswell and Jessica Evans (eds), *Representing the Nation: A Reader*, London and New York: Routledge.

HUGHES, Robert (1993), *Culture of Complaint: The Fraying of America*, New York: Warner Books.

—— (2004), 'Thoroughly Modern MoMA', *Guardian*, 28 October.

HUNTINGTON, Samuel P. (2004), *Who Are We? The Challenges to America's National Identity*, New York: Simon & Schuster.

HUYSSEN, Andreas (1995), *Twilight Memories: Marking Time in a Culture of Amnesia*, New York: Routledge.

—— (2000), 'Present Pasts: Media, Politics, Amnesia', *Public Culture*, 12(1): 21–38.

—— (2003), *Present Pasts: Urban Palimpsests and the Politics of Memory*, Stanford, California: Stanford University Press.

INTERNATIONAL Council of Museums (ICOM) (2001), *Development of the Museum Definition according to ICOM Statutes (1946–2001)*, http://icom.museum/hist_def_eng.html.

—— (2005), *Revised ICOM Strategic Plan 2005–2007*, May, http://icom.museum/strat_plan.html.

INTERNATIONAL Freedom Center (IFC) (2005), *The International Freedom Center: Content and Governance Report*, 23 September.

—— (n.d.). The International Freedom Center Vision and Mission Statement, http: //www.ifcwtc. org

INTERNATIONAL Herald Tribune (IHT) (2005), 'Leveling the Freedom Center', 30 September.

ITO, Toshio (1994), 'The Communication of Ideas', *GA Document*, 39: 63.

—— (1997), 'Image of Architecture in Electronic Age', http: //www.um.u-tokyo.ac.jp/publish_db/ 1997VA/english/virtual/01.html

—— (2001), 'Architect's Statement', *Blurring Architecture,* http: //www.artspace.org.nz/shows/Ito2. htm

JAMESON, Frederic (1995), *Postmodernism: or The Cultural Logic of Late Capitalism*, London: Verso.

—— (1997), 'The Cultural Logic of Late Capitalism', in Neil Leach (ed.), *Rethinking Architecture: A Reader in Cultural Theory*, New York: Routledge.

—— (1998a), 'Postmodernism and Consumer Society', in Hal Foster (ed.), *The Anti-Aesthetic: Essays on Postmodern Culture*, New York: The New Press.

—— (1998b), *The Cultural Turn: Selected Writings on the Postmodern, 1993–1998*, London: Verso.

JASMAX (1992), *Museum of New Zealand Te Papa Tongarewa Developed Design Report,* Vols. 1 and 2. Wellington: Jasmax Architects.

JAY, Paul (2004), 'Globalization and the Postcolonial Condition', in David Leiwei Li (ed.), *Globalization and the Humanities*, Hong Kong: Hong Kong University Press.

JEANNOTTE, Sharon M. (2003), 'Singing Alone? The Contribution of Cultural Capital to Social Cohesion and Sustainable Communities', *International Journal of Cultural Policy*, 9(1): 35–49.

JENCKS, Charles (1991), *The Language of Post-modern Architecture*, London: Academy Editions.

Jencks, Chris (1995), *Visual Culture*, London: Routledge.

Jolly, Margaret (2001), 'On the Edge? Deserts, Oceans, Islands', *The Contemporary Pacific,* 13(2): 417–66.

Jones, Nicholas (2005), W*e the People of More Than One Race in the United States: Census 2000 Special Reports,* Washington DC: United States Department of Commerce.

Joshi, Pradnya (2005), 'Families Protest WTC Freedom Museum', *New York Newsday*, 20 June.

Kaplan, Flora S. (ed.) (1994), *Museums and the Making of 'Ourselves': The Role of Objects in National Identity*, London: Leicester University Press.

Karp, Ivan (1992), 'On Civil Society and Social identity', in Ivan Karp and Christine Mullen Kreamer (eds), *Museums and Communities: The Politics of Public Culture,* Washington DC: Smithsonian Institution Press.

—— and Lavine, Steven D. (eds) (1991), *Exhibiting Cultures: The Poetics and Politics of Museum Display*, Washington: Smithsonian Institution Press.

—— and Mullen Kreamer, Christine (eds) (1992), *Museums and Communities: The Politics of Public Culture,* Washington DC: Smithsonian Institution Press.

Kasarhérou, Emmanuel (1992), 'The New Caledonian Museum', in Soroi Marepo Eoe and Pamela Swadling (eds), *Museums and Cultural Centres in the Pacific,* National Capital District, Papua New Guinea: Papua New Guinea National Museum.

—— (1995), '"Men of Flesh and Blood": The Jean-Marie Tjibaou Cultural Centre in Noumea', *Art and Asia Pacific,* 2(4): 90–5.

—— and Mozziconacci, Cécile (1998), *Centre Culturel Tjibaou,* Nouméa: ADCK

—— and Wedoye, Béalo. With Boulay, Roger and Merleau-Ponty, Claire (1998), *Guide to the Plants of the Kanak Path,* Nouméa: ADCK.

Kastner, Jeffrey (2004), 'How the Modern Said "Cheese" for Almost 3 Years', *New York Times*, 26 September.

Kavanagh, Gaynor (2004), 'Melodrama, Pantomine or Portrayal? Representing Ourselves and the British Past through Exhibitions in History Museums', in Bettina Messias Carbonell (ed.), *Museum Studies: An Anthology of Contexts*, Malden MA: Blackwell.

Kawharu, I. H. (2005), 'Foreward', in Michael Belgrave, Merata Kawharu and David Williams (eds) *Waitangi Revisited: Perspectives on the Treaty of Waitangi*, South Melbourne: Oxford University Press.

Keith, Hamish (2000), 'Let's Have More Museum and Less McDonald's', *New Zealand Herald,* 31 January.

—— (2001), 'Core Collections', *Sunday Star Times*, 11 November.

Kelsey, Jane (1995), *The New Zealand Experiment: A World Model for Structural Adjustment?* Auckland: Auckland University Press and Bridget Williams Books.

Kennedy, Roger G. (1996), 'Some Thoughts about National Museums at the End of the Century', in Gwendolyn Wright (ed.), *The Formation of National Collections of Art and Archaeology*, Washington DC: National Gallery of Art.

Kimmelman, Michael (2004a), 'Racing to Keep Up with the Newest', *New York Times*, 19 November.

—— (2004b), 'Art: MOMA Goes for the Grandiose', *International Herald Tribune*, 20 November.

King, Michael (2003), *The Penguin History of New Zealand*, Auckland: Penguin.

KIRSHENBLATT-GIMBLETT, Barbara (1998), *Destination Culture: Tourism, Museums, and Heritage*, Berkeley: University of California Press.

KLEIMAN, Neil Scott and Duitch, Suri (2001), *Going On with the Show: Arts and Culture in New York City After September 11*, New York: Center for an Urban Future.

KOHN, Richard (1995), 'History and the Culture Wars: The Case of the Smithsonian Institution's Enola Gay Exhibit', *Journal of American History*, 82(3): 1036–63.

KOSTURA, Zak (2005), 'Report Released by the International Freedom Center Clears the Way for Public Review', *Project Rebirth*, press release, 24 September.

KOWALSKI, Cecile and Best, Victoria (2003), *Recovery: The World Trade Center Recovery Operation at Fresh Kills, New York (Teachers' Guide)*, New York: New York State Museum.

KRAUSS, Rosalind (1990), 'The Cultural Logic of the Late Capitalist Museum', *October*, 54: 3–17.

—— (1996), 'Postmodernism's Museum Without Walls', in Reesa Greenberg, Bruce W. Ferguson, Sandy Nairne (eds), *Thinking about Exhibitions*, London: Routledge.

KREAMER, Christine Mullen (1992), 'Defining Communities Through Exhibiting and Collecting', in Ivan Karp and Christine Mullen Kreamer (eds), *Museums and Communities: The Politics of Public Culture*, Washington DC: Smithsonian Institution Press.

KREPS, Christina (2003), *Liberating Culture: Cross-Cultural Perspectives on Museums, Curation, and Heritage Preservation*, London and New York: Routledge.

KRIEGEL, Lara (2001), 'Narrating the subcontinent in 1851: India at the Crystal Palace', in Louise Purbrick (ed.), *The Great Exhibition of 1851: New Interdisciplinary Essays*, Manchester: Manchester University Press.

KYMLICKA, Will (1995), *Multicultural Citizenship: A Liberal Theory of Minority Rights*, Oxford: Clarendon Press.

LIEBER, Robert J. (2002), 'A New Era in US Strategic Thinking', in US Department of State, *September 11: One Year Later*, Washington DC: United States Department of State.

LINENTHAL, Edward T. (1995), 'Struggling with History and Memory', *Journal of American History*, 82(3): 1094–101.

—— (2001), *Preserving Memory: The Struggle to Create America's Holocaust Museum*, New York: Columbia University Press.

—— (2003), *The Unfinished Bombing: Oklahoma City in American Memory*, Oxford: Oxford University Press.

—— and Engelhardt, Tom (1996), *History Wars: The Enola Gay and Other Battles for the American Past*, New York: Metropolitan Books.

LONDON Development Agency (2005), *Crystal Palace Park Planning Framework: A Draft for Consultation*, London: London Development Agency.

LOSCHE, Diane (2003), 'Cultural Forests and their Objects in New Caledonia, the Forest on Lifou', *Australian and New Zealand Journal of Art*, 4(1): 77–91.

LOUKAITOU-SIDERIS, Anastasia and Grodach, Carl (2004), 'Displaying and Celebrating the "Other": A Study of the Mission, Scope, and Role of Ethnic Museums in Los Angeles, *The Public Historian*, 26(4): 49–71.

LOWER Manhattan Development Corporation (LMDC) (2003), *World Trade Center Site: Memorial Competition Guidelines*, New York: LMDC.

—— (2004a), *WTC Memorial Jury Statement for Winning Design*, press release, 13 January.

—— (2004b), *Report on the Memorial Center and Cultural Complex at the World Trade Center Site*, 19 February.

—— (2005), *LMDC, WTC Memorial Foundation, Civic Alliance, and New York New Visions Announce Workshop Series of Memorial Museum Programming*, press release, 30 August.

—— and New York State Council on the Arts, New York City Department of Cultural Affairs (2005), *Cultural Forum: World Trade Center Site*, 28 July, transcript, New York: Roy Allen & Associates.

LOWRY, Glenn D. (1998a), 'The New Museum of Modern Art Expansion: A Process of Discovery', in The Museum of Modern Art, *Imagining the Future of The Museum of Modern Art*, New York: The Museum of Modern Art.

—— (1998b), 'Building the Future: Some Observations on Art, Architecture, and The Museum of Modern Art', in The Museum of Modern Art, *Imagining the Future of The Museum of Modern Art*, New York: The Museum of Modern Art.

—— (2004), *Designing the New Museum of Modern Art,* New York: The Museum of Modern Art.

LUBOW, Arthur (2004), 'Re-moderning', *New York Times*, 3 October.

LUGAR, Richard (2003), *Opening Statement on Public Diplomacy and Islam,* US Senate Foreign Relations Committee Press Release, 27 February.

LUKE, Timothy W. (2002), *Museum Politics: Power Play at the Exhibition*, Minneapolis: University of Minnesota Press.

LUMLEY, Robert (ed.) (1988), *The Museum Time Machine: Putting Cultures on Display*, London: Routledge.

LUPU, Noam (2005), 'Memory Vanished, Absent, and Confined: The Countermemorial Project in 1980s and 1990s Germany', *History and Memory*, 15(2): 130–64.

LYNES, Russell (1973), *Good Old Modern: An Intimate Portrait of the Museum of Modern Art*, New York: Atheneum.

MACARTHUR, John (2001), 'Australian Baroque: Geometry and Meaning at the National Museum of Australia', *Architecture Australia,* 90(2): 48–61.

MACCANNELL, Dean (1989), *The Tourist: A New Theory of the Leisure Class*, New York: Schocken.

MACDONALD, Sharon J. (1996), 'Theorizing Museums: an Introduction', in Sharon Macdonald and Gordon Fyfe (eds), *Theorizing Museums*, Oxford: Blackwell.

—— (2003), 'Museums, National, Postnational and Transcultural Identities', *Museum and Society,* 1(1): 1–16.

MACKENZIE, John (1984), *Propaganda and Empire*, Manchester: Manchester University Press.

MACLELLAN, Nic (2004), 'From Eloi to Europe: Interactions with the Ballot Box in New Caledonia', http://www.usp.ac.fj/fileadmin/files/Institutes/piasdg/Electoral_Systems_2004/es2004_Maclellan.pdf.

—— (2005), 'Conflict and Reconciliation in New Caledonia: Building the Mwâ Kâ', *State Society and Governance in Melanesia* Discussion Paper 2005/1, Canberra: Research School of Pacific and Asian Studies, Australian National University.

—— and Chesneaux, Jean (1998), *After Moruroa: France in the South Pacific*, Melbourne: Ocean Press.

MADOEUF, Franck (1998), 'New Caledonia Cultural Center to Express Kanak Identity', in *Agence France Presse,* 3 May.

MAIN, Victoria (1998), 'New Caledonia Takes a Gamble on Beauty', *Christchurch Press*, 2 December.

MALLOCH Brown, Mark (2004), 'The UNDP's Commitment to Defend Cultural Diversity with UNESCO', *Museum International*, 224(56.4): 8–23.

MARRIOTT, John (2003), *The Other Empire: Metropolis, India and Progress in the Colonial Imagination*, Manchester and New York: Manchester University Press.

MARSHALL, Christopher (1997), 'Back in the Basilica: The New Museology and the Problem of National Identity in the Museum of Sydney', *Art Monthly Australia*, 100: 7–10.

MARTIN, Jerry L. and Neal, Anne D. (2001), *Defending Civilization: How Our Universities are Failing America and What Can be Done About It*, Washington DC: Defense of Civilization Fund, American Council of Trustees and Alumni, http://www.goacta.org/Reports/defciv.pdf.

MARTIN, Theodore (1876), *The Life of His Royal Highness the Prince Consort*, London: Smith, Elder & Co.

MARX, Karl (1977), *The German Ideology*, ed. C. J. Arthur, London: Lawrence & Wishart.

MATHUR, Saloni (2000), 'Living Ethnological Exhibits: The Case of 1886,' *Cultural Anthropology*, 15(4): 492–524.

MAXWELL, Anne (2000), *Colonial Photography and Exhibitions: Representations of the 'Native' and the Making of European Identities*, London and New York: Leicester University Press.

MAYHEW, Henry (1851), *1851: or the Adventures of Mr and Mrs Sandboys and Family*, London: George Newbold.

MBEMBE, J. Achille (2001). *On the Postcolony (Studies on the History of Society and Culture)*, Berkeley, CA: University of California Press.

McCARTHY, Sheryl (2005), 'Politics and Fear Sank the Freedom Center', *Newsday*, 3 October.

McCLELLAN, Andrew (1999), *Inventing the Louvre: Art, Politics, and the Origins of the Museum in Eighteenth-Century Paris*, Berkeley, CA: University of California Press.

—— (2003), 'A Brief History of the Art Museum Public', in Andrew McClellan (ed.), *Art and its Publics: Museum Studies at the Millennium*, Malden, MA: Blackwell.

McCLINTOCK, Anne (1992), 'The Angel of Progress: Pitfalls of the Term "Post-Colonialism", *Social Text*, 31/32: 84–98.

—— (1995), *Imperial Leather: Race, Gender, and Sexuality in the Colonial Contest*, London and New York: Routledge.

McGHIE, Gerald (2002), 'New Zealand and the Pacific: Diplomacy, Defence, Development', *New Zealand International Review*, 27(6): 13–16.

McGILLICK, Paul (1999), 'A Sublime Kanak Creation', *Australian Financial Review*, 13 March.

McGUIGAN, Jim (1996), *Culture and the Public Sphere*, New York: Routledge.

—— (2004), *Rethinking Cultural Policy (Issues in Cultural and Media Studies)*, Maidenhead: Open University Press.

McINTYRE, Andrew (2004), 'Independence in the Pacific: France's Positive Approach', *National Observer*, Summer: 12–15.

McLAUGHLIN, Moira (1993), 'Of Boundaries and Border: First Nations' History in Museums', *Canadian Journal of Communication online* 18(3), http://www.wlu.ca/~wwwpress?jrls/cjc/BackIssues/18.3/mclough.html.

McLEAN, Sandra (1998), 'Accent on Culture', *Daily Telegraph*, 5 September.

McMaster, Gerald and Trafzer, Clifford E. (eds) (2004), *Native Universe: Voices of Indian America*, Washington DC: National Museum of the American Indian, Smithsonian Institution (and National Geographic).

Mead, Margaret (1970), 'Museums in a Media-Saturated World', *Museum News*, 49(1): 23–6.

Memmott, Paul and Reser, Joe (2000), 'Design Concepts and Processes for Public Aboriginal Architecture', *PaPER*, 55–6: 69–86.

Message, Kylie (2000), 'Crystal Palace to Media Museum: A Conceptual Framework for Experience and Sight', in Roy Ascott (ed.), *Art Technology Consciousness: mind@large*, Bristol UK: Intellect Books.

—— (2005), 'Representing Cultural Diversity in a Global Context: The Museum of New Zealand Te Papa Tongarewa and The National Museum of Australia', *International Journal of Cultural Studies*, 8(4): 465–85.

—— (2006a), 'Contested Sites of Identity and the Cult of the New: The Centre Culturel Tjibaou and the Constitution of Culture in New Caledonia', *ReCollections: Journal of the National Museum of Australia*, 1(1): 7–28.

—— (2006b), 'The New Museum', *Theory, Culture and Society*, 23(2–3): 603–6.

—— and Healy, Chris (2004), 'A Symptomatic Museum: The New, the NMA and the Culture Wars', *Borderlands e-journal*, 3(3), http://www.borderlandsejournal.adelaide.edu.au/vol3no3_2004/messagehealy_symptom.htm.

Mitchell, Timothy (1988), *Colonising Egypt*, Berkeley, CA: University of California Press.

—— (1989), 'The World as Exhibition', *Comparative Studies in Society and History*, 31(2): 217–36.

Mitchell, W.J.T (ed.) (1992), *Art and the Public Sphere*, Chicago: Chicago University Press.

Montaner, Josep Maria (2003), *Museums for the 21st Century*, trans. M. Black, Barcelona, Spain: Editorial Gustavo Gili, SA.

Morgan, Nigel, Pritchard, Annette and Piggott, Rachel (2002), 'New Zealand, 100% Pure: The Creation of a Powerful Niche Destination Brand', *Journal of Brand Management*, 9(4/5): 335–45.

Morley, Catherine (1984), *John Ruskin: Late Work, 1870–1890. The Museum and Guild of St. George: An Educational Experiment*, New York: Garland.

Morley, David (2005), 'Theoretical Orthodoxies: Textualism, Constructivism and the "New Ethnography" in Cultural Studies', in Pepi Leistyna (ed.), *Cultural Studies: From Theory to Action*, Malden, MA: Blackwell.

Morris-Suzuki, Tessa (2005), *The Past Within Us: Media, Memory, History*, London: Verso.

Moss, Linda (2004), 'Cultural Diversity and Biculturalism: Congruences and Contrasts in Arts Policies and Practices between New Zealand and England', Paper presented to the Third International Conference of *Cultural Policy*, Montreal, http://www.hec.ca/iccpr/PDF_Texts/Moss_Linda.pdf

Mulhern, Francis (2000), *Culture/Metaculture*, London and New York: Routledge.

Mumford, Lewis (1940), *The Culture of Cities*, London: Secker & Warburg.

Murphy, Bernice (2002), 'Centre Culturel Tjibaou: A Museum and Arts Centre Defining New Caledonia's Cultural Future', *Humanities Review*, 9(1): 77–90.

Museum of Modern Art (1955), *The Family of Man*, New York: The Museum of Modern Art.

—— (1998), *Imagining the Future of The Museum of Modern Art*, New York: The Museum of Modern Art.

—— (2004a), 'Manhattan is Modern Again' MoMA reopening catalogue, New York: The Museum of Modern Art.

—— (Department of Communications) (2004b), *Inaugural Exhibition in Newly Reopened MoMA Celebrates Yoshio Taniguchi's Museum Architecture*, press release 52, 15 November.

—— (2004c), *The Museum of Modern Art Presents the First Projects Exhibition in its Renovated and Expanded Building*, press release 56, 20 November.

—— (2004d), *Reinstallation of MoMA's Architecture and Design Collection Showcases Design Icons, Many New Acquisitions*, press release 57, 15 November.

—— (2004e), *Reinstallation of Photography Galleries Surveys the Evolution of Photography's Modern Traditions*, press release 58, 15 November.

—— (2004f), *Scores of New Acquisitions on View in Newly Renovated and Expanded Museum of Modern Art*, press release 70, 15 November.

—— (2004g), *The Museum of Modern Art Reopens on November 20, 2004 in Expanded and Renovated New Building Designed by Yoshio Taniguchi*, press release 72, 15 November.

—— (2004h), *MoMA's Renowned Collection of Painting and Sculpture Returns to View in Elegant and Expansive Galleries*, press release 75, 15 November.

—— (2004i), *The Museum of Modern Art Counts Down to November 20 Reopening in Midtown Manhattan*, press release 22, 30 June.

—— (2004j), *The Museum of Modern Art to Reopen in Manhattan on November 20, 2004. Inaugural Celebrations to Commemorate Historic 75th Anniversary*, press release 19, 7 April.

MUSEUM of New Zealand Te Papa Tongarewa (1992), *Museum of New Zealand Te Papa Tongarewa Interpretive Plan: A Conceptual Framework for Exhibitions*, Wellington: Museum of New Zealand Te Papa Tongarewa.

—— (1997), *Language Policy*, Wellington: Te Aka Matua Library.

—— (1998), *Te Papa Our Place: A Souvenir*, Wellington: Museum of New Zealand Te Papa Tongarewa.

—— (2002a), *Te Papa Annual Report 2001–2002*, Wellington: Museum of New Zealand Te Papa Tongarewa.

—— (2002b), *Briefing for Right Honourable Helen Clark, Minister for the Arts and Culture*, Wellington: Museum of New Zealand Te Papa Tongarewa.

—— (2002c [1989]), *Statement of Intent (2002–2005)*, Wellington: Museum of New Zealand Te Papa Tongarewa.

—— (2004), *Icons Ngā Taonga: From the Museum of New Zealand Te Papa Tongarewa*. Wellington: Te Papa Press.

MUTU, Margaret (2005), 'Maori Issues', *The Contemporary Pacific*, 17(1): 209–15.

MWÀ VÉÉ, (1996a), '1931 Des Kanak à Paris', 13 (June).

—— (1996b), 'Courants océaniens, Pacific currents' special edition, 14 (October).

—— (Kanak cultural review) (2000), 'Living Heritage, Kanak Culture Today' special edition, October.

NATIONAL Arts Journalism Program, Arts International and the Center for Arts and Culture (NAJP, AI and CAC) (2003), *Arts and Minds: Cultural Diplomacy Amid Global Tensions* (conference transcript), New York: Columbia University Graduate School of Journalism.

NATIONAL Museum of the American Indian (2000), *The Changing Presentation of the American Indian*, Seattle: University of Washington Press.

NATIONAL Services of the Museums of New Zealand (1999), *He Wananga Tirohanga Rangapu mo Te Kaupapa Tikanga-a-rua I roto I Nga Whare Taonga: Wananga on Bicultural Developments in Museums*, Wellington: Museum of New Zealand Te Papa Tongarewa.

NEGT, Oskar and Kluge, Alexander (1993), *Public Sphere and Experience: Toward an Analysis of the Bourgeois and Proletarian Public Sphere*, Minneapolis: University of Minnesota Press.

NEILL, Anna (2004), 'National Culture and the New Museology', in Anna Smith and Lydia Wevers (eds), *On Display: New Essays in Cultural Studies*, Wellington: Victoria University Press.

NEWHOUSE, Victoria (1998), *Towards a New Museum,* New York: The Monacelli Press.

New York Daily News (2005), 'A Next Step for Ground Zero', 25 September.

NEW York New Visions (2005), *WTC Memorial Museum Programming Workshop (15 Sept)*, transcript, New York: New York New Visions.

New York Times (2004a), 'The Modern Gone By: Inspiration for a New Way of Art', 18 November.

—— (2004b), 'Opening a New MoMA', 20 November.

—— (2004c), 'The Modern Gone By: Inspiration for a New Way of Art', 18 November.

—— (2004d), 'Opening a New MoMA', *New York Times*, 20 November.

—— (2005a), 'The Real Meaning of Ground Zero', 14 July.

—— (2005b), 'The Governor's Exit Strategy', 28 July.

—— (2005c), 'Freedom or Not?' 23 September.

NEW Zealand Government (1992), *Museum of New Zealand Te Papa Tongarewa Act 1992,* http://rangi.knowledge-basket.co.nz/gpacts/public/text/1992/an/019.html

NEW Zealand Government, Ministry for Culture and Heritage Te Manatu Taonga (2000a), *Ministry for Culture and Heritage Report of Specific Issues Relating to the Museum of New Zealand Te Papa Tongarewa*, Wellington.

—— (2000b), *In The Heart of the Nation: A Cultural Strategy for Aotearoa New Zealand.* Wellington.

—— (2003), *Cultural Well-being*, Wellington, http://www.mch.govt.nz/cwb/index.html

—— (2004), *Report of the Ministry for Culture and Heritage Te Manatu Taonga for the Year ended 30 June 2004*, Wellington.

New Zealand Herald (2002), 'Te Papa has Desecrated Treasured Whare, Tribe Claims', 26 February.

—— (2004), 'Marchers Gather in High Winds for Hikoi through Capital', 5 May.

ORIN, Deborah (2005), 'Hillary Comes Out Against Freedom Center', *New York Post*, 26 September.

OUROUSSOFF, Nicolai (2004a), 'Even More Modern', *New York Times*, 12 September.

—— (2004b), 'Art Fuses with Urbanity in an Aesthetically Pure Redesign of the Modern', *New York Times*, 15 November.

PACIFIC Islands Forum Secretariat (2005), *A Pacific Plan for Strengthening Regional Cooperation and Integration (Final Draft)*, Suva, Fiji: Pacific Islands Forum Secretariat.

—— (nd), *Culture and the Pacific Plan*, Issue Paper no.3, Suva, Fiji: Pacific Islands Forum Secretariat.

PAPASTERGIARDIS, Nikos (2005), 'Hybridity and Ambivalence: The Places and Flows in Contemporary Art and Culture', *VISIT,* 7: 3–5.

PEARCE, Susan (1990), *Objects of Knowledge,* London: Athlone Press.

—— (1992), *Museums, Objects, and Collections: A Cultural Study*, Washington DC: Smithsonian Institution Press.

PEARSON, David (1990), *A Dream Deferred: The Origins of Ethnic Conflict in New Zealand*, Wellington: Allen & Unwin.

PEERS, Laura and Alison Brown (eds) (2003), *Museums and Source Communities: A Routledge Reader*, London and New York: Routledge.

PHILLIPS, Jock (1999), Presentation to *National Museums: Negotiating Histories Conference*, Canberra: The Australian National University.

—— (2001), 'The Politics of Pakeha History in a Bicultural Museum: Te Papa, the Museum of New Zealand, 1993–98', in Darryl McIntyre and Kirsten Wehner (eds), *National Museums: Negotiating Histories Conference Proceedings*, Canberra: The National Museum of Australia.

—— (2005), 'The New Zealanders', from *Te Ara – The Encyclopaedia of New Zealand*, http://www.TeAra.govt.nz/NewZealanders/NewZealandPeoples/TheNewZealanders/en.htm.

PHILLIPS, Patricia C. (1996), 'Introduction: Portraying the City', in Patricia C. Phillips (ed.), *City Speculations*, New York: Queens Museum of Art and Princeton Architectural Press.

PIANO, Renzo (1997), *The Renzo Piano Logbook,* London: Thames & Hudson.

PITOISET, Anne (2003), 'What is the Tjibaou Centre being Used For? Disappointed Hopes of the CCT', *L'EXPRESS.fr,* 10 October., http://www.lexpress.fr/info/france/dossier/caledonie/dossier.asp?ida=399125.

POGREBIN, Robin (2004), 'At Modern, Architect is Content (Mostly)', *New York Times*, 16 November.

—— (2005), 'Is Culture Gone at Ground Zero?' *New York Times*, 30 September.

POOVAYA-SMITH, Nima (1998), 'Keys to the Magic Kingdom: The New Transcultural Collections of Bradford Art Galleries and Museums', in Tim Barringer and Tom Flynn (eds), *Colonialism and the Object: Empire, Material Culture and the Museum*, London and New York: Routledge.

POULOT, Dominique (1994), 'Identity as Self-Discovery: The Eco-Museum in France', in D.J. Sherman and I. Rogoff (eds), *Museum Culture: Histories, Discourses, Spectacle*, Minneapolis: University of Minnesota Press.

POWELL, K. (1991), 'New Museology', in A. Papadakis (eds), *New Museums,* London: Academy Editions.

POWER, Liza (1998), 'French Tropical Twist', *The Age*, 26 September.

PRAKASH, Gyan (1996), 'Museum Matters', in Thomas Keenan (ed.), *The End(s) of the Museum*, Barcelona: Fundació Antoni Tàpies.

PRATT, Mary Louise (1986), 'Fieldwork in Common Places', in James Clifford and George E. Marcus (eds), *Writing Culture: The Poetics and Politics of Ethnography*, Berkeley, CA: University of California Press.

PRENDERGAST, Christopher (2003), 'Codeword Modernity', *New Left Review,* 24: 95–111.

PREZIOSI, Donald (2004), 'Brain of the Earth's Body: Museums and the Framing of Modernity', in Bettina Messias Carbonell (ed.), *Museum Studies: An Anthology of Contexts*, Malden MA: Blackwell.

—— and Farago, Claire (eds) (2004), *Grasping the World: The Idea of the Museum*, Burlington, VT: Ashgate.

PRIOR, Nick (2003), 'Having One's Tate and Eating It: Transformations of the Museum in Hyper-modern Era', in Andrew McClellan (ed.), *Art and its Publics: Museum Studies at the Millennium*, Malden, MA: Blackwell.

PRITCHARD, Stephen (2005), 'The Artifice of Culture: Contemporary Indigenous Art and the Work of Peter Robinson', *Third Text,* 19(1): 67–80.

PROJECT Rebirth (2005), 'Architecture: Cultural Center', *Project Rebirth,* press release, March.

PROJECT Development Board (1991), *A Concept for the Museum of New Zealand Te Papa Tongarewa*, Wellington: Museum of New Zealand Te Papa Tongarewa.

PROJECT Development Team for the National Museum of New Zealand Te Marae Taonga o Aotearoa (1985), *Nga Taonga o te Motu: Te Marae Taonga o Aotearoa. Treasures of the Nation: National Museum of New Zealand. A Plan for Development*, Wellington: Department of Internal Affairs.

PUNCH (1851), 'The Shilling Days at the Crystal Palace', 20: 240.

PURBRICK, Louise (1994), 'The South Kensington Museum: The Building of the House of Henry Cole', in Marcia Pointon (ed.), *Art Apart: Art Institutions and Ideology Across England and North America*, Manchester and New York: Manchester University Press.

—— (ed.) (2001), *The Great Exhibition of 1851: New Interdisciplinary Essays*, Manchester: Manchester University Press.

PUTNAM, Robert D. (2000), *Bowling Alone: The Collapse and Revival of American Community*, New York: Simon & Schuster.

QUATREMÈRE de Quincy, Antoine Chrysostome (1815), *Considérations morales sur la destination des ouvrages de l'art*, Paris: Crapelet.

QUAYSON, Ato (2000), *Postcolonialism: Theory, Practice, or Process?* Malden, MA: Blackwell Publishers.

RAY, William (2001), *The Logic of Culture: Authority and Identity in the Modern Era*, Oxford: Blackwell.

RETORT [Boal, Iain, Clark, T. J., Matthews, Joseph and Watts, Michael.] (2004), 'Afflicted Powers: The State, the Spectacle and September 11', *New Left Review*, 27: 5–21.

RICHARDS, Thomas (1990), *The Commodity Culture of Victorian England: Advertising and Spectacle. 1851–1914*, London: Verso.

RIDING, Alan (2000), 'Showcasing a Rise from Rebellion to Respectability', *New York Times,* 5 March.

RILEY, Terence (1998a), 'The Charette: Introduction', in The Museum of Modern Art, *Imagining the Future of The Museum of Modern Art*, New York: The Museum of Modern Art.

—— (1998b), 'The Architectural Competition: Introduction', in The Museum of Modern Art, *Imagining the Future of The Museum of Modern Art*, New York: The Museum of Modern Art.

—— (2004), *Yoshio Taniguchi: Nine Museums*, New York: Museum of Modern Art.

ROBERTS, D. (1988), 'Beyond Progress: The Museum and Montage', *Theory, Culture and Society*, 5: 543–57.

ROBINS, Kevin (1999), 'Tradition and Translation: National Culture in its Global Context', in David Boswell and Jessica Evans (eds), *Representing the Nation: A Reader*, London and New York: Routledge.

ROLLAT, Alain (1989), *Tjibaou le Kanak*, Lyon: La Manufacture.

ROSADA, Alexandre and Huneau, Philippe (2004), 'October 16, 2004: The Arts Centre of Hienghène Celebrates its 20 years', http://www.rosada.net/hienghene.htm.

ROSENBAUM, Lee (1997), 'MOMA Looks to the Future', *Art in America,* 85(2): 25.

ROTTENBERG, Barbara Lang (2002), 'Museums, Information and the Public Sphere', in *Museum International*, 54(4): 21–8.

ROYAL, Charles (2004), 'Matauranga Maori and Museum Practice' Version 3, Prepared for Te Papa National Services – Te Paerangi, Mauriora-ki-te-Ao/Living Universe Ltd.

RUGOFF, Ralph (1998), 'Beyond Belief: The Museum as Metaphor', in Lynne Cooke and Peter Wollen (eds), *Visual Display: Culture Beyond Appearances*, New York: The New Press.

RUMM, John (1995), 'History and the Culture Wars: The Case of the Smithsonian Institution's Enola Gay Exhibit', *Journal of American History*, 82(3): 1116–17.

RURU, Jacinta (2004), 'A Politically Fuelled Tsunami: The Foreshore / Seabed Controversy in Aotearoa me te Wai Pounamu/New Zealand', *Journal of the Polynesian Society*, 113(1): 57–72.

RYDELL, Robert (1993), 'The Literature of International Expositions', in *The Books of the Fairs: Materials about World's Fairs, 1834–1916, in the Smithsonian Institution Libraries,* Chicago and London: American Library Association.

SAHLINS, Marshall (2005), 'Preface', *Ethnohistory,* 52(1): 3–6.

SAID, Edward W. (1991 [1978]), *Orientalism. Western Conceptions of the Orient*, London: Penguin.

—— (1993), *Culture and Imperialism*, London: Chatto & Windus.

—— (1998), 'Opponents, Audiences, Constituencies and Community', in Hal Foster (ed.), *The Anti-Aesthetic: Essays on Postmodern Culture*, New York: The New Press.

—— (2005), 'Invention, Memory, and Place' in Pepi Leistyna (ed.), *Cultural Studies: From Theory to Action*, Malden, MA: Blackwell.

SALA, George Augustus (1868), *Notes and Sketches of the Paris Exhibition*, London: Tinsley Brothers.

SASSEN, Saskia (1991), *The Global City: New York, London, Tokyo*, Princeton, NJ: Princeton University Press.

—— (2003), 'The State and Globalization', *Interventions*, 5(2): 241–8.

SCHIVELBUSCH, Wolfgang (2003), *The Culture of Defeat: On National Trauma, Mourning, and Recovery*, New York: Metropolitan Books.

SCHLERETH, Thomas J. (2004), 'Collecting Ideas and Artifacts: Common Problems of History Museums and History Texts', in Bettina Messias Carbonell (ed.), *Museum Studies: An Anthology of Contexts*, Malden MA: Blackwell.

SECRETARIAT of the Pacific Community (2003), *Draft Regional Framework for the Economic Valuing of Expressions of Culture*, Working Paper 15, Nouméa, New Caledonia: Secretariat of the Pacific Community.

SEKULA, Alan (1984), 'The Instrumental Image: Steichen at War', in *Photography Against the Grain*, Halifax, Nova Scotia: Press of the Nova Scotia College of Art and Design.

SEWELL, William H. (1999), 'The Concept(s) of Culture', in Victoria E. Bonnell, Lynn Avery Hunt, and Richard Biernacki (eds), *Beyond the Cultural Turn: New Directions in the Study of Society and Culture (Studies on the History of Society and Culture , No. 34)*, Berkeley: University of California Press.

SHAPIRO, Ann-Louise (1997), 'Whose (Which) History IS It Anyway?', *History and Theory*, 36(4): 1–3.

SHATTUCK, Kathryn (2004), 'The Who, What, Where and When (the Why You Already Know)', *New York Times*, 19 November.

SHOHAT, Ella (1992), 'Notes on the "Post-Colonial"', *Social Text*, 31/32: 99–113.

—— and Stam, Robert (1994), *Unthinking Eurocentrism: Multiculturalism and the Media*, London: Routledge.

SIMPSON, David (2004), 'Politics as Such?' *New Left Review*, 30: 69–82.

SIMPSON, Moira (1996), *Making Representations: Museums in the Post-colonial Era,* London: Routledge.

SMITH, Anna and Wevers, Lydia (eds) (2004), *On Display: New Essays in Cultural Studies*, Wellington: Victoria University Press.

SMITH, Roberta (2004), 'In the Shards of the Past, The Present is Revealed', *New York Times*, 19 November.

SMOCK, Raymond W. (2003), 'Prologue to a Farce or a Tragedy? Accessing Government Records in the Wake of 9/11/2001', *The Public Historian*, 25(2): 123–7.

SORKIN, Michael (2003), *Starting From Zero: Reconstructing Downtown New York*, New York and London: Routledge.

SPENCER, Michael, Ward, Alan and Connell, John (eds) (1988), *New Caledonia: Essays in Nationalism and Dependency*, St Lucia, Queensland: University of Queensland Press.

SPOONLEY, Paul (1995), 'Constructing Ourselves: The Post-colonial Politics of Pakeha', in M. Wilson and C. Yeatman (eds), *Justice and Identity: Antipodean Practices*, Wellington: Bridget Williams Books.

STANISZEWSKI, Mary Anne (2001), *The Power of Display: A History of Exhibition Installations at the Museum of Modern Art*, Cambridge, MA: MIT Press.

STANLEY, Nick (1998), *Being Ourselves for You: Global Display of Cultures*, London: Middlesex University Press.

STEARNS, Peter (2003), 'Expanding the Agenda of Cultural Research', *The Chronicle of Higher Education*, 49(34): B7.

STEWART, Susan (1984), *On Longing: Narratives of the Miniature, the Gigantic, the Souvenir, the Collection*, Baltimore: Johns Hopkins University Press.

STOLER, Ann Laura (1996), *Race and the Education of Desire: Foucault's* History of Sexuality *and the Colonial Order of Things*, Durham and London: Duke University Press.

STONGE, Carmen (1998), 'Making Private Collections Public: Gustav Friedrich Waagen and the Royal Museum in Berlin', *Journal of the History of Collections,* 10(1): 61–74.

STROM, Elizabeth (2001), *Strengthening Communities Through Culture*, Center for Arts and Culture (Art, Culture and the National Agenda) Issue Paper, http: //www.cultural policy.org.

SYDNEY Morning Herald (1988), 'Separatists Still Divided on Caledonia's future', 18 July.

TANIGUCHI, Yoshio (1998a), 'The Charette: The Finalists', in The Museum of Modern Art, *Imagining the Future of The Museum of Modern Art*, New York: The Museum of Modern Art.

—— (1998b), 'The Architectural Competition: Excerpts from the Architects' Proposals', in The Museum of Modern Art, *Imagining the Future of The Museum of Modern Art*, New York: The Museum of Modern Art.

TAPSELL, Paul (1998), *Taonga: A Tribal Response to Museums*, Unpublished PhD thesis, University of Oxford.

—— (2001), '*Taonga, marae, whenua* – Negotiating Custodianship: A Maori Tribal Response to the Museum of New Zealand', in Darryl McIntyre and Kirsten Wehner (eds), *National Museums: Negotiating Histories Conference Proceedings*, Canberra: The National Museum of Australia.

—— (2005), 'From the Sideline: Tikanga, Treaty Values and Te Papa', in Michael Belgrave, Merata Kawharu and David Williams (eds) *Waitangi Revisited: Perspectives on the Treaty of Waitangi*, South Melbourne: Oxford University Press.

TAYLOR, Catherine (1998), 'Temple of Kanak Culture', *The Australian,* 14 August.

TAYLOR, Charles (2002), 'Modern Social Imaginaries', *Public Culture*, 14(1): 91–124.

TEAIWA, Teresia (2001), 'L(o)osing the Edge', *The Contemporary Pacific*, 13(2): 343–57.

TE Awekotuku, Ngahuia and Nikora, Linda Waimarie (2003), *'Nga Taonga o Te Urewera' a Report Prepared for the Waitangi Tribunal's Urewera District Inquiry,* Wai 894, doc B6, Wellington: Waitangi Tribunal.

THACKERAY, William Makepeace (1851a), 'May-day Ode', *The Times*, 30 April.

—— (1851b), 'What I Remarked at the Exhibition', *Punch,* no. 20: 189.

—— (1851c), 'Panorama of the Inglese – An Inglese Family', *Punch,* no. 21: 138–9.

THAKUR, Ramesh (1995), 'In Defense of Multiculturalism', in Stuart W. Greif (ed.) *Immigration and National Identity in New Zealand: One people, two peoples, many peoples?* Palmerston North: Dunmore Press.

THELEN, David (1995), 'History after the Enola Gay Controversy: An Introduction', *Journal of American History*, 82(3): 1029–35.

THOMAS, Nicholas (1991), *Entangled Objects: Exchange, Material Culture and Colonialism in the Pacific,* Cambridge, MA: Harvard University Press.

—— (1994), *Colonialism's Culture: Anthropology, Travel and Government*, Cambridge: Polity Press.

—— (1997), *In Oceania: Visions, Artifacts, Histories*, Durham and London: Duke University Press.

THOMPSON, Alastair (2004), 'Ten Thousand Hikoi Marchers Reach Parliament', *Scoop*, 5 May.

TJIBAOU, Jean-Marie (1996), *La Présence Kanak*, Paris: Editions Odile Jacob.

—— and Missotte, Philippe (1978), *Kanaké – The Melanesian Way*, trans. Christopher Plant, Papeete: Les Editions du Pacifique.

TOMLINSON, John (1999), *Globalization and Culture*, Chicago: University of Chicago Press.

TRAMPOSCH, W. J. (1996), 'Speaking with Authority: Scholarship and Matauranga at The Museum of New Zealand Te Papa Tongarewa', *Museum National,* August: 11.

—— (1998a), 'Exact Imagining: the Museum as a Journey', *Museum News,* 77(2): 44–50.

—— (1998b), 'An Invitation for Redefinition', *Museums International*, 199(1): 28–32.

UNESCO (2001), *UNESCO Universal Declaration on Cultural Diversity*, Paris: UNESCO.

UNITED Nations Committee on the Elimination of Racial Discrimination (2005), *Decision 1 (66): New Zealand Foreshore and Seabed Act 2004*, Geneva: United Nations Office of the High Commissioner for Human Rights.

UNITED Nations Development Programme (2004), *Human Development Report 2004: Cultural Liberty in Today's Diverse World*, New York and Geneva: United Nations Development Programme.

UNITED States Department of State (2005), *Society and Values: The United States in 2005, Who We Are Today*, Washington DC: United States Department of State.

VALE, Lawrence J. (1999), 'Mediated Monuments and National Identity', *Journal of Architecture,* 4(4.1): 391–408.

VAN den Bosch, Annette (2005), 'Museums: Constructing a Public Culture in the Global Age', *Third Text,* 19(1): 81–9.

VEBLEN, Thorstein (1994 [1899]), *The Theory of the Leisure Class*, New York: Dover Thrift Editions.

VENTER, Nick (2000), 'Pacific Architecture Puts NZ to Shame – Goff', *Dominion*, 12 July.

VERACINI, Lorenzo and Muckle, Adrian (2002), 'Reflections of Indigenous History *inside* the National Museums of Australian and Aotearoa New Zealand and *outside* of New Caledonia's Centre Culturel Jean-Marie Tjibaou', *Electronic Journal of Australian and New Zealand History*, http://www.jcu.edu.au/aff/history/articles/veracini_muckle.htm.

VERCOE, Caroline (2002), 'Art Niu Sila: Contemporary Pacific Art in New Zealand', in Sean Mallon and Pandora Fulimalo Pereira (eds), *Pacific Art Niu Sila: the Pacific Dimension of Contemporary New Zealand Arts*, Wellington: Te Papa Press.

VERGO, Paul (ed.) (1989), *The New Museology*, London: Reaktion Books.

VICTORIA and Albert Museum (1950), *The Great Exhibition of 1851: A Commemorative Album*, London: His Majesty's Stationary Office.

VIRILIO, Paul (1994), *The Vision Machine*, London: British Film Institute.

—— (2002), *Ground Zero*, trans. Chris Turner, London and New York: Verso.

WAITANGI Tribunal (2004a), *Report on the Crown's Foreshore and Seabed Policy* (Wai 1071), Waitangi Tribunal Report, Wellington: Waitangi Tribunal.

—— (2004b), *Turanga Tangata Turanga Whenua: The Report on the Turanganui a Kiwa claims* (Wai 814), Waitangi Tribunal Report, Wellington: Waitangi Tribunal.

WALKOWITZ, Judith (1992), *City of Dreadful Delight: Narratives of Sexual Danger in Late-Victorian London*, London: Virago.

WALLACH, Alan (1998), *Exhibiting Contradiction: Essays on the Art Museum in the United States*, Amherst: University of Massachusetts Press.

WALSH, Kevin (1992), *The Representation of the Past: Museums and Heritage in the Post-modern World*, London and New York: Routledge.

WARD, Frazer (1995), 'The Haunted Museum: Institutional Critique and Publicity', *October*, 73: 71–89.

WARNER, Michael (1992), 'The Mass Public and the Mass Subject', in Craig Calhoun (ed.), *Habermas and the Public Sphere*, Cambridge, MA: MIT Press.

—— (2002), 'Publics and Counterpublics', *Public Culture*, 14(1): 49–90.

WEIL, Stephen E. (2002), *Making Museums Matter*, Washington and London: Smithsonian Institution Press.

WESBURY, Brian S. (2002), 'The Economic Cost of Terrorism', in US Department of State, *September 11: One Year Later*, Washington DC: United States Department of State.

WESCHLER, Lawrence (1995), *Mr Wilson's Cabinet Of Wonder: Pronged Ants, Horned Humans, Mice on Toast, and Other Marvels of Jurassic Technology*, New York: Vintage.

WEST, Richard W. (2000), 'A New Idea of Ourselves: The Changing Presentation of the American Indian,' in National Museum of the American Indian, Smithsonian Institution, *The Changing Presentation of the American Indian: Museums and Native Cultures*, Seattle, WA: University of Washington Press.

WESTFELDT, Amy (2005a), 'Founders Defend Embattled Freedom Center', *Guardian Unlimited*, 22 September.

—— (2005b), 'Museum Founders: Freedom Center will Connect September 11 to Other World Events', *Newsday.com*, 22 September.

—— (2005c), 'Museum Dropped From WTC Site for Now', *Washington Post*, 28 September.

WHITE, A. (1990), *De-Stalinization and the House of Culture – Declining State Control Over Leisure in the USSR, Poland and Hungary, 1953–89,* London and New York: Routledge.

WILLIAMS, Paul (2003), *New Zealand's Identity Complex: A Critique of Cultural Practices at the Museum of New Zealand Te Papa Tongarewa.* Unpublished PhD thesis, University of Melbourne.

—— (2005), 'A Breach on the Beach: Te Papa and the Fraying of Biculturalism', *Museum and Society,* 3(2): 81–97.

WILLIAMS, Raymond (1981), *Culture,* London: Fontana Paperbacks.

—— (1984), 'State Culture and Beyond', in L. Apignanesi (ed.), *Culture and the State,* London: Institute of Contemporary Arts.

WISE, Michael (2003), *Arts and Minds: Cultural Diplomacy amid Global Tensions,* National Arts Journalism Program, Arts International and the Center for Arts and Culture, http://www.culturalpolicy.org.

WISE, Patricia (2002), 'Cultural Policy and Multiplicities', *The International Journal of Cultural Policy,* 8(2): 221–31.

WITCOMB, Andrea (2003), *Re-imagining the Museum: Beyond the Mausoleum,* London and New York: Routledge.

WOODS, Thomas. A. (1995), 'Museums and the Public: Doing History Together', *Journal of American History,* 82(3): 1116–17.

WOODS, Tim (1999), *Beginning Postmodernism,* Manchester and New York: Manchester University Press.

THE World Factbook, New Caledonia Statistics, 1 November. 2005, http://www.cia.gov/cia/publications/factbook/geos/nc.html.

WORNUM, Ralph Nicholson (1970 [1851]), 'The Exhibition as a Lesson in Taste', in *The Art Journal Illustrated Catalogue: The Industry of All Nations 1851,* London: George Virtue.

WORTH, Katie (2005), 'Guam Plans New Cultural Museum', *Guam Pacific Daily News,* 19 August.

YOUNG, James E. (1992), 'The Counter-Monument: Memory against Itself in Germany Today', in W. J. T. Mitchell (ed.), *Art and the Public Sphere,* Chicago and London: University of Chicago Press.

—— (2002), 'Germany's Holocaust Memorial Problem – and Mine', *The Public Historian,* 24(4): 65–80.

YOUNG, Linda (1995), 'Review: The Museum of Sydney on the Site of the First Government House', *Museum National,* August: 25–6.

YOUNG, Robert. J.C. (1995), *Colonial Desire: Hybridity in Theory, Culture and Race,* London and New York: Routledge.

YÚDICE, George (1992), 'We Are Not the World', *Social Text,* 31/32: 202–16.

—— (2003), *The Expediency of Culture: Uses of Culture in the Global Era,* Durham and London: Duke University Press.

ZINN, Christopher (1998), 'Cultural Centre Symbolises Island's Birth', *Manchester Guardian Weekly,* 15 November.

ZOHLBERG, Vera (1996), 'Museums as Contested Sites of Remembrance: the Enola Gay Affair', in Sharon Macdonald and Gordon Fyfe (eds), *Theorizing Museums,* Oxford: Blackwell.

ACKNOWLEDGEMENTS

The first case study in this book began its life as the final chapter of my PhD dissertation, which was conducted through the School of Fine Arts (Art History and Cinema Studies), Classical Studies and Archaeology at the University of Melbourne. I was a recipient of an Australian Postgraduate Research Award and received awards and grants from the Ian Potter Cultural Trust, the Centre for Cross-Cultural Research at the Australian National University and the Australian Network for Art and Technology (ANAT) for research during this period.

At that time I was writing about the redevelopment plans of MoMA, engaging with the dreams and desires of the recently appointed architects and the museum staff and board as they were represented to the public in a series of rhetorical texts. This was the seed for this book and I acknowledge Chris McAuliffe for his friendship and for his supervision of the dissertation. Ross Gibson's work inspired me to contest institutional structures and frameworks and I thank him both for commenting on my thesis and for conversations since then.

I have been privileged to work over a number of years with many inspirational academics in New Zealand. I have benefited enormously from conversations with Brian Opie, Lydia Wevers, Louise O'Brien, Verica Rupar and Lincoln Dahlberg (Victoria University of Wellington), Ben Dibley (University of Auckland), Huhana Smith (Museum of New Zealand Te Papa Tongarewa), Mark Williams (University of Canterbury). Thanks in particular to the second- and third-year Victoria University media students whom I taught during this time.

The main conceptual parameters for this book emerged during 2004, when I was Postdoctoral Research Fellow in the Department of English with Cultural Studies at the University of Melbourne, supported through the Australian Research Council Discovery Project, *Four South Pacific Museums: New Museums and Public Culture*, and I thank Gaye Sculthorpe, Paul Walker and Chris Healy for the opportunity to be involved in this project. Dialogue with Chris also helped shape my thinking about the field of research and I benefited from conversations with Tony Bennett, Lissant Bolton, Deidre Brown, James Clifford, Ross Gibson, Diane Losche and Paul Tapsell – who all contributed to the *Rebirth of the Museum?* conference. Most of my travel also received funding associated with this ARC grant.

Most recently I received an Australian Research Council Special Research Centre Research Fellowship at the Centre for Cross-Cultural Research at the Australian National University. I acknowledge my colleagues and friends for their support and intellectual stimulation,

especially Carolyn Strange, Monique Skidmore, Mary Hutchison, Laurence Brown, Debjani Ganguli and Howard Morphy. I have benefited enormously from the opportunity to meet a plethora of visiting scholars attending events at the Centre for Cross-Cultural Research and Humanities Research Centre and I would like to thank Lissant Bolton, Simon During and Ghassan Hage for insightful conversations and for commenting on my work. Numerous travel grants made fieldwork possible, and I thank the University of Melbourne, Victoria University of Wellington, the Australian Research Council and the Australian National University for providing these.

I acknowledge the students and guest lecturers contributing to the graduate programme in Museums and Collections, which I convene, and am grateful for the support of Howard Morphy (Director of the Centre for Cross-Cultural Research), Adam Shoemaker (Dean of Arts at the Australian National University) and Craddock Morton (Director of the National Museum of Australia).

Tristan Palmer from Berg and anonymous readers all took the time to respond to earlier proposals and versions of this book in ways that have strengthened and solidified my argument. Thanks to Angela Philp for compiling the index.

The staff of all the museums and cultural centres that I have visited and researched must be acknowledged, particularly the Sendai Mediatheque, the National Science Museum, Tokyo, the National Museum of the American Indian at the Smithsonian Institution, the American Museum of Natural History, the American History Museum, the Museum of Modern Art New York, the Museum of Chinese in the Americas, the National Museum of Australia, the Museum of Sydney, the Museum of New Zealand Te Papa Tongarewa, and the Centre Culturel Tjibaou. These institutions also generously granted permission for me to use images, as did the Historic Houses Trust of NSW and Ray Joyce Photography.

I acknowledge permission to reprint previously published work. Chapter 2 appeared as 'The Shock of the Re-newed Modern: MOMA' in *Museum and Society*, 4(1) (March 2006): 27–50, reprinted by permission of the editorial board of *Museum and Society*. Earlier versions of portions of Chapter 5 appeared in 'Contested Sites of Identity and the Cult of the New: The Centre Culturel Tjibaou and the Constitution of Culture in New Caledonia', *ReCollections: Journal of the National Museum of Australia*, 1(1) (March 2006): 7–28, reprinted by permission of the editorial board of *ReCollections: Journal of the National Museum of Australia*; and earlier versions of portions of Chapter 6 appeared in 'Representing Cultural Diversity in a Global Context: the Museum of New Zealand Te Papa Tongarewa and the National Museum of Australia', *International Journal of Cultural Studies*, 8(4) (December 2005): 465–85; reprinted by permission of Sage Publications.

Finally, and most of all, I would like to acknowledge Oscar and Ezra Johnston who are more familiar with museums than most other 2 and 3 year olds. My parents, Jill and Bob Message have been tremendously supportive. For years Meredith Martin has been my angel and I thank her and Ewan Johnston for their intellectual partnership. Most of all I would like to acknowledge Ewan – for everything really. This book is for him.